SEEING FILM AND READING FEMINIST THEOLOGY

A DIALOGUE

Ulrike Vollmer

palgrave
macmillan

First published in 2007 by
PALGRAVE MACMILLAN™
175 Fifth Avenue, New York, N.Y. 10010 and
Houndmills, Basingstoke, Hampshire, England RG21 6XS.
Companies and representatives throughout the world.

PALGRAVE MACMILLAN is the global academic imprint of the
Palgrave Macmillan division of St. Martin's Press, LLC and of
Palgrave Macmillan Ltd. Macmillan® is a registered trademark in the
United States, United Kingdom and other countries. Palgrave is a
registered trademark in the European Union and other countries.

ISBN-13: 978-1-4039-7435-8
ISBN-10: 1-4039-7435-7

Library of Congress Cataloging-in-Publication Data

Vollmer, Ulrike.
Seeing film and reading feminist theology : a dialogue/Ulrike
Vollmer.
 p.cm.
 Includes bibliographical references and index.
 ISBN 1-4039-7435-7 (alk. paper)
 1. Motion pictures–Religious aspects. 2. Feminist film criticism.
3. Feminist theology. I. Title.

PN1995.5.V65 2007
791.43′682–dc22 2007060043

A catalogue record for this book is available from the British Library.

Design by Macmillan India Ltd.

First edition: September 2007

10 9 8 7 6 5 4 3 2 1

Printed in the United States of America.

SEEING FILM AND READING FEMINIST THEOLOGY

To my parents,
Reinhold and Ursula

CONTENTS

LIST OF IMAGES

ACKNOWLEDGMENTS

This book owes much to the support, encouragement, and interest of others. I would like to thank, first of all, Professor J. Cheryl Exum, for her careful and diligent work on much of this text, for her presence of mind, her enthusiasm, and her continuing professional support. I also wish to thank Professor David Jasper for his input, encouragement, and help with this project, as well as for ongoing professional support. Also, I would like to thank Sally Potter for giving her valuable time to meet me, and for the permission to include the interview in this book. A big thank-you goes to the Department of Theology and Religious Studies at the University of Wales Lampeter for allowing me the freedom to complete the manuscript, and to my colleagues here who have made my time in Wales so enjoyable. I also wish to thank the editor at Palgrave Macmillan, Amanda Johnson Moon, and the editorial team for their interest in this project as well as their straightforward and flexible working style.

I owe many thanks to friends and family. Thanks go to all my friends who have had an interest in this book, including friends in Germany and those I have met during the completion of this text in Sheffield and Lampeter. Finally, I owe a very big thank-you to my parents, Reinhold and Ursula Vollmer, without whose support in various ways this book could not have been written, and to my husband, Dr. Peter Fearon, for his belief in me, his encouragement, and his unfailing optimism.

INTRODUCTION

Seeing and being seen deserve consideration as existential, human experiences. They cannot be avoided as they represent ways of human contact in everyday life. And yet, seeing and being seen have not been at the forefront of public awareness in the same way as, for example, touching and being touched have been. Most of us are well aware of the importance and the healing qualities of touching and being touched, and also of the immense potential damage that is caused by being touched against one's will. We see and are seen every day, and, as with touching, seeing has the potential to be healing or damaging, depending on the way in which one sees. I ask in this book what it means to see and to be seen, and I discuss in the process both positive and negative ways of seeing—positive ways that are respectful of that which is seen, and negative ways that are potentially damaging to the being that is opposite, the being upon which the gaze is resting.

Even though seeing and being seen have not been at the center of public awareness, there has been plenty of consideration, both in twentieth-century philosophy and feminist film theory, of the question what seeing and being seen mean. I begin this book, therefore, by taking stock of some twentieth-century philosophical texts on the topic of vision, and of the discussion of seeing within feminist film theory. The main part of the book and its main aim, however, consist in considering the question what it means to see from the point of view of feminist theology and of film, and to bring feminist theology and films into a fruitful dialogue with each other. This endeavor rests on the assumption that seeing and being seen describe a relationship, an assumption that forms the basis of the entire book.

To ask what it means to see and to be seen is not to ask a question about one person or another person, about one person who sees, or another who is seen, but is to ask a question about the relationship between the two, between the person who sees and the person who is seen or the "thing" that is seen, between the person who sees and an aspect of the visible world. Vision cannot happen in an empty space; it is no use to direct a look unless it is directed at something that shows itself. Vision always binds in a relationship those who see with what they see.

In philosophy, vision has been used frequently as a metaphor in order to describe the relationship that is thought to exist between human beings and the world they live in. It is the way in which the visual relation has been theorized philosophically that forms the beginning of this book. (That philosophical writings have often employed vision specifically as a metaphorical expression of "man's" relation to the world will become clear later.) This fact, the fact that vision is an expression of a relationship, brings vision close to the heart of much feminist theological thinking. In many texts related to feminist theology, great emphasis has been placed on the theme of relationality, as I will show. Relationships can be very varied in kind—beneficial or not to those who participate in them—and texts written from a feminist theological viewpoint have therefore been describing the particular kinds of relationships that are meant to exist, from a theological and a feminist viewpoint, between human beings and the world they perceive themselves in.

Relationships are expressed and given shape through the senses, through the way in which human beings are in contact with the surrounding world by means of their ears, eyes, and sense of touch. Indeed, one cannot describe a relationship as such, but can only understand the nature of a person's relationship to their environment by way of describing how this person relates through their senses, by observing how they hear, how they see, how they touch, and how they conduct their bodies in relation to other bodies. In this sense, a person's bodily way of relating through their senses is a manifestation—*the* manifestation—of the relationship they perceive between themselves and the world. Therefore, when considering the question what it means to see in this book, I am considering the issue of relation, and I take seeing and being seen as one manifestation in which relation is expressed.

In the first chapter of this book, I deal with various texts of twentieth-century philosophy that develop concepts of vision. All of these make the point that the experience of being seen, although a necessity

for the development of human identity, has negative consequences for the person who is seen, as he or she will be objectified by the gaze of the—normally unseen—Other. In these texts, seeing and being seen, I will show, implies a relationship of power on the part of the seeing subject over a powerless, seen object. While I begin this book by discussing these concepts of vision, which put a negative value on the act of seeing, it is my intention with this book to develop an alternative, more positive way of thinking about the experiences of seeing and being seen.

Feminist film theory, which will play an important part in my film interpretations later in this book, will first be introduced in chapter 2. In this chapter, it will become clear that feminist film theory, to some extent, continues from the philosophical texts discussed in chapter 1, as it considers the act of seeing in cinema as one of objectification and domination of what is seen by a director through the camera, and later by the viewers on the screen. Feminist film theory differs from the philosophical texts discussed in chapter 1 in that it considers the objectification of the seen person through the seeing subject as a gender imbalance, in which the image of the woman on the screen is defined by, and subordinated to, an all-powerful male gaze.

Neither the philosophy nor the feminist film theory I discuss offers much hope for recognizing in the act of seeing a positive act. In the main part of this book—the discussion of feminist theology and the film interpretations—I work toward an alternative concept of vision in which seeing and being seen, if carried out in a certain way, are an expression of a mutual relationship and not of objectification. I develop my understanding of vision through the interaction of feminist theology and film.

In feminist theology, which will be discussed separately in chapter 3 and brought in contact with the films in the remaining chapters of the book, the act of looking is not at the forefront in the same way in which this was the case in philosophy as well as in feminist film theory. And yet, because seeing is an act of relating, there is a strong connection between feminist theology, philosophy, and feminist film theory. In asking what it means to see, I ask for the relationship between what is in front and what is behind the camera. My discussion of feminist theology in this chapter is of a more general nature and covers aspects that I will build on later in the film interpretations. Thus, chapter 3 will outline a feminist theological understanding of mutuality in relation, of the term "redemption" understood as mutual relation, of women's creativity understood as a shaping of the world in positive ways, and of the worth of the visible world.

I develop my understanding of vision through engaging with film because film, as an art dependent on the act of seeing, most definitely has an important contribution to make to any discussion of vision, a contribution, moreover, that is enriched with practical experience. In order to provide a counterbalance to the male gaze, which has been theorized as objectifying, I interpret in this book three films with a female artist as the main character, two of which are directed by women. This allows me to examine whether women look in a different way, and whether their acts of seeing can contribute toward a more positive understanding of vision.

Camille Claudel (Bruno Nuytten, 1988), which I discuss in chapter 4, shows some of the life of the French, late nineteenth-century sculptor Claudel and contributes toward my discussion an awareness of the problems that women who have claimed the gaze in order to work as artists have been facing. *Artemisia* (Agnès Merlet, 1997), which will be discussed in chapters 5 and 6, is based loosely on the life of Italian Renaissance painter Artemisia Gentileschi. This film illustrates a number of the concerns discussed in the chapters on philosophy and feminist film theory, while also drawing attention to three major elements on which a more positive concept of vision might be based. Finally, *The Tango Lesson,* in my interpretation in chapters 7 and 8, picks up on the elements of vision that I draw from the discussion of *Artemisia,* and it develops these to an extent that allows me to formulate a more positive view of seeing and being seen.

It is important to emphasize that the development of my concept of vision does not arise from feminist theology only, but that it is carried out as an interdisciplinary project that owes as much to the films that I discuss as it does to feminist theology. For this reason, it is essential at this point to consider briefly how a dialogue between films and theology should function, as well as to explain and justify my methodology for analyzing and interpreting the films.

Out of the concern that theology reaches fewer and fewer people, a growing number of theologians over the last 30 years or so have sought dialogue with film, hoping that this dialogue might help theology to be better understood in contemporary society. While this book is situated partly within the field of feminist theology, it is also a contribution to the area of film and theology. Because this book contributes to the area of film and theology, I will outline some theological trends of interacting with film, so that I can situate my own approach clearly within this field of study.

Numerous writings engaged with film from a theological viewpoint employ the term "dialogue" for their attempts at bringing film

and theology closer.[1] This dialogue, however, is carried out in varying ways, and the authors are thus not unanimous in their understanding of the term "dialogue."

Two approaches can be delineated. One group of authors searches for religious themes and symbols in the films they discuss. They look for themes and symbols that are of particular importance in a theological tradition, such as the themes of "grace," "guilt," or "redemption," or the symbol of the cross. In their writings, the authors identify where these themes and symbols occur in the films. One difficulty of this approach lies in the fact that authors often take their theological understanding of these themes or symbols for granted and neither properly explain nor reevaluate it through the dialogue with film.[2] A second difficulty of the approach in discussion lies with locating theological themes or symbols simply at particular stages in a film plot without interpreting the entire film. This practice bears the danger of misunderstanding the meaning associated with a point in the plot because the meaning of a particular element within a film can only be determined from the context of the entire film. For this reason, I interpret the films I deal with in this book as whole films and in detail.

In contrast to the approach just described, in which theological terminology is not explained enough, another group of authors explains in too much detail what they mean when using a theological term. The danger, here, is to subordinate films to theology by using them merely as an illustration of theology. In this book, I will detail the theological viewpoint from which I proceed, but I will also allow this viewpoint to be questioned through the interdisciplinary encounter with film. In the process of this work, both the worldview inherent in the films and theology will come under scrutiny and it is hoped that both sides benefit from the insights of the other. In this way, I hope to avoid using the films as illustrative material for a theological concept.

Also, it is not conducive to a dialogue to think about films in nonappreciative terms, for example, as "low culture," which is opposed to the "high culture" of theology or a biblical text.[3] If films are seen in this light, they cannot be conversation partners in dialogue with theology, because avenues of respectful communication are closed down. Basic to my work is an attitude according to which culture is an entity that cannot be divided into high and low culture. I therefore consider films and theology as equal representatives of culture, and I will approach film as an art form that can share with theology ways of thinking about the world and about human beings.

Since there exists such a variety of approaches under the phrase "dialogue between film and theology," what does the term "dialogue" actually imply? The term describes a discussion between equal partners of a theme or question. In a dialogue, both partners have their view with regard to the question, but they have the explicit interest to review their opinions through the dialogue. If I understand "dialogue" in this sense, a number of ways of dealing with film are ruled out. First, an attitude that puts film in a subordinate position as "low culture" while identifying theology as "high culture" is ruled out, because in this approach the dialogue partners are not equal. Furthermore, theologians who wish to be in a dialogue with film cannot declare the task completed when they have detected theological themes in a film. Influenced through the dialogue with film, they need to reflect on their theology. Additionally, theologians in dialogue with film will not use films simply to illustrate a preconceived, theological opinion. Instead, they will allow film to contribute to their thinking.

If one wishes to enter a dialogue with film from a theological perspective, a clearly stated question can help to avoid the problems mentioned. This question serves to foreground one's theological interest on the one hand, and, on the other, guarantees that films are not simply used as illustration of a preconceived, theological view. To begin a dialogue with a question means that one is involved, as I am in this book, in a process of discovery, during which one hopes to learn from film.

In order to enter a dialogue with film, one needs to be able to access the meaning contained in a film. For this, an appropriate methodology is required, one that takes film seriously in its own right as a work of art, and as distinct from other art forms. But how can one extrapolate meaning from a film? In order to answer the question, a brief look at how a film creates meaning is helpful. In *Language and Cinema,* Christian Metz considers film as a textual system that creates meaning through combining codes (the combination of signifier and signified, of a sign with its meaning) in a certain manner. Some codes employed by film are specific to the medium of film. Montage, for example, the process of cutting and editing strips of film together, occurs only in the cinema. Metz calls this kind of code a "cinematic" code. But film also contains a large number of what Metz calls "extra-cinematic codes,"[4] codes that originate from other language systems.[5] Film uses the code of images from within the language systems of painting and photography, it employs the language system of music and sounds, it uses language in the dialogues, and it employs the code

of gesture from within the language system of theater. Some films employ codes that originate from a religious context.

When interpreting a film, it is tempting to rely solely on the extra-cinematic meaning of codes because this meaning is, to an extent, fixed and readily accessible, especially when a theologian is dealing with codes that originate from a religious context. But because codes in a film are combined to form a coherent textual system, the meaning of the codes in a film might differ from the meaning the same codes have in other contexts.[6] Metz calls the process by which codes from a particular context are removed from their original place and put in a new, filmic context "displacement."[7] More than simply combining codes, a film furnishes them with new meaning. And while integrating several codes, it cannot be reduced to any one of them. Metz points out that a film analysis has to cover the overall structure as well as particular codes in a film because each film arrives at its meaning only through the particular way in which it combines all its codes. Therefore, when interpreting a film, one cannot simply pick out certain themes or symbols without relating them to the film as a whole, because the meaning of a code within a film is only accessible through the overall combination of codes. The overall meaning of a film cannot be deduced from a few codes employed by the film, and the meaning of a particular code within a film can only be established by considering it in the context of the entire film.

For this reason, I have chosen to analyze the films *Artemisia* and *The Tango Lesson,* which contribute most toward my concept of vision, in detail before bringing them in dialogue with theological texts. There are two chapters, therefore, dealing with each of the films. Chapters 5 and 7 are based on a detailed film analysis carried out prior to the writing of this book. Both chapters present an interpretative report on the results of this analysis that forms the basis of the theological interpretation of the films. Chapters 6 and 8 engage films and theological texts in a dialogue on the question what it means to see by interpreting and bringing in contact those aspects of the films and the texts that contribute toward a concept of vision.

In order to analyze the films, I used a methodology developed by Johan G. Hahn that is aimed at detecting elements of worldview in a film. While taking into account a variety of specific features of film, this method is very flexible and can be tailored toward a particular question that one asks of the film.[8] In order to access meaning, Hahn analyzes films with an emphasis on their form and content. A film's images are made of particular iconic elements (the iconic content) that are combined in a particular visual form. The narrative of a film

also has content and form. A narrative, according to Hahn, contains narrative elements, such as characters and actions, and combines them in a particular form.[9]

With his method of emphasizing both content and form, Hahn treats film in Metz's sense as a combination of extra-cinematic and cinematic codes. Hahn's term "contents", similar to Metz's extra-cinematic codes, designates iconic and narrative elements in a film that come from other language systems. The meaning of Hahn's term "form" corresponds with Metz's cinematic codes, because it describes the way in which a film combines the elements it employs.

In practice, Hahn's method is designed like a toolbox out of which an analyst can choose tools for the analysis of a particular film. Hahn emphasizes the need to begin by asking a question, as I have done above. Through the choice of modules, the analyst can adjust the process of analysis to suit her question. In this sense, the process of analysis is quite subjective, but openly so. Each analytical tool concentrates on one aspect of a film, for example, on character development or the background of the picture, and it consists of a list of questions that helps the analyst to pay attention to one aspect in detail and throughout the whole film.

For both *Artemisia* and *The Tango Lesson*, I began with a shot analysis, which, according to Hahn, is essential. In this analysis, every shot is characterized briefly in written form. This requires interruption of the viewing process. Although time-consuming, this examination is important when watching a film for more than entertainment purposes. When watching a film uninterrupted, viewers will perceive it selectively, remembering details according to their personal interests, momentary mood, and previous experiences. The interrupted viewing of the shot analysis forces the analyst to watch the film more consciously and it disables, to some extent, the unconscious censor inside the viewer.

Following the shot analysis, I structured the film by combining several shots into units, as Hahn suggests.[10] A unit is, for example, a conversation recorded in several shots from different perspectives. This procedure follows the natural way of perceiving film, in which viewers combine shots instantly into meaningful units. The shot analysis carried out at the beginning transforms this automatic process of meaning making into a more conscious one. Also, the combination of shots into units yields a film protocol that makes it easy in the interpretation to refer to particular units.

When attempting a detailed film analysis, however, it is important to keep in mind that even the most detailed analysis will never

provide a "complete" understanding of a film. A single film contains such a multitude of visual and audible details that no analysis can ever explain them all. Nevertheless, a detailed analysis makes sense because its purpose is not to allow for complete understanding but to allow for a coherent interpretation. Even after a detailed analysis, one will find that various interpretations of the material are possible. No matter how many details one examines and includes in a film interpretation, one can still glimpse different possible interpretations based on the same details. In the case of the films I discuss in this book, I decide for one way of fitting the details together, not in an attempt to present the only possible, but a coherent interpretation.

CHAPTER 1

---❋---

SEEING AND BEING SEEN: A
PHILOSOPHICAL VIEW

Throughout the twentieth century, vision has been part of the thinking of a number of philosophers and psychoanalysts. In this chapter, I discuss some of the works of Jean-Paul Sartre, Michel Foucault, Jacques Lacan, and Emmanuel Levinas. What will be exposed in this exploration of philosophical concepts of vision is the type of relation that is implied in each of them; the way in which they theorize both the spectator and the one who, or that which, is seen; the way in which they conceptualize the effect of the visual relationship on each of its participants.

A number of elements are common to the philosophies under discussion in the following section. In general, the final outcome of all of the philosophies discussed is that seeing and being seen are theorized as a relationship of inequality, rather than one of mutuality. Although this main argument is of course structured in differing ways by different philosophers, some similarities can nevertheless be recognized even in the ways in which the main and final argument is established. Thus, four elements are characteristic of several of the approaches under consideration.

First, seeing and being seen are theorized as a subject-object relation. To see means to be the subject at the center of the world(view), whereas being seen means to be an object that exists within the world of, and for the benefit of, the subject. The seeing subject is considered to be in a position of dominance over the seen object, which is defined in terms of the subject's needs. None of the approaches discussed envisions the possibility of seeing and being seen as a

relationship between two subjects. Second, the position of the seeing subject is theorized as one of invisibility, an invisibility that establishes and helps maintain the subject's power over the object that is seen. The fact that the object is merely seen and cannot return the look of the subject underlines the lack of mutuality in the relationship of the look. The way in which all approaches arrive at a concept of the seeing subject as invisible is through dissociating the act of looking from the human body and describing it as an abstract category (as look or gaze). Third, the look of the seeing subject defines in its identity the object that is seen. In this sense, the object needs the subject for its very being, even though at the same time the subject's look defines the object as object. To be seen, although it means being objectified, is necessary in order to be at all. Being seen thus appears to be an evil that is absolutely necessary. Fourth, the fact that seeing and being seen are thought of in negative terms also manifests itself in a preference for other forms of human contact and relation (in particular, speech). It has to be said that not all of the philosophies discussed below argue every single one of the four points just described. Nevertheless, they do manifest striking similarities with regard to various of the above-mentioned four tendencies.

JEAN-PAUL SARTRE

Sartre reflects on what it means to see and to be seen in his work *Being and Nothingness: An Essay on Phenomenological Ontology*.[1] For Sartre, relationships cannot be subject-subject relations but always take the form of subject-object relations, and the look of the Other is instrumental in his definition of relationships as subject-object patterns. In short, Sartre argues that I understand the Other as subject and myself as object in the instant when I understand that the Other is looking at me. Through the look of the Other, I come to realize that there is a difference between the world as I see it from my viewpoint and the world as seen by the Other from his viewpoint.[2] I may want to perceive the world as relating to my own being at the center; I may wish to see objects around me as objects that are at a distance from, and relating to, my own eyes, but as soon as I realize the presence of the Other who sees, my being as subject at the center of my world is questioned. When I realize that the Other is looking at me, I realize that he has his own viewpoint of which I am not the center, but in relation to which I become an object. The Other sees me as one among various objects that are at a distance from, and relating to, his own eyes.[3] When I apprehend the look of the Other, I realize that

I am no longer a subject, but an object in the world that the Other sees and orders toward his own presence as central. The presence of the Other who sees me decenters my worldview, so that I can no longer be a subject for myself but only an object for the Other.

According to Sartre, I learn that not I but the Other is subject in the moment when I am seen: "If the Other-as-object is defined in connection with the world as the object which sees what I see, then my fundamental connection with the Other-as-subject must be able to be referred back to my permanent possibility of being seen by the Other," argues Sartre. When I am seen by the Other, I am placed as one object among other visible objects that the Other sees, and the Other's ability to place me as one object among many makes him a subject. I learn that the Other is subject only through acknowledging my own object state: "It is in and through the revelation of my being-as-object for the Other that I must be able to apprehend the presence of his being-as-subject."[4] To be sure, there is the possibility of the I not to be seen by the Other as subject, but to see him as object instead. But this objectification of the Other is only an attempt on the part of the I to protect itself from the Other's objectifying look: "The objectivation of the Other . . . is a defense on the part of my being which, precisely by conferring on the Other a being for-me, frees me from my being-for the Other."[5] With this, Sartre makes the point that there can be no mutual relationship between two subjects. While roles might be exchanged, there always will be a subject and an object in any relationship, and the look of the other person plays an essential role in Sartre's thought concept as both cause and manifestation of the subject-object relation between the I and the Other.

Apart from the consideration of seeing and being seen as a subject-object relationship, Sartre's work also manifests the second tendency mentioned above, the tendency to theorize the position of the seeing subject as one of invisibility. Sartre arrives at this theoretical position by making a distinction between the eye and the look. The eye is a bodily organ, but the look is not necessarily attached to the human body. A look, says Sartre, can be directed at us through a pair of eyes, but also from the window of a farmhouse in the distance, from a secret spot hidden away by branches and leaves, or from behind a curtain. Sartre places the eyes in one category with the farmhouse, the bush, and the curtain as "support for the look," thereby detaching the look itself from the tools of support through which it can manifest itself.[6] The eyes are a visible organ, but the look is invisible. In fact, Sartre argues that once we perceive the look of the Other, we are no longer able to see his eyes. The look overwhelms us to such an

extent that we no longer see the eyes of the Other as green or blue, as beautiful or ugly.[7]

The distinction between the eyes and the look accounts for the fact that the relation between the I and the look is not mutual. I can be looked at in my bodily being, but I cannot see the look. I can look at objects around me, but I cannot be conscious of a look and respond to it. Sartre writes:

> We can not perceive the world and at the same time apprehend a look fastened upon us; it must be either one or the other. This is because to perceive is to look at, and to apprehend a look is not to apprehend a look-as-object in the world . . . ; it is to be conscious of being looked at.[8]

Mutuality between the I and the Other through whom the I encounters the look is thus impossible, because the eyes are visible, but Sartre's category of look is not. It is a somewhat abstract category of which we can be aware but to which we cannot relate as to something we could see.

The look that I suspect might be directed at me through the farmhouse window or from behind the bush, even though I do not see it, reminds me of my visibility. When I hear the rustling branches, even if I do not think of someone there, I think of myself as being seen. And being seen, according to Sartre, means "that I am vulnerable, that I have a body which can be hurt, that I occupy a place and that I cannot in any case escape from the space in which I am without defense."[9] Being seen, in other words, reminds me of my bodyliness and confines me to a place.

The lack of mutuality in the relationship of seeing and being seen is also due to the fact that, on the one hand, the look is distanced from me insofar as I cannot see it, while on the other, I perceive the look directly upon me as a consequence of the fact that it is not connected to the pair of eyes located within the body of the Other at a distance. Being seen, I perceive the effect of the Other's look directly on the surface of my body, but I do not have the same effect on the Other who sees. The response on the part of the I to the penetrating look of the Other is a feeling of shame—not of shame in relation to a particular incident that the Other disapproves of, but of shame in relation to the I's very being as object: "Pure shame is not a feeling of being this or that guilty object but in general of being an object; that is, of recognizing myself in this degraded, fixed, and dependent being which I am for the Other."[10]

The look of the Other that causes this feeling of shame is not of a temporary nature but, because of its invisibility, has a permanent quality. Even though the Other might not always look, Sartre points out that the I perceives itself as permanently seen. The look of the Other and the feeling of being seen refers the I to the Other's existence: "On the occasion of certain appearances in the world which seem to me to manifest a look, I apprehend in myself a certain 'being-looked-at' with its own structures which refer me to the Other's real existence."[11] At the same time, however, the Other does not have to be there in order for the I to feel permanently looked at. Sartre writes: "It is possible that I am mistaken; perhaps the objects of the world which I took for eyes were not eyes."[12] And later: "What is certain is that I am looked-at: what is only probable is that the look is bound to this or that intra-mundane presence."[13] Thus, whether or not the Other is in fact permanently there to watch the I does not make any difference to the fact that the I feels permanently seen by him. He may be absent, but the I still feels his observing presence.

How can this be? In order to argue why this is the case, Sartre explains absence as a form of presence. Absence as a term, he maintains, relates specifically to human relationships because absence can be perceived only by human beings. A person can be absent only if he or she was once present. In this sense, presence is a precondition to absence, and absence one of the manifestations of the original presence: "Absence . . . is a bond of being between two or several human-realities which necessitates a fundamental presence of these realities one to another and which, moreover, is only one of the particular concretizations of this presence."[14] This argument allows Sartre to assume that the Other is always present even in the form of his absence, and that for this reason the I feels permanently seen by the Other. Being permanently seen by the Other who cannot be seen is, according to Sartre, an inescapable fact of life.

In addition to theorizing the relationship of seeing and being seen as a subject-object relationship, and as a relationship in which the seeing subject is invisible, Sartre also establishes the point that being seen means to be defined by the seeing, invisible subject. In addition to the first two, his work thus also manifests the third of the four tendencies outlined at the beginning of this chapter. The I, according to Sartre, is defined as object by the Other, especially through his look. Sartre makes this point by describing and analyzing an I who is engaged in the act of looking through a keyhole. Yes, the I can be described as "being" while it is looking—and unobserved. But the I can only

know itself and be conscious of itself when footsteps approach, footsteps that announce the presence of the Other who observes the I in the act of looking through the keyhole. Only then can the I understand itself and know itself as looking through a keyhole.[15] In the instant when the Other's eye is directed toward the I engaged in looking through the keyhole, the I is transformed from "being" to being an object within the Other's view. Thus, according to Sartre, the way in which the I can gain self-consciousness is by looking at itself as though at an object, through the eyes of the Other.

This, in turn, means that the I that desires to know itself is entirely dependent on the Other. "In order for me to be what I am," writes Sartre, "it suffices merely that the Other look at me."[16] Sartre points out that it is impossible for the I to acquire its objectness by itself. While, in order to be self-conscious, I have to be an object, I cannot achieve this object state out of my own powers, but am dependent on the Other to define me as an object. Sartre writes: "The Other reveals to me the impossibility of my being an object except for another freedom. I can not be an object for myself . . . For me the Other is first the being for whom I am an object; that is, the being through whom I gain my objectness."[17]

The self which I am given by the Other through his look is a self, however, that I will never know, a self that will always escape me, because I will never be able to see myself in the way in which the Other sees me (as sitting on a chair, for example). Thus, in the same moment in which I gain self-consciousness, I am alienated: "All of a sudden I am conscious of myself as escaping myself," writes Sartre, "not in that I am the foundation of my own nothingness but in that I have my foundation outside myself. I am for myself only as I am a pure reference to the Other."[18] Sartre distinguishes between "being-for-myself" and "being-for-others" and explains that both states of being are separated through an impassable nothingness that cannot be overcome by the I. He writes: "My being for-others is a fall through absolute emptiness toward objectivity. And since this fall is an alienation, I can not make myself be for myself as an object; for in no case can I ever alienate myself from myself."[19] The being that I am for the Other, even though it is a form of my being, therefore is a being that will always flee from me and will never be my own.[20]

What is at stake in this definition of the self through the Other, then, is not the self, but the freedom of the Other. Sartre's outlook on what it means to be seen is bleak: "Being-seen," he states, "constitutes me as a defenseless being for a freedom which is not my freedom."[21] In the

final conclusion, being seen means to lose one's transcendence, while the transcendence of the Other remains. In fact, according to Sartre, "the Other as a look is only that—my transcendence transcended."[22]

Seeing and being seen, in summary, is for Sartre a relationship of subject to object, in which the seeing subject is invisible and transcendent and the seen object visible and transcended by the subject's transcendence. Being seen means to be objectified, and this objectification is at the same time absolutely necessary in order to have self-consciousness and alienating, because the I's objectness is always beyond its own reach as it is given to it by the Other. On no account can seeing be recognition of the Other as subject.

Michel Foucault

Foucault presents many of his views on seeing and being seen through his considerations of the panoptic machine in his work *Discipline and Punish: The Birth of the Prison*.[23] Designed by Jeremy Bentham during the eighteenth century, the panoptic machine, or "panopticon" is a prison that functions through surveillance. Foucault summarizes Bentham's ideas: The panopticon has a circular structure, in which a ring of cells is arranged around a courtyard with a watchtower in the center. Each of the cells has two windows, one facing toward the watchtower, the other facing the opposite way, toward the outside of the circular building. The effect of backlighting achieved through this setup allows the person in the central watchtower to see the prisoners in the cells at all times.[24] The cells are separated from each other by a wall without windows. Thus, two factors are central to the panopticon: the total visibility of the prisoners to the surveyor in the watchtower, and the total invisibility of the prisoners to one another. In the panopticon, the prisoners are both individualized and observed.

It is essential to note that, for Foucault, the panopticon is not simply a prison but, much more generally, an architectural image of a type of society. In order to trace the origins of the panopticon as an architectural form, Foucault compares a society faced with the threat of plague with a society confronting the threat of leprosy. Societies faced with leprosy respond, according to Foucault, with policies of confinement and exclusion. The objective is to maintain a pure society, and in order to achieve this, all lepers are excluded. Thus, those who are excluded, despite being excluded, are still part of a group on the outside of "pure" society, part of an excluded mass.[25] With the arrival of

the plague threat, however, strategies of exclusion and confinement give way to strategies of individualization and observation that allow for control "from a distance," without direct, human contact.

Exclusion and confinement, as well as individualization and observation, can both be described as subject-object structures in which those who exclude and those who individualize are the powerful subjects, while those who are excluded and those who are individualized are the objects. The difference between both structures is, however, that seeing and being seen are infinitely more important in a societal structure of individualization and observation. Through a detailed account of rituals of quarantine that were set up in response to the plague, Foucault illustrates how the observation of individuals who were separated from each other helped to maintain order and discipline. In this order, those who observed (and those on whose behalf the observation was carried out) were the subjects in power, whereas those who were observed were the afflicted objects. Control was more easily established in quarantine because the observed and potentially afflicted were no longer part of an excluded but uncontrollable mass, but were individualized and prevented from contact with one another. Foucault describes the disciplinary mechanism of quarantine thus:

> This enclosed, segmented space, observed at every point, in which the individuals are inserted in a fixed place, in which the slightest movements are supervised, in which all events are recorded, in which an uninterrupted work of writing links the centre and periphery, in which power is exercised without division, according to a continuous hierarchical figure, in which each individual is constantly located, examined and distributed among the living beings, the sick and the dead—all this constitutes a compact model of the disciplinary mechanism. The plague is met by order; its function is to sort out every possible confusion: that of disease, which is transmitted when bodies are mixed together; that of evil, which is increased when fear and death overcome prohibitions.[26]

Foucault points out that it is not the case that structures of individualization and observation are introduced at the threat of plague and subside after the plague has retreated. He argues that, while the presence of lepers has established the practice of confinement as a response, the threat of the plague has given rise to a disciplined society that, far from disintegrating after the plague was overcome, has stayed in place. In fact, the "perfectly governed city" is considered by

Foucault to be the political utopia behind the arrest of the plague,[27] and the plague did not even have to be "real" in order for this society to take shape:

> In order to see perfect disciplines functioning, rulers dreamt of the state of plague. Underlying disciplinary projects, the image of the plague stands for all forms of confusion and disorder; just as the image of the leper, cut off from all human contact, underlies projects of exclusion.[28]

More than "just" a prison, Bentham's panopticon is an architectural image of this kind of society, in which discipline is maintained through individualization and surveillance. In this society, seeing and being able to survey means being in the position of a powerful subject, whereas being seen means to be an object of surveillance. The power of the state is maintained through surveillance of those who are part of it.

Apart from ascribing total visibility to the prisoners, the panopticon also makes the position of the seeing subject one of invisibility. In order to make the supervisor in the watchtower invisible, Bentham suggests venetian blinds within the tower and a system of partitioning the inside of the tower so that there is no backlighting. The panopticon is thus an architectural manifestation not only of the subject-object relation between those who see and those who are seen, but also of the fact that seeing is considered to be a position of invisibility. In similarity with Sartre's, and, as I shall explain later, Lacan's concepts of vision, Foucault distinguishes between the eye as part of a human body and a disembodied notion of the surveying power.[29] Referring to Bentham, he explains that through making the surveyor invisible, the watchtower of the panopticon makes power visible but unverifiable—visible because the watchtower is always present and the prisoners thus always aware of the surveying power, but unverifiable because the prisoners can never know whether or not they are being watched at a particular moment, and can never actually see the person who is looking.[30]

Due to the invisibility of the surveyor, the power of the surveying gaze becomes detached from any particular human body. Foucault argues that the panopticon as an architectural apparatus is "a machine for creating and sustaining a power relation independent of the person who exercises it."[31] In other words, while it is essential to this power relationship that the power of surveillance be permanently present to the prisoners, it does not matter who exercises this power at any

moment, or indeed whether anyone exercises it at all—surveillance is a system that exercises itself and has no need of any particular human body to carry it out. The power of surveillance does not depend on the presence of a particular pair of human eyes; it is "disindividualized" and can be operated by anyone who is ready to step in and work the machine.[32]

The object under surveillance in the panopticon is, like the object exposed to the look as understood by Sartre, defined in its objectness through the fact that it is seen. The purpose of the panopticon, writes Foucault, is "to induce in the inmate a state of conscious and permanent visibility that assures the automatic functioning of power."[33] By being seen, in other words, the inmate is defined as an object of power. And because the panopticon makes the visibility of the inmate permanent, the inmate's definition as object of power is permanent, too. In fact, inmates internalize their permanent subjection to the surveying power to such an extent that power need no longer be exercised. The panopticon functions by arranging things in such a way "that the surveillance is permanent in its effects, even if it is discontinuous in its action; that the perfection of power should tend to render its actual exercise unnecessary."[34]

The effect of the panopticon is to shape the object of surveillance in such a way that it includes the role of the surveyor as its own, internal function. The object responds to the permanently invisible, surveying power by assuming responsibility for its own objectification and by playing two roles simultaneously—that of the object and that of its surveyor: "He who is subjected to a field of visibility, and who knows it, assumes responsibility for the constraints of power; he makes them play spontaneously upon himself; he inscribes in himself the power relation in which he simultaneously plays both roles; he becomes the principle of his own subjection."[35] The definition of the inmate as object within the panopticon is thus arranged to maximum efficiency, since the presence of a surveyor opposite the object is no longer required. Through the setup of vision within the panopticon, objects define themselves as objects on behalf of a surveying subject whose actual presence is irrelevant for the process of objectification.[36]

It is important to note that the panopticon is considered by Foucault to be more than simply a type of prison. The panopticon, even though based as an architectural shape on disciplinary strategies that were developed in response to the fear of the plague, is quite different from those disciplinary strategies. The disciplinary measures of quarantine were established in response to the specific situation of the plague. The panopticon, by contrast, has much wider, societal

applications as a "generalizable model of functioning; a way of defining power relations in terms of the everyday life of men."[37] Foucault makes two points. He argues first that rather than only in prison circumstances, the panopticon is used as a disciplinary machinery wherever a particular task or form of behavior has to be imposed on many individuals. Thus the panopticon, according to Foucault, is an effective model for understanding educational and medical institutions, as well as the supervision of industrial production.[38] Subject-object structures of seeing and being seen are to be found in many societal institutions.

Foucault's second, more general point is that panopticism is useful as a concept for explaining modern society. He outlines how disciplinary mechanisms have been extended in three ways, arguing that these mechanisms are not only operative within certain societal institutions, such as hospitals, schools, and prisons, but are all-pervasive throughout society in general. First, the function of discipline has been extended from disciplining only those individuals who have broken rules to disciplining all individuals in order to produce useful members of society.[39] Second, disciplinary mechanisms in modern society are no longer carried out only within certain institutions, but are carried beyond institutions such as schools and hospitals into society by individuals who observe others' ways of life in order to ensure that it is "correct."[40] Third, the police force, which is acting on behalf of the state, has moved from disciplining individuals whose behavior is out of order to establishing a system of secret information-gathering about "suspicious" persons and possible plots.[41] Surveillance and discipline are thus all-pervasive in modern society, and Foucault concludes that "one can speak of the formation of a disciplinary society in this movement that stretches from the enclosed disciplines, a sort of social 'quarantine', to an indefinitely generalizable mechanism of 'panopticism.'"[42]

In summary, seeing and being seen do not offer any possibilities for a relationship of equality between two subjects in Foucault's approach. The act of seeing, no longer connected with human eyes, is a metaphor for a society of surveillance, while being seen is a state of objectification as a target of surveillance. Seeing while remaining unseen is, in Foucault's concept, a most efficient way of establishing discipline and order, because those who are seen in this way internalize the surveying gaze to such an extent that they effect their own objectification. Seeing is equivalent to disembodied power over those in prison, for whom, as Foucault says, "visibility is a trap."[43] Foucault, like Sartre, does not look toward other forms of human contact in order to present a more positive view of society.[44]

JACQUES LACAN

Jacques Lacan, like Sartre and Foucault, does not see the possibility of a mutual relationship in the act of seeing and being seen. In fact, he argues in his *Four Fundamental Concepts of Psychoanalysis,* that the look is evil.[45] Lacan argues this point in various steps. First, he makes a distinction between the eye and the gaze. He then establishes that this split determines the I, that the I, in fact, is dependent on this split in order to maintain its own identity. In a third step, Lacan argues that through this split the I becomes aware of its own visibility to the gaze and of its lack of power in comparison with the gaze. The eye, Lacan concludes, needs to look in a voracious way in order to fulfill the needs of the I, and yet it only ever looks in envy onto a completeness to which it has no access.

Lacan's distinction between the eye and the gaze in *Four Fundamental Concepts* is based on, and runs parallel to, a distinction that he makes elsewhere in his work between what we are "in reality" and what we desire to be, between the I and that toward which its drives are oriented.[46] In the visual, or, as Lacan says, the "scopic" field, the drive is manifested as a drive of the eye toward the gaze.[47] The difference between the eye and the gaze is in the limitation of the eye's viewpoint, in comparison with that of the gaze: the eye sees only from one point, whereas it perceives the gaze as something that will see the I from all sides.[48] In order to explain the nature of the gaze, Lacan uses the phenomenon of mimicry in animals as an example. Noting that insects often assume the shape of an eye (called "ocellus") in order to impress a predator or victim, Lacan asks

> whether they [the ocelli] impress by their resemblance to eyes, or whether, on the contrary, the eyes are fascinating only by virtue of their relation to the form of the ocelli. In other words, must we not distinguish between the function of the eye and that of the gaze?[49]

The question Lacan is asking here is thus whether the ocellus derives its power from its similarity with the eye, or whether both the eye and the ocellus derive their power from a force that is greater than them, a force that is communicated in a particular, eyelike shape. Lacan's argument is that beyond the eye there is the gaze as an underlying power that expresses itself equally through both the eye and the ocellus.

Lacan's second, major point is that it is through seeing that the eye learns that it is eye and not gaze, and that, as eye, it is part of the "picture" seen by the gaze, part of the spectacle of the world, and less powerful than the gaze. According to Lacan, we learn of the gaze first

through narcissism, which he describes in visual terms as the experience of seeing oneself see oneself. While we see ourselves, we become conscious of ourselves, but at the same time we learn to understand ourselves as seen from viewpoints that are not our own. "That which makes us consciousness institutes us by the same token as speculum mundi," argues Lacan, and later on: "The spectacle of the world, in this sense, appears to us as all-seeing."[50] The eye/I that sees surrounding objects from its viewpoint at the same time learns that it is seen from all angles by the gaze, which is an implied presence behind the objects that make the spectacle of the world.

In order to establish his point that the eye is seen by the gaze, Lacan opposes what he calls "geometral" vision with a concept of vision in which the eye is not at the center.[51] First of all, Lacan questions the validity of geometral vision in two ways. Geometral vision, he argues on the one hand, is not so much related to sight, but is simply a mapping of space in which outlines of objects are related back to the perceiving eye through lines and measured distances. Geometral vision, because of its concern with the distances between objects in space rather than with the way in which they appear, is something that a blind person is capable of. It is not necessary to be able to see in order to be capable of geometral vision, and in this sense, geometral vision does not explore the field of vision to its full potential.[52] On the other hand, Lacan refers to the perspectival grid introduced by Albrecht Dürer and explains that, while this tool has been used in order to represent an image of a "restored" world with "correct" relations between objects, the very same tool has also been used in order to distort the restored world.[53] The concept of geometral vision and its associated tool, the perspectival grid, is thus not seen by Lacan as a concept suitable to describe vision.

Rather than consider the subject to be at the center of vision, Lacan maintains the subject's inferior position in relation to the gaze and the image. He interprets Holbein's famous painting *The Ambassadors* in order to make his point. Seen from a viewpoint directly opposite, the painting shows two standing figures, surrounded with various objects that represent vanity. In the foreground of the picture can be seen an oblique object that cannot be identified from the viewpoint directly opposite the painting. It is represented through the technique of anamorphosis (distortion), and can be recognized as a skull when the painting is seen from the side. By using this technique, Holbein, according to Lacan, makes the viewer feel as though annihilated in the sense that the viewer is reminded of castration. The skull that cannot be identified from the position from which the rest of the painting is

best seen emphasizes that the viewing subject is not in the center of vision. Leaving the room, and noticing that the skull can be identified from a different position, the viewer realizes that there are viewpoints other than his own, viewpoints from which the viewer may have been seen while not being aware of it.[54] In other words, the skull reminds the viewer of the gaze. To be sure, the gaze is not directly visible in the painting, but the painting refers to this invisible, "pulsatile, dazzling and spread out" power through each of its points.[55] This, Lacan says, is the same for every painting we see. In each painting we seek to grasp the gaze as an object of desire; behind each painting, the gaze disappears. Through each painting, I perceive myself as seen by the gaze and as lacking in comparison with its power.

In order to further emphasize the powerlessness of the eye in comparison with the gaze, Lacan argues that the eye, in relation to the gaze, is picture. Recounting an experience with a can he once saw floating on the surface of the sea, Lacan makes the point that vision is about being seen by objects as much as it is about seeing objects.[56] We are seen by objects in the sense that the object in the distance is a point from which light proceeds in the direction of the eye. Through the point of light that sees me, I am no longer in the center of the geometral perspective. Instead, the eye, in relation to the point of light, becomes a surface on which the light creates an impression; it becomes a picture inscribed by the light. Lacan writes: "I am not simply that punctiform being located at the geometral point from which the perspective is grasped. No doubt, in the depths of my eye, the picture is painted. The picture, certainly, is in my eye."[57] As the eye becomes the surface onto which the picture is inscribed, the I loses control. The impression created in the eye is not mastered by the subject, but grasps the subject. Seeing, we thus realize that we are defined as picture by a gaze that is infinitely more powerful than ours.

At the same time as defining the eye as picture, being seen by the gaze is an experience of estrangement, of "not fitting into the picture."[58] Lacan makes this point by portraying vision in a triangular graph. The point of light is in this graph situated at one end of the triangle. Opposite this is the surface of the picture, represented by a line, the end points of which are connected with the point of light in order to form the triangle. In between the picture and the point of light, and in parallel to the picture, is what Lacan calls the "screen." With reference to this triangle, Lacan explains that the eye, even though it is picture, is never *in* the picture in the sense that it is the screen in front of the picture, rather than part of the picture that forms the background to the screen, rather like the skull in *The Ambassadors*

that seems to be removed from the surface of the painting and hovers in its foreground.

The only possibility for the subject to "fit into the picture" and to thus receive an identity within the picture is by way of mimicry. Mimicry, according to Lacan, means to become a picture, or, more precisely, to become part of the picture behind, and it is through mimicry that the subject is inserted into the picture in front of which he appears.[59] Thus, the subject seen by the gaze is not an original individual but is an imitation of a given "background," by which it is defined. To be seen by the gaze means "for the subject to be inserted in a function whose exercise grasps it."[60] Thus, through seeing objects around it, and especially through seeing paintings, the subject realizes that it is seen by a gaze that is infinitely more powerful than the eye.

Because the gaze is more powerful than the eye, it functions for the subject as an object of desire. Lacan relates the split between the eye and the gaze with an internal split that separates the subject from its object of desire. By doing this, he links the split of eye and gaze with the formation of the subject's identity. The subject emerges, according to Lacan, from a primal separation, a split from a privileged object, which he calls "objet *a*," and in relation to which the subject continues to define itself. The gaze is such an objet *a*: "In the scopic relation," writes Lacan, "the object on which depends the phantasy from which the subject is suspended in an essential vacillation is the gaze."[61] Thus, the subject depends in its very being not only on the separation from the gaze, but also on its own drives to be continually oriented toward the gaze. Lacan refers to Sartre's notion of the look at this point, and to Sartre's way of describing the I's relation to the look of the Other. Explaining that Sartre's concept of the look refers to the look of specific people, Lacan argues that the gaze is distinct from Sartre's look in that it is "a gaze imagined by me in the field of the Other."[62] The gaze is not a specific Other looking at the subject but "the subject sustaining himself in a function of desire."[63] The split between the eye and the gaze, and therefore the subject's act of seeing, does not describe a relation between the subject and the Other but only between the subject and himself.

Seeing a painting is no different from seeing objects that surround the subject. Seeing a painting, too, fulfills the subject's desire toward the gaze as objet *a*.[64] The gaze emanates from a painting in the same way in which it emanates from other objects. Lacan points out that the gaze the viewer encounters in a painting is not anyone's particular gaze, for example, the gaze of the painter. On the contrary: the

painter, too, is in a relation of desire toward the gaze. Lacan explains that the gaze operates in painting through a "descent of desire," in which the painter functions as though by remote control. Making the point that he considers desire to be unconscious, Lacan writes that the painter's desire is "a sort of desire on the part of the other, at the end of which is the *showing* (*le donner-à-voir*)."[65] The painter thus acts on behalf of the Other, and for the satisfaction of the Other's desire gives something to see, but the gaze, the object of desire, is not any more his than it is the Other's.

Lacan's conclusions describe the act of seeing in a negative way: the eye, he argues, is a voracious eye that has to see in order for the subject to be. Moreover, the eye needs to see something to which it will never have access, because, in order to sustain himself, he needs the relation with an unattainable object of desire. Seeing, the eye realizes that as a bodily organ it is incomplete because it will never own the complete vision that only the disembodied, invisible gaze has. Thus, the eye is only capable of a look of envy at a completeness to which it has no access.[66] Seeing, according to Lacan, does not enable a mutual relation. Instead, it places the seeing person in a hierarchy in which it is always less powerful than the disembodied power of the gaze. In this hierarchical system, a look can never be imagined as something positive. "It is striking," Lacan concludes, "when one thinks of the universality of the function of the evil eye, that there is no trace anywhere of a good eye, of an eye that blesses."[67] He makes this point even more emphatically in an answer to a question following the seminar, regarding the tradition of protecting eyes:

> I was thinking that in the Bible, for example, there must be passages in which the eye confers the *baraka* or blessing. There are a few small places where I hesitated—but no. The eye may be prophylactic, but it cannot be beneficent—it is maleficent. In the Bible and even in the New Testament, there is no good eye, but there are evil eyes all over the place.[68]

EMMANUEL LEVINAS

In his book *Totality and Infinity: An Essay in Exteriority,* Levinas outlines his view of vision by relating vision to the concepts of totality and infinity that form the basis of his work, and by contrasting vision with language and the act of speech. In order to understand the meaning of vision, and the place it inhabits within Levinas's cosmos of totality and infinity, one must first understand what Levinas describes with the terms "totality" and "infinity."

Levinas uses the terms "totality" and "infinity" to describe different ways in which the I can be seen to relate to the world. Totality describes a way of life in which the I is seen as a grounding principle to which everything relates. The term "totality" applies if everything is seen as either the same as, or different from, a singular concept believed to be at the center of the world. Levinas describes how the I, in order to continually identify itself, sees itself in relation to, and mirrored in, the objects that surround it. The I comes into being by seeing itself as the same as, or different from, the world that surrounds it; the I is carved out by defining the objects to which it relates as either the same as or different from the I.[69] The idea of sameness is thus the basis of the processes of identification—the idea of an overarching totality within which everything relates to the same categories, whether positively or negatively.

Infinity, by contrast, describes a concept according to which the I is faced with a world that does not fit within the categories of totality, a world that cannot be explained as either the same as, or different from, a singular concept, but which is entirely Other. Infinity thus describes a relationship between the same and the Other in which the Other is of such alterity that he or she cannot even be understood to be limiting the same. If the Other was limiting the same, the shared frontier between the two would mean that they are once more part of a singular concept, and that the Other is not fully Other.[70] For this relation between the same and the Other, in which the same and the Other, strictly speaking, are not related, Levinas reserves the term "religion." Religion is "the bond that is established between the same and the other without constituting a totality"[71] and a "relation . . . that results in no community of concept or totality—a relation without relation."[72] The Other within Levinas's concept of infinity truly transcends the same. Ethics, according to Levinas, originates in this relationship between the same and the Other, between the I and the stranger, who, although completely unknowable, nevertheless approaches the I and expects a response. This ethical relation is not one that the I could opt out of, for the Other is already awaiting the I when it comes into being as sameness; the Other is "prior to every initiative, to all imperialism of the same."[73]

For Levinas, vision is situated clearly within totality. It is not related to transcendence but to the finite.[74] Vision, therefore, does not allow for an ethical relation between the I and the Other. Levinas arrives at this argument in the following way: vision, he argues, requires light, for without light nothing can be seen. At the same time, the light that enables vision shows up the distance between the subject and the

objects it perceives; it highlights the space between the subject and the object that has to be crossed by vision or touching. What is made visible, in a certain sense, by the light is the void between the subject and the object, the void in which the subject finds itself.[75] Levinas distinguishes three states of being: that of infinite space (which is terrifying), that of the "there is" (the illuminated void), and that of the object. Vision takes place within the illuminated void of the "there is" and has therefore no relation with infinite space. Vision is centered around, and of benefit to, the subject in that the presence of an object that can be seen allows the subject to forget the void by which it is surrounded. Vision thus equals the forgetting of infinity: "Vision is forgetting of the *there is* because of the essential satisfaction, the agreeableness of sensibility, enjoyment, contentment with the finite without concern for the infinite," argues Levinas.[76] Vision is thus oriented toward the enjoyment and contentment of the subject and does not hold the possibility of an ethical relationship with the Other. Indeed, vision describes a relationship of domination over objects: "Inasmuch as the access to beings concerns vision, it dominates those beings, exercises a power over them. A thing is given, offers itself to me. In gaining access to it I maintain myself within the same . . . for in visual or tactile sensation the identity of the I envelops the alterity of the object."[77]

Related to the act of vision is that of representation. Levinas uses the term "representation" to describe the process through which a once-exterior object becomes an object of thought in the I who perceives the object. The I makes sense of the object it perceives by "thinking" it, by representing to itself the exterior object. The I, by representing objects to itself, makes them meaningful, intelligible. The similarity between vision and representation consists in the fact that both vision and representation take place within the light: "The intelligible is precisely what is entirely reducible to noemata and all of whose relations with the understanding reducible to those established by the light."[78] Vision appears almost to result invariably in representation, because representation is grounded in the perception of objects within the light.

What does representation mean for the objects thus represented? Through representation, objects lose their exteriority and become part of the same. Representation, the giving of meaning, is thus an act of mastery on the part of the I: "Intelligibility . . . is a total adequation of the thinker with what is thought, in the precise sense of a mastery exercised by the thinker upon what is thought in which the object's resistance as an exterior being vanishes. This mastery is total and as

though creative," writes Levinas, and later: "In the intelligibility of representation the distinction between me and the object, between interior and exterior, is effaced."[79] Thus neither vision, nor the act of representation based upon vision, allow for an ethical encounter with the Other, in which the Other remains truly other and relates to the I's sameness from infinity.

Levinas presents language as a positive contrast to vision and representation. Language, and in particular the act of speech, allow for an ethical relation between the I and the Other, according to Levinas. This is because language operates on the basis of infinity. Vision is a way of relating to the Other that subsumes the Other into the totality of sameness. In language, this totality is transcended as the Other addresses the I from a point outside the totality of the I. "Language," Levinas writes, "accomplishes a relation . . . such that the other, despite the relationship with the same, remains transcendent to the same."[80]

The Other stays outside the totality of the I because of his capacity to express himself.[81] Through his self-expression, the Other contests any meaning that might be ascribed to him by the I and makes clear that he does not require to be defined by the I in order to have meaning. Equally, the Other, who shows himself in his face, refuses to succumb to any images the I might have of him: "The face of the Other at each moment destroys and overflows the plastic image it leaves me, the idea existing to my own measure and to the measure of its ideatum—the adequate idea."[82] This otherness of the Other, his overflowing any image or knowledge the I might have of him, becomes manifest in conversation: "To approach the Other in conversation is to welcome his expression, in which at each instant he overflows the idea a thought would carry away from it."[83] To be in conversation means "to receive from the Other beyond the capacity of the I, which means exactly: to have the idea of infinity."[84] Levinas compares speech and vision directly in terms of their ability to establish an ethical relation in which the Other remains other:

> Speech cuts across vision. In knowledge or vision the object seen can indeed determine an act, but it is an act that in some way appropriates the "seen" to itself, integrates it into a world by endowing it with a signification, and, in the last analysis, constitutes it. In discourse the divergence that inevitably opens between the other as my theme and the Other as my interlocutor, emancipated from the theme that seemed a moment to hold him, forthwith contests the meaning I ascribe to my interlocutor. The formal structure of language thereby announces the ethical inviolability of the Other and . . . his "holiness."[85]

Vision, unlike speech, has no potential for relating to the Other in an ethical way.

Despite his privileging of speech over vision, Levinas describes a visible entity, namely the face, as the location from which speech proceeds. Indeed, the face-to-face relationship is where the ethical relation originates.[86] Sadly, however, Levinas is at pains to establish that the face, in fact, is not perceptible through vision. Having described how vision dominates the beings to which it has access, he immediately states: "The face is present in its refusal to be encompassed. It is neither seen nor touched."[87] But how could Levinas base his ethics on the epiphany that shines from the face of the Other, without considering visual perception as a potentially ethical act? Why locate the origin of ethics in the—obviously—visible face of the Other, if one considers vision to have no potential for an ethical relationship?

Throughout this book, I argue toward a more positive view of the act of seeing. In contrast to Sartre, Foucault, Lacan, and Levinas, I will attempt to demonstrate that seeing and being seen can mean being in a mutual relation, that seeing, while being an existential, human experience, is not necessarily objectifying, and that, in seeing, one is never only invisible but visible at the same time. Before I can argue my case in relation to feminist theology and films, however, it is necessary to consult feminist film theory in the next chapter, as it, too, has reflected in detail on what seeing and being seen mean.

CHAPTER 2

———✦———

SEEING AND BEING SEEN IN CINEMA: FEMINIST FILM THEORY

The emphasis on the negativity of the look discussed in the previous chapter has also been a characteristic mark of the field of feminist film theory. In this field, too, writers have not seen any possibility for a relationship of mutuality in seeing and being seen. In contrast to the philosophers discussed above, however, writers of feminist film theory have conceptualized the relationship of seeing and being seen in terms of gender, and have thus equated masculinity with the privileged position of the seeing subject and femininity with that of the seen object. The question what it means to see is thus at the heart of reflections on the medium of film, as various texts in feminist film theory consider the relationship between spectator and screen and the implications of the look through the camera.

Women's relationship to films is constituted in two ways. Women are both seeing and seen; they are spectators and filmmakers behind and characters in front of the camera. When asking what it means to see, I am asking about the act of looking as well as about what it means to be looked at. Both questions have been issues in feminist film theory that began by problematizing images of women on cinema screens. Molly Haskell, one of the first to write on representations of women in films, pointed out that women are represented in male-authored cinema through a limited number of stereotypical roles. In her book, *From Reverence to Rape: The Treatment of Women in the Movies,* she outlines women's roles as reaching from an idealized, feminine principle to motherhood, from earth goddess to being feared and subjected to violence.[1] Haskell assumes a connection

between the way in which women are seen in male-authored films and the life of real women. Women's film roles, she maintains, reflect the roles of women in society and, at the same time, influence the life of real women.[2]

Claire Johnston denies this connection. Although concerned with the way in which women are seen, she makes the point that the representations of women have no connection with women's real lives. Approaching film from the viewpoint of semiotics, she argues that "woman" functions as a sign, defined in its meaning through a patriarchal context. Within the male-dominated cinema, she says, "woman is presented as what she represents for man," while "woman as woman is largely absent."[3]

Laura Mulvey, too, is concerned with how women are seen in films. In her view, women are defined through their representability; as a sign in the discourse, they connote "to-be-looked-at-ness."[4] Approaching film from the background of Sigmund Freud's and Jacques Lacan's psychoanalytic theories, she explains that the woman's to-be-looked-at-ness on screen is necessary to satisfy the needs of the male spectator. Through voyeuristic and fetishistic looks directed at the woman, the male spectator is reassured in his masculinity, since he is in possession of the gaze.[5]

Like Mulvey, Mary Ann Doane is concerned with the definition of women through their visibility. Extending Mulvey's argument of the difference between the activity of the male gaze and the passivity of female to-be-looked-at-ness, Doane makes out an "opposition between proximity and distance in relation to the image."[6] "Historically," she writes, "there has always been a certain imbrication of the cinematic image and the representation of the woman."[7] This occurs because the desires to look voyeuristically and fetishistically at the cinema screen originate in the desire to look at the female body.[8] Woman, in a way, is the screen for male desire.

Haskell, Johnston, Mulvey, and Doane have, each in their own way, pointed out that the ways in which women have been seen in films have often not benefited real women. Women have been stereo-typed, have acted as a sign defined by a patriarchal context, a screen for male desires. In this sense, these authors have a view of the act of seeing that is quite similar to that of the philosophers discussed in the previous chapter.[9] Seeing benefits the needs of the person who is looking, in this case the needs of the male ego, while making the seen person into an object. Haskell, Johnston, Mulvey, and Doane argue that women should not be seen in this objectifying way. In order for women to be seen differently, Mulvey aims at destroying the pleasure

in watching films where women connote to-be-looked-at-ness, while Johnston argues for a countercinema.

The interest of feminist film theory has thus moved from the critique of ways in which women are seen in film to the act of seeing. The act of seeing occurs at different levels in the cinema. The filmmaker looks through the camera; the spectator, later on, looks at the film. Mulvey's and Johnston's critiques concern the act of looking at the level of film production and film reception. Mulvey's aim of destroying cinematic pleasure is directed at the spectator's pleasure, while Johnston's call for a countercinema is directed at filmmakers. But while both the level of film production and reception are addressed, the emphasis of much of feminist film theory, as far as the act of looking is concerned, has been on film reception.

With regard to film reception, most feminist film theory deals with both the spectator constructed by the film and the real spectator. Mulvey argues that the spectator implied by the male-dominated film is male because a film that enables voyeurism and fetishism serves the needs of the male ego. She raises the question what it might mean, for a female spectator, to see. In Mulvey's scenario, the act of seeing entails a masculinization of the female spectator. Whether in fact male or female, the viewers are all constructed as male.

Mulvey speaks of the viewer using only the male pronoun and she points out that the act of looking in male-dominated cinema is always a male act, whether it is the look of the filmmaker at the woman as spectacle in front of the camera or the look of the male main character at the woman within the screen space. Because the male character owns the gaze while the female character is vulnerable in her to-be-looked-at-ness, viewers will identify with the male and distance themselves from the female position.[10] In a later response to her article, "Visual Pleasure and Narrative Cinema," Mulvey tones down her argument somewhat, saying that, for women, the act of seeing does not have to be a case of masculinization but can simply be a case of transvestism. Trans-sex identification, she argues, is an age-old cultural tradition for women.[11]

Seeing that there is little potential in being addressed as a female spectator by films with male main characters, some feminist film critics shift their focus to melodrama that, because of its female main character, might appear more suited to the needs of female spectators.[12] In melodrama, however, the female character suffers, even though she occupies the center of the narrative. Identification with her results in masochism, concludes Doane, saying that "in films addressed to women, spectatorial pleasure is often indissociable from pain."[13]

The act of seeing, thus, cannot reassure the female spectator's identity. Seeing means either masculinization or masochism. This impasse raises the question whether a different type of film might offer other possibilities. Instead of simply concentrating on the film spectator's act of seeing, some authors call for an alternative way of filmmaking. I have already mentioned Johnston's call for a countercinema. Doane, too, argues for a feminist film practice.[14] Mulvey has tried her own hand at directing a film that seeks to make a difference.[15]

Has this move finally turned the attention on a woman's act of looking through a camera creatively, so that asking what it means to see is asking what it means to direct a film? The question what it means to see has developed. At first, there was no interest in women seeing. Women were there to be seen, defined as spectacle, was the verdict of some writers. Out of this unsatisfactory situation arose the question what it means for a woman to see, but what was really asked was the question how she could be a spectator. Then the question came to be asked in yet another way: "What does it mean to see?" came to mean "What does it mean to make a film?" Or did it?

I would argue it did not. Doane's article, "Woman's Stake: Filming the Female Body," shows in an exemplary fashion precisely which question is asked in relation to women's seeing and it also points to a gap, a question that is not asked, and it is this question that I will take as my point of departure in this book. Doane's article, on the one hand, claims to be about what it means to see as a woman, and yet, on the other hand, the argument only concerns the act of seeing the female body.

Typical of her line of argument is, for example, the discussion of women's and men's relations to language and the conclusions she draws for a feminist film practice. She explains that language, according to psychoanalytic and semiotic theories, is founded on lack. In Lacanian theory, the phallus is the signifier of lack. Against the argument that this signifier privileges the male over the female body, Lacan and his followers would argue that men do not own this signifier any more than women because the penis is not the phallus. In contrast to this opinion, Doane argues that the phallus, even though a signifier, is still based on the image of the male body. Men, therefore, have access to it because they possess the penis as that which reminds of the phallus but is not it. If language is founded on the image of the male body, asks Doane, then how can women with their different bodies have access to language?[16] She writes:

> The greatest masquerade is that of the woman speaking (or writing, or filming), appropriating discourse. . . . How can she speak? Yet we know

that women speak. . . . And unless we want to accept a formulation by means of which woman can only mimic man's relation to language . . . we must try to reconsider the relation between the female body and language. . . . Does woman have a stake in representation or, more appropriately, can we assign one to her?[17]

Doane starts out with women's relation to representation, asking how it is that women can speak, write, and see. But in her attempt to answer this question, Doane concentrates only on the act of seeing the female body in a new way, delineating an essentialist and an antiessentialist way of representing the female body.[18] The examples she uses to describe her feminist film practice relate only to a particular way of seeing the female body. Doane's article is, after all, not about what it means to see as a woman, but only about how women see themselves. Surely, however, women are capable of seeing more than their own bodies. The question what it means for a woman to see must mean not only how she sees herself but also how she sees male and female bodies, how she sees the world. Only in this way can women have a stake in representation.

When I ask what it means for women to see, I ask not only how a female filmmaker, or a female character within the screen space, might see her own body or that of other women, but also how she sees people, things, and nature, and what her look does for those looked at. I have chosen three films that are about seeing, about producing art, and, thus, about participating in representation. In all three films, the act of seeing is one of looking at the world and not simply of looking at the female body.

Camille Claudel, in the film of the same title, is presented as an artist with an interest in a variety of motifs, who is fully aware of the originality of her artistic gaze and who fights fiercely in order to protect her independence. Unfortunately, her struggle to gain the public recognition she would rightfully deserve is unsuccessful. The film *Artemisia* follows the development of the seventeenth-century painter Artemisia Gentileschi, who starts out painting her own body and learns to direct her gaze at the male body and at nature, looking at the world through a perspectival frame. In *The Tango Lesson,* the seeing woman is in front of and behind the camera, for Sally Potter both directs and acts in the film. As the filmmaker, she directs her look not only at herself in front of the camera but also at her dance partner. In discussing the three films, I shift the attention from the act of seeing women to the act of seeing.

This shift is not entirely new. E. Ann Kaplan, even though proceeding from an analysis of the gaze as male, is concerned, in a general

way, with the relation between the seeing and the seen person. She describes the structure of the gaze as a "dominance-submission pattern" that replicates dominance-submission structures within male-female sexual relations as expressed in the way men and women dream about sexuality.[19] While emphasizing that it is possible for women to own the gaze, she argues that this is only practicable if the man assumes the submissive position; in other words, if the dominance-submission pattern remains intact. She concludes that the dominance-submission pattern of the look must be questioned.[20]

My aim in this book is to develop an alternative understanding of seeing and being seen as something other than a pattern of dominance and submission. Since feminist film theory has generally associated the male gaze with the domineering look, I focus on women who practice the gaze in the hope of finding an alternative. But, one might ask, has this question not been asked long ago within feminist film theory? My answer in this book is that there is still space for the question to be asked, and for an answer to be put forward. Indeed, feminist film theory seems to have reached a point of closure during the 1990s. Writing about the United States, Alison Butler argues that feminist film theory had run out of steam during the 1990s, while cinema, during the same years, was characterized by nostalgia for a lost masculinity, which showed itself in a new cycle of US cinema, "in which extreme violence, narcissism and misogyny became the stock-in-trade for young filmmakers."[21]

Butler sees the reason for the disappearing of feminist film theory in its overemphasis on the problematization of femininity in cinema, and in its resulting neglect of specific aspects of women's filmmaking. Leaning heavily on psychoanalytic theory, much of feminist film theory has theorized femininity as a sign of absence and lack—and has thus robbed itself of its very own subject of enquiry. Butler writes: "For feminist film scholars studying a cultural form so massively dominated by men, the construction of a theoretical paradigm in which the absence of female subjectivity is a first principle has been more or less a disaster."[22] B. Ruby Rich, too, considers the age of feminist cultural work, such as feminist film theory, as being over: "What sprang up in the seventies and was institutionalized in the eighties has been stagnating in the nineties, its vigor bypassed by queer culture, on the one hand, multiculturalism on the other, and cultural studies in general."[23] Rich is even more outspoken than Butler in her view that the reason for this stagnation is to be seen in the overemphasis on psychoanalytic theory. "The domination of psychoanalysis as a theoretical approach cut off too many avenues of inquiry and invention,

all defeated along the way and dealt out of the game. I think that the influence of psychoanalysis as a hegemonic theory with one singular world-view has been a disaster as a literary device and critical tool in literary analysis and feminist studies."[24] Whether or not one wishes to agree with this strong criticism of feminist film theory's emphasis on psychoanalytic theory, it is important to acknowledge Rich's and Butler's point that, because of its focus on male-dominated cinema through the lens of psychoanalysis, feminist film theory has moved too far away from women's filmmaking. While feminist film theory has concentrated on what it means for women to be seen in male-dominated cinema, it has not asked with enough rigor what it means for women to see, and thus has not given adequate attention to women's filmmaking.

Meanwhile, feminist film theory, as hinted at by Rich in the above quotation, has been supplanted with gender theory and concepts of the performativity of gender, as well as with an emphasis on gay and lesbian sexuality.[25] Alison Butler acknowledges that the performativity of gender has made gender categories more open. At the same time, however, she warns that notions of "femininity" and "masculinity" have not been deconstructed in an equal way. "The feminine," she argues, "has come to designate something profoundly negative, a position no-one really wants to occupy."[26] Masculinity, by contrast, is not seen in the same, negative light, as can be seen in the nostalgic revival of masculinity in films of the 1990s. Thus, problems of gender inequality, rather than having been solved, have simply been forgotten, and the 1990s have seen the introduction of the "forgotten woman" as a new cultural phenomenon.[27] Butler's as well as Rich's conclusions are, therefore, that it is important to try to remember women's contributions to filmmaking.[28]

Even though the route feminist film theory has chosen seems to have come to an end, Rich still thinks that a "process of giving credit and remembering" is necessary, and that there is much to be gained from remembering what women have achieved in filmmaking in the past, and from bringing to attention women's ongoing contributions to cinema.[29] Feminist film theory, because of its focus on how women have been seen, has not dealt enough with women who see and make films. To pay tribute to some of women's filmmaking, and to ask what it has meant for women to see is what I do in this book.

Artemisia's painting teacher tells her that she must learn to look at things in a new way. When I ask what it means to see, I ask whether it is possible to conceive of the act of seeing in a way other than as an act of domination and objectification, whether it is possible to look

at things in a new way, and whether Camille Claudel's, Artemisia's, and Sally's look differs from male ways of seeing. I consider the work of several women, fictional and real, who show what it might mean to look at things in new ways, and who write about the act of seeing as an act of relating. Some of my hopes thus rest on the character Camille and her awareness of the worth of her own art; on Artemisia, the young painter with a fresh brush stroke; on Agnès Merlet, the director who sees Artemisia; and on Sally Potter, who looks through eyes more mature than Artemisia's. I am also interested in feminist theology. Seeing is an act of relating between the seeing and the seen person, and relation is one of the main concerns of much feminist theology. Concentrating on relation in this way, I consider religion as well as the act of seeing in terms of ethics, and I ask whether we can look at things in a way that feminist theology might describe as ethical, as enabling relation.[30] Perhaps feminist theology's ways of thinking about relation can provide a model for seeing the act of seeing in a new way.

CHAPTER 3

———◆❱◉❰◆———

SEEING AND BEING SEEN: A
FEMINIST THEOLOGICAL VIEW

Seeing and being seen have been theorized by a number of twentieth-century philosophers as a relationship with negative consequences for the person who is seen. As illustrated in chapter 1 of this book, seeing and being seen have been understood to imply a subject-object relationship in which the seeing subject is powerful and invisible, and the seen object is at the mercy of, and entirely defined in its identity by the seeing subject. Feminist film theory has emphasized this understanding of the act of seeing while adding the insight that, in cinema, the relationship between the seeing subject and the seen object is a gendered one in which the male usually occupies the powerful position of the invisible director or spectator, whereas the female acts as the visible object on screen. Despite its powerful and convincing analysis of the film medium, however, feminist film theory seems to have reached an end point beyond which no alternative theory of the act of seeing has been developed.

In this book, I wish to present an alternative to such negative understandings of seeing and being seen. In order to give a more positive understanding of the act of seeing, I will theorize seeing and being seen as a relationship with a potential for mutuality that can encourage the growth of those involved in it and help them to develop toward redeeming their full potential. Because feminist film theory has identified convincingly the male cinematic look at the female object as a major factor in the unequal relationship of seeing and being seen, I pay particular interest in this book to women who see, asking whether or not women see in a different way, and whether

or not their look is less objectifying than that of males. For this reason, I consider three films (*Camille Claudel, Artemisia,* and *The Tango Lesson*) about women artists who look in order to produce art. The two films I focus on closely, *Artemisia* and *The Tango Lesson,* not only deal with women artists but are also directed by women.

Feminist theology, because of its emphasis on relation, offers an excellent foundation on which to develop a theology of seeing as being in mutual relation. Feminist theology has developed the theme of "relationality" like no other branch of theology.[1] Feminist theological texts often describe God in images and in terms of relationships. When imagining God in a particular role, as father, mother, lover, or friend, for example, texts focus on the kind of relationship implied by such imagery.[2] By thinking about God in terms of human relationships, feminist theology establishes a connection between God and human beings. Human relationships originate in, and are meant to be in the image and likeness of, God's way of relating. Belief, in this view, is not spoken as a credo but practiced as a way of relating with others that mirrors God's way of relating. The interest in relationships pervades feminist Christological writings, too. Here, the relational emphasis becomes apparent as a shift in ways of thinking about the redemption accessible through Jesus. Traditionally, Christ is seen to be redemptive because of his essence, his nature that is both human and divine. Many feminist Christological texts, by contrast, concentrate on the biblical Jesus, as opposed to the figure of Christ, and point out that it is Jesus's way of relating to people that is redemptive.[3] The reflection on relationships is thus an essential part of many feminist approaches to theology. Human relationships are the site where people's beliefs about the divine become visible.

When I discuss *Artemisia* and *The Tango Lesson* later in this book, I will make the theme of relationship the point of contact between feminist theological concepts and the films. Both *Artemisia* and *The Tango Lesson* have a particular interest in the relationship between an artist and the subject of her work. In both films, the artists are connected with the subject of their work in a relationship that reaches beyond art into their personal lives. The painter Artemisia poses for her own painting *Judith Slaying Holofernes,* together with Tassi, her painting teacher and lover. She thus paints Judith and Holofernes and, at the same time, herself and her own lover. Sally, a filmmaker, makes a film about the tango, in which she and Pablo, her dance partner, act. Thus, the film about the tango is at the same time a cinematic representation of Sally and the man she relates to.

This overlapping of art and relationships allows me to interpret the films in terms of the theme of relating, and to establish a connection with the feminist theological emphasis on this theme. Artemisia and Sally use their eyes to create their art, that is to say to recreate their relationships with Tassi and Pablo as art. Their ways of looking are symbolic of their ways of relating. The connection between the films and feminist theology will, therefore, hinge on the eye, and the act of looking will be seen as a way of relating. Some feminist theological texts actually discuss the act of looking as an act of relating and such texts will be most useful in the interpretation of the films. Generally, however, only few authors discuss the theme of relating in terms of the act of looking. But because of the connection between looking and relating in the films, my exploration of feminist theology will include texts even if they deal with the theme of relationship in a more general sense only. With the help of feminist theology, I will ask what it means to see. I will, in other words, interpret the act of seeing, and understand different ways of seeing as different ways of relating. I want to discover whether ways of seeing in the films mirror God's way of relating and whether Artemisia's and Sally's gazes might be thought to represent a God who casts a loving eye onto the world. It will become clear in my discussion of the films later on that not all films directed by women present a different way of looking simply by virtue of the fact that they are directed by a woman. In fact, *Artemisia*, as will be illustrated, differs from *The Tango Lesson* in its illustration of the act of seeing.

The film *Artemisia* shows a young girl who is eagerly learning to paint.[4] The aspirations and the potential of a new beginning associated with the figure of the young girl who breaks into the male-dominated world of painting meet in the film with two older painters, one of them being Artemisia's father (Orazio) and the other her painting teacher (Tassi). The film strikes a very hopeful note when Tassi says to Artemisia in one of her lessons: "You have to look at things in a new way." The film suggests, however, that Artemisia casts her painterly look at Tassi while at the same time posing with him as Judith slaying Holofernes. Artemisia's painterly look is thus associated with negative connotations of beheading and castration, and, instead of being a new way of looking, is simply a confirmation, as I will show, of old stereotypes. Despite its overall negative portrayal of Artemisia's act of looking, however, the film will still be a useful dialogue partner in profiling what a positive way of seeing might or might not be.

The Tango Lesson suggests an idealistic understanding of what it means to see and to be seen. This idealistic vision is most apparent in Sally's statement, "I love you with my eyes," directed at Pablo, the

partner whom she looks at through her camera. In contrast to the objectifying nature of many looks in *Artemisia*, Sally's statement proposes that a look can be a sign of deepest interest in another person's being, that it can help the other to become a subject. Her statement thus implies that a look centers around two aspects, a relationship between people and a sense of self that they develop. If a look is mutual, it establishes a relationship between two or more people that helps each person involved to become a subject.

This description of the look is reminiscent of understandings of redemption proposed by various texts in feminist theology. Redemption, like the look, is seen as centered around the poles of being in relation and becoming a self. Redemption is not, however, seen in terms of a visual relationship in these writings. In this book, I argue that seeing can be redemptive, basing my argument on the way *The Tango Lesson* understands seeing and on the way feminist theologians understand redemption. After exploring how some feminist theologians describe redemption, what kind of a self and what type of a relationship they envision, I will examine what feminist theology says about the act of making visible and the kind of relationship expressed in this act. This will enable me to establish whether or not the experiences of seeing and being seen are redemptive. The theological connection is necessary in order to elaborate whether, and how, Sally's work of making visible can be described in theological terms, and whether, and how, her look is redemptive.

REDEMPTION: BEING IN RELATION AND BECOMING A SELF

Much of feminist theology speaks about God, the world, and human beings in terms of relation. Buber's thoughts on relationship, especially his paraphrasing of the beginning of the Gospel of John, "Im Anfang ist die Beziehung," feature in many writings.[5] Mary Grey, for example, has made the focus on relation the basis of her theology of redemption. In her view, to be in relation is redemptive on two grounds: that the basis of the world is relation and that God is relational.[6] The basis for a feminist concept of redemption, she suggests, is a "wide fellow feeling for all that is human," a phrase she borrows from George Eliot's novel *The Mill on the Floss*.[7] This feeling is grounded in the belief that the world, in its essence, is relational. Grey explains as the heart of her book that "interdependence and relating are the very threads of the complicated tapestry of the world" and that patterns of affiliation and mutuality are "the very raw material of the world."[8] Relating is

redemptive because the world is meant to be relational, and to relate is to fulfill the world's purpose. Grey's argument for a worldview based on relation focuses on two thought concepts, systems theory and process thought.

Systems theory considers reality in terms of different systems that have an integrative as well as an assertive tendency. This applies to everything that exists, societies, ecosystems, and atomic particles. Everything is related but at the same time everything needs to assert itself in order to be able to relate.[9]

From process thought Grey takes the insight that being means being in process, and concludes that "to be engaged in the process is itself part of the redemption."[10] Relating is an important part of process thought, too, because it is through relationships that the process is achieved.[11] Process thought also emphasizes the importance of a balance between interdependence and autonomy. Thus, redemption, in Grey's model, comes about both through relating and through becoming an autonomous self. Grey's view of redemption forms a basis for my argument below that seeing can be redemptive. The emphasis on relation has remained a constant in feminist theology, most notably through the development of ecofeminism. Having grown from feminist theology and philosophy as well as from a concern for ecology, ecofeminism maintains that an awareness of the relation between human beings and nature is essential in order to live a sustainable life, and thus in order to respect the world as divine creation.[12]

Most important for Grey's model of redemption is the way in which process thought connects ways of understanding the world and God. God is in process in the same way in which the world is in process, and the transformed world is seen as becoming God's body.[13] This view of God as becoming in the world enables Grey to consider redemption and creation as two sides of the same coin. Human beings have a responsibility to act creatively with God, and thus to redeem the world by transforming it into God's body.[14] My discussion of positive ways of seeing later in the book is based on Grey's emphasis on redemption as being in relation while developing a sense of self, as well as on her understanding of creation as redemptive and redemption as brought about through creation.[15]

Right Relation

To say "Im Anfang ist die Beziehung" is, of course, only the beginning of reflecting what exactly "relationship" means. While being in "right relation" has been at the heart of much of feminist theology

as an imperative, the understanding of right relation has developed in various ways.[16] Some writers have used texts from the Bible as inspiration for their thoughts on the type of relationship they envision, especially the descriptions of Jesus and his relationships in the Gospels. Elisabeth Moltmann-Wendel uses the Gospel of Mark's portrayal of Jesus to underline her vision of relation. She describes Jesus's relationship especially to women as one of mutuality, in which both partners of a relationship learn from each other.[17] The aspect of mutuality between Jesus and his fellow human beings is enforced most strongly in the Gospel of Mark, because it values Jesus's human over his divine nature and emphasizes his emotional and bodily way of relating with people.[18]

Rosemary Radford Ruether, too, refers to Jesus as described by the Gospels in order to spell out her idea of a relationship. For her, it is Jesus's antihierarchical stance that has implications for relationships fashioned on his way of life.[19] The move away from hierarchical relationships will enable brother-sister relationships between people.[20] Sallie McFague is inspired by the life of Jesus in her reflections on what it means to relate. She emphasizes three aspects of Jesus's life that are part of a positive way of relating:

1. Jesus speaks in parables through which he destabilizes reality and overcomes dualisms with an egalitarian way of relating.
2. His hospitality is all-inclusive and shows that he treats even outcasts as friends and not simply as needy.
3. Jesus's death, caused by his total identification with the lowest of society, shows his non-hierarchical way of life.[21]

In McFague's view, relationships fashioned on Jesus's way of life will contain a destabilizing, an inclusive, and a nonhierarchical element.

Even though it is legitimate to direct attention to biblical texts and characters in search for ways of relating, it is unnecessary to restrict reflection to the Bible as a source. In fact, Daphne Hampson argues that there is no point in turning to biblical texts as sources for equal relationships between men and women. Biblical texts originate from a sexist culture and, according to Hampson, will always be colored by sexist attitudes because of their origin.[22] The Bible is not concerned with the equality of women and men and is, therefore, only of limited significance to any search for relationships of mutuality between men and women.[23] Hampson even goes so far as to consider Jesus's teaching as irrelevant, saying that "one can without further ado judge Jesus' teaching as irrelevant or mistaken. Such a stance is

the only possible one for a mature human being with moral responsibility. It is what women who are feminists must demand."[24]

Hampson's conclusion is extreme, and it is not helpful to dismiss biblical texts in this way. Aspects of the portrayal of Jesus and his relationships in the Gospels are indeed useful in describing positive ways of relating. Nevertheless, Hampson's criticism must be taken seriously. The Gospels may have an interest in Jesus's relationships to people and to his God, but they are not concerned with the relationship between men and women or with issues that have arisen from this problematic relationship since the rise of feminism. It is necessary to look for inspiration not only from the Bible but also in contemporary thinking about what it means to be in relation, what it means to relate as men and women.

Some writings in feminist theology take into account philosophical reflections on relationships and on problems inherent in male-female relations. Generally speaking, philosophical reflections relevant to texts in feminist theology deal with the relation between self and Other. In a patriarchal world, the relation between self and Other becomes problematic when it is the relation between male self and female Other, and it is this problem that is at the heart of some feminist theologians' criticisms of male-dominated religion.[25] Radford Ruether accuses patriarchal religions of thinking in dualisms of immanence and transcendence, matter and spirit, body and soul, and of gendering the terms of these dualisms as male and female. "Gender," she explains, "becomes a primary symbol for the dualism of transcendence and immanence, spirit and matter."[26] This thinking in gendered dualisms makes it difficult to achieve equal relations between men and women.[27] Daly, like Ruether, criticizes patriarchal religions for thinking in stereotypes. A patriarchal way of thinking sets up role models, and people develop as a self either by identifying with or rejecting the model. The most obvious patriarchal model is, of course, the figure of the father, and Daly explains the process of developing a self in relation to this figure: "It seems to have been part of the patriarchal mind-set to imitate slavishly a master or father-figure with an almost blind devotion and then to reject this figure in order to be oneself."[28] Relationships between self and Other work according to stereotyped patterns and are characterized by what Daly calls the "imitation-rejection syndrome."[29] The importance of Daly's concern will become evident in my discussion of the act of filmmaking later. Stereotypical film characters whom the viewer is supposed either to identify with or to reject are a problem in many films. I argue that *The Tango Lesson* shows something other than a stereotyping look. Within feminist theology, the thinking in

stereotypes has been a consistent point of criticism until very recently. Tina Beattie's discussion of religious societies, which contain as a crucial element the idea of sacrifice as René Girard has described it, can serve as an example here. Noticing what Girard failed to see—namely that societies based on sacrificial cults are characterized by the fact that women tend to have a marginal role in them—she points out with help from Luce Irigaray and Julia Kristeva that this marginalization of women stems from the sacrifice of the mother, an originating sacrifice on which sacrificial cults are based.[30] An effect of this marginalization is that women, in such societies, are stereotyped. "The female body," she writes, "does not inhabit the house of language, because . . . the female sex has been evicted in order to serve the purposes of a trans-gendered masculine imaginary."[31]

As a radical cure to the problem, Daly proposes that the act of stereotyping itself must be abolished and sex stereotyping overcome. She writes:

> Unlike the so-called "First Coming" of Christian theology, which was an absolutising of men, the women's revolution is not an absolutising of women, precisely because it is the *overcoming* of dichotomous sex stereotyping, which is the source of the absolutising process itself. . . . Far from being a "return" to the past, it implies a qualitative leap toward psychic androgyny.[32]

Daly is correct in critiquing the act of stereotyping as highly problematic. Indeed, it makes impossible relationships in which people engage as subjects because it objectifies people as representatives of certain types. She is right in saying that the exchange of one stereotype for another is not enough, and in demanding instead the overcoming of the act of stereotyping itself. But her conclusion, the envisioned leap toward androgyny, is not a solution to the problem she identifies. In fact, androgyny is a model just as masculinity and femininity are, and it does not overcome the concept of model as such.[33]

A more realistic solution to the problem identified by Daly is provided, in my view, by texts that explore the notion of difference. Shawn Copeland argues that the once-popular concept of sisterhood should be replaced by the concept of difference.[34] Copeland refers especially to the need for differing critical theologies for the liberation of women instead of the one concept of sisterhood, but her description of difference is useful also in the wider context of relationships. She makes two important points. One, difference is understood in

the sense of variety, and not as deviation from a norm. It is not to be understood in Jacques Derrida's sense as that which intervenes in the unchangeable, as though there existed a polarity between the unchangeable and something that opposes this.[35] The kind of difference Copeland envisions does not imply polarities but variety. She writes: "Vielmehr bringt Differenz einen Kampf voran für das Leben in seiner Einzigartigkeit, Veränderung und Fülle; Differenz ist eine feierliche Option für das Leben in all seiner Integrität, in all seiner Besonderheit."[36] Referring to Italian feminist writers, Copeland also points out that difference is not to be understood as contrary to equality. Rather, difference implies a variety of ways of being that are all equal.[37]

Two, in addition to understanding difference as variety, Copeland considers difference as necessary for relationships in which people rely on each other. Difference, she writes, is the authentic context for interdependence, and community is built on both difference and interdependence.[38]

Copeland is not the only writer to emphasize difference over a romantic ideal of sisterhood. Schüssler Fiorenza uses the spelling "wo/men" when introducing her concept of *ekklēsia of wo/men* in order to create an awareness that the women belonging to the ekklēsia are not unified in sameness. She explains: "I introduce here a particular spelling of 'wo/men' that seeks to indicate that women are not a unitary social group but rather are fragmented and fractured by structures of race, class, religion, heterosexuality, colonialism, age, and health."[39]

Arguing along similar lines, Grace Jantzen introduces a feminist philosophy of religion that values plurality and diversity over sameness. Jantzen uses Hannah Arendt's concept of natality, the fact that we are born, to counter a male philosophy of religion that is characterized by necrophilia and a desire to define everything in terms of the same. Arendt argues that natality is even more crucial to human nature than mortality, because mortality presupposes natality. And with birth comes not the definition in terms of the same, but plurality and uniqueness. Jantzen therefore suggests "that a symbolic of natality enables a different approach to alterity, one in which plurality is welcomed and diversity is a necessary context for the flourishing of all."[40] As human beings, we depend in our growth on the web of relations, characterized by uniqueness and diversity, which we are born into—a web of relations that we are called to sustain through our lives.[41]

Even though Copeland and Schüssler Fiorenza discuss difference with a special emphasis on feminist theologies and Christologies, the

notion of difference as they describe it is also helpful in the context of discussing relationships. The process of stereotyping in religious texts, criticized by feminist scholars, is also at work in the act of seeing. When I try to construct the act of seeing in a positive way, I share with the writers discussed their concern for a way of relating beyond polarities, dualisms, and stereotypes. My discussion of the films later on will explore whether they show such a positive way of seeing.

The question how people should relate to each other is only one aspect of feminist theological thinking about the relation between self and Other. The theorizing of the relation between human beings and God is also a way of thinking about the relation between self and Other. In some ways, this way of asking the question how self and Other relate encourages more creative answers than does the question how people relate. As far as relationships between people are concerned, many feminist theological texts are somewhat hesitant as regards the definition of self and Other . The emphasis is on the dealings of more or less fixed selves among each other and these are described sometimes with very general words, such as "love," "justice," "friendship," "equality," or at other times in more philosophical terms as relationships without stereotypes and dualisms that embody the notion of difference. The nature of what is meant by "self" or "Other" is not discussed, nor the way in which "self" and "Other" come to be. Discussions of the relationship between human beings and God are different because, in the context of this relationship, it is the nature of "self" and "Other" that is at stake.

It seems obvious to writers who address the relationship between human beings and God that the Other in it, as far as theological reflection is concerned, is of an imaginary nature. All writers acknowledge that this Other is not really accessible through language or imagery, and that descriptions of it are not in any way "real" but are products of the human imagination. If the Other in question is "God," then the Other becomes a blank surface, like the empty screen in cinema, and, as a result, a site for all manner of fantastic fruits of the human imagination. The emphasis then shifts from consideration of what is between the self and the Other to what the self and the Other are and how they come to be what they are. The fact that the Other cannot be seen as "real" in the sense that it is a body in front of me seems, in many writings, to open doors to considering the boundaries between self and Other. Suddenly, different questions dominate the thinking of the relation between self and Other. Where does the self end and the Other begin? Is the God-Other a part of the self? Is God immanent in the sense that God reaches into the world and the self? Or is God

completely Other, transcendent? How do the self and the God-Other depend on each other? Do they require each other in order to be? Does the God-Other create the self so that the term "self" will only be a meaningful term if there is an "Other"? These questions are my starting point when I argue, discussing the films, that in a relationship, people are created newly because they imagine each other.

Daphne Hampson must be credited for recognizing that the question of the relationship between human beings and God is a question of the relation between self and Other. She sees most clearly that the search for metaphorical descriptions of God is really a form of asking about the relation between self and Other. For her, the relation between self and Other is a leading question in the search for a future theism. With regard to relation between self and God-Other, Hampson explains:

> We need, then, to find ways of conceptualising that "membrane" which lies between the self, as we ordinarily think of it, and that which lies beyond the self but to which it is immediately connected. . . . We do not want to suggest a self which lacks integrity or which lacks its own agency. Nor, on the other hand, do we want to suggest a self which is simply set in opposition to that which is other than the self.[42]

Writers see the boundaries between the self and the God-Other that Hampson draws attention to in different ways. McFague, for example, thinks of the relationship between the self and God-Other in terms of an encounter, not of submersion; in other words, the boundaries between the God-Other and the self appear to be quite distinct.[43] Hampson upholds that the God-Other is accessible in the world and even within the self. In her attempt to outline a future theism, Hampson describes God as "somehow mental, or mind, or spirit."[44] In Christianity, she claims, God is always Other than the self, because the Christian God is a God of revelation.[45] Hampson wishes to recast this understanding of God so that God is seen as part of the self. "The issue becomes one of how humans may be in touch with their deepest selves (if you will, with that which is God in them)," she writes.[46] God and human beings are part of the same reality.[47] Therefore, the dichotomies Hampson sees in Christian thought must be overcome:

> That further step . . . must be to claim that in being most fully ourselves we are also realizing God in the world. We need to overcome the dichotomy, fundamental to the major tradition of Western thought, whereby God's greatness is at the expense of our weakness. . . . Rather, God should be conceived to be the fullness of our potentialities.[48]

The God-Other, in Hampson's approach, reaches into the self and comes into being when the self develops its potential. Catharina Halkes, too, conceptualizes God as reaching into the world and the self. She dreams of the world as being God's body and this allows her to look at the human body as an image of God within the self, as a sacrament, a self that manifests the holy, the God-Other, within it.[49]

My point here is not to argue for or against any particular concept of how the self relates to the God-Other. The point is, simply, to show that whenever writers of feminist theology have discussed the relation between human beings and God, they have thought about the relation between self and Other in a much more radical way than when thinking about the relationships between people. They have been much more imaginative about how the self and the God-Other relate to each other, invade each other, and create each other because the imaginative nature of the God-Other has, somehow, allowed for the freedom of the mind necessary to think radically about what "self" and "Other" might mean. With regard to the relation between self and God-Other, writing theology has meant making an image of the Other and of the self in relation to it. This is the point where theology connects with the act of seeing in the films discussed in this book. Seeing, there, means for the women to imagine their self in relation to an Other.

This kind of radical thinking about self and Other should, however, not only take place with regard to the relation between self and God but also with regard to the relation between the self and a human Other. It is necessary to acknowledge the imaginary nature of human Others in order to achieve this radicality of thinking. Human beings are not accessible to each other as "real" simply because they have a body. True, a human Other is physically manifest, but there is more to relating to this Other than her or his physicality. In addition to the Other's physicality, it is the way in which I construct, imagine, see, the human Other in my mind that determines how I will relate to them. There is little more "reality" in human relationships than there is in a relationship between God and human beings. In both types of relationship, "I" see the Other as this or that, "I" create an image of the Other and of myself in relation to it and act according to it. Self and God-/human Other create and continually transform each other.[50]

Many feminist theological writings on human relationships have not been quite radical enough, in this sense. It is very good but not enough to speak of human relationships in terms such as "love," "justice," the politics of "equality" and "difference." The questions are what love is,

how to achieve justice, and how to maintain equality; and the answers can be found only by thinking radically about what the self and the Other are and how they come to be. We should be asking—as we do with regard to the relation between the self and the God-Other—where the self ends and the Other person begins, whether another person is completely outside of our selves or reaches into us and forms a part of us. We should ask how it is that we depend on each other in our being and becoming, how we create each other. These are the questions that Buber asks in *Ich und Du,* the book that formed the starting point for many feminist theological writings on relationships. If we think, as Grey does, that human beings have a responsibility for bringing about redemption by being creative, we must credit human beings with the ability, in some ways, to create each other as self and Other, and we must ask how it is that we can be creative of each other.

Seeing and being seen have been described in the philosophies discussed in chapter 1 as a relationship of inequality, even of dominance and submission. In this book, I understand the act of seeing each other as a way of relating and as a way of creating each other. Seeing each other and imagining each other cannot be avoided. The act of seeing, as feminist film theory has pointed out, has destructive potential. But I will argue that it can be a way of relating that is creative also.

Developing a Sense of Self

In Grey's concept of redemption, it is essential to develop a sense of self because we can only be in relation if we have this sense. At the same time, she maintains that it has been difficult, in the past, for women to come to a sense of self because existing theological categories are inadequate for interpreting women's experiences.[51] Building on Carol Gilligan's book, *In a Different Voice,* Grey shows that women develop a different sense of self from men, one that is based on relation rather than on separation.[52] Grey warns that this characteristic of the self has often been used against women in that they were stereotyped into myths about the feminine (such as the myth of the maternal, nurturing, and caring nature of women).[53] As a consequence of these myths, it has often been thought to be in the "nature" of women to sacrifice themselves for others rather than to develop a sense of self. Nevertheless, Grey attempts to show that it is the relational self that has redemptive strength, and that being in relation does not necessarily hinder self-development.[54] The argument that a sense of self is found through relationships will form the

cornerstone of my discussion of the films in this book, where I consider seeing and being seen as expressive of a relationship in which a sense of self is created.

There is a strong consensus among writers of feminist theology that male stereotyping of femininity has hindered women's development of a sense of self.[55] Daly, for example, argues that women have been the scapegoats of a sexist society that uses the myth of Eve as a tool for the condemnation of women.[56] Radford Ruether unmasks as false consciousness the roles of the pretty girl-child, sexy lady, and good wife that women have assumed in order to please men. These roles, she argues, prevent women from developing their own sense of self.[57] Elisabeth Gössmann examines aspects of the Christian tradition as far as it is influenced by Platonism, Neoplatonism, and Aristotelianism, and finds that women are stereotyped as being the deviation of the male norm. She criticizes the fact that the aspects of Christian tradition she examines are based on a singular principle that prevents women from developing a sense of self independent of their construction as the opposite of this principle.[58] Ina Praetorius writes about the status of women in a patriarchal society along similar lines. She accuses androcentric language of not giving women the chance for authentic self-expression. Androcentric language allows women to express themselves only as either the same as or different from the male norm.[59] Hampson finds that Western religion is a male-defined understanding of reality that assigns women a particular place. Western religion, thus, functions like Western culture as analyzed by Simone de Beauvoir: "man" is the absolute and "woman" is stereotyped as the Other.[60] Schüssler Fiorenza warns that, as a result of many women's abilities for building relationships, women in general are stereotyped into being responsible for relationships because they are thought to have a "natural" gift for relationships.[61] The image of women as the ones responsible for relationships is part of kyriarchy.[62]

The writers discussed above claim that it is necessary to break free of male stereotyping of any kind in order to develop an authentic sense of self as a woman. A prerequisite for redemption, writes Grey, is to look at how women see themselves and not only at how they are seen by men.[63] I will show later in what way *Artemisia* demonstrates that seeing oneself outside of male stereotyping is difficult. As Artemisia learns to see, she paints herself as Judith, thereby casting herself in the old stereotype of the castrating woman. In contrast, when Potter, in *The Tango Lesson,* sees her look as life giving and as an act of making herself vulnerable, she represents herself outside the stereotype of the powerful and objectifying spectator.

To support this emphasis on the development of a sense of self, many feminist theologians develop an understanding of sin that differs from the concept of sin in traditional Christian theology, written from a male viewpoint. Rebecca S. Chopp takes Reinhold Niebuhr as an example of male writing on sin, according to which sin is equivalent to self-assertion and love to self-sacrifice. Arguing that this understanding of sin is based on a male sense of self, she proposes, along with numerous other writers that, for women, sin means not to develop a sense of self, to renounce their sense of self in an act of self-sacrifice.[64] Moltmann-Wendel is looking for a sense of self in the experience of bodily integrity and beauty.[65] Daly finds it important to affirm the female ego over forces that try to deny it.[66] Hampson points out the danger of self-destruction that is inherent in the idea of self-sacrifice and concludes that, for male-female relationships to function, women need to come into their own.[67] Grey thinks that a sense of self-worth should be acquired by reclaiming the original wholeness of redemption and creation through the experience of oneself as God's good creation.[68] Beverly Lanzetta argues that women need to acquire a place of stillness in which they can find a new sense of self by undoing ways in which they have been named/stereotyped by others, and by celebrating their renaming as beloved and worthy in the eyes of God.[69]

There are differing suggestions as to how women can develop a sense of self. While there is a basic consensus that a sense of self is gained through identification, writers differ with regard to whom women should identify with. A number of writers within feminist theology, and also in biblical studies, have developed an interest in female characters in the Bible and in female figures associated with Christianity, as well as in goddesses of other religions.[70] Opinions differ as to whether female characters of past texts and traditions are suitable role models for contemporary women. Moltmann-Wendel tries to trace as role models the figures belonging to female trinities in representations of the motif of St. Anne with her daughter and grandchild and in representations of the women who witnessed Jesus's resurrection.[71] Grey suggests that remembering female characters in the Bible is liberating for women today and important when they ask how redemption can be achieved. Her argument is grounded in the conviction that the Bible actually portrays women in liberating action, "claiming power-in-relation."[72]

Hampson, on the contrary, argues that female biblical characters are not suitable as role models for women who are searching for equality with men. The biblical texts, she argues, originate from a patriarchal

context and are not interested in the equality between men and women.[73] Similarly, J. Cheryl Exum, writing about female figures in biblical texts, points out that what may seem to be positive images of women actually serve patriarchal interests.[74]

Unlike feminist theologians who argue for or against the identification of women with female characters from the past as a way of developing a sense of self, Elizabeth Green discusses the possibility of transgender identification. She is occupied with the question whether the female sex should be divinized either through complementing a male, Christian God with female attributes or through creating an independent, female divine figure in order to give women the possibility of self-transcendence and identification with a divine figure of the same sex.[75] Having drawn attention to dangers inherent in the attempt to feminize the divine, Green comes to the conclusion that it is useful for both men and women to be able to identify not only with an Other of the same sex but also of the opposite sex. Women have been able to identify with Jesus and have been included in the redemption through him; men, therefore, need to learn to identify with Mary and gain full participation in humanity through her.[76]

The idea of transgender identification is appealing as a way of developing a self that is not based on identification with the self-same.[77] Green's particular example, Mary, is, however, not chosen wisely, because she has a lower status in comparison with Jesus. Jesus is a partly divine being; Mary is fully human. Green's example shows exactly where the problem lies. Given the choice between the male hero and the female figure of lower status, why would we identify with the female figure? While transgender identification is possible, it is not an ideal if it only happens because of the absence of female characters suitable for identification. Transgender identification is a strategy of survival for women who live in a culture where the heroes are male, whether it is the culture of cinema or religion.[78] Transgender identification can be a fascinating way of developing a sense of self, but only if it is practiced by men and women alike, as a matter of choice and not of necessity, and in a culture where the heroes are male and female. Perhaps it is necessary to have a female divine figure in order to make transgender identification easier for men and same-gender identification easier for women.

Elsa Tamez sees the possibility of developing a sense of self in the interactive relationship between a woman and a text. Tamez describes the body of a woman as structured like a text and texts as having a body. "Der Text ist Körper," she explains, "und der Körper (eines Wesens) ist Text, und zwischen beiden kann eine tiefe Beziehung stattfinden."[79]

Because they are similarly textured, text and body can overlap and enrich each other and, Tamez states, a mutual realization can be achieved.[80] In such a relationship of mutual realization, the text and the woman need each other in order to become. The woman needs the text in order to give meaning to her life and the text needs the body of the woman in order to become alive. Tamez's model of developing a sense of self is different from models of identification discussed above in that she places more emphasis on the mutuality of the process. The realization that Tamez envisions is happening not only for the person who identifies today with a character of a text written a long time ago but also for the textual character. Her model is not about a person today using a character to identify with in order to develop a sense of self, rather it is a process of equal exchange between the body of a woman and a text in the past that becomes alive as the woman identifies with a character in it.

Most important, however, is not whom we identify with in order to develop a sense of self, but what purpose we identify for. The purpose of identification should not be the search for one's mirror image, for the self-same body,[81] but relation. A character whom one identifies with always appears in a context, in a story, a film, or a painting, and to identify means to place oneself in that context. Identification thus enables the development of a sense of self through relating to a context different from one's own. The fascination of identification lies not in the ability to recognize an Other as my mirror image, independent of the context of the Other, but to recognize myself as an Other, the ability to be something that I am not normally through being in a new context. Seen in this light, the emphasis on identification of women with female characters limits the possibilities for developing a sense of self, whereas transgender identification can liberate women to the experience of seeing themselves as someone else.

Being seen, as discussed in chapter 1, has been understood as having one's identity determined entirely by the one who sees. Seeing, as a consequence, has meant to determine someone else's identity and to fit them into the structure of the same, in which no difference is allowed. By contrast, seeing, if it is understood as finding a self that is able to relate, is an act of developing one's own identity by relating to others who are visibly different. I will show later on how both Artemisia and Sally develop a sense of self through identification. Artemisia puts herself in the context of the story of Judith, Sally in the context of Jacob's fight with the angel. The two women's ways of identifying highlight another aspect of the act of identification. While both women place themselves within the context of a biblical story,

they also stay outside it at the same time in order to see themselves through the perspectival frame in Artemisia's case or the film camera in Sally's. To identify by seeing oneself as someone else implies the coexistence of two parts of the self, one part that becomes someone else and another part that is aware of and observes this.

WOMEN'S SEEING AND COCREATIVITY

So far, I have discussed what aspects the term "redemption" includes. According to the writers discussed above, redemption means being in relation and developing a sense of self at the same time. The two are interdependent. Real relationships, on the one hand, are only possible between people who have a sense of self, and on the other hand, people develop a sense of self through being in relationships. To answer my initial question whether seeing can be redemptive, I will first seek to establish a place for human creativity within a concept of redemption. I will do this by examining the contribution to redemption that women are thought to be making, according to feminist theology. In a second step, I will look at the act of seeing in particular, in order to answer whether seeing might be a creative act that contributes toward redemption.

Women's Creativity

The consequence of a feminist theology that sees God as relational is that redemption relies on the activity of all who are involved in this relationship. Various writers have therefore argued for the responsibility of human beings with regard to redemption. Carter Heyward argues that God needs people in order to bring about redemption. God needs people in order to act,[82] and even in order to create the world through being in relationship.[83] God, for her, is only real in relationships between people, only exists in human activity.[84] I noted earlier in this chapter that Grey sees redemption and creation as a unified process, in which redemption is transformation and humans share responsibility in the divine task of transforming the world.[85] Because redemption and creation are two sides of the same coin, Grey describes human creativity as participation in the redemptive transformation of the world. She even sees redemptive transformation as a bodily process when she describes women's activity as "helping the earth to deliver."[86]

Feminist theologians write about women's creativity in different ways. Some see women's cocreative abilities foremost in the act of

giving birth. Radford Ruether, for example, writes about Mary's role in creation, described in the Gospel of Luke as an act of physical birth giving. In her discussion of Lucan Mariology, she draws a general conclusion about "woman" from Mary's specific act of giving birth. "Lucan Mariology," she claims, "suggests a real co-creatorship between God and humanity, or, in this case, woman."[87]

Women's creativity, expressed in the bodily act of giving birth, is often complemented with images of a motherly God who, like women, is seen to be creative in the physical act of birthing the universe. McFague, for example, in her search for alternative images of God and of the relationship between God and the world, imagines the world as God's body.[88] In this view, all things in the world have their origin in God and God gives them their bodily reality.[89] McFague then personifies this image of God by means of the metaphor of the mother whose divine creativity is expressed in the act of giving birth.[90] McFague argues that this image of bodily creation of the world through a mother-God is preferable to the image of artistic creation through a male God as presented in the creation accounts of the book of Genesis. Whether the male God creates the world with his intellect—by word—or with his hands—as a sculptor—makes no difference to the fact that in both cases God creates out of something totally different from God, argues McFague.[91] She thus dichotomizes strongly, and, in my view, unnecessarily, different ways of being creative. I will show later that *The Tango Lesson* puts forward a view of human creativity that does not divide between bodily and artistic creation.

In recent years, various writers have criticized descriptions of women's creativity solely in terms of the bodily act of giving birth and of motherhood especially, as the mother role has come under criticism. Criticism of the mother role is situated on two levels. On one level, writers point out that femaleness is too often defined in terms of motherhood only. On another level, writers criticize the way in which motherhood is theorized. Johanna Kohn-Roelin's argument falls under the first group of writers. She argues that the education of girls to be mothers is, at the same time, an education to be second-class citizens.[92] Feminist theology, she demands, must question the traditional view of femaleness in terms of motherhood only.[93]

One way to develop a wider view of both maleness and femaleness would be to view not only mothers but also fathers as caring. Kohn-Roelin, however, finds the image of the "breastfeeding fathers," as she calls them, unhelpful.[94] She argues that the father is important in his difference from the mother in order to help the child break away from the mother and to develop self-confidence.[95] Kohn-Roelin's

argument, sadly, only perpetuates a traditional understanding of parental roles, whereby the mother stands only for the symbiosis or, in Freudian terms, the pre-oedipal, phase and the father is necessary for the child to break free from the symbiosis with the mother and enter the symbolic realm. Whereas Kohn-Roelin rightly criticizes the limitation of femaleness to motherhood, it is also necessary to criticize the limitation of motherhood to a pre-oedipal symbiosis and to develop a more positive understanding of motherhood.

Ursula King tries to widen the meaning of the term "motherhood" from an understanding limited to bodily functions to a view that includes spiritual motherhood.[96] This understanding of motherhood includes artistic creation as an act of cocreation. Interestingly, and in contrast to Kohn-Roelin's understanding of motherhood in terms of a pre-oedipal symbiosis, King mentions several examples of goddesses in Hinduism, who are described as mothers not only in bodily terms. One, Saraswati, for example, is considered to be the mother of the writing talent and of eloquence.[97] This indicates that the divine mother can have more than the physical function of giving birth to the universe. With regard to human mothers, such an image of a divine mother shows that the role of the mother is not limited to a bodily function or to a pre-oedipal phase but that the mother plays an important role in introducing the child into the realm of language and symbolic creation (termed as the realm of the father by Lacan).

Green, who discusses the works of Diotima, a group of Italian feminists, also tries to see motherhood in other than bodily terms. She ascribes importance to the symbolic and sees the ability of women to name reality as a way of giving birth to the world.[98] The figure of the mother, she argues, referring to Diotima, must be discovered as a source of symbolic competence.[99] Radford Ruether, even though not discussing the role of the mother in particular, argues along similar lines. She sees an equation of femaleness with body, matter, and immanence, and of maleness with mind, spirit, and transcendence at work in the patriarchal mind-set and wants to undo these ties so that femaleness can signify not merely bodyliness and materiality but also spirituality and creativity of the mind.[100]

To summarize, the scholars discussed above take a critical stance with regard to motherhood and emphasize the need to see femaleness in terms of symbolic and not only of bodily creation. This applies whether writers argue that femaleness should not mean motherhood only or whether they point out that motherhood should not mean bodily creativity only. In any case, in the texts discussed, women are

thought to make an important contribution toward creating the world as a material reality as well as a symbolic order. Both *Artemisia* and *The Tango Lesson* represent creative women. *Artemisia* deals more with symbolic creation, whereas *The Tango Lesson* refers to bodily and symbolic creation, with one being the metaphoric expression of the other. Perhaps this film will show that the two cannot be separated.

The Significance of Making Visible

If the creativity of women should not be restricted to their role as mothers, how else can women be seen to be creative? Both women and men have the capacity for artistic creation. If creation, as Grey has said, belongs with redemption as two sides of the same coin, does it follow that the creation of a work of art is, in some way, redemptive? The creation of a work of visual art begins with the act of seeing, envisioning something that is then created, made visible. If creation belongs with redemption, does it follow that seeing and making visible are part of redemption?

There are different opinions within the feminist theological debate regarding what it means to see and to make visible, and regarding the question whether or not there is positive potential in these acts. It is the value of the visible world that is at stake here. Some writers deal with the value of the visible world in itself, others describe it by comparing the visible and the invisible world in their relation to each other. Catharina Halkes, in reflecting on the visible world, finds the idea of the sacramental character of the world attractive. A sacrament is considered a part of the visible world that manifests the divine. To ask about the sacramental character of the world means, therefore, to think about the value of the visible world in terms of God's presence in it. According to this view, the visible world is valuable because the divine is thought to dwell in it.[101]

Even though the visible world, in this view, is valued highly as a locus of the divine, there is a danger inherent in this way of seeing the visible world. The visible world and the divine could still be seen as separate in the sense that one is the dwelling place lived in by the Other. What if the Other leaves the dwelling place? Is the visible world still valuable then? Does the visible have value in and of itself or is it only worthy if it is entered, penetrated by the divine?

Halkes makes a suggestion that can help to solve this problem. She postulates the sacramental character of the world, rather than of particular "holy" events or "holy" places in it, explaining that

we defraud the world if we only speak of God's presence when God's word is proclaimed or the sacraments are celebrated . . . If we can imagine the world as God's body, we not only include all people but also all structures in which people gather together; we include the whole of created reality.[102]

If God is not only thought of as entering the visible world in particular places or through particular rites but is also thought to permeate it fully, then the separation between the divine and the visible could be broken down. Then it would be possible to argue not only that God enters the visible but also that part of God is the visible world. The idea of the world as God's body that Halkes speaks of suggests as much. God does not enter or leave the visible world as God pleases, but God partly is the visible world. This is to say that the visible is worthy because it is divine, and that the divine exists partly through the visible world.

Daly, too, emphasizes the importance of not seeing God and the visible world as separate, although she argues this point in a different way. Criticizing patriarchal theology for understanding God in an abstract way, as a being opposed to the becoming world, she argues that God exists when God develops, that God is in becoming. The unfolding, visible world is valuable because it is part of God's being that continually develops. Seeing and making visible, according to Daly's view of the visible world, must be positive because they help to bring forth the visible world in its divine potential. This valuing of the visible world and of the act of seeing is shared by Grey in her presentation of an ecofeminist spirituality that "values God's immanence and presence in the materiality of what is actually seen."[103] Seeing, listening, and paying attention to the world are ways of recognizing the divine in creation.[104] This view of seeing as a way of paying attention to and valuing the visible world will be one of the building blocks in my argument for a positive view of the act of seeing later on in this book.

More recently, however, feminist theological discussion about the visible world and its value has turned in a different direction. The debate about seeing and being seen has lost its innocence. Writers are aware that being seen is not always positive. Indeed, as I have shown in chapters 1 and 2, a number of philosophers and feminist film theorists have drawn attention to the fact that being seen often has negative consequences for the person who is seen. Problems arise when the visible and the invisible are seen to oppose each other. There is an imbalance as soon as one thing or one person is defined as totally

visible, over against another that is completely invisible. Like feminist film critics, feminist theologians point out that in Western culture, it is most often women who are defined through total visibility by men who make themselves unavailable to any gaze.[105] Anne Marie Hunter refers to Foucault's description of the panopticon in order to explain that an unequal relationship between the visible and the invisible implies a relationship of power, in which to be visible is a sign of oppression.[106] She argues that women are victimized if they are defined as totally visible.[107] The victimization is increased since women are not only scrutinized by men but also scrutinize themselves. In the panopticon, prisoners are visually exposed to the look of a surveyor who is invisible to the extent that the prisoners do not know when they are being watched. The prisoners feel under continual surveillance even when the surveyor is not looking. Thus, the panopticon works on the basis of the internalization of the scrutinizing gaze. This internalization results in an identity that is split between an internalized surveyor and the persona of the surveyed victim.[108]

Feminist theology's analysis of the visible and the invisible world, however, goes beyond a simple critique of the fact that in patriarchy maleness is often associated with invisibility and femaleness with visibility. Feminist theology, in its analysis of the relation between the visible and the invisible, shares a fundamental argument with feminist film theory and its analysis of the gaze. In feminist film theory, the discussion of the power relation between visible women and invisible men has been based on theorizing the position behind the camera as the place of the invisible spectator with the powerful gaze, "The Absent One."[109] Even though the Absent One is out of reach for male spectators, they are made to believe in the illusion that they own the powers of this Absent One.[110] Likewise, feminist theology has found that the unequal relationship between the visible and the invisible is grounded in the concept of an invisible, absent God. This invisible God occupies the place that is beyond reach, yet always aspired to—aspired to by men because, even though invisible, this God is still gendered male.[111] The concept of the invisible male reaches an extreme and, at the same time, touches its true argumentative basis, in the belief in an invisible God.

The belief in the invisible God is at the heart of so-called "negative theology" that, as Elizabeth A. Pritchard explains, insists "that the divine is what it is precisely because it resists representation."[112] Pritchard, on the one hand, acknowledges that the idea of an invisible divinity has been attractive to feminist theologians as a way of avoiding a male-defined God who justifies patriarchal oppression.[113]

On the other hand, however, Pritchard warns that an entirely invisible, unknowable divinity is elitist if it is thought of at the same time as the all-knowing counterpart to human incomprehension.[114] Moreover, Pritchard points out that negative theology is not entirely what it seems. With regard to a divinity defined as nonrepresentable, she states: "It is important to recall that the ability to deflect or avoid the gaze of scrutiny has consistently served as an index of male privilege."[115] Thus, the supposedly unknowable deity who defies representation is in fact male because "the ability to resist representation is widely, if not always consciously, regarded as a prerogative of elite males."[116]

In the context of such views of women and men, of the world, and of God, seeing and making visible cannot be redemptive. To be seen is to be objectified and victimized. Not to be seen is to be a subject and to be powerful. The visible is the unworthy, defined and put in its place by its more powerful counterpart, the invisible God of negative theology or the Absent One in cinema, whatever it is called.

Are there ways to reach a more equally balanced view of the visible and the invisible? Cynthia Eller considers the problem of the unequal relation between the visible and invisible as a problem between women and men, and she suggests taking a different look at how women and men come to be women and men. For men, who have typically been defined by their invisibility, it is necessary that they, too, are represented, painted, photographed, and seen, especially by women.[117] For women, who have been restricted to being visible, it can be important to refuse representation in order to show that women have a value beyond their bodies.[118] Then, she explains,

> one can hope . . . that female representation of men would lead not to an equality of objectification but to a recognition by all that we are embodied; that no one has a monopoly on rational thought or bodily connectedness; and that we can all take up the position of viewing subject and viewed object interchangeably.[119]

The real problem, however, lies not where Eller sees it, in the fact that the viewing subjects have so far been male and the viewed objects female. The real problem is the worth of the visible and the invisible. Whether it is women who are objectified as visible or men is of little consequence; problematic is the notion that to be visible means to be objectified. Eller's solution is, therefore, not really useful. Of course, if we believe in the representation of human beings, both men and women should be represented. But it is not enough to perceive of human beings as both "viewing subjects and viewed objects

interchangeably." Our view of vision will only seriously change if we manage to see that viewing does not always make us a subject and that being viewed is not necessarily objectifying. This is a point that I shall underline with the discussions of the films later in this book.

In attempting a more equal balance between the visible and the invisible, many feminist scholars have turned to the work of Judith Butler. In *Bodies that Matter: On the Discursive Limits of "Sex,"* Butler introduces a way of conceptualizing the relation between language and materiality that is a useful pattern for theorizing the relation between the visible and the invisible. Butler considers language as a system of signs that tries to capture materiality by naming it, and materiality as that which can never be captured fully by language.[120] Nevertheless, materiality is not completely outside language. In fact, Butler argues there can be no ontological distinction between the two. Language and materiality cannot be seen as totally distinct from each other any more than the visible world should be seen as separate from an invisible God. Instead, Butler shows that language and materiality reach into each other. Language is always material as its signs work by being visible and materiality is partly accessible through language. And yet materiality is never fully contained in language. Butler writes: "Always already implicated in each other, always already exceeding one another, language and materiality are never fully identical nor fully different."[121] Materiality, in relation to language, is a loss, something that can never be named, but which nevertheless "takes its place in language as an insistent call or demand that, while *in* language, is never fully *of* language."[122] Materiality is an indescribable element both in and outside of language that calls for the continual renaming of the material, causing perpetual transformation of language's visible signs.

Pritchard, in discussing Butler, explains that there is an invisible side to every visible referent, just as the materiality theorized by Butler belongs with language but is also always beyond it. No visible sign is able to capture fully what it signifies.[123] This failure, however, is not to be understood as a shortcoming. On the contrary, it allows for a "radical democratic politics of contesting definitions," because every referent continually questions its representation.[124] Anne Daniell discusses Butler along similar lines, arguing that there is an "outside" to every referent, a "no-thingness" to every thing, something unnamable, unknowable to each sign, that disappears as soon as it is named.[125]

Pritchard goes on to compare the discursive failure of signs, outlined by Butler, with negative theology. In negative theology, the word is thought to be incapable of capturing its divine referent, thereby encouraging an open-ended theology. To refuse representation, at

least to an extent, is, therefore, a divine privilege. It is a privilege, however, that all referents should participate in. Pritchard explains:

> If the idea that language fails to grab hold proves to be a goad to critical thought, why not allow all referents to enjoy the benefits of more judicious descriptions and to outgrow their signs that have become too snug? What's good for God ought to be good for the globe.[126]

This way of thinking about the visible and the invisible does away with a strict separation between the two worlds. Not only is God thought to be both invisible and visible, as we saw above in the work of Halkes and Daly, but every thing, every person, every reality is both visible and invisible. No one person can be seen as completely visible and another defined as totally invisible. No body, no soul, no thing, divine or not, is completely one or the other.

One could ask, as I have done above, whether in this concept, too, the visible is revalorized through the invisible that belongs with it; whether the worth of the visible is something added to it by its invisible counterpart. One might suspect that the visible is, once more, not worthy in and of itself, if it lacks the invisible, just as the visible, in the sacramental theology I mentioned above, is not valuable without the penetration of the divine invisible into it. But Pritchard's and Daniell's texts are concerned with the visible *and* the invisible. Every visible thing, they argue, has an invisible side to it, by which it is enriched. At the same time, every invisible "thing" needs a visible side that alludes to the invisible. The visible and the invisible require each other. The balance between the visible and the invisible that Pritchard and Daniell strike will be important in describing a way of seeing that is redemptive.

Before I move on to discuss the films in relation to these texts of feminist theology, it may be helpful to summarize what redemption means in feminist theological thinking as a starting point from which to argue, in what follows, whether and how seeing can mean to be in relation, and whether and how seeing can be redemptive. Redemption, according to the texts discussed, means being in relation and becoming a self, and it means being creative and being created in a particular way. Relation, as we have seen, is described in different manners. Some authors base their understanding on the Bible, mainly on the figure of Jesus, and describe what happens between partners in a relationship with words such as "mutuality," "justice," and "love." Others take philosophy as their point of departure and dwell on the difficult relationship between the male self and the female Other in

patriarchy, concluding that in future relationships, men and women should not be seen in terms of stereotypes but in terms of difference. I have argued that, in speaking about relationships, it is essential to explore the boundaries between self and Other and to recognize that self and Other do not exist in and of themselves but are created through the way in which each is imagined in relation to the Other. This point will become clear in the following interpretations of both *Artemisia* and *The Tango Lesson*. In *Artemisia*, Tassi and Artemisia are partly defined as people through their being Holofernes and Judith to each other. In *The Tango Lesson*, the created nature of the self and the Other is emphasized when Sally and Pablo are cast as relating to each other in a film and in the dance. While making Sally and Pablo visible as individuals, the film still makes obvious that the characters are created and shaped through the relationship with the other person.

The scholars discussed above follow various paths in order to discover how a person can be redeemed through developing a sense of self. For some, the understanding of how a sense of self is achieved is closely linked to the understanding of relation. A sense of self, they argue, needs to be developed within a relationship and can be found only if the developing self is not bound by stereotypes. Others think that a sense of self can be developed through identification with female biblical figures, or with goddesses. Still others have focused on the possibility of transgender identification or interaction with a text. I have argued that it is important to consider relating as the purpose of identification. The ability to identify is the ability to place oneself in a context one would not normally be in. It is not the ability to see an Other as one's mirror image, but to see oneself as an Other.

Creation, scholars have argued, belongs with redemption like one side of a coin with the Other. God is an unfolding God who needs to become visible in order to be. Human beings participate in the unfolding of God through their creative acts. Women can be creative and redemptive in two ways: either through giving birth physically or through artistic creation and their capacity for symbolic competence. In this sense, the women artists in the films to be discussed all have the potential to contribute toward redemption.

If redemption is creation, then to be created is to be redeemed. Is being visible, therefore, being redeemed? Some theologians say yes, because the visible world is a sacrament, it is God unfolding. Others warn that being visible can mean being victimized in a world where there is a strict division between people defined as totally visible and people who are themselves invisible, while taking pleasure from the Others' visibility. Seeing can only be redemptive, I concluded above,

if there is believed to be a balance between the visible and the invisible, if every visible thing is believed to have an invisible side.

The following discussion of the films approaches them in terms of what they show about the act of seeing. By way of introduction, *Camille Claudel* will show some of the problems that female artists, women who claim the gaze, have had to face. The main discussion of *Artemisia* and *The Tango Lesson* focuses on two aspects. First, I seek to relate the act of seeing as illustrated in *Artemisia* and *The Tango Lesson* to the idea of redemption as I have described it here. Seeing and being seen, I argue, means being in a relationship and becoming a self; seeing and being seen mean being creative and being created. Second, I will raise throughout the interpretation of *Artemisia* three questions that remain unanswered in this film—the questions of how seeing can be positive, how it can be recognized as an activity that shapes reality rather than as an impartial "registering" of it, and how a balance between the visible and the invisible is struck. I treat *The Tango Lesson* as a response to these questions and develop an understanding of the act of seeing in three aspects: I argue that seeing is redemptive, that it is an act of faith, and that the recognition of a balance between the visible and the invisible is an essential gesture of respect toward the seen Other.

I use theological and philosophical texts in relation to both *Artemisia* and *The Tango Lesson*. In the interpretation of *Artemisia*, I engage with McFague's concept of the loving and the arrogant eye, and I treat the film and the theological text as dialogue partners in the sense that each of them will contribute toward the interpretation of the Other and that each will be questioned in the process.

The Tango Lesson alludes, in one scene, to Martin Buber's *Ich und Du*, and I proceed from Buber's book in my interpretation of this film. Given the emphasis of this book on feminist theology, the use of Buber's philosophy might surprise. Buber's thoughts, however, are useful in order to understand the processes at work in *The Tango Lesson*.

Indeed, Buber's work is one of the keys to the film, as Potter has indicated in her screenplay.[127] Moreover, in the light of the references to Buber in feminist theology, the use of Buber is also a way of returning to one of the sources that have inspired feminist theology for a long time.

CHAPTER 4

———❦———

CAMILLE CLAUDEL

The film *Camille Claudel* (Bruno Nuytten, 1988) focuses on part of the life of the French sculptress Claudel. Claudel was born in 1864 in Villeneuve and began to sculpt as a child. At the age of 18, Alfred Boucher, a local sculptor, was so impressed with Claudel's art that he introduced her to the director of the Ecole des Beaux-Arts, Paul Dubois. In 1881, Claudel's family moved to Paris where Claudel rented a studio together with three English women, one of whom was the sculptress Jessie Lipscomb. Boucher came to the studio to give advice to the artists occasionally, and, when he went away for six months, asked the sculptor Auguste Rodin to take over visiting Claudel's studio.

Thus, Claudel met Rodin when she already had her own studio.[1] Claudel became Rodin's apprentice, then collaborator and lover. She first went to work in Rodin's atelier together with her artist friend, Jessie Lipscomb. Toward the end of the 1880s, Rodin and Claudel moved into a studio together that they shared until the early 1890s, when their relationship became troubled.[2] In 1892, Claudel moved out of the shared atelier because she felt the need to assert herself as an artist independent of Rodin, with whom her work was constantly associated.[3]

During the period 1893–1913, when Claudel worked in the solitude of her own atelier, she was able to consolidate her own artistic style, which, as Angelo Caranfa suggests, is quite different from that of Rodin.[4] Eventually, Claudel broke all contact with Rodin in her attempt to establish herself as an artist independent of him, even though Rodin did continue to try to support her by obtaining commissions for her. During her years of solitary work, Claudel developed

persecution fantasies that were severe enough for her family to decide to have her committed to the mental hospital Ville-Evrard in 1913, and from there later on to the asylum of Montdevergues, where Claudel died in 1943. Claudel was committed only a few days after the death of her father, who had always supported her. Claudel's brother, the writer Paul Claudel, took the final decision for Claudel's confinement, as he was then the only male and therefore seen to be the head of the family. Claudel's mother and sister never visited her during the 30 years in the asylum; Paul visited only a couple of times. Upon the request of her family, Claudel was placed under orders of sequestration. After some years in Montdevergues, the director of the institution wrote to Claudel's mother, confirming that her situation had improved to the point where Claudel might be able to live a fairly normal life outside of the asylum. Claudel's mother insisted, however, that she be kept at Montdevergues. Claudel was encouraged by staff in Montdevergues to continue to sculpt, but she refused.

After her confinement, Claudel was more and more forgotten; her works were not exhibited and a number of them are lost to this day. In 1982, the first biography of Claudel appeared.[5] Reine-Marie Paris's biography and a first major exhibition followed in 1984 and 1988.[6] Paris has been consulted in the production of the film *Camille Claudel*, which should be acknowledged as another step toward safeguarding the memory of Claudel.

The film begins in 1885, the year within which the film dates the first encounter between Claudel and Rodin. Tracing Claudel's relationship and collaboration with Rodin during its first part, the film concentrates during its second half on Claudel's life and work in her own atelier, away from Rodin. It ends in 1913, with a shot of Claudel in the back of a van that brings her to Ville-Evrard. The film's credits display a sentence of written text, explaining how Claudel spent the time until her death in 1943, next to a photograph of Claudel in Montdevergues, taken in 1929 by Jessie Lipscomb's husband, William Elborne. As a film that aims to show a female artist, *Camille Claudel* can demonstrate what it means for women to see in order to create art, while also demonstrating the difficulties that women who claim an artistic gaze have had to face in a male-dominated art world. *Camille Claudel* presents three areas of difficulty with which Claudel had to deal during her lifetime, and which still play a role in the recognition of her work today. The areas of difficulty that I will highlight have been typical not only for the life and work of Claudel but for that of other women artists as well. The following discussion of *Camille Claudel* thus serves as an introduction to important

issues that surface when women use their eyes in order to see and to create art.

WOMEN ARTISTS AND RELATIONSHIPS WITH MALES

Relationships with males have often represented an obstacle for women who have tried to exercise an artistic gaze, and to work independently as artists. Two issues are at stake here. First, because of the absence of other female artists, women have actually had to learn from male teachers, and, as a matter of fact, personal or love relationships may have developed in some cases. The second issue is less to do with the actual life of a female artist and with the actual relations she might have had with males, but with the relationships she is seen to have had with those males. In other words, whatever relationships women did in fact have with men in the art world, "society" often had, and still has, a particular interest in seeing women artists in relationships with men. Women artists, therefore, have often been represented in terms of the relations they might have had with a man, rather than as an artist in their own right. Under these circumstances, it has been very difficult for women artists to be recognized in their ability to see and to produce art.

In the film under discussion here, Claudel becomes Rodin's apprentice because she wants to see how he works in order to learn from him. It is important to note that Rodin is not represented in the film as Claudel's teacher but as her colleague. By the time Rodin and Claudel meet for the first time, Claudel already has her own atelier. She obviously was able to work independently before she met Rodin. Also, in one of the film's scenes, Rodin offers to teach her but Claudel refuses, saying that she does not need any lectures. Rodin acknowledges Claudel's independence as an artist to a male colleague later on when he says: "She does not need lessons; she just has to be allowed to work."

During the process of working with Rodin, the two artists did in fact fall into a love relationship, which the film represents. Caranfa argues, however, that their relationship lacked the sincerity of real love and was based on too much manipulation to last.[7] Nevertheless, it has to be acknowledged that the personal relationship between Rodin and Claudel has actually happened.[8] Claudel recognizes during the film that her own artistic identity, her ability for artistic seeing, is suffering in her close collaboration and relationship with Rodin. This is evident when she leaves the atelier that they shared, explaining that, having worked exclusively on Rodin's sculpture *The Burghers of*

Calais, she has neglected her own work, and that she will therefore need to work for herself from now on. The need to break free from her male colleague and partner is also emphasized by the film when, shortly before the conversation just described, Rodin reveals Claudel's bust of him to an audience of male assistants. One of the audience mistakes Claudel's work for Rodin's self-portrait, and the film thus makes the point that Claudel's artistic gaze is suffering because she is seen as Rodin's pupil who works in his style, rather than as an independent artist with her own vision who has worked as his colleague.

At the same time as showing and supporting Claudel's need to break free from Rodin in order to be recognized as an artist, the film also shows her difficulties in obtaining the recognition she deserves. Even though Rodin says in the film, "I showed her where to find gold, but the gold she finds is truly hers," Claudel still fears that her work will be seen as owing to that of Rodin.[9] The lack of recognition that her work suffers in comparison with Rodin's is emphasized in the film through a scene that shows a sculpture exhibition. While many visitors are shown to be gathering around a work by Rodin (which, according to the film, was inspired by Claudel's artistic vision), only very few notice Claudel's sculpture in the same room. In summary, the film represents both Claudel's relationship and collaboration with Rodin, as well as her decision to break free from this relationship in order to work independently of Rodin, and her attempts to gain the recognition that is due to her as an artist in her own right. *Camille Claudel* thus shows to a certain extent how the actual artist Claudel was involved with Rodin and how this relationship, in actual fact, influenced her life.

As a film, however, *Camille Claudel* also manifests the tendency to represent a woman artist in terms of her relationship with a man rather than in terms of her own art. The *Chicago Sun-Times* critic Roger Ebert is right in saying that the film is concerned with Claudel's personal life and passions rather than with her art, and that "this is not a movie about sculpture."[10] The film begins when Claudel first meets Rodin and traces her relationship with him as well as her attempts to break free from it. As for Claudel's artwork, the film does not pay any close attention to this or attempt to make visible the distinctiveness of her style.

According to the film, the initiative toward the romantic relationship came from Claudel. On one occasion, she is shown to expose her neck to him in an attempt to inspire him with an idea for a sculpture as well as with the idea of kissing her. On another occasion, she throws herself at Rodin and they begin to kiss. This impression of Claudel's

fascination with Rodin and of her initiative to begin the relationship, seems to contradict information that can be extracted from letters that the two sent to each other. According to these, Rodin was over-flowing with admiration for Claudel, while Claudel responded rarely and in a matter-of-fact way.[11] In reality, she seems to have been a lot more cautious about a relationship with Rodin than the film suggests. The film, however, upholds the idea that Claudel was deeply in love with Rodin and initiated their relationship.

The film also suggests that, in the process of her romantic involve-ment with Rodin, Claudel makes herself into his model willingly and on her own initiative. The scene just described of Claudel exposing her neck begins with an image of Rodin who has clearly lost his inspiration, sitting motionless in front of a posing model, unable to create. Camille enters the scene and the model is told to get dressed. Camille, supposedly in order to show Rodin what to do and thus to reverse the roles of teacher and pupil, arranges herself in front of Rodin's eyes in the pose with her neckline exposed. Rodin regains his inspiration and later produces this pose in marble. Through this gesture, Claudel is shown to make herself Rodin's teacher while at the same time making herself into his model. She passes her artistic vision on to Rodin and as a result becomes merely seen by him as a model to be cast in marble and a neck to be kissed. The scene thus ends rather disturbingly by emphasizing Claudel's relationship with Rodin over her artistic genius and her willingness to be seen as a model over her attempts to ascertain her own artistic gaze.

The representation of Claudel mostly in terms of her relationship with Rodin becomes most evident in two very revealing paragraphs on the cover of the commercial DVD of *Camille Claudel* that describe both Claudel and Rodin. Claudel is described in the follow-ing words:

> Born in 1864, she is thought to be the most significant French sculptress of impressionism. At the same time, she was the pupil and lover of Auguste Rodin . . . After the break with Rodin in 1898, she attempts to work as an artist in her own right, but she is unable to overcome the influence of Rodin on her works. Camille becomes mentally ill. . . . In 1913, Camille is arrested and confined to the asylum of Montdevergues, where she dies 30 years later.

About Rodin, the cover states:

> Born in 1840, he is known as the founder of impressionist sculpture. His outstanding works are influenced by the works of Michelangelo.

Often, he only sculpts the main, figurative accents from the block, with the result that an impressionist effect is created through the soft play of light and shadow. In a nuanced fashion, his sculptures embody the psychic, as well as the stirrings of the human soul. . . . He dies in 1917 in Meudon.

Rodin is seen only in terms of his artistic achievements while his relationships are not mentioned. Claudel, in striking contrast, is seen in terms of her relationship with Rodin and her mental illness, while the characteristics of her artworks remain unmentioned and her artistic achievements largely ignored.[12]

To see women artists as lovers and pupils of males seems to have been a way to avoid acknowledging their artistic vision and independence. Unfortunately, this remains a tendency in the representation of women who exercise their artistic vision in an independent way, as the film *Artemisia* will demonstrate.

WOMEN ARTISTS AND THE HUMAN BODY

A second obstacle to the freedom of female, artistic gazes has been the restrictions placed on the look of women at the human body in the nude. These restrictions are alluded to in *Camille Claudel*.[13] Women in Claudel's time were not supposed to exercise the same gaze upon the human body and sexuality as men. The film, even though made toward the end of the twentieth century, is not entirely free from such conceptions of female gazes. Claudel's sculptures were explicitly sensual, but they were no more explicit than Rodin's. Nevertheless, her look at the human body and sexuality was seen at the time as a liberty she should not have taken as a woman. Claudel dared to exercise a freedom that should of course be the right of every human being. In a male-dominated society, however, for Claudel to exercise this freedom of the look has meant to come to be seen as a rebel.

In 1892, Claudel approached the ministry of fine arts, asking to receive a commission for a marble version of her group *The Waltz*. The ministry did not agree straightaway but sent an art inspector, Armand Dayot, to Claudel's atelier in order to evaluate the plaster model of the group. In his report, Dayot clearly recognized Claudel's talent and finesse when he saw the piece but wrote of two reasons why he could not support the sculpture as it was:

First, the realistic and violent accent that emanates from it forbids placing it in a public space, in spite of its unquestionable value. The closeness of the sexual organs is rendered with a surprising sensuality,

which is considerably reinforced by the absolute nudity of all the human details. Second, the idea of the subject is too imperfectly expressed. . . . The nude waltzers are heavy and don't twirl. And, as I was saying above, the heaviness of their allure is mostly due to the lightness of their clothing.[14]

Claudel, in the end, agreed that she would dress the figures, and the commission was then supported by the art inspector. Finally, however, the director of fine arts, Henry Roujon, stopped the letter of good news from being sent to the artist, and Claudel never obtained the state commission for this piece. Ayral-Clause concludes: "When Camille chose to symbolize sexual intoxication, she stepped into an area long off-limits to women. As such, her piece was unacceptable."[15]

The film hints at the restrictions regarding the look at the human body placed on women. When Rodin sees Claudel's sculpture of a male nude during a visit to her studio, he says to her that she is daring, even though he himself represents male and female nudes constantly. But obviously, when Claudel as a woman looked at the male body, this meant something different. Later on, Claudel alludes to the restrictions placed on her artistic gaze when she writes to her brother, Paul, of her new ideas for sculptures, saying that her figures will all be dressed, unlike those of Rodin. Of course, Claudel's statement has a double meaning. It shows, on the one hand, her awareness that her sculptures might be more "acceptable" if the figures are dressed. On the other hand, it shows that Claudel was dressing her figures in order to distinguish her work from that of Rodin.

More interestingly and more subtly, however, the film shows through the way in which it is made that the restrictions placed on the female act of looking during Claudel's time are still operative to some extent at the end of the twentieth century. The film displays great caution with regard to Claudel's act of looking especially at the male body, while Rodin's look at the female body is treated very differently. Rodin is shown twice with a female model posing for him in the nude. On one of the occasions, the pose of the model is erotic, and Rodin is shown to model a miniature erotic sculpture of her that he immediately squashes in his hand as though out of bad conscience. While Rodin is shown to have female models, Claudel is shown in the film to have a male model, Giganti. Unlike Rodin, however, Claudel is never shown to be looking at her male model in the nude, even though she does produce a sculpture of him in the nude. Claudel and her model are shown when she has just finished the sculpture, at which time Rodin enters her studio unannounced. We see Giganti's head sticking up from behind a screen where he is getting dressed,

but we never actually see Claudel looking at him in the way we see Rodin looking at the female body. It seems as though to show Claudel as a woman looking at a male model in the nude would have been too daring even for a film made in 1988. Giganti does return half-dressed from behind the screen in order to face the camera, but this only happens on Rodin's command, as he demands to see Claudel's model. It is fine for a man to look at another man, the film seems to suggest, and it is fine for the viewers to look at this man as long as a pair of male eyes is directing the looking, but it is better not to show how a woman might look at a man in the nude.

In this context, it also has to be emphasized that Claudel and Rodin have both created sculptures of each other, and the film shows Claudel's sculpture of Rodin as well as Rodin's of Claudel. But while the film shows Claudel posing for Rodin more than once, it never shows us Rodin posing for Claudel. There is an imbalance in this film that seems to suggest that it is acceptable for Rodin to look at Claudel's body, but not for Claudel to look at Rodin's.

Apart from showing Rodin's gaze but not Claudel's (a characteristic of the film that may or may not be noticed by viewers), it has to be said that, overall, the film does very little to draw attention to the problems Claudel was facing as a result of her exercising the same look at the human body as her male colleagues. The two hints discussed above, given within the film's dialogue, do not do enough to highlight this problem. Rodin's remark that it is daring for a woman to sculpt a male nude does not point to any specific problem Claudel encountered. It simply informs Claudel and the viewers of the cultural atmosphere at the time of the fact that a woman's look at the male body was seen to be daring. And, as was said above, Claudel's decision to dress her figures, expressed in her letter to Paul, is as much an attempt to distinguish her work from Rodin's as it is an acknowledgment of any difficulties she had to face as a result of her undressed figures.

The incident concerning the group *The Waltz* would have been enlightening in this respect as it illustrates the difficulties Claudel was facing because of her "daring" look. This incident shows clearly that the lack of recognition for Claudel's work is due to the fact that she was not supposed to look at the world and the human body in the same way in which her male colleagues were allowed to look. Unfortunately, the film does not deal with this incident. As a result, the film appears to explain the lack of recognition for Claudel's work with the fact that "she never got over her separation from Rodin," as her dealer, Eugène Blot, says in the film, as well as with the fact that she scared

her audience off through her eccentric appearance.[16] It is a shame that the restrictions imposed on the look of women at the human body, which have been an obvious problem for Claudel and which account for the lack of recognition she suffered, remain under-represented by the film and are not really acknowledged as an obstacle. It seems that a tribute to a female artist, which *Camille Claudel* certainly aims to be, should begin by acknowledging the restrictions placed upon a woman's look at and representation of the human body as a real and crucial problem.[17]

WOMEN ARTISTS AND THE DANGER OF OBLIVION

A third obstacle to the exercising of a female, artistic gaze and to its proper recognition over time, has been the oblivion in which many female artists have been shrouded. A lot of Claudel's works, for example, have been lost. Owing to the lack of recognition for Claudel's works during her lifetime, not enough care was taken in order to preserve and exhibit her works. A first major exhibition of her works only took place in 1984. Another way to hinder a female, artistic gaze, apart from allowing works of art to disappear, is to "forget" the female gaze by claiming it as that of a male. Numerous female artists have been claimed as part of a male-dominated art world in this way. Instead of being acknowledged as the creators of their works, the women as original creators fell into oblivion as their works were ascribed to male artists.

In two scenes, *Camille Claudel* shows the oblivion that female artists face to be a problem. In the first scene, Claudel shows her brother a marble foot she has carved. Convinced of the quality of the piece, she exclaims: "He [Rodin] will like it so much that he will sign it." Rodin does indeed mark the foot later on with his own signature. This scene alludes to the fact that Rodin certainly signed a number of Claudel's works that makes it difficult later on to identify her works.[18] Ayral-Clause points out, however, that this practice was not specifically a treatment of women artists but was the way in which the work of apprentices was treated at the time of Claudel.[19] Nevertheless, the scene does show that Claudel did not get the credit for all her works.

A second scene shows more clearly that the attribution of Claudel's inspiration, genius, and skill to Rodin was not just a fabrication on Claudel's part but a real threat. The scene occurs after Claudel has separated from Rodin. By chance, they meet one night in the street and return to Claudel's studio, where Rodin looks at Claudel's works.

A bitter argument breaks out when he sees *The Age of Maturity*, a sculpture of a man who is guided by an older woman away from a kneeling young woman who stretches out her arms toward him but is unable to hold him back. Rodin, feeling that the sculpture is a caricature of himself drawn between Claudel and his long-time companion Beuret, demands that Claudel produces the sculptures he tells her to produce. She voices her determination and right to go her own way and to sculpt what she wants, whereupon he demands instead that she give him her ideas. Claudel, furious, expresses rage at the thought that she has for too long been seen as Rodin's pupil only, and that, in her words, she has been thought to have put her sculptures together from the crumbs of the master's table. This angry conversation makes clear the very real threat to Claudel of drifting into oblivion as an independent artist through being related to the work of a male artist who makes authorial claims over her work.

In Claudel's case, it could be argued that the loss of her works is partly due to her own destruction of them, and that her fears of not being credited for her own work result from persecution fears she developed that focused to a large extent on Rodin.[20] It has to be said, however, that Claudel's allegations of Rodin are not unfounded. Ayral-Clause explains that when Rodin saw *The Age of Maturity* for the first time in an exhibition in 1899, he reacted with hurt, shock, and anger. A short time after Rodin had first seen the plaster, a state commission of the work in bronze, which had already been promised Claudel, was cancelled. Considering that the state had already financed the plaster sculpture, and thus approved Claudel's work, Ayral-Clause concludes that the decision to withdraw the bronze commission can only have been the result of pressure from Rodin on the ministry of fine arts.[21] During the first few years after their split, Rodin tried to support Claudel by using his influence to obtain commissions for her. After *The Age of Maturity*, Rodin stopped his support for Claudel completely. Claudel was thus realistic in assuming that Rodin was no longer well disposed toward her.

Also, Claudel's mental illness should not be overemphasized. Ayral-Clause writes: "Madness is a word too often misused. Camille was not mad. She created, she exhibited, and she interacted socially. But she had moments of irrationality that scared the people who loved her."[22] Certainly, Claudel had a violent streak in her, but it is interesting to note that her brother, Paul, was of a very similar character. To support this point, Caranfa mentions that Claudel used the expression "poison in her blood" to describe Rodin, and that Paul,

almost echoing her words, used the word "poison" to describe the influence of masters such as Rimbaud and Voltaire on his writing.[23] For some reason, Caranfa notes, Camille's words have been interpreted as a sign of her "madness," whereas Paul's words were seen in terms of his development as a poet. Ayral-Clause quotes from a letter Paul wrote to a priest friend in which he acknowledges: "I am exactly like my sister, although more of a weakling and a dreamer and, without God's grace, my story might have been hers or even worse."[24] Paul was obviously attributing his success as a poet to his conversion to Catholicism, and his sister's failure as an artist (as he saw it) to her lack of faith. The fact, however, that Paul succeeded as a man, whereas Camille struggled to be recognized as an artist in her own right because she was a woman is probably closer to the truth.

If this is the case, then Claudel's supposed "madness" cannot be seen as an illness that afflicted only her as an individual. Instead, her "madness" has to be seen as the symptom of a male-dominated art world in which, in the words of the painter Marie Bashkirtseff, "the woman who becomes so emancipated . . . is almost ostracized; she becomes strange, noticed, blamed, crazy, and therefore even less free than if she did not shock the idiotic customs."[25] Claudel did shock the "idiotic customs," and all of the above characterizations apply to her with surprising accuracy, including her eventual loss of freedom. In this sense, Claudel's "madness" was not her own "madness" but that of a male-dominated art world in which only men were supposed to do the looking. It is true that Claudel did destroy many of her works, and the film shows her hammering them to pieces and burying them in the earth. This too, however, should not primarily be seen as a sign of mental problems but as the simple expression of an undeniable fact: that Claudel's artwork as well as that of other women was not recognized as worthy artwork and in this sense was "destroyed" in a male-dominated art world. Claudel is a poignant reminder of the "forgotten" female artist, of the female gaze that was not supposed to be in a world where male artists did the looking. Truly silenced in her confinement, she was even declared dead in 1920, 23 years before her actual death. She was shrouded in oblivion even in the face of her very existence.[26]

The Renaissance painter Artemisia Gentileschi, on whose life the film *Artemisia* is based, has been "rediscovered" recently by art historians. The film should be counted as part of that process of rediscovery. It will be interesting to see, however, in what way the film remembers this artist's gaze. Will she be allowed in the film to be

a painter in her own right, independent of any relations with men? Will she be allowed by the film to look at the human body in the nude? And does the film preserve the memory of her artwork? Does this work from the late twentieth century give Gentileschi any chances that Claudel was deprived of at the end of the nineteenth century?

CHAPTER 5

ARTEMISIA

The film *Artemisia* is a biography of the Italian painter Artemisia Gentileschi (1593–1652/3) that describes her relationships with both her father, Orazio Gentileschi, for whose studio she works, and her teacher, Agostino Tassi, who is at the end of the film convicted of having raped her.[1] The film does not follow Artemisia into her adult life but rather places its emphasis on the process of Artemisia's growing up, a process related in terms of the process of learning to paint.

Painting involves for Artemisia matters such as the choice of a viewpoint, the contrast between observing and being observed, and the relation between reality and its reproduction as an image. The film presents these issues on the level of both its contents and its form. My interpretation of *Artemisia* deals first with the contents of the film. I discuss Orazio's, Tassi's, and Artemisia's ways of seeing and reproducing reality, before going on to show how Artemisia's way of seeing and reproducing reality changes through her relationship with Tassi, her teacher and lover. Next, I analyze the film's form by looking at its techniques of seeing, focusing on the contents of the images and on what it means for Artemisia to be a woman—specifically on what it means to paint as a woman and whether Artemisia as a woman is shown to see and reproduce reality in a particular way. Where it is appropriate, I draw on feminist film criticism, as it, too, links issues of seeing and reproducing with questions of gender. When addressing the film's form, I interpret the relationship between the viewer and the film's images. The issue here is whether Merlet's camera practices the principles of seeing that are introduced on the level of the film's contents.[2]

DIFFERENT WAYS OF PAINTING

By highlighting how Orazio, Tassi, and Artemisia paint, *Artemisia* aims at more than a simple description of different painting techniques. Through showing techniques, the film shows us how the painters perceive themselves in relation to the image they paint and also to the reality they try to represent. Artemisia's way of painting is set against both her father Orazio's and her teacher Tassi's painting techniques. Understanding how Orazio and Tassi paint will help to see the particularity of Artemisia's painting and self-perception. I shall, therefore, begin by looking at how both Orazio and Tassi paint, by looking at their self-perception in relation to what they paint.

Orazio's and Tassi's ways of painting resemble each other in various respects. When painting, they both create distance between themselves as painters and the objects they paint. Orazio paints only human beings. He works indoors and arranges his characters on a stage in front of him, while positioning himself at a distance from the scene and offstage (Appendix 1, units 5 and 8). With Tassi, who paints outside, the distance becomes even more pronounced, for he introduces a dividing element between himself and what he paints. He looks through a perspectival grid, a crisscross of wiring held together by a wooden frame, dividing everything behind it into squares. The frame works as a division particularly in shots where we look at it from the side, with Tassi to its right and what he is painting to its left (for example, in unit 12). Reality, to Tassi and Orazio, is distant from them—an object to be painted.

The reality to be painted appears in front of their eyes. In contrast, the reality Artemisia paints does not always appear before her eyes. By directing their gaze away from themselves onto the object opposite, Orazio and Tassi establish a relationship of control over the reality they paint. Not long after the beginning of the film, we see Orazio painting a scene with characters he has arranged according to his imagination, including a child who poses as an angel, suspended from the ceiling on a rope that allows him to be moved up and down at Orazio's command. Orazio also controls the light. He illumines his scene artificially with candles arranged on a plate, moved by his assistant to wherever Orazio wishes the source of light to be. Numerous ropes that hold everything in place are scattered across the picture, and, in the midst of all this, Orazio resembles a puppeteer directing his figures (unit 5).

Tassi seems less in control of the background to his paintings. He chooses natural backgrounds that have a life of their own. Nevertheless, Tassi exercises control over his image by choosing a particular

part of the landscape and placing his frame in front of it, subjecting the landscape to the borders of his frame. Tassi's interest is in painting ships at sea (units 12, 30, and 32). But instead of painting a real ship on the sea, he inserts a miniature model of a ship between the frame and the stretch of sea he has chosen for a background. The ability to position his object in the picture gives him control over the composition.

Having created in front of them the reality to be painted, Orazio and Tassi are anxious to reproduce this reality as naturalistically as possible. Orazio, for example, tells the child-angel in his scene to smile, for he seems to be able to paint the smile only if it is there before him. It is surprising that, having created and controlled his composition up to this point, he would now try meticulously not to exert any personal influence by being anxious to reproduce only what he sees. The concern for realism becomes absurd when Orazio, in another scene, paints a character indoors in front of a blue sky with white clouds (unit 8). In this scene, Orazio places his model in front of an artificial sky painted on wooden boards and proceeds to copy this background, which is itself only a painting, from the scene onto his canvas. Tassi, too, emphasizes realism. His concern is with proportions. The perspectival grid, he explains, tells him the exact relations between things before his eyes and helps him to reproduce these on the canvas in a precise manner. By painting realistically, each in his own way, Tassi and Orazio create for themselves and the viewers of their pictures the illusion of an uninfluenced representation, of unbiased, "objective" observation that allows reality to appear "as it is." But having seen to what extent their "reality" is constructed and influenced by Orazio and Tassi before they even begin to paint, we recognize the illusion.

The aspects of distance between painter and painted reality and the concern with realism reveal most clearly the difference between Tassi's and Orazio's ways of painting, on the one hand, and Artemisia's, on the other. Artemisia seems less distanced from the paintings of others that she looks at and from the reality she paints. In five voice-overs, which we hear when she looks at paintings and when she paints, Artemisia describes what she sees. Common to all but the last voice-over is Artemisia's description of details in the pictures as if she were watching them from very close. She sees individual limbs ("a raised hand" in unit 1; "muscles taut," "twisted faces" in unit 60); she is so close that she does not even recognize at first what she sees ("a leg which is not a leg but an arm" in unit 1);[3] she sees a particular color ("the color red erupts onto the canvas" in unit 60). Details of pictures float through her mind without any sense of order

("a confused ballet of gigantic bodies" in unit 1, "faces upside down" in unit 60). During the first voice-over at the beginning (unit 1), the camera adopts Artemisia's close and unstructured look by feeling its way through the fresco that Artemisia looks at from up close, revealing detail after detail, a head after a leg, a piece of drapery, without giving a distanced overview of the picture at any stage.

Later, when Artemisia works on *Judith Slaying Holofernes,* she describes her painting from close up in a voice-over: "Legs spread, muscles taut, twisted faces, upside down, an arm stretches out, a fist is raised, a round breast escapes from a corset, a sword strikes, cutting with all its edge, an eye stares and the color red erupts onto the canvas" (unit 60). The camera adopts Artemisia's way of watching her painting close-up. In several shots, it approaches the painting, reducing its distance from the painting in every shot until, finally, it follows the tip of the paintbrush across the canvas. Artemisia's close relationship to paintings is also apparent during a visit to the Academy for Painting (unit 14). While looking at a painting by Caravaggio, Artemisia notices the wrinkles in a character's face and actually feels them by touching the painted face. Again, the camera identifies with Artemisia's look by assuming a close position in relation to the painting.

While showing Artemisia's closeness to what she sees and paints, the voice-overs also emphasize the absence of a controlling influence on details that impress themselves visually onto Artemisia's mind. The details are allowed to remain "a confused ballet" (unit 1) or, in another voice-over, "a confused mixture of forms and dreams" (unit 43). Unlike Tassi and Orazio, Artemisia does not order the details or construct relations between things. There is as yet no "framework" to her vision. Corresponding to Artemisia's voice-overs, her drawing concentrates at the beginning of the film on individual body parts: on a face, a leg, a breast, or a hand.[4] Artemisia's way of painting further differs from Orazio's and Tassi's in that, at the beginning of the film, she does not use models or objects to paint. She does not direct her gaze onto something opposite but uses a mirror to look back at herself in order to paint parts of her own body. As the painting subject, Artemisia is not distant from, but coincides with, the reality she paints. Two shots in particular emphasize the fact that Artemisia is painting and painted, subject and object, reality and image, at the same time. One shot shows Artemisia in the act of painting a portrait of herself painting (unit 16). On the right-hand side of the frame we see Artemisia painting; a mirror that reflects Artemisia as she paints occupies the middle of the frame, while on the left-hand side we see

the self-portrait of Artemisia in the act of painting.[5] Shortly after this, Artemisia shows her self-portrait to Tassi. After Tassi leaves the frame, we see Artemisia on the left, holding her portrait to her right, and it looks as though the painted Artemisia in the portrait is looking at the "real" one (unit 25). Both shots show that, for Artemisia, the borders between painting and being painted, subject and object, reality and image, are fluid. Constants that mark opposite ends of a spectrum for Orazio and Tassi are almost interchangeable positions for Artemisia.

Artemisia's habit of painting from memory makes the point that, when painting, she needs nothing in front of her eyes. She paints what she sees within rather than what is in front of her. Thus, Artemisia is less concerned with realism than Orazio and Tassi. What matters to her is whether she can express an impression that has remained within her. Early in the film, for example, Artemisia paints a portrait of an influential citizen, commissioned by him. Artemisia paints him in silver armor because silver suits the colors of her composition, even though he has posed in gold armor (unit 11). Her own expressive powers are a priority for her. Her father cautions her, explaining that the painter should respect the client's wish, but Artemisia counters, headstrong, "I paint for myself."

Realism is not Artemisia's purpose. Twice we see her painting in order to work through personal experiences. On the first occasion, Artemisia tries to express herself after she has watched an orgy in Tassi's house (unit 22). The second incident occurs after Tassi takes her virginity without intending to. Under the impression that Artemisia had lovers before him, Tassi makes love to her during a painting lesson, ignoring her objections. Artemisia is shocked at the hurt and the bleeding Tassi causes and reacts with anger. Realizing that Artemisia was a virgin, Tassi apologizes and says he loves Artemisia (unit 39). After this, Artemisia returns home to paint and cry alone. In both scenes, the camera allows us to share Artemisia's very private act of painting. We see Artemisia confused, sad, and angry while she paints. She is not doing work but is working through experiences. The camera underlines the importance of her emotions in the process of painting by showing her face from close-up.

While painting has a public dimension for Orazio and Tassi, who both have a crew of assistants around them, it is private and personal for Artemisia, who paints in her bedroom when she is by herself. Unlike Tassi's assistant, who paints pornographic pictures of the orgy at Tassi's house with the purpose of selling them, Artemisia does not

paint her paintings to be seen. Instead, her statement, "I paint for myself," makes clear that painting is her means of self-expression.

ARTEMISIA DEVELOPS AS A WOMAN PAINTER

In her development as a painter, Artemisia learns from two male painters, her father Orazio and her teacher Tassi. In this section, I discuss whether the film shows Artemisia, as a woman, painting in a different way from Tassi and Orazio. Ultimately, the film is concerned with how the painters look at what they paint rather than with the individual characteristics of the paintings of Orazio, Tassi, and Artemisia. The film indicates this priority on the act of looking in various ways. The very first shots of the film are extreme close-ups of Artemisia's eyes that form a dark background to numerous reflections of candle flames that impress themselves upon Artemisia's dark iris as if upon a strip of black film (unit 1). The film thus begins with Artemisia looking. Later, Tassi's perspectival grid becomes an important symbol in the film. Through it, he looks at the world, and he introduces Artemisia to the grid in a lesson (unit 34). The grid helps to order the painter's vision of the landscape. The last shots of the film show Artemisia once more, looking through Tassi's perspectival grid, so that the act of looking is prominent at the very beginning and at the very end of the film (unit 67). In addition, the camera work makes the act of looking one of its central themes by assuming, on the one hand, the viewpoints of Orazio, Tassi, and Artemisia while they look, and, on the other, exposing them in the act of looking.[6] Tassi, in one of the painting lessons, foregrounds the issue of looking and provides a key to Artemisia's development as a painter. While Artemisia draws a ship, Tassi criticizes her not for her way of drawing but for her way of looking by saying: "You have to look at things in a new way" (unit 32). By raising the question of looking explicitly, the film raises the question whether Artemisia, as a woman, sees things in a new way.

Merlet's film could be seen as an artistic discussion of the questions that have dominated feminist film theory, since the film is concerned with a woman who is both seeing and seen. On the one hand, *Artemisia* brings to the forefront the issue that women are defined through their visibility, that they connote to-be-looked-at-ness.[7] Artemisia is a woman in an environment where women are seen, where they act as models for the paintings of male painters. And Artemisia is herself mistaken for a model by Tassi.[8] On the other hand, *Artemisia* is also about the question how women can see. Artemisia casts a creative look not only at her

own body, but also at men and at the world in general. The film, thus, has the potential to answer a question that is underdeveloped in feminist film theory—the question how women can see, as opposed to the question how they can see themselves—even though female spectatorship and female ways of looking creatively have been discussed in detail in feminist film theory.[9] *Artemisia* foregrounds the tension between seeing and being seen as a woman. Being seen, Artemisia experiences the pattern of dominance and submission inherent in a look. It will be difficult for her to claim the power to see because Tassi, among others, assumes that she is there to be seen. Through seeing, Artemisia encounters the problem that a look is structured in a certain way, that it follows a pattern of dominance and submission, no matter whether it is a man or a woman who does the looking. Is Artemisia free to see things differently, to overcome dominance-submission patterns?

Artemisia's development as a painter is inseparably connected with her growing up as a woman. Indeed, Artemisia's development is a development of personality expressed in visual metaphors; the artistic development is the manifestation of the personal one. Artemisia's interest in her own body on a personal level, for example, is expressed when she looks at and paints her body. Her growing sexuality, too, is manifest as a personal and an artistic development. Sexuality concerns Artemisia personally, as her childhood friend becomes interested in her as a woman (unit 6), and it is something to look at, to paint. Her interest in the male body as a subject for her drawings, apparent when she talks her male friend into posing nude, reveals her growing interest in sexuality (unit 10).

In another scene Artemisia, from behind a dune, spies on a man and a woman while they have sex on a beach (unit 7). When they leave, Artemisia abandons her position as spy in order to lie down in the hollow created by the couple. She arranges herself in the form of the woman, impressed into the sand by the weight of the man on her. Sexuality crystallizes in Artemisia's mind as a visible shape, a particular body form. Tassi's rape of Artemisia, too, takes a visible shape, like Artemisia's sexuality. The camera catches the blood-covered fingers of Artemisia's raised hand as visual expression of her shock.

Artemisia's personal and artistic developments also coincide in her relationships. Her relationship with Tassi is shown in the film to be personal and sexual as well as artistic. Also, the process of separating herself from her father is not only a part of growing up, but also an artistic development. Artemisia becomes more independent by trying out the apparently new fashion of painting outdoors, which she has not learned from her father and which he disapproves of. By relating

personal to artistic development, the film engages in issues that concern film theory. Theorists have connected artistic issues with the psychoanalysis of Freud and Lacan and discussed how cinematic processes can represent processes in personal development.[10]

Building on Freud's theory of the Oedipus complex, according to which the child needs to separate from the symbiotic union with the mother in order to grow up, Lacan's psychoanalytic theories are relevant to *Artemisia,* because Lacan, like the film, sees personal growth as related to the acquisition of symbolic competence. The role of the father, in Freud's model, is to disrupt the mother-child union and thus to promote the child's growth.[11] Lacan is concerned with the subject as it is constituted by language, and he describes the child's acquisition of language and of symbolic competence in terms of the oedipal process theorized by Freud. Thus, the child needs to free itself from the pre-oedipal, pre-language, mother-child union in order to become a self that is capable of speech. The father initiates the child into language and symbolic representation—into the realm of the father.[12]

Significant with regard to *Artemisia* is the fact that both Freud and Lacan speak of the child only using the male personal pronoun. Can Freudian and Lacanian psychoanalysis account for a film such as *Artemisia,* with its emphasis on female development, if they concentrate on the development of the male child in this way? For Freud and Lacan, the male child has to sever its ties with the mother in order to grow up and to enter the realm of the symbolic, considered as the realm of the father. This account of growing up cannot explain Artemisia's development. The film never mentions Artemisia's mother, only her stepmother who has no influence on her. Artemisia is shown to grow up by separating from her father, not from her mother. To discover her own, new language means to cut the ties with her father. But can she find a new language as a woman after separating from her father? Artemisia is trapped because her teacher, too, is a man, another father figure. *Artemisia* raises the issue of female personality development and of female, symbolic competence in a male world. But can the film let Artemisia find a realm of symbolic representation that is not occupied by the father? Only partially.

When the relationship between Artemisia and Tassi begins to develop, the act of painting, or rather the act of looking in order to paint, becomes a metaphor for ways in which men and women relate to each other. Tassi's way of relating sexually to women mirrors his way of relating to them as a painter. In both cases, his relationships show

patterns that, as we saw above, Kaplan has analyzed as dominance-submission patterns in film, with Tassi in the dominant role in each situation.[13] As a man, he has the financial power that allows him to hire prostitutes for an orgy at his house (unit 22), and as a painter he owns the power of the gaze upon his female models.[14] In his personal life, Tassi does not treat women as his equals; he is interested in them only insofar as they can satisfy his sexual needs. For Tassi, then, there are two ways to be a woman. A woman can either fulfill his sexual wishes on request or she can be his model, defined through her to-be-looked-at-ness, like the women in Laura Mulvey's analysis of Hollywood films.

In painting, women are Tassi's subordinates because he does not allow them to be anything but a sign within the discourse that he creates and controls. The way in which Tassi chooses his models shows that, for him, the women act as signs without a connection to reality. As a painter, Tassi thus exemplifies Claire Johnston's argument that "woman," as a sign within patriarchal discourse, is a construct that is not connected to real women.[15] For Tassi, the women do not count in their difference from each other, in their originality and reality. On the contrary, Tassi has a fixed idea, a certain "type" of woman in mind, and he chooses the models according to whether they represent the concept in his mind. Only with such a predefined concept in mind can he dismiss a woman as "too skinny" (unit 17). If the women do not fit the type of sign Tassi has in mind, they are of no use to his discourse.

Artemisia likes to observe and, thus, does not fit into these ways of being a woman. The relationship between Artemisia and Tassi begins when Artemisia watches Tassi from a distance as he paints outdoors. Artemisia is the first to direct her gaze at the other—Tassi does not even notice that he is being looked at (unit 12).[16] The first encounter in which Tassi is conscious of meeting Artemisia begins when Tassi's assistant, at the sight of Artemisia, exclaims, "Agostino, look!" (unit 20). Tassi stands high on a scaffold in the church that he and Orazio decorate and looks down on Artemisia, who brings some drawings she has done for the vaults. Now Tassi is in full possession of the powerful gaze. The dominance of his look is expressed through the different height levels in this scene. Tassi is far above Artemisia and looks down on her. But Artemisia, from her supposed position of submission far below, proclaims that she will not be a model, that she will not suffer a dominating look. Tassi's power is challenged. Artemisia surprises him because she does not fit into his concept of a

woman. Tassi immediately addresses Artemisia as a potential model, an object of his artistic look. But Artemisia does not conceive of herself as an object to be looked at by other painters. Instead, she is a painter herself and in full command of her ability to look. The fact that Artemisia paints herself, that she describes herself in this scene as a painter as well as her own object (she says she poses for herself only), further confuses Tassi, and, when Artemisia leaves, he moves toward a window to look at her in wonder as she runs across the grass.

A few scenes later, we see the two in a situation that further confuses Tassi's notion of what it means to be a woman (unit 22). Artemisia, looking in through a window, watches him and others while he holds an orgy in his house. This time, Tassi notices that he is the object of Artemisia's gaze. After deliberately mistaking her for Orazio's male pupil the next day while Artemisia paints, Tassi declares: "First, I mistook you for a model, now for a boy, and also perhaps for a ghost at my window" (unit 24). Tassi treats Artemisia in the same way in which Hollywood films, according to feminist film critics, have treated women. As a woman, Artemisia is considered to exist in order to be looked at. If she wants to look, she should be male. Can Artemisia claim the gaze as a woman? Does the film help her to claim it? Artemisia does not fit into Tassi's ways of thinking about men and women. She is a woman and yet she is no model, she paints and yet she is no man. Does she exist at all? Tassi cannot place her; he simply calls her a ghost and a "chameleon child," unable to locate her in any category available to him. Nevertheless, the film presents Artemisia in this scene as though she were a man. The camera looks at her through Tassi's eyes, and we do not notice she is a woman until he notices. With this technique, the film traps Artemisia in models of male growing up. Lacan and Freud speak of girls as though they were boys, using the male personal pronoun; this film sees Artemisia here as though she were a young man.

Tassi cannot come to terms with the fact that Artemisia, as a woman, has acquired the power to look in order to paint. When he sees her self-portrait, he assumes instantly that it is her father's work (unit 25). Artemisia asks Tassi to teach her perspective, his way of looking at things, but Tassi refuses, perhaps foreseeing problems with Artemisia's growing interest in the male nude, perhaps unable to deal with a woman who is determined to look and not to be looked at. Only through Orazio's intervention is Tassi persuaded to teach Artemisia.

During the first lessons, Artemisia learns to see things as Tassi sees them; she adopts Tassi's perspective on the world. We see her looking at objects through a wooden frame (unit 31), and later through

Tassi's perspectival grid (unit 34). To learn from Tassi thus means for her to learn to distance herself from what she paints, to perceive the reality to be painted as a discourse that involves relationships between a number of objects. Losing her close relation to individual things that she looks at or paints, she learns instead to look at a number of things from a distance and relate them to each other.[17]

Not only does Artemisia learn to see things differently, she also learns to see different things, things that she has not seen before. At the beginning of the learning process, she declares that painting without characters is like painting a void, that, in other words, she cannot see anything but characters (unit 32). When she first looks through Tassi's wired frame, she says, "All I see is land and water" (unit 34). Tassi replies, "You're not looking," and, paradoxically, asks her to close her eyes in order to learn to see things she has previously been blind to. Artemisia is allowed to participate in Tassi's vision of the landscape, to do the physically impossible—to look through another person's eyes. Suddenly, the elements that form the landscape become meaningful and vivid; together they are a discourse of elements that interact and define each other's place within the composition. The earth becomes powerful and pushes the sky upward in the composition. The sun becomes alive and relates to the water, dancing on its surface. Opening her eyes, Artemisia confirms that she can now see the sun. While emphasizing that what Artemisia sees in these first lessons is very much what Tassi sees, that she learns to look the way he does, this scene also shows that seeing is a process within the mind, behind rather than in front of one's eyes. The scene implies that seeing does not refer to a distanced relationship between the person who looks and the object looked at, but that it is a process that takes place within a person.

The fact that Artemisia learns to look through Tassi's eyes shows that Tassi has not made any concessions concerning his power of the look. Ultimately, it is he who owns the gaze. Artemisia may look at objects in front of her, but Tassi watches her while she looks, a fact drawn to the viewer's attention through Artemisia's accusing Tassi of observing her, and through camera shots of Tassi watching (unit 31). Artemisia may look through the wired frame at her maid, Marisa, but it is Tassi who arranges Marisa in a pose, who decides what Marisa should look like, what Artemisia should look at, and what Artemisia should paint.

Artemisia, independent of the lessons and independent of Tassi's power of the gaze, had previously used a male model to practice painting the nude; in drawings accomplished outside the lessons, she

is in command of the gaze. This irritates Tassi and he wants to know who the model was. Instead of answering, Artemisia asks Tassi to pose for her. Tassi agrees without thinking too much, but, quickly, feels uneasy as an object in Artemisia's picture. From behind the wired frame, Artemisia is now in full command of her picture and Tassi has completely lost the power of the look. He is powerless because he cannot look through his frame any more but is only looked at.

Tassi's powerlessness is increased as Artemisia uses him to pose for Holofernes in her painting *Judith Slaying Holofernes*. The painting refers to a text from the Apocrypha, in which Judith, all her wits about her, beheads Holofernes, who had intended to seduce her but is too drunk and sleeps in his tent (Jdt 12:10–13:10). Tassi has to lie with his head hanging off the edge of a bed—like the drunken Holofernes about to be overpowered by Judith—trying to defend himself against Artemisia as she moves from behind the frame to try out poses for Judith. Tassi escapes from Artemisia's grip; he manages to push her back and ends the lesson on the spot. Suddenly experiencing exposure, vulnerability, and powerlessness under the influence of Artemisia's gaze, he reaches quickly for his clothes, holds the pile against his chest in a protective gesture, and sends Artemisia away. The power of Artemisia's look is ambiguous in its meaning. Yes, Artemisia is now finally in the position to look and to direct her gaze not only at herself but also at a man. But she cannot change the structures of the look. She is looking through Tassi's frame, and the dominance-submission pattern inherent in the gaze is maintained with the roles reversed. Artemisia, in this film, cannot grow up to be anything but a woman who paints like a man.

The painting *Judith Slaying Holofernes* will later be used against Artemisia. During the course of the film, Artemisia and Tassi develop a love relationship. When Orazio finds out about this, he brings Tassi to court, accusing him of having raped Artemisia. In court, Tassi's defense claims that Artemisia was a criminal, like Judith, and Tassi, like Holofernes, was her victim.[18] Tassi does indeed resemble a victim when he poses for Artemisia. He is but a sign in her discourse, an object to be looked at. The rape of Artemisia by Tassi occurs in the painting lesson following the one where Tassi is the object of Artemisia's gaze. Tassi is determined to have sex with Artemisia. He tricks her companion into staying outside the house while he goes inside with Artemisia. Approaching Artemisia, he ignores her signs of fear and unwillingness and simply attempts to make her relaxed while he proceeds with the sexual act. The close succession of the two lessons—Tassi posing as Holofernes and Tassi raping Artemisia—shows that being a sign within

Artemisia's discourse hurts Tassi deeply in his masculinity (unit 39). Sexuality, for him, is a means to reinstate the "correct" power balance. The film, however, plays down Tassi's guilt, for he is shown to apologize to Artemisia and to confess his love for her. Artemisia, in the film, forgives him and returns to his house for another lesson. Tassi seems to have learned from his destructive attempt at reclaiming power. He poses again, and this time he lies quietly, looking like a patient animal, evoking again the idea of the victim. Tassi and Artemisia are in love.[19]

In her *Judith Slaying Holofernes,* Artemisia combines Orazio's and Tassi's styles of painting and transforms them into a new way of painting, her own way. Like Orazio, Artemisia paints a scene with characters (Judith and Holofernes). The scene she paints is not her own creation entirely but rather her individual reworking of, in this case, a biblical story handed down to her as an artistic subject. When painting these subjects, Orazio and Artemisia combine a number of predefined signifiers that belong to the subject to form a new, individual discourse that must still be recognizable as the subject chosen. Orazio combines an organ, a female character, an angel, and a male character in a scene depicting St. Cecilia (unit 5); later, a male character, a sword, and a shield represent the subject of Daniel killing the lion (unit 8). Artemisia's picture contains a male and female character, a sword, and the color red, signifying blood.

Orazio and Artemisia use human characters as signifiers in their paintings and they use models, but they differ in the priority they place on the signifiers and the signified. Orazio, in composing a painting, chooses models according to their ability to represent the intended signified. Once in the picture, the meaning of the models is unambiguously defined as "Cecilia" or "Daniel." The people who act as models are of interest to Orazio only in their capacity to represent the intended, predefined signified; they are not expected to enrich the characters "Daniel" or "Cecilia" with an additional layer of meaning originating in their own personality. In other words, Orazio's priority is on the signified; the models who act as signifiers in the picture are subordinate to the signified, as they serve only to represent it.

Artemisia places her priority differently as far as the importance of signifiers and signified is concerned. In her painting, she uses Tassi and herself as models in order to signify Holofernes and Judith. The difference between Artemisia and Orazio is that Artemisia does not only choose models for their capacity to represent a predefined signified as perfectly as possible but also for their ability to enrich the signified, to add new and original meaning to it. Artemisia chooses

her models because, in their individuality, they contribute something to the picture that no other model could contribute. It is significant that Artemisia, in the film, paints her picture during her relationship with Tassi, that the process of painting accompanies the shock and hurt she feels when losing her virginity as well as the suffering during the rape trial. By painting *Judith Slaying Holofernes,* Artemisia is shown to come to terms with events in her life and thus to verify her earlier statement, "I paint for myself." Through the picture, Artemisia counterbalances her "real" life; her power in the picture helps her to survive her powerlessness in reality.

The subject of *Judith Slaying Holofernes* offers itself as a subject involving a powerful woman, but the invaluable and decisive contribution to the picture lies in the meaning that Artemisia and Tassi as models add to the subject. Orazio's paintings prioritize the signified, but in Artemisia's painting the priority lies on Artemisia and Tassi as signifiers. Not only do they represent Judith and Holofernes, but they also remain Artemisia and Tassi—otherwise the picture would lose its significance for Artemisia. The signified of the picture is thus suddenly ambiguous. A picture of Judith and Holofernes to some, it can be a depiction of Artemisia and Tassi to others. Not only Artemisia and Tassi but also Tassi's defender in court recognizes the importance of the signifiers in Artemisia's painting. Trying to save Tassi from being charged for rape, he takes the offensive and accuses Artemisia of victimizing Tassi. He uses the painting as evidence, implying that Tassi as Holofernes was the victim of Artemisia as Judith, suggesting that Artemisia's look at Tassi equaled in significance Judith's act of beheading Holofernes.[20]

In addition to Orazio, Artemisia is also influenced by Tassi. From Tassi, Artemisia learns the technique of painting with the perspectival grid. The frame has a twofold function for Tassi. He uses it in order to keep at a distance from himself the part of the world he has chosen to paint. In addition, the frame, through the wiring, helps to define the relations between things. The fact that Tassi is only interested in looking at landscapes and the relation between things through his frame mirrors his attitude toward human relationships. Tassi is irresponsible in personal relationships. A former lover comes to his house and accuses him of having left without saying good-bye (unit 33); later, in court, we hear of his broken marriage as well as his sexual relations with his former wife's sister (unit 57). Neither in his life nor in his pictures does Tassi have any interest in relationships between human beings. The film, perhaps attempting to make him more likeable, portrays his relationship with Artemisia as an exception. In the

trial, Tassi never speaks against her, and he confesses to rape in order to end the torturing of Artemisia.

Artemisia uses Tassi's frame, but changes his technique in two ways. She uses it not to paint a landscape but to paint characters, not to paint relationships between things but between human beings. Also, Artemisia does not stay behind the frame but moves from one side of it to the other, arranging the scene, getting physically involved with her composition, even making herself part of the picture by posing for it. Thus, as in her earlier self-portrait, Artemisia is at the same time painting and painted, only this time she paints herself in relation to another person. The frame does not keep Artemisia from being immediately connected to what she paints. Her new way of looking differs from Orazio's and Tassi's techniques of painting in that it establishes a relationship between her life and her painting, an aspect that is missing in Orazio's and Tassi's works.

When Artemisia paints, she is at one and the same time distant from and near to her subject. She is distant when she takes her place on the painter's side of the frame, opposite her painting, directing her gaze onto her composition. She is separate from her picture since she is the one to arrange the discourse between its signifiers. But at the same time, she is close to her painting, for her own life is its subject and she is one of its signifiers. Painting is Artemisia's way of dealing with her life by looking at it as if from a distance. The handed-down subject of Judith and Holofernes gives her a chance to step outside her life and look at it from a distance, from her position behind the frame.[21] She paints her own story as if it were someone else's story and places herself in the role of Judith almost in the same way in which she placed herself in the hollow left by the lovers on the beach earlier in the film. A voice-over, too, makes the point that, when painting, Artemisia looks at her life as if from a distance. Anticipating the second time when Tassi and Artemisia make love during the process of painting, the voice-over occurs while the camera pans over Tassi's/Holofernes's body. Artemisia describes her relationship with Tassi as if it were someone else's story: "The exalted lover held the young woman against him. He entered her and embraced her" (unit 43). Artemisia is a third-person narrator who is distanced through the position as organizer of the discourse and through the implication that the story does not happen in the present but happened in the past, and yet it is her own story that she is telling. She wonders at her paradoxical relationship with the subject of her painting at the end of her voice-over: "Such faraway material, so miraculously near now" (unit 43). Her picture is distanced from her through the frame, and it

has to be, if it is to help her to reflect on her life. But at the same time, she is not distanced from the painting; she is present on both sides of the frame, as signifier and as organizer of the discourse.

In fact, as with the earlier self-portrait, Artemisia's life and painting become almost interchangeable. On the one hand, her life resembles a picture because her experiences, as noted earlier, crystallize in shapes, forms, or colors that will eventually enter her paintings; on the other hand, Artemisia's painting *Judith Slaying Holofernes* is connected with her life and her relationship with Tassi because Artemisia and Tassi pose for it. Tassi's and Artemisia's use of metaphorical language with regard to their relationship also underlines the connection between life and painting. Speaking of his past, Tassi confesses: "If only I could erase it all." Tassi wishes his life could be like a canvas on which things can be painted over. But the picture of one's life is not as easy to control as a picture of ships in a landscape setting. Artemisia replies, "You're part of me now. That cannot be erased" (unit 59). Tassi has become part of Artemisia in a sexual sense and, as her model and her painting teacher, he has become part of the picture of her life, just like other experiences that, as forms and shapes and colors, find their way into Artemisia's painting.

Has Artemisia, then, learned to look at things in a new way? And has she been able to grow up to be a young woman who is not mistaken for a male pupil? Is she recognized for her new way of looking at things or because she paints like a man?[22] How has she developed as a painter and as a woman? If, as Lacan claims, the process of becoming a subject occurs through the separation of the subject from objects, then Artemisia has developed through Tassi's lessons as a painter and a person. The wired frame between her and the composition in front of her indicates her awareness of the separation between herself and surrounding objects, and the purpose of the frame is to enable Artemisia to look at things from a distance. Artemisia does, however, differ from the Lacanian model of personality development because she develops not only through separating but also through connecting. In painting *Judith Slaying Holofernes,* Artemisia separates and connects the two sides of the frame.

Artemisia's connectedness is underscored also through the physical, sexual unity she reaches with Tassi as well as through the unity of viewpoints they develop. When Artemisia visits Tassi in prison toward the end of the film, they share the view from the window in Tassi's cell, even though they are, in fact, not meeting in Tassi's cell and not physically looking out of that window (unit 59). But Tassi describes his view in words and Artemisia and Tassi "look" together with closed

eyes. Through looking in this way, they make their viewpoints fully congruent; although two people, they look through one pair of eyes. This unity of perspective with Tassi is underlined when Artemisia, at the end of the film, repeats Tassi's description of his view of the hills in front of his window, thereby sharing it with him once more, even though she is alone and is actually facing the sea (unit 67). This last scene features Artemisia looking through the perspectival grid onto the sea, but at the same time, in her mind, looking out of Tassi's window onto the hills she has never seen except through his description. Artemisia looks from behind the frame; she has learned to perceive herself as separate from what she looks at. But she has also internalized the view she shared with Tassi. Growing up as a woman painter means both learning to be separated and retaining a sense of connectedness.[23]

CAMERA WORK IN *Artemisia*

On the level of its contents, *Artemisia* is concerned with different styles of painting, with the way in which painters relate to their artistic subjects, and with the act of looking. It describes learning to look at things in a new way as the key issue in Artemisia's artistic development. Any film presents, on the level of its form, a particular way of looking; the camera always relates to what it records in a particular way. In what follows, I shall explore the formal side of *Artemisia* and investigate whether or not, on a formal level, the film puts into practice Artemisia's new way of looking.

Artemisia, in her new way of looking, questions the traditional separation between painting subject and painted object by occupying both positions at the same time. Although the film does not illustrate this principle by means of a simple parallel—with the director of the film appearing on both sides of the camera, filming and filmed at the same time—it does, in its own way, question the principle of separation between the subject in control of the discourse and the discourse itself. At the same time, however, it is still implicated in the ways of looking practiced by Tassi and Orazio.

The film makes the viewer aware of the separation and the power structure associated with Tassi's and Orazio's ways of looking. While they, through the concern with realism, try to conceal their separation from and power relationship with the subject of their painting, the camera makes this very separation and power relation the theme of its shots by showing both the painting subjects and the painted objects together. When Orazio paints Cecilia, for example, the camera

shows the subject of his painting first, and, in the next shot, takes a step backward to reveal Orazio in his relation to his painting, Orazio directing his models from offstage (unit 5). Later, the camera observes Tassi in relation to his composition, separated from it through the wired frame, subjecting the landscape to the frame's squares. Tassi and Orazio may be under the illusion of being faithful to their compositions, but the camera exposes as a power structure their relationship with the reality they paint.

The camera's act of making viewers aware of the nature of Tassi's and Orazio's relationship to their subjects is an act that disempowers their look. To be sure, Tassi and Orazio have subjected their compositions to their gaze, but at the same time they are subjected, together with their compositions, to the camera's—and the viewer's—look. When Artemisia first observes Tassi while he paints, his look is disempowered on two levels (unit 12). His look at his composition loses its power when it is subjected to Artemisia's gaze directed at him while he looks—a gaze he is unaware of. Artemisia's gaze, in turn, is disempowered through the camera that observes her while she looks. The next scene repeats the pattern of disempowerment on two levels. Artemisia, trying to copy Tassi's style, paints in the garden, looking at the landscape. Simultaneously, she is subjected to the gaze of her father, who watches her while she does not notice. Orazio, in turn, is exposed, through the camera's gaze, in his act of looking at Artemisia (unit 13). Each of the characters has power by looking at others unnoticed, making them part of a discourse. But at the same time each character is the object of someone else's look and a part of somebody's discourse without knowing it. It is, on the one hand, positive for viewers to be reminded of the power involved in directing an unseen gaze at another person. On the other hand, however, the camera, in exposing the film characters' secret looks at each other, behaves in the very same way, observing others while remaining unnoticed.[24]

Not only does the camera expose the characters in their acts of looking, but it also tries to make viewers aware of the power of their look. But again, the camera is ambiguous in its technique. When Artemisia watches Tassi's orgy, for example, it is not Artemisia but the viewer who, through the camera, first assumes the power of the gaze upon Tassi and the people in the house (unit 22). In one shot, the camera gazes through the window at Tassi, in the very next shot, the camera steps back in order to reveal the back of Artemisia's head while she looks through the window at Tassi. While I, as a viewer, watch Artemisia observing, I might realize that, only a moment ago,

I was in the very same position, doing the same thing, subjecting Tassi to my gaze through the window. The camera makes the viewers assume the gaze upon the film's characters just as much as the characters themselves assume this power. But will viewers be conscious enough to understand from this sequence of shots that, while perhaps being critical of Artemisia's act of spying, they are involved in the same activity? Is the camera trying to educate viewers or does it simply please those viewers who will enjoy a secret gaze? And even if viewers understand the nature of their own gaze in relation to this film, there is no escaping it. We can only see what the camera shows us.

The use of anamorphosis, the technique of the distortion of an image, also used in painting, is perhaps the most convincing attempt of the film at making viewers aware of the power of a look. The technique is illustrated through the film's images and then used by the camera two units later (units 19 and 21). Artemisia, preparing drawings for the vaults of the church, sketches a disproportionate head and points out to her companion that this drawing seems proportionate only from one particular angle, that it is dependent in its effect on the viewer's choice of viewpoint (unit 19). Having introduced the technique, the camera itself assumes the power of the viewpoint. When Tassi looks at Artemisia's drawings for the vaults, the camera surges upward within one shot, so as to change its viewpoint and look down on Tassi in between Artemisia's drawings, making Tassi appear small all of a sudden (unit 21). Whether Tassi appears normal sized or small depends on the viewpoint that the viewers, through the camera, assume. By introducing the power of the viewpoint through its contents, the camera makes its own technique a theme in the film. Earlier, the cut from the view through Tassi's window to the view on Artemisia looking through the window was hardly noticeable. In the present context, the camera movement is more obvious because the surge upward occurs within one shot, and viewers realize that the camera has the power to choose a viewpoint. The film's ambiguity, however, remains. Viewers may understand that they are endowed, through the camera, with the power of the look, but there is no escape from taking the powerful role. It is impossible for viewers to renounce the powerful look, and, in this, viewers may be just as powerless as the characters in comparison to the supreme eye, the camera.

The film does not only expose as a power structure the relationship between the seeing subject and the object seen, but in addition, the camera also makes sure that none of the characters owns the gaze onto other characters for the whole length of the film.[25] The camera appears to work on the principle that if the relation between the

seeing and the seen must be a power relation, at least whoever owns the power of the gaze should not own it for long. The characters are given the power of the look, but never for any length of time. Instead, all the characters within the film who look are also being looked at. The look, in this film, appears like a role that characters step into and out of, an independent position that can only be assumed temporarily. Its power cannot be seized completely by any character.

Artemisia, for example, directs her gaze onto her male model, Fulvio, and the camera, for a moment, takes part in her act of looking—it zooms in from behind on Fulvio's back, revealing the structure of its muscles to the viewer. But in the next shot, Artemisia's gaze is exposed; she is looked at in her act of looking (unit 10). In the same way, Tassi, during a painting lesson, stands behind Artemisia and directs his voyeuristic gaze onto her back. Again, the camera assumes his gaze momentarily. In the very next shot, however, it exposes Tassi's gaze as a cowardly act of voyeurism—watching another person from behind while the person is not aware of being watched. The camera disempowers Tassi's look in the most powerful way—by facing him directly (unit 32). Orazio, in another scene, sets out to spy on Artemisia during a lesson with Tassi. He watches Artemisia's maid outside Tassi's house from behind her back, only to be exposed in his act of looking by the camera that faces him directly. Although he does direct his gaze onto Artemisia and Tassi, he does not own it for long because the camera in turn directs its look at Orazio and unmasks him as a spy who looks in on his daughter in her lover's house (unit 48).

At times, the look even exists prior to and beyond any of the characters assuming it. Tassi and Artemisia, for example, meet consciously for the first time in the church where Tassi and Orazio paint (unit 20). Tassi speaks from the height of a scaffold, looking down on Artemisia. But before we see him notice that Artemisia has walked into the church, the camera is already there, gazing down on her. Only in the next shot is Tassi informed by his assistant of the presence of someone to be looked at; only then is he encouraged to assume the power of the look. The look is not naturally Tassi's own but is a role that he plays temporarily, a position he steps into and out of. Soon after this, and like with the meeting between Tassi and Artemisia in the church, the camera anticipates Artemisia's gaze on Tassi's orgy by being there before Artemisia arrives, predefining the position of the gaze for Artemisia to assume (unit 22).

The examples show that, while to own the look is still a position of power in *Artemisia*, the film does not allow any of its characters exclusive ownership of it. But the examples show more than that.

They underline the fact that complete ownership of the look nevertheless exists in the role of the camera that sees always before any of the characters see, and hands out little portions of the privilege of seeing to the film's characters. Viewers, one might think, are more powerful than the characters, for they participate in the camera's continual look. But the ability of viewers to see exists only courtesy of the camera; unlike the camera, viewers do not have a choice in what they see. The camera imposes itself on them as their eye, an eye, however, which is not theirs to control.

Only once is the camera, and with it the viewers behind it, exposed in the act of looking. During the first painting lesson, Artemisia sits, drawing various objects, while the camera moves around her slowly in a quarter-circle, looking for the best position to observe Artemisia (unit 31). When the camera faces her, Artemisia looks into it and accuses it and the viewers of irritating her by looking at her: "I can't paint with you watching," she complains. Only after this complaint does a cut of the film reveal that Tassi, too, had been watching her draw. The camera, after this cut, looks from behind Tassi's back onto Tassi and Artemisia facing each other. Artemisia exposes the camera, the viewers, and Tassi in their act of looking but, through the editing of the film, the finger is pointed at the camera and the viewers first of all. It is important that this scene should be part of *Artemisia* to remind viewers of the nature of their own and the camera's gaze. But it is a brief moment only in a film where the camera, for most of the time, acts as the most powerful eye.

Artemisia tries to make viewers aware, on the level of its form, of the power structure inherent in the relation between seeing subjects and seen objects. The film tries to achieve this aim by showing painters in their acts of looking, exposing them in their controlling gaze onto their compositions. Once aware of the power involved in a look, the camera makes sure that none of the characters owns it for long. What is original in this film is not the quality of the look—for it is still the powerful position—but its distribution within the film. None of the characters is associated with the powerful position only—or the powerless one, for that matter. The film can be said to take a step in the direction of creating awareness for the dominance-submission pattern associated with the look, criticized by Kaplan.[26] The look is still powerful, but none of the characters are allowed to own this power. Whether or not the film succeeds in overthrowing the power structure inherent in seeing and being seen thus remains questionable. Any power taken from the characters serves to underline the power of the camera itself. Only for a brief moment does the camera

register Artemisia's complaint at its irritating look and, thus, allow itself to be questioned for its voyeurism. Finally, the look in *Artemisia* is still associated with voyeuristic activity, and the connection between looking and being powerful is not interrogated.[27] The question whether the look can be conceptualized as something other than powerful still remains.

Artemisia must also be criticized for its handling of Artemisia Gentileschi's life. Had it been based more faithfully on events in Gentileschi's life, accessible through historic records, the film could have had the power to disturb.[28] As it is, the emphasis of the film is on the smooth discourse of a love story, uninterrupted by any events that might prevent Artemisia and Tassi from loving each other. As a love story, the film is presented without too many rough edges that would make the business of interpretation more difficult but also more interesting. The genre of the love story is familiar to many viewers and the film is thus easy to understand. But the seventeenth-century Artemisia Gentileschi, who was raped, and the seventeenth-century Agostino Tassi, who raped her, have lost their disturbing power as signifiers and now serve only to represent the genre of the love story. In this the film is reminiscent of Orazio's paintings, where the subject is decided on before Orazio chooses models to represent the roles that are part of this subject. With *Artemisia*, it seems as though the decision for the creation of a love story was a priority, and the characters, Artemisia and Tassi, were fashioned so as to fit the genre. The film's emphasis is thus on showing a love story, rather than on being faithful to the people it fictionalizes, people who once existed.[29]

Thus, the film does, on the level of its contents, succeed in bringing to the forefront the concern for a new way of looking at things, and it suggests a new way of looking by describing how its character Artemisia looks at the world. But the film *Artemisia* does not subscribe to a new way of looking on the level of its form. This discrepancy, and the search for a way to overcome it, will be fundamental to the interpretation of *The Tango Lesson* later in this book.

CHAPTER 6

⊹⊱✦⊰⊹

LEARNING TO SEE IN A NEW WAY: *ARTEMISIA* IN DIALOGUE WITH FEMINIST THEOLOGY

As discussed in the previous chapter, *Artemisia* foregrounds different ways of looking that are practiced by three painters. The ways of looking are distinct in the handling of closeness and distance between the painters and the subjects of their paintings. Also, the technique of linear perspective is introduced as generative of a particular relationship between a painter and the reality to be painted.

Sallie McFague considers the act of seeing in her book *Super, Natural Christians: How We Should Love Nature*. She delineates two different ways of looking according to how close or distant the viewer is to that which is seen and according to the viewpoint a viewer assumes. In fact, McFague describes the ways of looking in terms of different painting techniques used by the characters in *Artemisia*. This interest in ways of looking makes *Super, Natural Christians* a very strong candidate for dialogue with *Artemisia*. No other work of feminist theology discusses ways of looking in such detail. I will not, however, deal uncritically with *Super, Natural Christians*. Artemisia's new way of looking cannot be placed neatly into McFague's categories and I use it as a basis to criticize McFague's concept.

I create a dialogue between *Artemisia* and *Super, Natural Christians* by introducing McFague's concept of two ways of looking: with the loving eye and with the arrogant eye. McFague's concept parallels Tassi's, Orazio's, and Artemisia's styles of painting. Tassi's and Orazio's styles exhibit her concept of the arrogant eye and

Artemisia's style that of the loving eye. In her process of learning to paint, Artemisia seems to adopt a style that comes close to McFague's idea of the arrogant eye. But instead of arguing that Artemisia's eyes are becoming arrogant while she develops as a painter, I question McFague's concept of the arrogant eye. The questions that emerge provide a basis from which to criticize McFague's approach in a more general way. Objectifying vision, she argues, occurs when the distant look is privileged over the close-up, and single point perspective over multiple perspective. Opposing this concept, but in line with Sartre's, Foucault's, and Lacan's arguments discussed earlier, I argue that objectifying vision occurs where an invisible subject takes a privileged position over a visible object. Artemisia's new way of looking is important because it offers an alternative to this objectifying way of looking. The film as a whole, however, still characterizes Artemisia's look as victimizing, despite the relational potential it is credited with in some of the film's scenes.

The Arrogant Eye and the Loving Eye

McFague's concepts of the arrogant and the loving eye are symbolized in two differing impressions of the world that surrounds a person: the impression of the world as landscape in the case of the arrogant eye, and the impression of the world as maze in the case of the loving eye.[1] The arrogant eye's landscape view of the world implies a look that is disembodied and emphasizes distance, while claiming to be objective. McFague associates the technique of linear perspective with the arrogant eye. Vision in general emphasizes, according to McFague, the distance between the viewer and the world because it does not express a reciprocal relationship between a person and the world. Touch, taste, and smell, by contrast, require reciprocity. We cannot touch, for example, without being touched at the same time, but we can see without being influenced at all by what we see.[2] The distant view of the world as landscape is disembodied vision. It maintains the illusion of individualism because, according to McFague, the distant spectator of landscape painting is separated from the world at which he or she looks. The distant eye surveys the world as canvas from an outside position.[3] This view results in a dualistic setup of spectator-subject versus landscape-object. The seeming independence of the spectator/painter from the world creates the illusion of objectivity, of an innocence of the look that simply registers what is there.[4] This illusion of objectivity makes the landscape view an arrogant way of looking, as it

glosses over the fact that we are capable of seeing only what we expect to see, what fits into preexisting categories of things.[5]

Connected to the landscape view is the technique of linear perspective that, says McFague, was introduced during the Renaissance and classifies the position of the spectator-subject as the privileged point of view.[6] Linear perspective emphasizes the centrality of the spectator/painter; everything in the composition relates to this superior position. Thus, linear perspective as a technique epitomizes the subject-object relationship inherent in the landscape view of the world. At the heart of the tradition of the arrogant eye is the image of God as the all-seeing, distant, disembodied eye that surveys the world—like the painter of a canvas—from outside.

In contrast to the arrogant eye, the loving eye's view of the world as maze implies closeness. The loving eye is embodied and is not interested in objectivity but in a detailed perception of the world. McFague associates the representational technique of multiple perspective as used in the so-called "primitive art" with the loving eye. She argues that if our sense of self were based on touch and not on sight, we would not perceive ourselves as independent of the world that surrounds us but as in reciprocity with it. With a good measure of idealism, she states: "Our thesis is that a sense of self coming from touch rather than from sight gives us a way to think about ourselves as profoundly embodied, relational, responsive beings, as created to love others, not to control them."[7] If we thought of ourselves as in mutual relation with the world, our look would be an experience of reciprocity. The emphasis of the loving eye is not on the world as landscape but on the world in detail. The loving eye's attention to detail comprises closeness between the seeing subject and that which is seen.[8] McFague maintains that this closeness makes the look embodied.[9]

As a result of the embodiment and closeness of the loving eye's look, the relation between the seeing subject and that which is seen is not a subject-object, but a "subject-subjects" relationship.[10] Because of its emphasis on subjects in the plural, the subject-subjects relation moves away from the dualism of the subject-object relation toward an equality of the subjects who participate in a relationship expressed in visual terms. The relationship between subjects is characterized by an intimacy that recognizes the difference of the others. Subjects who look through a loving eye will not project their fantasies onto others but simply perceive them in their difference. McFague's optimism with regard to her concept of the loving eye, however, has a visual naïveté shimmering through it when she speaks of the objective perception of

reality intrinsic to the loving eye. "This is the eye," she claims, "trained in detachment in order that its attachment will be objective, based on the reality of the Other and not on its own wishes or fantasies."[11] With this statement, McFague contradicts her earlier view that the eye is not capable of objective vision but only of perceiving things in terms of categories that preexist in the mind. "Our eyes always come ancient to their task; we cannot, as Dillard says, 'unpeach the peach', simply see patches of color," she writes elsewhere.[12]

The representational technique that belongs with the subject-subjects model of being is that of multiple perspective. McFague describes the technique without using its name, "multiple perspective," implying that the technique is removed from the use of perspective. Within this technique, as within the subject-subjects model, there is not one privileged point of view. What is painted is seen from various angles and the viewing subject has, therefore, no central position, unlike the subject of linear perspective.[13] It is not clear how McFague would picture God within her subject-subjects model. She discusses Martin Buber's I-Thou model of relating, in which every Thou in the world leads to the one Thou, God, but she warns that this model gives no value to the world itself, apart from its capacity to lead to God.[14] McFague's model, unlike Buber's, simply suggests "a way of being in the world rather than a way for an individual to find God."[15]

ARROGANT WAYS OF LOOKING IN *Artemisia*

In *Artemisia,* both Artemisia's father, Orazio, and her teacher, Tassi, exemplify McFague's concept of the arrogant eye. The film portrays their relationships as painters to what they paint in terms of the subject-object relational pattern that McFague associates with the arrogant eye. Their look at what they paint is distant, controlling, and disembodied, just as the look of McFague's arrogant eye. Orazio distances himself through staging what he is about to paint, Tassi through inserting the perspectival frame between him and what is to be painted. Both painters prefer arranging things in front of their eyes to painting from memory. What they paint has the quality of being outside and distant, while Artemisia paints what is inside her mind. To have models or landscapes pose while they paint is for Orazio and Tassi a way of positioning themselves at a distance from their "objects."[16]

Both Tassi and Orazio further objectify what they paint by exercising control over it. Rather than exposing themselves to the influence of the subject(s) of their paintings, whether people or landscapes, they eliminate any effect that the painted subject might have on them as

painters by painting only what conforms to their own, preconceived imagination.

In the previous chapter, I explained how Orazio controls the models, the lighting, and the background of his scene, and I pointed out that the film suggests a connection between Orazio and a puppeteer.[17] The image of the puppeteer emphasizes Orazio's control while also alluding to a lack of subjectivity, even a lack of life, in the items and models that are part of the composition. The sense of lifelessness is evoked not only through the ropes but also through the way in which the film introduces Orazio's models. At the beginning of the film, they are shown to proceed through a succession of theatrically slow gestures until their movements come to a complete halt in Orazio's desired pose. The music used here, a requiem for the dead, transforms this desired pose into the models' rigor mortis. Orazio's models turn into lifeless objects under the influence of his controlling gaze.

Tassi controls what he paints by subjecting the landscape to the borders of his frame. It is true that Tassi exposes himself more to earth and skies than Orazio, who paints a sky by copying an artificial sky on a board at the back of his scene.[18] Still, Tassi, too, imprints his influence on his composition—in the way in which one would mark one's territory—by inserting a dead object in the middle of his setup. His object of choice, the miniature ship, occupies the center of his canvas to which the landscape provides only a background. Its purpose is to act as a context for Tassi's object, but it lacks significance of its own.[19]

Both Orazio's and Tassi's looks exemplify McFague's concept of the arrogant eye because their looks are disembodied. Both painters try to withdraw from a reciprocal relationship to what they see. A reciprocal, embodied relationship would be one in which they, as painters, influence what they paint and are influenced by it at the same time. Orazio's and Tassi's looks are disembodied, as both try to hide the fact that they are in a reciprocal relationship with what they see. They do this in two ways. On the one hand, they try to remain uninfluenced by what they see, and, on the other, they try to hide their own influence on what they see.

Orazio and Tassi, when painting models, are not interested in the inspiration particular models—in their uniqueness as people—might have upon the creation of their work of art. They do not wish to be influenced by their models. Instead, both painters have a preconceived vision of what their work will look like, and they choose their models according to how well they can represent what they,

the painters, imagine. Orazio has particular poses in mind, the smile of the angel, for example, and all that the models need to do is to assume them. Tassi, when we see him use models once in the film, has a particular body shape in mind and surveys models in order to find the one who corresponds to his image (Appendix 1, unit 17).[20] Neither of the painters allows the models to show themselves as unique. They will not have their imagination influenced by what they see in front of them. Instead, they use the models simply to flesh out their preconceived vision.

Orazio and Tassi are both obsessed with realism. Of course, neither of the painters succeeds in creating a realistic representation. In fact, it is not possible to represent things "as they are." But Orazio and Tassi are interested in realism nevertheless because it allows them to hide their controlling influence on what they see. In the previous chapter, I explained how Orazio needs to see everything he is about to paint in front of him, even the tiniest detail, the smile of the angel. So great is his concern with realism that, instead of mounting his characters onto a sky painted from memory in one scene, he uses a blue sky, painted on a board, to back his models, thus copying onto his canvas the copy of a sky.[21] This is realism turned absurd.

In Tassi's case, the perspectival frame becomes the tool and symbol of realism. He claims to be able to represent the "exact relations" (unit 34) between the things inside the frame, while glossing over the fact that these relations are determined by his own standpoint in relation to the frame. The relationship that the frame creates between the painter and the painted subject does not enable a realistic view. The painter is not able to remain an observer who does not interfere with what he paints. Tassi's belief in the possibility of realism through the frame only hides the fact that his perception is not "objective" but very much determined by his personal interests.

In using the technique of linear perspective, symbolized in the perspectival frame, Tassi embodies McFague's concept of the arrogant eye particularly well. Linear perspective, for McFague, is the technique corresponding to the arrogant look.[22] Linear perspective, McFague explains, considers the eye of the painter/spectator as a center to which everything relates.[23] The eye of linear perspective is the eye outside the composition, the superior position in relation to which everything else is inferior. Tassi, in *Artemisia*, is shown in this center position in two ways. In one of the painting lessons, when he describes to Artemisia his vision of a landscape involving the sun and the sea, he speaks of the sun's reflection on the water.[24] The sun, he says, was forming a mirrored path on the water to meet the painter/spectator.

Wherever the painter/spectator stands, the sun will be connected to him or her in a straight line, just as every other visual point in linear perspective will relate to the eye as the central point of reference in a straight line.

The use of the perspectival frame as a tool emphasizes the centrality of the painter/spectator using it. It singles out as worthy of a look a fragment of the world and comes to stand for the painter's own particular interest in relation to the world. It is not the world "as it is" that appears in the artist's vision, but a particular aspect, related to the painter's interest, that is allowed to come forward.[25] The perspectival frame thus comes to stand for the painter's interest, formulated prior to his or her encounter with the reality to be painted, for the prestated question that will allow only certain aspects to shine forth. In describing linear perspective to Artemisia, Tassi sounds as though the technique allows for an "exact" representation of the world as it is. But even though he emphasizes his interest in the exact relations between things, he is not able to represent these relations. What he is able to represent instead are only the relations between things as seen from his viewpoint. While the frame surely stands for Tassi's interest in representing accurately, it is also a poignant reminder of the centrality of Tassi as the painter, of the centrality of his interest in relation to the composition.

Tassi's and Orazio's belief in the possibility of realism is, therefore, misplaced. Their paintings cannot be "objective," but are determined by their personal, artistic interest. Even though representations cannot be realistic, it is still possible to explain Tassi's and Orazio's pronounced interest in realism. In explaining this interest, I will complement McFague's concept of the arrogant eye with an aspect she does not develop. Realism, I argue, is, in Orazio's and Tassi's cases, a form of fetishism.

If fetishism is a strategy to cover up lack, then Orazio's and Tassi's obsession with realism is fetishistic in that it is an attempt to cover up the lack of reality in their representations.[26] A representation can never show reality "as it is." Every representation implies a restriction to a particular viewpoint. A representation is always a reminder of the limitations of the painter/spectator, who cannot see reality "as it is," but only from one embodied position. Representations tie the painter/spectator to an embodied viewpoint in relation to the work of art. The fetish of realism works by covering up the fact that the painter's/spectator's body limits his or her vision to one viewpoint.

Orazio's and Tassi's emphasis on realism is an attempt to hide the bodily restriction of their viewpoint. This is done in two ways.

First, they try to hide the fact that their view is restricted by giving their work a public character. They paint paintings to be sold and seen by others and immortalize their vision in church frescoes that will be seen by numerous churchgoers. Second, through their way of painting, they maintain the illusion of the innocence of the look that simply registers what is there; they claim to be able to show "the exact relations" between things, thus giving an air of factuality to what they see. Through both the public character of their work as well as its attempt at factuality, Orazio and Tassi try to give their individual, embodied, and limited view a more general appeal as a normative view that has liberated itself from the restrictions of their bodies. They wish their view to be "real" in the sense that it should have general validity. The fetish of realism covers up the limitation of their viewpoint, a limitation that results from the fact that their eyes are part of their bodies. Because realism is used to cover up the limitations of the body, it is a fetish in the sense Freud has attached to the term.

Tassi's interest in realism is most pronounced in the symbol of the perspectival frame. I propose that Tassi's interest in using the frame is not the respect for things "as they are," for exact relations. It is revealing that Artemisia, in the painting lesson mentioned above, observes that Tassi "cuts the world into pieces" and that Tassi explains in response how the frame allows him to "cut up the canvas" (unit 34). If realism is fetishism, then the cut through the world on the canvas must be the feared cut of castration.[27] Tassi's interest in using the frame is, on the one hand, to reassure himself that lack adheres not to his side of the frame, but to what lies beyond it. On the other hand, the frame allows him to disguise the object's lack through the fetish of realism. The frame thus makes Tassi's look at the landscape similar in appearance to the male gaze in cinema, directed onto women through the camera. The landscape behind the frame is characterized by lack like the woman on the screen; looked at through the frame, the landscape is the site that manifests the feared cut of castration like the woman in front of the camera.[28] Indeed, the look through crisscross wiring is first introduced in *Artemisia* when Tassi looks at a woman—not a landscape—through a church window with individual windowpanes connected by a crisscross of iron bars. Beyond the window runs Artemisia, shocked because Tassi has told her a moment ago that he sees her as a potential model only, a woman to be seen, not one who is herself able to see.[29] Artemisia, however, runs into the distance, leaving the landscape empty, escaping Tassi's look. Eventually, she will claim Tassi's side of the frame.

To sum up, Orazio's and Tassi's looks can be described as arrogant in McFague's sense because both painters withdraw from a reciprocal, embodied relationship to one of distance, separation, and control over what they paint. The relationship that results is one of dominance of the painters as subjects over what is painted as object. This subject-object relationship is disguised through the interest in realism and the seeming respect for things "as they are." Each representation is connected to one viewpoint just as each eye is part of one body and, therefore, restricted to one place at a time. Realism is fetishism if it is used to make the painters forget that their bodies restrict their view. The privileged position of the painter as subject suffers a crack at the end of *Artemisia*. In one of its last scenes, the film shows once more a window with a crisscross of iron bars. It is the window of Tassi's prison cell; Tassi is behind it and looks at the landscape beyond.[30] This image puts a nagging question mark on the position of the subject, as it suggests a paradox. Although the subject has the power of the look over the landscape, it is the spectating subject who lacks freedom in this relationship, who is imprisoned in the act of seeing by a crisscross of iron bars all too reminiscent of the perspectival frame.

Loving Ways of Looking in *Artemisia*

Artemisia's look before she takes painting lessons from Tassi resembles McFague's concept of the loving eye. The type of relationship that Artemisia's look manifests can be described in McFague's terminology as a subject-subjects relationship. Artemisia's look at what she paints is not distant, controlling, and disembodied, like the look of the arrogant eye, but close, noncontrolling, and embodied. I explained in the previous chapter how Artemisia, when looking at the paintings of others, is close to what she looks at. Also, she is shown to be close to her own paintings and to the reality she paints.[31] The voice-overs, in which she expresses what she sees when she looks at paintings, give a description of details of the paintings as seen from up close, not from a distance. Artemisia also shows her interest in detail when she draws individual body parts up close. According to McFague, attention to detail is opposed to the distant, objectifying look of the arrogant eye and is, instead, part of a loving way of looking.[32]

Artemisia is in a relationship of touch with what she sees. She often "looks" with her hands. She feels Caravaggio's *Judith Slaying Holofernes* with her hands,[33] and examines her male model, Fulvio, with her hands before sketching him.[34]

Apart from being close to and in touch with what she paints, Artemisia exemplifies the idea of the loving look because she does not control what she paints. This becomes evident in the voice-overs, in which Artemisia describes the process of painting and of looking at paintings (units 1, 16, 43, and 60). She mentions individual details that seem unrelated to each other; arms, legs, colors, and movements all appear as though out of context, remaining "a confused ballet" (unit 1), "a confused mixture of forms and dreams" (unit 43). Artemisia does not order what she sees and her use of the term "dream" makes the lack of control even more evident by evoking the unconscious as a dimension of Artemisia's vision.

The fact that all but one of Artemisia's voice-overs are in the present tense further stresses the absence of a controlling influence on her part. The present tense creates the impression that she does not have a preconceived vision of what she will paint. On the contrary, it is as though, while she paints, she stands to one side and sees what appears on her canvas. "An arm stretches out, a fist is raised, a round breast escapes from a corset, a sword strikes, cutting with all its edge, an eye stares and the color red erupts onto the canvas," this is the voice of a commentator who describes things as they happen. The voice-overs in the present tense characterize Artemisia as an eyewitness of the events that come to pass on her canvas rather than as a painter who works out her preconceived vision on the canvas. As an eyewitness, Artemisia is not in control of but exposed to her canvas, exposed to what she herself will paint on it, exposed to unconscious dreams that might take shape.

In addition to being close to what she paints and to not controlling her composition, Artemisia exercises a loving look in McFague's sense in a third way. Artemisia is in an embodied, reciprocal relationship to what she paints. If Orazio's and Tassi's relationships to what they paint are disembodied because both painters try to deny their involvement with their subjects, Artemisia's relationship to what she paints is embodied, as she is personally touched and concerned by what she paints. Unlike Orazio and Tassi, who try to remain uninfluenced by and hide their influence on what they paint, Artemisia is both influenced by and influencing her paintings.

On the one hand, Artemisia is influenced by what she sees and paints because she is affected by it. She paints twice after a disturbing experience, and her statement, "I paint for myself," suggests that painting is a way to work through those experiences.[35] This shows that Artemisia's paintings are influenced by her impression of reality. She allows herself to be affected by the reality she experiences, and she works this reality into her paintings.

On the other hand, Artemisia does not hide her influence on her paintings. On the contrary, she is fully aware of her creative powers and uses them to influence her compositions. One scene, discussed in the previous chapter, shows Artemisia justify her unrealistic use of color in a portrait with artistic reasons. Her argument shows that she has no intention to represent realistically. She takes pleasure in experimenting, in having an influence on what she paints, and her ability to argue with her father over the use of color makes clear that she is very conscious of her influence on her painting.

Artemisia's lack of interest in realism is evident whenever she paints from memory. When she draws in private something that affected her, she does not copy things arranged in front of her. She draws what she saw earlier, filtered through her memory, influenced by her imagination. It is her vision that she paints, not the "real," and she does not hide this fact by arranging people, objects, or landscapes in front of her. She paints what is inside her, not what is outside.

The voice-overs, too, show that Artemisia's look is an activity of her mind. They suggest that Artemisia is not "simply registering" but that she is thinking while she sees. There are two parts to Artemisia's look; with her eyes she sees and with her thoughts, expressed in the voice-overs, she reacts to what she sees by describing it. *Artemisia* thus shows that seeing is not done without thinking, and that "simply registering" is not possible for human beings. For Artemisia, seeing is not passive; seeing is an act and she makes no attempt to deny her activity in seeing.

Painting represents a reciprocal relationship for Artemisia also in the sense that she is both seeing and seen. This reciprocity is symbolized through the mirror that Artemisia uses in order to paint parts of her own body and her self-portrait. The mirror that reflects Artemisia as seeing and seen makes the borders between reality and image fluid. In fact, the way in which Artemisia's self-portrait appears in the context of the film makes Artemisia out to be image and reality at the same time. The shot, which shows Artemisia on the left-hand side of the picture, holding her self-portrait to her right, reverses the positions of the painter and the painted person.[36] The woman in the self-portrait is caught in the act of painting and it looks as though she were painting Artemisia, who is holding up the portrait for the viewers of the film. Artemisia is not painting parts of the visible world from a position outside the visible world. On the contrary, with her self-portrait, she is placing herself firmly within the visible; she is one among many things and people to be seen and does not claim a privileged position. In addition, the self-portrait is imbued with

subjectivity. It is the woman in the image who holds the paintbrush, hers is the tool of representation, she is the one who sees and yet she is an image. While her self-portrait in front of her comes to life as it is gifted with the ability to see, Artemisia takes the position of the person who is seen, seen by her own portrait. For Artemisia, the boundaries between seeing and being seen, reality and image are not outside her but run right through her personality. She is seeing and seen, reality and image. Everything converges in her.

To sum up, Artemisia represents McFague's concept of the loving eye to the extent that she is shown to be physically close to what she sees, that she does not exercise control, and that she is in a reciprocal, embodied relation to what she sees. Her relationship to what she paints falls into McFague's subject-subjects relational pattern, as she does not distinguish between painting subject and painted object but, rather, sees herself as well as what she paints as part of the visible world in which everything, even an image, is imbued with subjectivity.

ARTEMISIA BETWEEN AN ARROGANT AND A LOVING WAY OF LOOKING

Learning to paint, for Artemisia, means obtaining distance from what she paints and learning to use the tools of linear perspective. This view of Artemisia's development as a painter could be taken as contradicting my earlier comparison of Artemisia's look with that of McFague's loving eye. McFague associates both distance and the technique of linear perspective not with the loving eye but with the arrogant eye. I shall take this dilemma as my point of departure for discussing Artemisia's development as an artist. My aim is to show that even though Artemisia develops distance between herself and the subjects of the paintings and even though she learns to work with linear perspective, she is not looking at what she paints in an arrogant way. This insight will enable me to look critically at McFague's concepts through the eyes of Artemisia as a painter.

Learning to paint and growing up are closely linked for Artemisia. I argued in the previous chapter that Artemisia's artistic development was a manifestation of the development of her personality. The difficulty in Artemisia's personal and artistic development lies in the fact that to develop personally means to develop as a woman, but to develop as a painter means to grow up into a male world. After spying on a couple making love on a beach, Artemisia places herself into the hollow in the sand left by the woman underneath the man.[37] This gesture shows that to grow up sexually, for Artemisia, means to

become a woman. Second, to become a woman means to be assigned to visibility. Once the couple has departed from the scene, it is the woman's body that has left its visible mark in the sand; through it she remains visible. The man has vanished into invisibility although it was, of course, his influence, the weight of his body, that increased the woman's visibility in the sand.

To grow up as a woman means to take one's place within the visible. And to be visible means to be lacking. The image of the hollow in the sand signifies both visibility and lack. It is the place for Artemisia to be as a woman, the shape that is visibly lacking contents and is ready to be filled by whoever can fit herself into it.

Growing up as a woman for Artemisia also means to have her sight restricted. She is allowed to admire paintings by male painters, as for example Caravaggio's *Judith Slaying Holofernes*. She should admire the citizen whose portrait she is supposed to paint according to his taste. But seeing and painting her male models and even her own body has to be done in secret.

As a consequence, Artemisia, in order to learn to see and to paint, has to become like a man. The film shows that learning to see and paint means passing into a male world, for there is little female influence on Artemisia. Artemisia's mother is dead and Orazio's new wife has no authority over her. Instead, moving into the world of painting means growing up with two father figures, Orazio and Tassi. And as if two fathers were not enough, there is the Pope, the "holy father," whom Orazio refers to as the highest aesthetic authority (unit 3). At the beginning of the film, Artemisia is taken from the female environment of the convent school home to her father's house and is told, "You have much to learn, but not here." This implies that she can learn to see and paint only in a male environment. In order to secure a place at an academy for his daughter, Orazio reassures the man in charge that although Artemisia is a woman, she paints like a man. The conversation between Tassi and Artemisia after Artemisia spied on the orgy in Tassi's house reveals the whole dilemma (unit 24).[38] Artemisia can either be a female model or a male pupil. If she, as a woman, takes the position of the viewer, she is neither a woman nor a man in Tassi's view. In fact, he cannot really see her as a human being at all—he calls her a ghost.

How can Artemisia learn to paint as a woman under these conditions? How will she look? Does she, by learning distance and linear perspective, simply adopt a male way of looking? Artemisia's development of distance and linear perspective as techniques of seeing and painting has to be considered in the context of her experience of

touch. In McFague's concept, touch is positive; it implies a subject-subjects relationship. Touch is part of what makes a look a loving look. Distance, in contrast, makes a look arrogant. Artemisia's experience of touch, however, is not positive. On the contrary, touch, for her, is most intimidating. Tassi touches her, to be sure, but rape is a subject-object relationship in its purest form.

McFague is correct in assuming a connection between touching and looking. But the connection does not necessarily make a look loving. Touching and looking are connected insofar as Tassi's rape of Artemisia occurs just after he posed for her for the first time, just as he is losing the privilege of the gaze. By raping Artemisia, he makes up for his loss of vision. His touch does not imply a reciprocal, loving relationship but is a substitute for his objectifying vision. And, to spell out the opposite end of the connection between touching and looking, Tassi's vision of Artemisia earlier was only a substitute for his objectifying touch.[39]

Just as touch does not necessarily make a look loving, so does distance not necessarily make a look arrogant. In fact, distance is healing for Artemisia. Artemisia is confused by the deep impact of Tassi's physical attack. Directly after this attack, Artemisia feels herself with her hand. Her shock finds expression as she holds up her hand with blood-covered fingers. Shortly after the experience of the rape—Artemisia is now by herself—she "sees" her blood-covered fingers again when she remembers the trauma. The fingers have become a visible sign that contains the memory of the hurtful touch. But the fingers are out of focus; they are beyond Artemisia's visual command because they are too close to her eyes. Artemisia cannot focus on the disturbing memory contained in her blood-covered fingers.

Painting *Judith Slaying Holofernes*, in contrast, gives her the sense of distance from her experience that she needs in order to come to terms with it. In order to paint a whole scene involving several characters rather than painting individual body parts, Artemisia needs more distance from what she paints. Painting a scene with characters, therefore, allows her to take a step back from the disturbing experience of being touched. Being touched was objectifying for Artemisia; seeing is healing because it implies distance.

The perspectival frame, too, helps Artemisia to come to terms with the physical attack on her. It allows her to give visual order to her experience, to see the disturbing touch in a context. Artemisia is, literally, putting things in perspective. By creating a text with the help of the perspectival frame, by integrating her experience into a context rather than visualizing it as a fragmented, unfocused body part turned

into a sign, Artemisia is working through the overwhelming experience. The impression of the unfocused, blood-covered fingers holds sway over Artemisia and is beyond her control. The act of creating a text that involves her experience, in contrast, shows Artemisia dealing consciously with what happened to her. To be touched, for Artemisia, was to be passive, acted upon. To see is an act; it is an act of dealing consciously with hurtful memories; it is an act of healing.

In Artemisia's process of growing up, seeing is not only a means of coming to terms with a trauma but also of developing a unified sense of self. According to Lacan's theory of the mirror stage, it is essential to develop a unified self in order to grow up. This self is defined by its separation from surrounding objects, and it is through sight that this self is acquired.[40] McFague, however, argues that a person's sense of self should be based on touch rather than on sight. To "see oneself," to her, implies the absence of a reciprocal relationship to the world, whereas a sense of self based on touch results in a subject-subjects relation with it.[41]

Through her development as a painter, Artemisia develops a sense of self based on sight. Her process of learning to see and to paint herself not only as fragmented body parts but also as a whole body suggests, in one way, a development of subjectivity along the lines of Lacan's theory of the mirror stage. Artemisia's development of a sense of self is, however, different from the Lacanian model in one respect. The concept of the mirror stage is based on the idea of sameness. The mirror reflects the child who looks into it in an image of a coherent body, and it is this sameness of the child's real body and its reflection that produces the joyful sensation of identity. The child whose sense of self is based on the mirror reflection will, even as an adult, always look for the possibility of identifying with others as if they were the child's own mirror reflection. If the self and the Other cannot be seen in terms of sameness, the child of Lacan's concept will find it difficult to relate, as the incongruity of self and Other causes the child's aggression toward the Other.[42]

At the beginning of the film, Artemisia seems to embody Lacan's concept of self as she uses mirrors in order to paint parts of her body and in order to paint a self-portrait. But in the process of learning to paint, Artemisia develops beyond the use of the mirror as a representational tool. When Artemisia paints *Judith Slaying Holofernes,* using Tassi and herself as models, she still "sees" herself while painting. Her sense of identity is still based on sight, but it is not based on the idea of sameness. Artemisia does not see herself as a reflection in the mirror but as a different person. When Artemisia paints herself

as Judith, her relationship with herself is not as close any more as it was when she painted her mirror image, but it is still a relationship that deserves the term. The attraction in painting herself as Judith lies not merely in the joyful recognition of sameness between painter and painted, but in the sensation of difference between them.[43] Although there must be sameness to a certain degree so that Judith can be a suitable character for identification, it is the closeness to, as well as the difference between, herself and the character of Judith that Artemisia explores in her painting. To paint herself as Judith gives Artemisia a sense of power that was absent in her previous relationship with Tassi. If she simply painted her mirror image, she would not be able to perceive this new side to her identity.

To see herself as someone else, to base her sense of self on sight but not on the fascination with sameness means that Artemisia's sense of identity is less fixed than the Lacanian child's identity. This opens up the possibility of relating to others because difference is seen not so much as threatening but as enriching. Difference does not have to be kept at a distance, outside the boundaries of identity. When Artemisia inserts Tassi's frame between herself and her painting, this is not to fence off her self against Judith's difference but, rather, to locate within herself permeable boundaries that allow for an internal relationship, a dialogue between differing parts of Artemisia's identity. Artemisia is on both sides of the frame, painting and painted, seeing and seen, Artemisia and Judith; the relation between differing roles is part of her very identity.

And just as Judith is part of Artemisia's identity, so Tassi becomes a part of her. He teaches her to paint and, at the end of the film, Artemisia tells him: "You are part of me now" (unit 59). Artemisia is able to integrate a part of Tassi into her identity. She is enriched, not threatened, by somebody who is different from her. Contrary to McFague's suggestion that a sense of self based on sight rules out the ability to relate, Artemisia's sense of self is based on sight and it still enables her to relate. While Tassi uses the distance created by the frame in order to dominate what he paints, Artemisia is able to relate to what she paints through the distance generated by the frame, a distance the mirror does not allow for.

Through the sense of distance that Artemisia discovers by using the frame, she develops her ability to create a discourse, her symbolic competence. She moves on from the exclusive representation of individual body parts out of context to the representation of things in context, in relation to each other. The perspectival frame makes this development possible because it helps represent the relation between

things, as Tassi has said. Only Artemisia, in contrast to Tassi, does not stay outside the discourse that she paints. Instead, she creates herself in it, herself in interaction with a context relating to Tassi. It is essential for Artemisia to acquire symbolic competence in her development as a painter, not as a way of dominating, but as a way of relating things to each other and of being in relation to things.[44]

For McFague, symbolic competence, the ability to see things in relation to each other from a more distanced viewpoint, is not part of a loving way of looking. To her, what is expressive of a loving way of seeing and relating is the experience of the maze, of perceiving the world through touch and in detail. The overview that is interested in how things relate to each other is not part of the concept of the loving eye. Artemisia, however, in contrast to McFague's view, shows that symbolic competence does not prevent the painter from being in relation to what she paints. Symbolic competence is a necessity for Artemisia that helps her to survive in a world in which she, as a woman, is inscribed with visibility, in which the space created for her is a visible hollow in the sand. Symbolic competence helps Artemisia participate in the creation of meaning, and, thereby, to overcome being created by others as meaningful. To be created as meaningful, to be seen, is to be acted upon. To see, by contrast, is an act of creating meaning.

To sum up, Artemisia, through her development as a painter, learns the use of distance and of the perspectival frame. By distancing herself from what she paints and by putting things in perspective with the help of the frame, Artemisia learns to relate. Faced with the challenge of being a woman in a male world where a look is, by definition, male, Artemisia succeeds in seeing things in a way that differs from the male painters' ways of looking. Even though the tools of distance and the perspectival frame are typical of Orazio's and Tassi's ways of seeing and painting, Artemisia is shown to employ them in ways that are distinct from theirs. The distance that seeing implies is not separating but healing. To see her traumatic experience at a distance as a work of art gives Artemisia the power to deal with it, to relate to it, and it helps her to resist the danger of being completely overwhelmed by it.

The use of the perspectival frame has the same effect. It allows Artemisia to deal with her experience by putting things into the perspective of an artistic creation. Because Artemisia is on both sides of the frame, seeing and seen, the frame does not become—as it does for Tassi—a tool to separate her from what she paints. Instead, it represents a permeable boundary between differing parts of Artemisia,

allowing for a dialogue within. Artemisia's development of a unified sense of self, expressed in the image of a coherent body, too, foregrounds the distance that is growing between Artemisia and what she paints. Painting herself as a whole body rather than as individual body parts requires distance. But, unlike the Lacanian child's self-image, Artemisia's self-image is not exclusive of difference. Instead, Artemisia develops the ability to relate to others by seeing herself as someone else. Artemisia's ability to see while still being able to relate contains within it the hope for an alternative to the objectifying look identified by the philosophers discussed at the beginning of this book, which they thought could never enable a mutual relationship.

Distance and the use of linear perspective, which are two characteristics of McFague's arrogant eye, are, in Artemisia's experience, not arrogant. The experience of touch, which, for McFague, evokes a subject-subjects relationship, is objectifying for Artemisia and is no guarantor of a loving look and relationship. If distance is not necessarily arrogant and touch not always loving, what is it that makes a look arrogant or loving? In the following section, I will propose a different characterization of arrogant and loving ways of looking.

A DIFFERENT VIEW OF VISION

In contrast to McFague, I would argue that it is impossible to describe different attributes of a look, as, for example, distance and closeness or linear and multiple perspective, as arrogant or loving per se. Rather, each of the characteristics that McFague allocates to a particular way of looking can generate a subject-object or a subject-subjects relationship. Distance and closeness, linear and multiple perspectives each contain love as a potential and arrogance as a threat. In order to work toward a subject-subjects relationship, it is crucial to be aware that no way of looking can be described unambiguously as generating love or arrogance, that each way of looking contains potential for and danger to a subject-subjects relationship.

I have pointed out above that McFague's view of distance as arrogant and closeness as loving must be questioned from the point of view of Artemisia's experience. In Artemisia's case, physical closeness was not loving but hurtful, while the distance of her look contained not arrogance but positive potential for healing. For McFague, the act of seeing is positive only when it is connected to the act of touching. If connected to touching, seeing can be positive because touching, as McFague—perhaps a little naïvely—thinks, is positive.[45] She writes: "If sight is understood within the context of touch, it will not be

the distant, disembodied, objectifying, controlling arrogant eye of subject-object dualism. Rather, it will be 'in touch' vision, a relational, embodied, responsive paying attention to the others in their particularity and difference."[46]

But touch, as *Artemisia* shows, is not always so positive, not always attentive to the Other. In fact, McFague's emphasis on the connection between seeing and touching evokes Freud's view of these senses, a view that does not consider seeing and touching in terms of a subject-subjects relationship at all. According to Freud, seeing is derived from touching. To see someone is only a substitute for the stronger wish to touch the Other.[47] Neither seeing nor touching are valuable in themselves, though, since they are both directed toward the fulfillment of the sexual act as their final aim.[48] According to this view, neither seeing nor touching are interested in the particularity of the Other or, as McFague would have it, in the Other's simultaneous responsiveness and resistance to touch.[49] Instead, the wish that the Other should give up resistance and become accessible in order for sexual relaxation of the subject to be achieved is, according to Freud, the basis of the wish to touch.[50] My point here is not to put forward Freud's theory on seeing and touching as the "correct" one but to emphasize that touch is not always oriented toward a relationship but can be as selfish and haughty as the look of McFague's arrogant eye.

Just as distance or closeness and seeing or touching are not arrogant or loving in themselves, so, too, the techniques of linear and multiple perspective cannot be defined unambiguously as positive or negative in terms of the relationship between the painter and the subject. McFague is not alone when she theorizes linear perspective as privileging the spectator and creating a subject-object relationship between the person who sees and that which is seen. Albrecht Dürer's woodcut *Draughtsman Drawing a Recumbent Woman* shows exactly what McFague describes. The perspectival grid used for linear perspective occupies the center of the picture; the scarcely veiled, recumbent woman lies to its left and is being looked at by the fully dressed painter to the right of the grid. Mieke Bal, in her discussion of this woodcut, points to the genderedness and subject-object relation implied in this depiction of linear perspective.[51] The perspectival grid divides the picture into two sides. The man in the act of looking occupies one side. He holds a pen, the tool of representation and of the power to create meaning, in his hand. The opposite side of the frame shows the woman, who merely acts as display, as an object to be seen and to be inscribed with meaning by the painter's pen.

But even though linear perspective certainly has the potential to foster a subject-object relationship, it does not necessarily have to be seen in this way. In fact, it is possible to see linear perspective as restricting the spectator's vision. Within the technique of multiple perspective, the spectator occupies various viewpoints simultaneously. Within linear perspective, the spectator is restricted to one viewpoint, is forced to accept the bodily limitation of being able to be in one place only at a time. Linear perspective also means that, because of the restriction to one viewpoint, the spectator can see only one side of what he or she looks at. Seen in this way, the spectator who uses linear perspective is not all-seeing.

On the contrary, to see through linear perspective can mean to acknowledge that the Other shows itself only from one side, that it keeps its invisibilities and is never fully accessible to the viewer, that the spectator is only capable of partial view. The Other, which is seen, could thus be described as responsive and resistant; responsive in the sense that it shows itself partly and responds to the spectator's wish to see, and resistant in the sense that it never reveals itself completely. Linear perspective would thus allow for precisely the type of relationship that McFague calls for—one characterized by responsiveness and resistance. But McFague dismisses it as arrogant and, instead, sees the potential for a loving look only in the technique of multiple perspective or indeed anything that is not called linear perspective.[52]

Multiple perspective does not guarantee a loving look, and it is not necessarily less objectifying. Multiple perspective allows the spectator to see something from different angles. In the case of the representation of a body, for example, the body is not painted as a whole from one side but is taken apart and each body part painted from the "best" viewpoint in relation to this particular part. The body is thus fragmented and each individual part shown from its most revealing side. Through the use of multiple perspective much more than linear perspective, the body becomes accessible to the viewer; it is made visually available from all sides.

The spectator who uses multiple perspective is not restricted to one viewpoint. He or she can revel in the illusion of being able to escape the limitation to one place, the restriction to a body. And so it is not the look of linear perspective, but that of multiple perspective that is disembodied because the simultaneity of viewpoints is only achievable if the eye is freed from the body that is restricted to one place. If there is an all-seeing spectator, it is surely the one who uses multiple perspective.

McFague is right in pointing out that there are different ways of looking, but it is not possible to align particular painting techniques with a loving or an arrogant look in a straightforward way. A consideration of the issues of physical distance between the eye and what it sees and of perspectival techniques does not serve to solve the problem of the arrogant look. Instead, I propose that the crucial issue with regard to arrogant and loving ways of looking is the issue of visibility versus invisibility, an issue that McFague does not touch upon.

In place of McFague's concept of the arrogant and the loving eye, I propose a view of vision that emphasizes three aspects. First, it is important to discover the positive potential in the act of looking. Second, it is essential to be aware that seeing involves the activity of the person who looks. Finally, in order to avoid arrogance in the act of looking, both the seeing person and that which is seen should remain visible and invisible at the same time.

Our sense of sight contains as much potential for a reciprocal relationship as the other senses with which we relate to the world. McFague maintains that our senses of hearing and touching put us in a more reciprocal relation to the world than our sense of sight. Touch, she says, "is a total sense of existing, of being alive, affecting all parts of us, but a sense of being that is totally relational and responsive: I cannot touch without being touched."[53] Our sense of hearing has a similar effect: "Listening puts us immediately into a responsive relation to others; in fact, hearing depends on waiting until the other speaks or makes a noise."[54] By implication, seeing does not immediately create a responsive relationship, as it is possible to see without being seen. Indeed, this circumstance, and not physical distance or perspectival technique, is where the threat of the arrogant look lies.

Since McFague compares sight with other senses, it is necessary to evaluate critically her view of the senses of hearing and touching. Both senses can imply unresponsiveness. One need only think of the listening devices employed by totalitarian states in order to survey people acoustically to realize that an ear can be just as disembodied, controlling, and unresponsive as an eye. And even touch does not always imply responsiveness. Even though we are in constant touch with the earth, we are not aware of it most of the time, and we will often touch people or things without consciously feeling anything. Also, if people have experienced hurtful touch, they may, as a result, grow numb to touch and may withdraw every emotional involvement from the sensation of being touched. If people are in physical

touch, it does not necessarily follow that they are in emotional touch. Neither hearing nor touching are responsive acts by nature and it is not useful to idealize them over against the act of seeing.

Instead, it is important not to privilege some of our senses over others. All our senses have the potential both for responsive and objectifying relationships. To be sure, a responsive relationship with the world and with people requires people to learn how to see, hear, and touch in nonobjectifying ways. But seeing is not any closer to objectification than touching. Seeing can be objectifying; the solution, however, is not to concentrate on other senses but to learn to see in nonobjectifying ways. In the discussion of *The Tango Lesson* in the next chapter, I will point out that one person's appreciative look can encourage personal growth in another. I will also discuss, in connection with *The Tango Lesson*, the possibility of redemption inherent in an appreciative, nonobjectifying look.

An awareness of the activity involved on the part of the viewer is part of learning to look in a nonobjectifying way. It is important to realize that vision is not objective, realistic, simply registering, but that the person who looks influences what he or she sees, that the viewer has a choice in how to see things. *Artemisia* emphasizes the spectator's activity involved in seeing when Tassi and Artemisia see with their eyes closed. This shows that seeing involves the imagination of the viewer and that seeing, even though it may be stimulated by the physical presence of that which is seen, is not dependent on that presence. In the scene in prison during the night, which I discussed earlier, Tassi describes in words to Artemisia what he sees from his window during the day.[55] It is not relevant that Tassi's view from the window is not physically available because Artemisia and Tassi are in a prison room with solid walls. Vision, in this scene, is an inner activity of the spectator that is not dependent on the physical presence of the Other.

At the end of the film, Artemisia's activity in looking is even more strongly underlined. Artemisia looks out onto the sea through Tassi's frame but, through her voice-over, we know that she sees what Tassi sees from the window in his cell. What is physically present in front of her is not relevant to her vision (unit 67).[56] These scenes make the point that seeing is not a relationship of display on the part of the object looked at and of objective registering on the part of the spectator. Instead, seeing involves the spectator with all of his or her creative and imaginative activity.

McFague criticizes linear perspective, the technique used by Tassi, for isolating the spectator through the limitation to a single viewpoint.[57]

Although this criticism is justified, it is still possible for Artemisia and Tassi to relate to each other as spectators. If vision is seen as simply registering, as dependent on the physical presence of the Other, it does isolate spectators, as every spectator will appear as limited to one viewpoint from which he or she sees something that nobody else will see in exactly the same way. If, however, vision is seen as an act of imagination, it is possible for people to share the same view and, like Artemisia and Tassi, to be united in one viewpoint.

It is important for spectators to be aware of their own activity in seeing, of the involvement of their imagination. This will help them understand the rift between an image and the reality it represents. If spectators are aware of their activity in seeing, their look will not be objectifying because they will know that the reality of the Other is never fully accessible to their vision and their image never fully congruent with the original. This awareness is a sign of respect for the Other. While enjoying the visibility of the Other, the imaginative spectator will always be aware of and respect that the Other has invisible sides.

The crucial factor that makes a look arrogant is an unequal balance between an invisible eye and the visibility of that which is seen. A look is arrogant if the spectator is invisible whereas that which is seen is considered to be totally visible. If that which is seen is expected to render all its secrets and to become visually completely accessible to a viewer who is, in turn, completely inaccessible, then the look is objectifying.

The most disturbing example of a look of this kind may be the ideal prison, described by Jeremy Bentham in the eighteenth century with the word "panopticon." In this prison, the inmates live in cells that are all visually accessible from a tower in the center. The surveyor is invisible in the tower but the inmates are constantly aware of the controlling gaze. Michel Foucault, in his reflections on Bentham's concept, points out that the physical presence of the surveyor is superfluous, as the inmates will internalize the controlling gaze.[58]

McFague mentions the panopticon as an example of the arrogant eye, which it surely is. It is not arrogant through the use of distance or linear perspective but because it functions through the contrast between the complete invisibility of the surveyor and the utter visibility of the inmates. It is surprising that McFague should mention the example of the panopticon in relation to her concept of the arrogant eye without touching on this. A relationship of total visibility versus total invisibility results in a subject-object relation where the visible reality in front of the spectator's eye is characterized by lack of power

and the place of the invisible spectator is one of power and dominance over the visible. As I explained above, feminist film theory has criticized this way of looking not only as a pattern of dominance and submission, but also as a highly gendered relational setup in which the side of the visible that is lacking is gendered female, whereas the gaze of the invisible spectator is gendered male.[59]

This view of the relationship between the spectator and that which is seen echoes a particular view of the relationship between God and the world. According to this view, God is all-seeing and the world all-visible. McFague rightly recognizes the connection between this concept of God and the arrogant eye. She compares God's view of the world with the landscape view taken by the arrogant eye and describes the parallel between this God and the arrogant spectator: "Like the all-powerful God who sees and knows all, who surveys the entire earth from the privileged perspective of heaven, penetrating even into the innermost secrets of each and every creature, so we, made in the divine image, see and know all from our lesser but similar stance."[60] But McFague acknowledges only that God is all-seeing, distant through the landscape view and watching from a privileged perspective. What makes God's look arrogant is, however, not just the fact that he is all-seeing but also that he is at the same time invisible. It is no coincidence that God is sometimes represented in iconography as an eye inside a triangle. This emphasizes that God is vision, but it shows at the same time that he is invisible, as the eye in the triangle is disembodied.[61]

A relationship in which one part is defined by complete visibility whereas the Other is totally invisible satisfies the voyeuristic pleasure of the invisible spectator, whether he or she is God, a spectator behind the camera, a painter behind the perspectival grid, or a child behind the keyhole. The emphasis of this relational pattern is not on the relationship itself, nor on the uniqueness of the Other, but solely on the fulfillment of the spectator's pleasure. The arrogance inherent in the voyeuristic look cannot be avoided by reducing the physical distance or changing the perspectival technique but only by acknowledging that both partners in a relationship have visible and invisible sides.

Elizabeth Pritchard explains that invisibility becomes a privilege if it applies to one party of a relationship only. The privilege to resist representation has been seen as a male privilege and as the privilege of a God described as male.[62] According to Pritchard, it is necessary to acknowledge that everything—people, things, and God—defy representation to some extent, that nothing is completely visible but everything has an invisible side.[63]

In the interpretation of *Artemisia* in the previous chapter, I concluded that Artemisia learns to see things in a new way on the ground that she handles the issue of visibility versus invisibility in her relationship with what she paints in a different manner. Artemisia learns to distance herself from what she paints and she learns to use linear perspective, but her way of painting and looking differs from that of the men who taught her in that she is both visible and invisible as a painter. Even though she paints from behind the perspectival grid, she is still present on both sides of the frame, she is painter and painted, visible and invisible. Artemisia's way of painting thus offers an alternative both to McFague's concepts of the loving and the arrogant eye, and to the strict division between visible object and invisible subject that has so often been made in philosophical concepts of the act of seeing.[64]

Artemisia's new way of looking, however, is contained in a film that still practices a strict division between visible and invisible. In *Artemisia*, only the character within the film, Artemisia, is shown to be visible and invisible, inside and outside her picture at the same time. The camera itself acts as an invisible spectator throughout. As a final step in this discussion of *Artemisia* and McFague's theology of looking, I will now direct my look away from the character Artemisia onto the film as a whole. I do this in the awareness that my own vision is now framed by the ideas I developed through bringing in contact Artemisia's experiences and McFague's theory.

ANOTHER LOOK AT *Artemisia*

My ideas on vision, developed in the section above, will provide the framework for taking another look at *Artemisia* as a whole. I underlined above three aspects that are important with regard to seeing. Seeing can be positive and has just as much potential for a nonobjectifying relationship as other senses, for example, touching. Seeing is never a passive, "objective" registering of reality; on the contrary, it always involves the viewer's activity. In order to avoid an arrogant look, it is crucial that both partners in a relationship remain partly visible and partly invisible.

When we view *Artemisia* in relation to these three aspects of seeing, we discover that the distance seeing allows for encourages a positive relationship. Watching *Artemisia* can lead us to question McFague's preference for the act of touching over that of seeing. Seeing is not necessarily more positive when related to touching. For Artemisia, seeing allowed her to free herself from Tassi's objectifying touch. The distance in seeing was healing precisely because it was not

related to touch but, instead, helped taking a step back from Tassi's physical attack. Seeing through the perspectival frame was positive because it helped Artemisia make sense of her experience and to "put it in perspective." At the same time, relating things to each other with the help of the perspectival frame meant that Artemisia could develop her symbolic competence.

But even though the film, on one level, postulates Artemisia's symbolic competence and values the distance in seeing, it thwarts, on a different level, its own attempts at representing the act of seeing as positive. Artemisia, the female painter, must still be the one who is "in touch" with things, who lacks distance and symbolic competence. Even though Artemisia paints a complete picture, *Judith Slaying Holofernes,* the film does not show the painting as a whole at any time, except for one brief moment during the trial in which Tassi is convicted of rape. Instead, the camera records the painting in close-ups, showing its individual parts rather than the whole.[65] While Artemisia develops her painting skills and symbolic competence through the use of distance and perspective, the camera refuses to acknowledge this development by insisting on seeing Artemisia's painting close-up, by being "in touch" with it rather than in an appreciative distance from it. The camera practices this way of looking at Artemisia's pictures right up to the end of the film. A short summary of Artemisia's life after the events presented finishes off the film. During this summary, one part of the picture is always taken up by text, while the other part shows details of paintings by Artemisia Gentileschi. Again, the camera shows the paintings only in close-ups of individual parts. We never get to see whole pictures.

The camera's way of looking is echoed by Artemisia's voice-overs that accompany her in the act of painting. While Artemisia's interest as a painter develops from painting individual, disjointed body parts to painting two complete bodies in relation to each other, her voice-overs are made to reflect, until the very end, Artemisia's initial way of looking at individual body parts from up close. When she shows her ability to relate things to each other and to create a discourse by painting *Judith Slaying Holofernes,* she describes her painting like a surreal work, a collection of details that are unrelated to each other ("an arm . . . , a fist . . . , a round breast . . . , a sword . . . , an eye . . . , the color red . . . "). In an earlier voice-over, when she and Tassi pose for her painting, Artemisia even speaks of "the confused mixture of forms and dreams," as though she were incapable of creating a discourse that "makes sense."[66] The confusion referred to, the lack of an

ordering perspective, is reminiscent of the perception of the world as maze, which McFague refers to as loving.

The camera's way of looking at Artemisia's paintings only from up close and the film's way of making Artemisia describe her own painting as lacking coherence both show that the film does not take seriously Artemisia's acts of seeing and creating a discourse. Artemisia has to develop her symbolic competence and healing vision in spite of a filmic format that denies her these capacities. The film reduces Artemisia's artistic competence to the abilities of being in touch and of perceiving things in "a confused mixture of forms and dreams."

It is interesting and disturbing that Tassi, by contrast, is permitted symbolic competence by the film. In his verbal descriptions of two views, one of the sea and one out of his cell window, he is allowed to describe how things relate to each other; how the earth pushes up the sky; and how the sun, through its mirrored path on the water, relates to the painter.[67] If Artemisia's acts of seeing and of putting things in perspective are not valued positively simply because she is a woman and if, simply because she is a woman, she has to "be in touch" with things and to be lacking the capacity for ordering vision, then the film does not only value touching over seeing, but also represents a very "old" and traditional way of looking at a woman.

In the previous section, I described as a second aspect of vision the fact that seeing always involves the imaginative activity of the viewer. *Artemisia* emphasizes this point by showing Artemisia's development as a painter. To learn to see and to paint means to learn to use her imagination in order to create a discourse of things that relate to each other. Artemisia's painting *Judith Slaying Holofernes* shows that she is in full command of her creative powers, capable not only of perceiving herself and Tassi but also of actively imagining herself and him in a context that differs from the momentary context of their lives. The film thus acknowledges that seeing is an act of the painter's imagination.

But what an act it is! It is constantly associated with sexual dominance, with the intrusion of the Other's space, and with the fear of losing sexual power. It is not at all an act of imagining others positively. In Tassi's case, the power to see is a substitute for his sexual power. As I argued earlier in this chapter, this connection is most obvious when Tassi is about to be painted by Artemisia, and, therefore, about to lose the power of his gaze. In this situation, Tassi makes up for the impending loss of vision through asserting his sexual power over Artemisia. If it is necessary for Tassi to handle his loss of vision through sexual domination, then vision is little else than a substitute

for the power to penetrate.[68] The film does not criticize Tassi's way of seeing/penetrating. Instead, it excuses Tassi's act of raping Artemisia by creating a love story from it, by making it a mere peccadillo.

For Artemisia, seeing is linked both to being penetrated and to penetrating. Learning to see is not possible for Artemisia without losing her virginity. In the previous chapter, I explained that the film shows Artemisia's sexual and artistic development as closely linked. Through this connection, the film seems to suggest that Artemisia cannot acquire the power to see and, as a virgin, be independent of and beyond male influence at the same time. If Artemisia insists on acquiring vision independent of male vision, then, so the film seems to say, she has to pay her sexual independence as a price, she has to be controlled in some way. The possibility of independence both as a woman and a painter is not developed in the film. All impulses of independence are bound into the love relationship with Tassi. The point where Artemisia becomes independent after the end of the relationship with Tassi represents the end of the film and the theme of Artemisia's independence is never explored.

Not only does independence of looking come at the cost of becoming an object of sexual power, but it also means becoming a subject of sexual power. Seeing, whichever way one looks at it in *Artemisia,* is always connected to the sexual act. At the end of the film, when Tassi is in prison and the relationship between Tassi and Artemisia has ended, Artemisia takes Tassi's perspectival frame. In a reversal of the rape scene earlier, Artemisia now forces her entry into Tassi's empty house by breaking open the door with the help of a stone. Earlier, Tassi tried to regain the powerful position of his vision through an act of penetration. Now, Artemisia is gaining Tassi's vision—she takes his perspectival frame from his house—through forcing her access to Tassi's space. In each case, seeing is an act, but it is an act of violating somebody else's space.

Tassi's rape of Artemisia turns Artemisia's forced entry into his house into a male form of sexual behavior. Artemisia's violation of Tassi's space, coming as it does at the end of the film, completes Artemisia's process not only of learning to see things in a new way but also of learning to see things like a man. The act of forcing one's entry into somebody's space is not necessarily a specifically male behavior. But in the context of *Artemisia,* in which this act balances the earlier act of rape and in which Artemisia is described by her father with the words, "she paints like a man" (unit 14), her forced entry into Tassi's space is replete with associations of male sexual behavior.

Yes, seeing is shown to be an activity, but the film does not grant
Artemisia the possibility to see things in a new way. Seeing, to a large
extent, means to act like a man, whether one is in fact a man or a
woman, and *Artemisia* does not challenge that.[69] Artemisia's act of
seeing is connected with a male perception of sexuality in yet another
way. Her painting, *Judith Slaying Holofernes,* shows that, in her act
of seeing, she comes to represent male fears of castration. Artemisia
Gentileschi painted *Judith Slaying Holofernes* around the time of the
rape trial. Her choice of subject may have been influenced by her experi-
ence with Tassi and is sometimes seen as an act of visual revenge.[70] The
film, however, makes the connection between Artemisia and Judith
and between Tassi and Holofernes much stronger by having Artemisia
and Tassi pose as Judith and Holofernes. Artemisia's act of seeing Tassi
is thus closely linked to Judith's act of beheading Holofernes.

In her discussion of Gentileschi's *Judith Slaying Holofernes,* the
work that Artemisia is shown to be painting in the film, Mieke Bal
identifies two different ways of looking at the act of beheading in
Gentileschi's work. One can equate decapitation with castration and
see the Judith theme as a representation of the male fear of castration.
Bal suspects that the popularity of the Judith topos is an indicator that
Freud's understanding of beheading as a symbol of castration is cor-
rect.[71] Indeed, Judith figures in Freud's treatment of virginity and his
theories can, therefore, enlighten the interpretation of Gentileschi's
painting and of the film. The fear of castration is generated by a
visual fiction—the fiction that the absence of a penis in the mother
means that she is lacking—and, for this reason, Judith's beheading of
Holofernes is tied up with the act of seeing.[72]

By having Artemisia pose as Judith, the film links her gift of vision
with the feared castration that the Judith topos stands for. Her vision
as a woman becomes negative as it is transformed into a threat to Tas-
si's masculinity. Even Artemisia's interruption of the process of seeing
and painting in order to make love with Tassi does not do enough to
take the threat out of her vision. Artemisia's and Tassi's lovemaking
pose—Artemisia is on top and Tassi has his head still hanging off the
edge of the bed—is too reminiscent of the pose of Judith beheading
Holofernes in Artemisia's picture. Bal points out that, in Freud's text
on virginity, the character of Judith has a very ambiguous function,
as it represents male fears of both castration and virginity. The film's
view of lovemaking on the edge of beheading/castration is an echo
of Freud's connection between the fear of castration and the fear of
virginity, even though Artemisia is no longer a virgin. According to

Freud, it is the male fear of being castrated by making love to a virgin that is behind the taboo of virginity.[73]

Artemisia's posing as Judith not only in her painting but also in her lovemaking makes clear that the film sees Artemisia's vision in terms of a threat to the power to create, defined as male. Artemisia, in her act of looking through the wired frame, becomes Judith, the castration threat personified. No matter whether it is Artemisia or Tassi who is looking through the frame, the look in *Artemisia* is always shown to be "cutting into pieces." Bal calls this way of theorizing the act of seeing the "boy's fiction." This "boy's fiction" is, at least according to Lacan, so prevalent that everybody, whether male or female, assumes it. Bal writes:

> The story of origin, of original sight, covers up the embarrassing situation that the girl had no other mode of seeing available than the boy's fiction, taken over from those who looked before him. This, precisely, is the nature of the gaze as Lacan has theorised it. Like a discourse, it is ready for you to step in and work with, but whatever you make of it, whatever you see, is structured and, to a certain extent, semantically filled for you.[74]

If the scene of Judith slaying Holofernes is seen as an act of castration and Artemisia, in her act of seeing, is connected to Judith who represents the threat of castration, then Artemisia is stepping into the "boy's fiction."

But to see Judith as a threat of castration is, according to Bal, not the only possibility of interpreting Gentileschi's painting. Bal points to an ambiguity in the painting that is situated in Holofernes' arms. Holofernes' arms, she notices, look like thighs. She explains: "Seeing, in a glance, thighs in Holofernes' arms, imposes a choice of two fictions: either the head is a head, but of a baby, or the head is a penis, and being cut off."[75] Artemisia's posing as Judith could, therefore, mean that her act of seeing represents either castration or birth giving. But in order to see this ambiguity, in order to see Holofernes' arms as thighs and Artemisia's vision as birthgiving, we would need to see Gentileschi's painting as a whole. Since the film does not show us the painting as a whole, Artemisia's act of seeing remains an act of castration.

In order to avoid an arrogant look, I argued above, it is necessary that both the viewer and the person or object seen are considered to have visible and invisible sides. *Artemisia* shows a number of situations where this is not the case. Both Orazio and Tassi, for example,

make a clear distinction between themselves and what they look at. As painters, they are only seeing but are not seen in their paintings. By contrast, Artemisia is both seeing and seen; she poses for her own painting.

But the issue of visibility versus invisibility is not only addressed in styles of painting; it is also most prominent in the act of spying. Spying relies on the invisibility of the spy and the visibility of the person who is observed. In *Artemisia*, Tassi, Orazio, and Artemisia spy. Tassi spies on Artemisia through the crisscross of a church window; in a painting lesson, he looks from behind on Artemisia's neck while she is unaware of his look. Artemisia spies on Tassi during an orgy at Tassi's house and on the muscular back of her male model, Fulvio, while he is not looking; she also spies on a couple making love on a beach. Orazio, after hearing rumors about Artemisia's and Tassi's relationship, spies on them to find out the truth. I explained above that the camera criticizes Tassi's, Orazio's, and Artemisia's voyeuristic looks in that it exposes them in the act of spying.[76] It makes visible the characters who believe themselves to be invisible.

But even though the camera exposes others in their act of spying, it is itself deeply implicated in the voyeuristic look. Whenever it shows people spying, it looks for a moment at what they see—Artemisia's neck from up close, Fulvio's muscular back, Tassi and Artemisia behind a window. In this way, the camera takes part in the voyeuristic look of the film's characters; it enjoys the character's visibility while remaining invisible, and forces the viewers into doing the same.

But the camera does more than simply share the character's voyeuristic pleasure. It pushes the act of spying to an extreme; it is the most efficient spy in *Artemisia*. By exposing the characters in their act of watching, it spies on the spies. While "pointing the finger" at others for enjoying invisibility, it is involved in the same activity of enjoying others' visibility while remaining invisible. The look of the camera that shares the characters' voyeuristic look and, additionally, spies on the spies, is always more powerful and always sees more than any of the film's characters. It is, like the Lacanian gaze, "ready for [the characters] to step in and work with, . . . but whatever [they] see is structured and . . . semantically filled for [them]."[77] Whether it is Tassi or Artemisia who looks through the frame, the camera will always see more. It is the camera that has the last word as it watches whoever looks through the frame.

The film's last image shows Artemisia looking through Tassi's perspectival frame, perhaps attempting to see things in a new way. But the camera plays a trick on her; it looks back at Artemisia through

the wiring, from the opposite side of the frame. With this view of Artemisia, the film has come full circle. From the moment when the cutting crisscross was introduced by a look through a church window behind which Artemisia was seen to this last moment, when Artemisia is again seen behind the wiring, the camera is always claiming the position of an invisible viewer behind the frame. And Artemisia, at the beginning and the end of the film, is made to occupy the "visible" side of the frame. Even in her attempt to see, Artemisia is marked through the wounds of lack. Artemisia's fingers, cut to the point of bleeding through torture during the rape trial, are prominent in this last glimpse of her. While she looks through the perspectival grid, she lifts her hands to her face and frames her eyes with them. Her eyes and her hands, all that she needs in order to see and to paint, are not seeing any more but merely seen, cut through torture and the wired frame, wounded by the look of the invisible camera.

Looking Back at *Artemisia,* and Ahead at *The Tango Lesson*

Creating a dialogue between *Artemisia* and *Super, Natural Christians* brings to light not only different ways of looking at people and the world but also different ways of thinking about vision. McFague introduced a concept of two different ways of looking, the arrogant and the loving eye, and identified these ways of looking in terms of different ways of handling distance and perspective. Both the parallels and the differences between *Artemisia* and *Super, Natural Christians* proved to be fruitful for discussion. On the one hand, the concepts of the arrogant and the loving look shed some light on the painting styles of Tassi, Orazio, and Artemisia. On the other hand, Artemisia's development as a painter, because of its differences from McFague's concept, calls into question McFague's view of what it means to look in a loving way. It is not the issue of distance or the handling of perspective that determines whether or not a look is objectifying, even though McFague is right in assuming that different ways of looking can generate objectifying or nonobjectifying relationships. The critique of McFague's concept provides a basis for a new view of vision centered on three aspects. First, seeing has as much potential for a nonobjectifying relationship as other senses. Second, it is important to be aware that seeing is an act of the viewer's imagination, not an "objective" registering. Third, an arrogant look can only be avoided if the act of seeing is mutual and both partners in this relationship are granted visibility as well as invisibility. This threefold view of

what it means to see reveals *Artemisia* to be a film that practices an arrogant look. Artemisia's act of seeing is not shown as positive; even though she acquires the power to see, the film still prefers her vision to be "in touch" and to be lacking the possibilities for abstraction and discourse that looking allows for. While seeing is described as an act, it is not shown to be an act of imagining the Other in a positive way. Instead, it is an act of domination that is a substitute for sexual power. Seeing, as far as the camera work in *Artemisia* is concerned, is not interested in considering visibility and invisibility as something that should adhere to both the viewer and what is seen. Instead, the camera enjoys being an invisible spy and defining as totally visible what it sees.

The Tango Lesson relates to the view of vision proposed here in a way that differs from *Artemisia*. Seeing and being seen are shown to be more positive and are part of a nonobjectifying relationship. Additionally, we can see in *The Tango Lesson* a different way of situating the act of seeing in the space between the spectator's imagination and ability for perception. Finally, *The Tango Lesson* handles the issues of visibility and invisibility in a way that differs from *Artemisia*, allowing for a more equal balance between the characters', the camera's, and the spectators' visible and invisible sides.

CHAPTER 7

THE TANGO LESSON

Rage: THE SCRIPT FRAGMENT

Sally Potter's *The Tango Lesson* (1997) appears to be of relevance more readily than *Artemisia* to a book that seeks to create a dialogue between film and theology. Religion features directly in its plot. During a scene in a café, Sally, the female main character, tells Pablo, her male counterpart, that while she does not believe in a God as a superior, controlling power, she still feels Jewish. Pablo says he is a dancer and a Jew; to dance and to be a Jew make up the two major components of his identity (Appendix 2, unit 24). Occasionally, the film returns to its main characters' Jewishness to emphasize not so much their specific beliefs but their quest for what exactly it means to feel like a Jew (Pablo introduces the last unit of the film with this question).

Pablo's Jewishness and Sally's feeling Jewish do not manifest themselves as a lifestyle influenced by Jewish festivals and rites. On the contrary, their inner distance from a Jewish lifestyle becomes evident during a visit to a synagogue, when they both sit at the very back of the almost-empty room, somewhat touched by the cantor's voice at the front but very far away from it. The fact that Potter has Sally read the Jewish philosopher Martin Buber's *Ich und Du* in the film indicates that Jewishness is understood in a more general sense as a way of being in relation. Although the film does not seem to answer explicitly what it means to feel Jewish, it does deal with different ways of being in relation through filming and dancing. Filming and dancing can therefore be seen as metaphorical descriptions of what it means to be in relation and of what it means to feel Jewish.[1] I am thus pursuing an approach to *The Tango Lesson* similar to the one I chose

for *Artemisia,* considering the film's portrayal of filming and dancing as metaphorical for ways of relating in the same way in which I earlier considered painting as a way of relating.[2]

The Tango Lesson is an autobiographical film, directed and written by Sally Potter. In addition, Potter acts as the film's main female character, Sally. The film deals with Sally's relationship to professional tango dancer Pablo Veron, a relationship described as an exchange of skills. Pablo teaches Sally to dance the tango professionally and Sally makes a film with Pablo about the tango. Embedded in the black and white film are fragments of an earlier script, shot in color. During *The Tango Lesson,* Sally abandons the earlier idea, which was written to be produced in Hollywood, for the idea of making the film about the tango.

The fragments of the earlier script are set apart clearly from the rest of the film through the use of color film, but are opposed to the black and white part of the film in more than this way. In my interpretation, I shall consider the fragments of the earlier script separately, concentrating on how the characters within it relate to each other and on how Sally, the writer and director, relates to her script. I shall employ feminist film theory in order to problematize ways of relating as they are portrayed in the first script and to find reasons why the script is abandoned. I shall then compare the black and white part of the film that deals with the tango and with filming the tango to the fragmentary color parts of the script, in order to find out whether the black and white part of the film shows alternative ways of relating.

The fragmented script *Rage* is developed over several units during the first third of *The Tango Lesson* (units 1–20). *The Tango Lesson* shows Sally working on the script in her flat in London and on a research trip for the shooting of the script in Paris. In between the black and white shots of Sally working are shots in color, illustrating Sally's script ideas. In order to examine Sally's relationship to her script, it is necessary first to describe the script itself with regard to its characters, its plot, and its artistic conventions.

The characters that feature in *Rage,* a criminal story, are three female models, one dressed in red, one in blue, and one in yellow; a fashion designer whose dresses the models exhibit; a number of paparazzi photographers who take pictures of the models; two male bodyguards; and a number of female seamstresses. *Rage* relates the deaths of the models.

The plot of *Rage* presents us with the peculiarity that it begins where it will eventually end. At the beginning of *The Tango Lesson,* Sally starts to write on a fresh sheet of paper (unit 1). The color shots that we now see, which show what Sally sees in her mind, begin

with a gunshot directed at the model in red. Immediately after the gunshot, Sally crumples up the sheet of paper and attempts another beginning on a new, white sheet. Now, the script unfolds in the way described above; after the deaths of the models in yellow and blue, it ends where it began, with the death of the model in red. The fact that *Rage* arrives twice at the point where the woman in red dies is suspicious. Has Sally seen *Rage* many times in her mind? Has she written it down time and again and crumpled up many sheets of paper because *Rage* always ends where she does not want it to end—with the death of her models? For some reason, Sally is unable to create a different ending for *Rage*. Instead, she writes the script she does not like over and over again.

Rage deals with some of the same issues feminist film theory deals with and feminist film theory can therefore help to clarify why Sally always arrives at the same ending of *Rage*. In her analysis of Hollywood films of the 1930s, 1940s, and 1950s, Mulvey speaks of a "sexual imbalance" inherent in the films she considers, according to which to be male means to be active and to see, and to be female means to be passive and to be seen.[3] Mulvey and other theorists try to find reasons for this imbalance. In their search for explanations, they draw heavily upon the psychoanalysis of Freud and his followers.[4]

Kaja Silverman explains why psychoanalysis is useful. Both the cinema and, from the viewpoint of psychoanalysis, the subject are organized around absence.[5] For Freud, human subjectivity is based on the lack of the phallus in the case of women and, in the case of men, on the fear of this lack. Lacan, who operates within the Freudian tradition, too, considers the experience of lack as essential to human subjectivity. Silverman understands Freud and Lacan to be saying that the child becomes a subject the more it perceives itself as separated from surrounding objects.[6] The losses of objects are experienced as symbolic of castration because the child once considered the objects as part of its own self (as, for example, the mother's breast).[7]

Film theory, too, builds upon the notion of lack, as well as on psychoanalytic terms, in order to explain the experience of viewing film. In cinema, it is reality that is lost behind its representation through images.[8] Metz, in fact, even goes so far as to speak of castration when referring to the cinema.[9] But most film theorists do not draw any parallels between psychoanalysis and films beyond the observation of lack.[10] Silverman argues that Mulvey has established the parallels between psychoanalysis and film with more resolution than her male colleagues, because she pays attention to two of Freud's concepts that are not addressed by "mainstream" film theory.

Not only did Freud theorize the castration complex, he also developed the concepts of voyeurism and fetishism as ways to come to terms with the threat of castration. Both voyeurism and fetishism are particularly male behavioral patterns because the castration crisis assumes a different role for men and women. Because males are supposed to represent the phallus, castration is much more threatening for them than it is for females. Males have a lot more to "lose" through castration.[11] Voyeurism and fetishism are strategies especially used by males for dealing with the threat of castration. In both strategies, the image of "woman" becomes the site onto which lack is projected. "The source of unpleasure," Silverman explains, "is externalized in the form of the female body."[12]

Mulvey defines voyeurism as a "preoccupation with the re-enactment of the original trauma (investigating the woman, demystifying her mystery), counterbalanced by the devaluation, punishment or saving of the guilty object."[13] Fetishism is "complete disavowal of castration by the substitution of a fetish object or turning the represented figure itself into a fetish, so that it becomes reassuring rather than dangerous."[14] Fetishism thus builds up the physical beauty of the object, whereas voyeurism has associations with sadism.

Within "mainstream" film theory, Metz pursues the connection between psychoanalysis and film furthest when he refers to Freud's concept of fetishism in connection with films. For him, however, fetishism occurs only in the technical virtuosity of the cinematic apparatus.[15] He does not notice the connection to female characters in films. In contrast, Mulvey argues that classic Hollywood films represent Freud's concepts of voyeurism and fetishism not only by analogy, but quite literally. On the one hand, Hollywood films perpetuate the concept of the male as the owner of the look, a look that is situated within the films on three levels, the levels of the camera, the male main character within the diegesis, and the viewer, who is conceptualized as male.[16] On the other hand, the male look within the entire cinematic system is directed not somewhat vaguely at the world in general but quite pointedly at the female character.

The male character, according to Mulvey, is the one who advances the plot, whereas the female character acts as a display within the narrative without any direct influence on it. The female character thus functions both "as erotic object for the characters within the screen story, and as erotic object for the spectator within the auditorium."[17] As her performance within the narrative is potentially disruptive to the diegesis, it has to be contained by the male character, who, through his look, is able to integrate the female spectacle into the narrative.[18]

The viewers identify with the active, male hero, who seems to have the power of control over the plot and over the female character, mastered through the male character's vision.[19] The male character, the site of identification, stands for potency, while the female character, the site of objectification, comes to represent lack.

In line with the Freudian idea of fetishism, Hollywood films emphasize the physical beauty of the woman, in order to "disavow castration," as Mulvey has argued; in other words, in order to hide the problem of lack.[20] Silverman argues similarly when she reveals the representation of "woman" as a site of lack in Hollywood films as a male projection, introduced in order to arm male viewers against the return of loss.[21] "Classic cinema's female subject is the site at which the viewer's discursive impotence is exhumed, exhibited and contained. She is what might be called a 'synecdochic representation'—the part for the whole—since she is obliged to absorb the male subject's lack as well as her own."[22]

In *The Tango Lesson*, Sally writes *Rage* with the intention of getting it produced in Hollywood. When the script is finished, she has a meeting with three Hollywood producers, after which she abandons the idea. This is not surprising, as *Rage* does not fit into conventional Hollywood style. Instead, the fashion show in *Rage* can be seen as an analogy, a cinematic summary of the essence of classic Hollywood film as criticized by Silverman and Mulvey. *Rage* is characterized by what Mulvey has called "sexual imbalance." The three models are opposed to the other characters through their colorful dresses and the emphasis on their physical beauty. The dresses, along with the high heels and the long hair, make the models appear stereotypically feminine. The women in their dresses are rendered even more spectacular through the use of color as opposed to black and white film. As models who exhibit fashion, they are designed to attract attention, to be seen; they are women who connote "to-be-looked-at-ness."

By contrast, all other characters wear black. The use of color film does not enhance their appearance, as they would look virtually the same on black and white film. Visually unobtrusive themselves, the characters dressed in black are the ones who look at the magnificently dressed women. Belonging to this group are mostly males—the designer, the photographers, the bodyguards—but also the female seamstresses. The fact that women are also among the people who look, not only among those who are looked at, is, of course, true not only for the fashion show but also for the cinematic event. Potter's depiction of the women among the viewers is reminiscent of Mulvey's analysis of the workings of Hollywood film. Whether male or female in reality, Mulvey's viewers

are conceptualized as male, because the only possible identification is with the male main character. Potter's women among the viewers are dressed in black; like the male onlookers they do not attract attention but direct it onto the staged women. In fact, the women among the viewers are almost hidden, as it takes at least two viewings of *Rage* to notice that the people in black are not all male. *Rage* thus makes visible a split in female identity. On the one hand, there are the exhibitionist models, the creations of the male designer, the women who are looked at, and on the other, there are the invisible seamstresses who are the people who actually produce the designer's creations, but who are not credited for their work.[23]

Within the group of the male onlookers, two different ways of seeing are discernible and personified as different people. There is the designer, whose seeing is an inner process, who conceives an inner vision, before giving shape to it and making it visible for others. His seems a potentially creative vision. The photographers, by contrast, see everything that has already taken shape. Their cameras register whatever they are directed at. Theirs seems a potentially appreciative vision.

Unfortunately, though, while the two ways of seeing are potentially creative and appreciative, it is striking how closely the personifications of the two looks fit into the Freudian concepts of fetishism and voyeurism. The designer's vision is not so much creative as fetishistic. His own lack is strikingly visible—he has no legs. Instead, his creations are all the more perfect. Their tall and slender bodies are overaesthetisized to the point of danger. The woman in the yellow dress dies of aesthetics; she trips over her immensely high and thin heel and falls down the stairs (unit 7). The woman in the blue dress is in danger of falling when she has to turn, upon the designer's gesture, inside a shell-shaped stone in a lake, in order to present herself for the photographers' gaze (unit 8). This is performance of aesthetic perfection for the eyes of the male photographers; "display," as Mulvey would say.[24] Even when two bodyguards protect the last surviving model, aesthetics are more important than security; the bodyguards walk on their toes in the manner of ballet dancers (unit 10).

It is as though, through the perfection of his mind's vision, the designer makes up for his physical lack. Potter's fetishistic designer thus embodies Silverman's description of the fetish: "The fetish classically functions not so much to conceal woman's castration as to deny man's."[25]

Because the women represent the designer's imagination, they are characterized by a lack of reality. They are works of art who seem stereotypically feminine but not realistically female. Through the colors

of their dresses—red, blue, and yellow—they appear typified rather than "real." Red, blue, and yellow are the prime colors out of which the whole spectrum of color emerges; by way of mixing red, blue, and yellow, a whole range of other colors can be created. Through the use of these basic colors, the designer characterizes his models as basic types; the differences typical of "real" people are missing in his creations. The models are reduced to stereotypical representations and do not bear the qualities of human subjectivity. They really are models, not people; they are objects created by the designer for his own use. The bodily perfection of his creations makes him forget his own bodily lack. It is not the models' subjectivity that is at stake here but the designer's; the models are simply satellites of the designer's imagination.

The photographers' looks are not so much appreciative as voyeuristic. The males, dressed in simple black, direct their cameras at the models, who embody everything that the photographers have excluded from their self-image—femininity, color, beauty, and exhibitionism. Not only in relation to the designer, the fetishist, but also in relation to the photographers, the voyeurs, the models appear not like "real" people but indeed, quite literally, as models, objects that represent aspects that the photographers themselves do not exhibit. Silverman's analysis of voyeurism rings true for the photographers. Through voyeurism, "an unwanted part of the self is shifted to the outer register, where it can be mastered through vision."[26]

Mastery through vision requires the object of the vision to be as passive as possible. In *Rage*, the photographers can best master the models with their cameras when the models are at their most passive, in the moment of death. The passivity of the model in the yellow dress, for example, is emphasized when a photographer approaches her and rearranges her appearance for a photograph while she lies dead on the stone steps (unit 7). Her death allows him to push her hair aside for a photograph that reveals her breast without any opposition from her. In the cases of the other models, too, it is their deaths that attract the photographers' attention most. As soon as the gunshots come out of nowhere, the photographers run in order not to miss the opportunity for a photograph. Their task is to photograph the models while they live, but the climax of their photographic desire seems to be to photograph the moment of death, to photograph utmost passivity.

It is evident why Sally tells the producers in Hollywood that *Rage* was "about beauty and the glamorization of death" (unit 27). "Beauty" refers to the designer's way of seeing, to his perfect creations, while "glamorization of death" refers to the photographers' ultimate desire to photograph the models dying, to turn their deaths

into a spectacle to be watched. It is the death of the models, Sally explains to the producers, that increases the interest of the media.

The reason, then, why the models die is because their subjectivity is never an issue within the fashion show in *Rage*. From the beginning, they are passive objects of the designer's imagination, for the photographers' eyes.[27] To objectify the models in this way is to postulate their deaths as subjects. There is hope once, toward the end of *Rage*. The woman in red, the last one alive, becomes active, offering resistance by pointing a pistol as if to shoot (unit 20). But she does not know where to aim and points wildly in all directions without pulling the trigger. She finds it impossible to act and, finally, she too is shot.

The fashion show in *Rage* not only summarizes some of feminist film theory's criticism of Hollywood films but also aspects of feminist philosopher Luce Irigaray's analysis of the patriarchal symbolic order. The models in *Rage* illustrate Irigaray's argument that the present symbolic order is not one where women are dominated and not given equal rights but one where women do not exist. What exists instead is an image of "woman" as a male projection, containing what the man is not.[28] Women do not exist as subjects in their own right.

The interaction between the designer, the models, and the photographers remind one again of Irigaray, who considers the present symbolic order as an essentially hom(m)osexual system where men communicate only with other men. Women are used as objects of exchange to the effect that this society appears to be heterosexual but is in fact homosexual.[29] *Rage* is about the dealings between the designer and the photographers. They are the ones who act in the fashion show. The models are objects that bring the designer and the photographers together more or less as business partners. The designer's vision is a business instinct through which he produces what other males can afterward consume.

The designer's way of seeing is, after all, not creative but productive; the photographers' vision not appreciative but consumerist. For the models in *Rage*, vision is nothing but destructive. Subjectivity, it seems, is annihilated through the look. But are there no other ways of seeing, ways that would not annihilate but constitute the identity of the Other? In order to answer the question about alternative ways of seeing in the black and white part of *The Tango Lesson*, it is necessary to look at director Sally's role in relation to *Rage*, at her way of seeing the script.

What we see in *The Tango Lesson* is not the actual shooting of *Rage* but Sally in the process of writing the script. The color shots that represent *Rage* are thus not scenes that Sally has already shot but they

show us what goes on in Sally's mind. They alternate with black and white shots that show Sally either in her flat as she writes down what she sees in her mind, or on a research trip, as possible settings inspire her imagination. While she writes *Rage,* the tango becomes more and more important as a hobby and a route of escape from the script. The tango itself becomes work when Sally finally abandons *Rage* and decides to make a film about the dance instead.

Although Sally makes a film for Hollywood, in her relationship with her script she lacks qualities that are normally required in order to write a script for Hollywood. Once more, feminist film theory proves useful because it clarifies how a story suitable for Hollywood is normally constructed and what role its writer should ideally play. I noted earlier that cinema is based on the notion of lack. It is not only reality that is lost behind its cinematic representation but also the site of production itself that is hidden to the viewer.[30] Silverman argues that the foreclosed site of production is equivalent to the phallus. Both the phallus and the foreclosed site of production are unreal. Although the phallus is aligned with the penis, she maintains that "it is never more or less than a distillate of the positive values at the centre of a historically circumscribed symbolic order."[31] Likewise, the cinematic apparatus credited with the telling of the story, cinema's unseen enunciator, is a symbolic position that sums up positive values—authoritative speech and the power of the look—but is always unreal since no viewer can ever access this position. Both the phallus and the unseen enunciator of cinema are disembodied, and "real" people can never live to be as positive and powerful as these symbolic constructs.[32] In relation to the powerful, unseen enunciator, viewers of film can only perceive themselves as lacking both actuality, the contact to the real, and symbolic mastery, the possibility to influence the discourse.

Silverman points out, however, that this experience of lack is much more threatening for male than for female viewers, since male identity is defined through identification with the phallus. Within the phallic symbolic order, female subjectivity is always constituted through lack. For women to experience lack once more in cinema does therefore not threaten the basic conception of their identity. By contrast, male identity is based on the phallus and male lack projected onto "woman." For this reason, the experience of lack in cinema poses a fundamental threat to the identity of the male viewer.[33]

Different techniques have been developed to protect the male viewer from experiencing lack in cinema. One such technique is to create an impression of reality in cinema by hiding the influence of the camera that interferes between reality and representation.

Thus, smooth montage creates the impression of a diegesis without any ruptures. Also, in the visual organization of Hollywood films, all elements of the picture have a point of reference within; nothing should refer to any point beyond what is accessible to the viewer.[34] At the end, the film should not leave any questions open, so that the viewer feels like an omnipotent, all-knowing, and all-seeing subject with direct access to reality. Another technique that helps to hide from the male viewer his own lack is the inscription into the diegesis of a male character who appears omnipotent.[35] Mulvey describes this character as the one with the power to make things happen and with the power to look.[36] This male character offers the possibility of identification to the male viewer[37] and can act as the viewer's ideal ego: "A male movie star's glamorous characteristics are thus not those of the erotic object of the gaze, but those of the more perfect, more complete, more powerful ideal ego conceived in the original moment of recognition in front of the mirror."[38]

As a scriptwriter for Hollywood, Sally would have to write a story that fulfills the criteria just described. A Hollywood writer should write a story that poses no unanswerable questions, that contains no inexplicable ruptures, and she should insert into the story a male character suitable for identification, who appears to advance the story and submits the female character to his gaze. Then male and female viewers could leave the cinema all-knowing, all-powerful, and all-seeing. In order to achieve that, the writer herself would need to be in a position of control in relation to her script. Indeed, *The Tango Lesson* shows how Sally attempts to be in control of what she writes. She writes *Rage* "from the outside looking in,"[39] that is to say, Sally does not appear within *Rage* but writes it from a more distanced point of view, perhaps hoping to be able that way to control better what she writes.[40]

Rage appears removed from Sally's personal life as a writer. Not only is *Rage* shot in color while Sally's life is shot in black and white, but, also, in *Rage* there is always movement—dresses and long hair blowing in the wind, photographers running, combined with very fast cutting of the shots. By contrast, Sally's life is predominantly still—she sits at her desk quietly, waiting for inspiration. The camera transmits the stillness through long shots and little movement. In addition to this, Sally is very different from the female models in *Rage*. She dresses plainly while they are flamboyant, they wear high heels while she wears comfortable, thick socks and no shoes. In her quiet, practical, black-and-white life, Sally prefers a story that does not concern her over one in which she is personally involved, since a position outside the story allows for more control of it.

While she works on the script, Sally's life is characterized by an attempt to create order. The very first shot of the film shows her hand, wiping her table before she begins to write (unit 1). Later on, her love for order and cleanliness becomes obsessive. She begins to interrupt her work on the script in order to wipe away invisible stains from the table, and she engages the services of a builder because of a tiny crack in the floorboards. When Sally wants to see what looms behind this little sign of threat to her order, her flat becomes, ironically, all the more chaotic. The builder rips out all the floorboards, and a heap of rubble from the ceiling ends up on Sally's desk (unit 20).

The way in which Sally works also shows her attempt to establish control. When she sits down to write, she does so in an extremely orderly way. First, she wipes the table, then she puts a pile of clean, white sheets on it, uses her hands to adjust the pile so that no single sheet sticks out of it, and places a pencil on the table in a line parallel to the pile. Then she sits down and, before she picks up the pen, places her arms parallel to the paper and her feet in a parallel position under the table (unit 1). Sally's absolute precision is an attempt to create order, to be in control. She repeats this ritual whenever she sits down (units 7, 8, 10, and 20); cleaning the table is followed by arranging piles, which is followed by sharpening her pencil. Incidentally, order plays a part in *Rage*, too. It is set in a French park, an embodiment of ordered nature (unit 4).

None of Sally's attempts to create order can hide the fact that she is unable to control her script. In fact, it seems as if Sally makes up for her inability to control the diegesis by overemphasizing order in her style of working. Sally's inability to control the diegesis becomes evident when color shots of the script begin to appear not only as she sits down to write but also before she sits down or while she does something else (units 10 and 20). *Rage* has its own life and appears in Sally's mind in a disruptive, rather than a controlled fashion. Sally's inability to prevent the deaths of the models also reveals that she is not in control of *Rage*. As explained above, *The Tango Lesson* begins with the end of *Rage*, as Sally sees in her mind the death of the model in red. After this, she tries to make a new beginning. She crumples up the sheet of paper and throws it on the floor. When we see a close-up of the pointed, black end of the pencil hovering over the clean, white sheet as Sally begins again, we associate it with "new creation." But, again, the models die, one by one, and Sally leaves her desk after each death, worrying over her inability to prevent the deaths.

Sally is thus not the all-powerful writer in control of the diegesis because she lacks control over her story. She is not all-knowing, as she

lacks knowledge about the story. The women in *Rage* die through gunshots from unspecified directions, "mysteriously," as Sally points out to the Hollywood producers. The murders are not explained, questions remain unanswered. In relation to *Rage*, Sally is not all-seeing either. Instead, recurring white screens regularly interrupt Sally's visionary access to *Rage*. Sometimes the dissolves coincide with the flash of a photographer that seems to erase the whole picture; at other times they occur independently of any source within the picture and without any explanation. The flow of images is interrupted by moments that leave Sally—and with her the viewers—feeling impotent as they are refused the power to see.

Also, Sally has not inserted into *Rage* an omnipotent male character, suitable to hide, via identification, the male viewers' own lack. Out of all the male characters in *Rage*, the designer is the only one singled out as an individual, and thus he presents to the viewers the only possibility of identification with a male character. But instead of being omnipotent, this character is lacking; he has no legs. Instead of hiding the male viewers' lack, he makes it all the more obvious.

It is self-evident that *Rage* is unsuitable for Hollywood. The producers say they like aspects of *Rage*—the costumes, the colors, the murders (unit 27). Sally has, in other words, created enough spectacle for them. But they point out to Sally that the writer should have the power of control over the diegesis, that "the writer is God" (unit 27). They insist on an explanation of the murders: "The writer," they say, "should know everything" (unit 27). The figure of the designer, too, provokes their criticism, because he has no legs.

As Sally is not the writer-God in control of her story, *Rage* is unsuitable for Hollywood. Or is it because Sally does not hide well enough the fact that she is not in control? In other words, is it because Sally does not hide but, on the contrary, makes quite explicit the fact that making a Hollywood film is not about being in control as a writer but rather about being controlled as a writer? Sally tries hard to make a difference and her pencil on the fresh paper evokes all the hopes of a new beginning. But, in fact, it seems no matter how many sheets of fresh paper she uses, she will always write the same story. It is therefore more appropriate to say not that Sally writes *Rage* but that *Rage* writes itself time and again through Sally's hand. *Rage* is not a story that Sally writes and controls but is part of something much bigger, of which Sally is not the writer but only the agent of reproduction.

Sally is written by *Rage* in the same way in which Lacan's human subject is spoken by language.[41] Like the Lacanian subject who

reproduces language, Sally does not make an artistic new beginning but reproduces Hollywood's worldview. What Sally thus reproduces is a system where positions are clearly defined, where males look and females are looked at, and where the producers resemble quite literally what Silverman named the "unseen enunciator," as they look through sunglasses that protect their eyes from being seen (unit 27). In this system, the writer serves as an instrument to create the story in such a way that male viewers do not feel their lack.

The writer is not supposed to make a creative, new beginning but to anticipate what viewers would like to see. Sally is shown to anticipate viewers' expectations when sitting down among a group of empty chairs at the bottom of a stone staircase (unit 4). The viewers' position is represented by the empty chairs, from which Sally watches her own script taking place on the staircase. In the meeting with the producers, too, the influence of the implied viewers over what Sally should write is quite pronounced. The laws of the market limit Sally's artistic possibilities. The language of the film cannot be French, for example, as this will not accord with the expectations of most viewers and will, in fact, lower their number by 75 percent. The Hollywood system is determined by many people, not the least of which are the viewers themselves, and the director has to operate within a set of tight rules.[42]

Sally, the writer, is only a wheel in the machinery in this system, not at all God. Sally's situation is even worse, as she is a woman writer within a system determined by the phallus. Although Sally writes *Rage* as a writer who is "outside" of the story insofar as she is not at the same time a character in it, she does identify with the character of the designer. Several aspects point to this identification. The designer and Sally are similar in what they do; they both wish to be creative. The designer is the character in the film who creates the dresses that are, of course, in reality Sally's creations. Twice, Sally looks at possible locations for *Rage* from the point of view that will later, in the "film" she sees in her mind, be occupied by the designer. She walks along a balustrade and, as she walks, places hand over hand on it as if she were walking on her hands (unit 4). Later in *Rage,* the designer walks on top of the same balustrade on his hands (unit 8). On another occasion, Sally runs along a hedge, crouching (unit 4). Later, the designer moves along the same hedge in his wheelchair (units 4 and 10). Sally had anticipated his viewpoint when she crouched by placing her eyes at the height of the designer's eyes.

Sally's identification with the designer indicates her position as a woman writer within the film industry of Hollywood. Although a

woman biologically, she does not feel like a woman but like a man. Her identification with a man whose most striking feature is his physical lack signifies that, in terms of Hollywood conventions, Sally, the woman writer, is not seen as a woman but as a man with a lack. Once more, *Rage* seems to illustrate Irigaray's analysis of a symbolic order based on the phallus. Describing how Freud defines the woman always in comparison to the man and the female sexual organ always in relation to its male counterpart, Irigaray comes to the conclusion that, within a phallic symbolic order, females are seen as incomplete males. Women as different from men, she argues, do not exist within this order. What exists instead are "men minus certain attributes."[43] "A man minus the possibility of (re)presenting oneself as a man = a normal woman," is Irigaray's bleak view of female identity within a phallic order.[44]

While writing *Rage,* Sally embodies Irigaray's "normal woman"; she is a woman who neither represents herself as a woman nor as a man but as a "man minus certain attributes." Within the symbolic system of Hollywood, Sally cannot be creative in the sense of making a new beginning as a woman, because she does not exist as female but only as insufficiently male within this order. The symbolic system of Hollywood leaves Sally with little possibility of personal expression, neither as an artist, nor as a woman, and perhaps that is why Sally's script is called "Rage." Rage might be what she feels when she thinks of filmmaking that is not about creating but about reproducing, not about seeing someone but about projecting lack onto someone, and not about appreciating but about objectifying someone through a gaze. *Rage,* Sally explains to Pablo after the meeting with the producers in Hollywood, is a script she does not like and a film she would not want to make (unit 28). It is washed away by the sound of a big tidal wave that we hear at the end of the meeting in Hollywood, in order to make way for a creative new beginning (unit 27).

THE TANGO

The black and white part of *The Tango Lesson* is devoted to the tango and to Sally's love relationship to the professional tango dancer Pablo. It relates how Sally and Pablo fall in love through the tango and how they try to embody their love through a professional tango performance that they dance together and through a film about the tango in which they both act. The fact that Sally and Pablo's love materializes in a film indicates that there is a connection in *The Tango*

Lesson between loving and seeing. A conversation between Pablo and Sally about the making of the film repeats this connection (unit 55). Pablo feels estranged from Sally because the camera seems to interfere in their relationship. "You are not here with me," he says to Sally, "you have become a camera." Sally replies that she loves Pablo with her eyes as well as her work as a film director, explaining that, for her, to see means to love. In order to counter the objectifying ways of seeing in *Rage*, I shall search, in the remainder of this interpretation, for ways of seeing that are expressive of a love relationship between a person who sees and another who is seen.

I discussed earlier in this chapter the fashion designer and the photographers in *Rage* as personifications of two different ways of seeing. Both ways of seeing had negative effects for the fashion models. The designer's vision was fetishistic. What he saw was a creation that covered his own lack, a lack that he projected onto an object at a distance from himself. The photographers' way of seeing was voyeuristic. Their cameras received as objects to be photographed what the designer's vision had provided for their consumption. Their vision could best master the object to be photographed when it was at its most passive—in the moment of death.

Although both ways of seeing eventually had a destructive effect on the models, both ways of seeing have a positive potential originally. The designer's look has the visionary potential to create something new, something to which he can relate rather than onto which he can project. The photographers' look has the potential to be appreciative of what is in front of the camera, to perceive the distinctive features of what they photograph. In order to explore to what extent the black and white part of *The Tango Lesson* features the two ways of seeing in their positive potential, we need to consider more closely the two looks. Silverman's ideas, presented in her book *The Threshold of the Visible World* are particularly useful in this undertaking, since she ponders, in terms of different ways of seeing, on what Lacan has termed "the active gift of love."[45]

Central to Silverman's development of the notion of a loving look are her concept of the "self-same body"[46] and her theorizing of ways in which identification normally functions. Both the principle of the self-same body and the ways in which we normally identify are opposed to Silverman's idea of a loving look. Silverman profiles the loving look by first explaining these oppositional ideas. She describes the principle of the self-same body as providing the up-until-now unidentified basis for Lacan's theory of the mirror stage.

According to Lacan, it is crucial that human beings develop an image of their own body in order to become subjects.[47] A person's reflection in the mirror provides the first image of a coherent bodily ego. Later, the subject will always search for its own original reflection in the mirror when confronted with a bodily Other. The ego maintains itself through this permanent search for its bodily reflection, for bodily sameness.[48] Silverman defines the principle of the self-same body as a twofold process through which the ego develops: "The ego consolidates itself by assimilating the corporeal co-ordinates of the other to its own—by devouring bodily otherness. The 'coherent' ego subsequently maintains itself by repudiating whatever it cannot swallow—by refusing to live in and through alien corporealities."[49]

Inherent in identificatory relations formed by the ego is therefore what Lacan has termed an "either you or me logic."[50] Either the ego swallows up the Other as its own ideal image—in which case the ego persists while the Other ceases to be—or the Other remains an unattainable ideal to the ego—in which case the ideal image remains but the ego is decomposed.[51] With regard to identificatory relations, the ego has, according to this logic, two possibilities. It can either incorporate an Other as its own ideal or repudiate an Other that refuses to be incorporated.

Projection is closely linked to repudiation. The ego that functions on the basis of the either-you-or-me logic projects its own unwanted parts onto an Other that it subsequently repudiates. The normative psyche, Silverman writes, "works to constitute as alien and external what it cannot accept about itself—lack, but also those terms through which it is visually specified: specularity, embodiment, and subordination to the gaze."[52]

The personifications of the two ways of looking in *Rage*, the photographers and the designer, stand as representatives of incorporation and projection/repudiation. The photographers consume with their cameras just as the ego grounded on the principle of the self-same body swallows. The designer, in line with this ego, projects his lack onto the models and, because he repudiates lack, clothes the models in flamboyant dresses that will hide their "lack."

Neither the mechanism of incorporation nor that of projection/ repudiation work toward establishing a genuine relationship, for they both aim to annihilate one partner of a possible relation between the ego and an Other, according to the either-you-or-me logic. Consequently, when searching for a loving look, Silverman is looking for an ego that identifies differently—according to a "you and me" logic.[53]

In order to help a loving relationship to exist and a new cinema to develop, Silverman questions the principle of the self-same body:

> The cinema I am imagining would, first, challenge the very principle of an integral self, both because that principle is tantamount to an inexorable insistence upon sameness, and because of its hostile or colonising relation to the realm of the Other. Confronted with difference, the ostensibly coherent bodily ego will either reject it as an unacceptable "mirror", or reconstitute it in digestible terms. The cinema I am elaborating here would dismantle the illusory unity of the body schema, and situate the visual imago insistently outside, where it can be renegotiated.[54]

Without the principle of the self-same body at the heart of identificatory processes, the Other can be accepted as an Other; only then can identification work to acknowledge the loved object's separateness.[55] Instead of attempting to make the Other into the same, the loving ego would recognize the Other in its difference, and instead of fiercely separating between the self and the Other (and subsequently repudiating the Other), the loving ego would acknowledge the Other within its own self. Silverman describes this ego as a seeing subject: "Instead of assimilating what is desirable about the other to the self, and exteriorizing what is despised in the self as the other, the subject whose look I am here describing struggles to see the otherness of the desired self, and the familiarity of the despised other."[56] Therefore, there are two ways of looking that are expressive of a genuine relationship. One is to look appreciatively at an Other, simply to receive with one's eyes the Other in her or his uniqueness and difference instead of incorporating her or him as part of one's own self. The other way of looking, the creative look, would, like a vision, conjure something new into existence that has not been seen before, instead of simply reproducing as Other what is an unacceptable part of the self.

The tango as a dance is shown in *The Tango Lesson* to stand metaphorically for ways of relating between two people. Although not intrinsically about looking, I shall afford it consideration because it gives a particular shape to a relationship. *The Tango Lesson* indicates at several points the close connection between the tango and relationships. Formally, the film is structured as 12 lessons, indicated through titles. The first four titles are followed either by a tango lesson or tango dance (units 5, 9, 11, and 21) so that the word "lesson" in the titles seems to mean "tango lesson." After that, however, the

titles, although still announcing lessons, are followed by scenes that describe aspects in the relationship between Sally and Pablo, with the result that viewers may wonder whether the titles announce tango lessons or "life" lessons on what it means to be in a relationship—or whether in fact a tango lesson equals a lesson on relationship.

Not only is the tango like a relationship but, conversely, Sally and Pablo's relationship is also like a tango. Unit 25 shows their good-bye at the airport before Sally leaves for Hollywood. Pablo says good-bye to Sally by dancing across two travelators; Sally arranges her body in a dance pose in response. The tango in *The Tango Lesson* does not feature as a dance scene but as a way of life. Sally and Pablo do not dance only in dance cafés but also dance their way through everyday life. Instead of walking along the Seine in Paris, for example, they dance along it (unit 23). When they arrive together in Buenos Aires, they dance on the street while rain pours down on them (unit 45).[57] Indicative of the tango as a way of life is also the fact that the tango music in *The Tango Lesson,* while starting as dance music in one unit, often runs on for a number of units (units 12–13, 16–17, 21–22, 33–34, 45–46, and 50–51). It thereby connects, like an undercurrent, different times and places and provides the "tango atmosphere" that lies at the heart of Sally's and Pablo's lives.

For Pablo, the tango is neither a pastime nor simply his profession, but something that constitutes his identity. In the fifth lesson (unit 24), a conversation with Sally in a café, Pablo describes himself as a dancer and a Jew. Dancing accounts for one of two aspects that are essential to his personality; it is as important as his religious conviction. Pablo lives his life—and therefore enters every relationship—as a dancer. Suggestive of a connection between Sally's feeling Jewish and Pablo's Jewishness with the tango is also unit 43, where they mime a picture of the biblical theme of Jacob's fight with God or an angel at the ford of the Jabbok river (Gen. 32:23–33). Sally and Pablo's rendition of the fight appears like a tango hold. Thus, unit 43 shows once more that the tango functions as a metaphor for an encounter between two people.[58] The tango in *The Tango Lesson* is an artistic form that allows the dancers to express their relationship in the dimensions of space and time; through the steps that order space and through the rhythm that orders time, Sally and Pablo dance their relationship.

Potter's lyrics to the song that she sings to Pablo while they dance in the film's last scene sum up the essence of the relationship expressed through the tango (unit 57). The lyrics "one is one and one are two" emphasize the simultaneous unity and separation at the heart of a relationship as well as the tango. Similarly, the tango

in *The Tango Lesson* symbolizes a relationship that is characterized by unity as well as separation. This is made most apparent by the dancers' movements that alter between parallelism and symmetry on the one hand and countermovement on the other. Sometimes, Sally and Pablo move as one by taking parallel steps, as, for example, at the end of unit 21, when they dance across the room in a straight line. At other times, they form a symmetrical figure with their bodies, as, for example, in the dance café in unit 22. Here, their bodies build together an axis from which they extend one leg to either side. In both instances, parallel movement and symmetrical positions, Sally and Pablo make equal contributions toward the unity of the dance.[59] The relationship described by the tango is thus, with regard to the visual unity sometimes achieved in it, one of equality.

The moments of parallel movement and symmetrical poses are balanced by moments of countermovement, when the dance assumes the character of a dispute rather than a harmony. At times, Sally and Pablo do not face each other or move in one direction but rather appear to attempt to move around each other. In unit 22, for example, Sally and Pablo cross the empty dance floor of a café in a straight line. Pablo is attempting to move forward while Sally faces in the opposite direction. Sally thus appears like an obstacle in Pablo's way and Pablo moves to the left and right side of her body alternately, as if to get past her. Since Pablo never actually passes Sally, this movement characterizes the tango as a fight without a resolution. In this fight, neither of the partners is supposed to prevail over the other at any stage. In fact, this fight is not about the power of one over the other but about an encounter that finds expression in the friction between the dancers.

If the tango is seen in this way, there emerges another parallel between it and the biblical theme of Jacob's fight. Like the tango, the fight between Jacob and the stranger remains unresolved; the two characters part after the fight, or encounter, without one having gained power over the other.[60]

Sally and Pablo can be forceful at times in their dancing. Although Pablo is leading and Sally following, they both use force. Pablo's use of force when leading is countered by Sally's kicks between his legs.[61] Her aggression is taken seriously, as unit 16 shows, where her dance teachers, Gustavo and Fabian, remind her not to kick too forcefully, lest she should hurt them. The tango between Sally and Pablo is thus about striking a balance between two different but equally forceful dancers. The act of balancing is rendered visible in a dance gesture in unit 33, where Sally and Pablo lean toward each other and move back and forth the knot of their hands on which they both lean toward

each other. The tango is an attempt of two dancers to be balanced while representing antithetical forces. The dancers are usually a man and a woman,[62] they strike a balance between leading and following and the dance only exists if the dancers, although assuming different roles, both contribute equally toward it.

The relationship embodied in the tango is opposed to the either-you-or-me logic according to which one partner prevails over the other, either by making the other part of the self or by rejecting the other completely. The tango, by contrast, can work only according to a you-and-me logic, where both partners continue to exist as separate yet one in the dance.

With regard to the movements of the couple, it is important to note that although separate, the dancers at times "overlap." A movement characteristic of the tango is the kick between the legs of the partner.[63] This signifies that neither of the partners has a space that is designated their own, but rather that each dancer's space is partly invaded by the other. In this sense, the tango danced in *The Tango Lesson* is expressive of Silverman's ideas on identification within a relationship. The dancers remain separate but recognize within the other parts that belong to themselves and acknowledge within their selves parts that are Other.

In line with the you-and-me logic, the tango in *The Tango Lesson* is characterized as a conjoining of antithetical forces. As a dance, the basis of the tango is movement, but the tango also includes moments of meditative stillness. Every now and then, the movement gives way to a pose in which the dancers rest. When Pablo and Sally prepare to dance professionally, Pablo leads Sally into a jump that he describes to Sally as a moment where she should stay in the air as if everything stopped (unit 36). Also, the tango danced by Pablo and Sally alternates between closeness and distance. Again, Sally's jump expresses these opposites most clearly, since it is the moment where she is most distant from Pablo, yet bound to return to him.

When Sally and Pablo dance, the film is often characterized by stark contrasts between darkness and light. Apart from the dance lessons, the tango is mostly danced at night, and contrasts between the dark night and artificial lighting become more pronounced than during daytime. This is most apparent in unit 23, when Sally and Pablo dance in dark clothes at nighttime along the Seine. The darkness of the scene is contrasted by bright lights coming from a ship passing in the background.

All the opposites through which the tango is characterized make it symbolic of a relationship between antithetical forces that must exist alongside each other because they render one another meaningful.[64]

Only because of the darkness can we perceive the light, only because of their distance can the dancers be close, only because there is stillness do we know what movement is, and only because there are two can there be one.

Although the tango describes how a relationship can work, it does not do so in terms of looking. On the contrary, the dancers in *The Tango Lesson* often do not look at each other. The leading partner indicates the direction of the dance through his body, and, when Sally follows, she often does so with closed eyes (esp. unit 17). Also, when Sally and Pablo dance at the beginning of their relationship, their dance is not seen by others. In unit 22, they dance in an empty café on a completely empty dance floor, and afterwards they dance alone along the Seine (unit 23).

THE PROFESSIONAL TANGO

The tango danced by Sally and Pablo in lonely places leaves unfulfilled a need basic to human subjectivity—the need to be seen. The mirror stage, at which a person recognizes for the first time her or his reflection in the mirror, constitutes human subjectivity by providing a symbolic representation of the human being within the visible world, just as the first person pronoun symbolizes the person within the realm of language. Visual acknowledgment is thus essential for human subjectivity,[65] and Silverman speaks of "the necessity for every subject to be seen in order to 'be.'"[66]

Pablo has a very strong wish to be seen. In contrast to the models in *Rage,* for whom being seen means not to be, Pablo is dependent on the looks of others in order to be what he is—a professional performer of the tango. Both his profession as a tango performer and his wish to be in a film (unit 23) testify to his desire to be seen. Sally, too, dreams of being seen; she tells Pablo that she always wanted to be a dancer (unit 23). Shortly after this conversation, Sally and Pablo strike a deal, whereby they dance together in a professional tango performance and, afterward, Sally will put Pablo in a film. *The Tango Lesson* is thus as much about what it means to see and to be seen as it is about the tango. Pablo's wish to be seen has narcissistic reverberations, however, and is not so much focused on a relationship with the Other who sees him. In fact, Sally and Pablo end their personal relationship just as they begin practicing for their professional tango performance.

The professional tango performance, in contrast to Sally and Pablo's lonely tango earlier, is not any more about a relationship between

them but about Pablo's relation to the audience, a relation with narcissistic connotations as far as Pablo is concerned. Symbolic of Pablo's narcissistic wish to be seen as well as to admire himself are mirrors that appear on several occasions in connection with Pablo and the tango. Just before Pablo asks Sally to dance professionally with him, for example, Pablo performs a dance solo for Sally (unit 28). While looking at Sally during the solo, he ends it in front of a huge mirror, smiling with fascination at his reflection in it. Even before Pablo asks Sally to dance with him, we know that the performance will be a vehicle for Pablo's narcissistic search for his own mirror image. Later on, when Sally, Pablo, and two other dancers prepare for the film on the tango, Pablo pushes aside the two other dancers, pirouettes in front of a huge mirror, and blows himself a kiss (unit 47). The film, as Pablo sees it, is for him another possibility to be seen and admired and to admire narcissistically his mirror image.

Pablo's relationship to the audience when he performs works in ways similar to his relationship with his mirror image. In Pablo's performances, the audience is never profiled as a counterpart to which Pablo would relate on an equal basis. In unit 2, the audience is a faceless crowd of heads seen from behind. Pablo, by contrast, is given the chance to present a relatively detailed image of himself as a dancer. The camera moves closer twice during Pablo's performance to allow him to present himself with his particular face and appearance, while the audience remains an unspecified mass of people. When Sally and Pablo perform together, the camera observes them from a position at the back of the stage, thus facing the crowd of people (unit 37). But because of the backlighting, the crowd still seems a faceless and diffuse parameter.

What fascinates Pablo about the professional tango performance may be that it allows for a "relationship" between himself and another, which is not an Other, another, which is not specified as different from the self but remains unspecified. The function of the audience is not to be a counterpart for Pablo to relate to properly but simply to catch his image as the mirror does, and to reflect, like the mirror, his admiration of himself. Even after the performances, when Pablo meets members of the audience, they do not relate but only admire (units 3 and 38). Thus, Pablo can be sure of the beauty of his image through their faces that are full of adulation.

Pablo stages his appearance as if posing in front of a mirror; he decides how he wishes to be seen and, as choreographer, creates his own image. The audience has a fixed place during the performance; unlike a film camera, it cannot move around and view from different

angles but is assigned one perspective. Pablo designs his image to be seen from the viewpoint of the audience. When Sally and Pablo practice for the performance, Pablo steps aside once and, pointing to where they were dancing a moment ago, explains to Sally what a particular dance figure should look like from the point of view of the audience (unit 36). As the audience is designated one viewpoint only, Pablo can control how he wants to be seen, what he wishes to show, and hide what does not benefit his image. As Sally states in a conversation after Pablo's first performance, Pablo "gives, but not too much" and "uses his presence" (unit 3). Both formulations are expressive of Pablo's controlling influence on how he is seen.

Because the audience is situated in a fixed place at a fixed distance all the time, it cannot be a counterpart for a proper relation. The audience's look holds no surprises for Pablo; he integrates it into his choreography as the preconceived gaze that will simply receive his self-presentation.[67] The audience is not free to be a real Other to Pablo and, consequently, there is no relationship between equal partners.

The absence of a relationship is also indicated by the fact that Pablo, while wanting to be seen, does not return the look. Because the spotlight is directed onto him from behind the audience, Pablo can only perceive the bright light when looking at the audience; he cannot see individual people (unit 37). Sally notices Pablo's unwillingness to return a look. In a telephone conversation after the performance, she points out Pablo's inability to use his eyes and accuses him of having an interest only in being looked at, not in looking (unit 40).

Not only is there no real relationship between Pablo and the audience but the relationship between Sally and Pablo as dancers, too, is no longer the relationship between equals that it was when they danced unseen by an audience. Now their relationship seems under strain. Because the camera observes their performance from quite close—not at all from the fixed viewpoint Pablo has assigned to the audience—we do not see a perfect image of Pablo. Instead, we notice the stress between Sally and Pablo, indicated through the nervous clicking of heels and interlacing of legs that make us fear they will trip over each other. Earlier, when they danced on the empty dance floor and by the Seine, they took turns in circling each other. Now, Pablo is in the center and Sally circles him with hasty steps, finding it difficult to keep up with the speed.

While Pablo imagines having a relationship with the audience, his relationship with Sally is in danger not only from the physical strain but also from the spotlight that, as backlighting in relation to the camera, threatens to swallow Sally and Pablo. When Pablo and Sally

come on stage, they fade away completely into a screen all white from the spotlight, and, later during the performance, their bodies appear like silhouettes threatened to be eaten up by the spotlight.

Their relationship as well as their dance is under threat because Sally feels she does not exist in the performance as a partner. After the performance, she accuses Pablo: "You danced as if I wasn't there. Like a soloist" (unit 38). Sally's perception strengthens once more the impression that this tango performance is a means for Pablo to stage himself in an idealized way with the help of Sally and the audience. Pablo is at the center of this tango; he leads; Sally, the spotlight, and the gaze of the audience follow.

THE FILM ABOUT THE TANGO

Karlheinz Oplustil notes that the film about the tango that the fictional Sally makes is mingled with *The Tango Lesson* as a whole.[68] In fact, there are no scenes that could be singled out as a film about the tango within *The Tango Lesson*. *The Tango Lesson* in its entirety is the film about the tango. For this reason, the following discussion concerns *The Tango Lesson* as a whole. Later in this section, I shall comment on Potter's technique of connecting the film about the tango with *The Tango Lesson* itself.

When Sally and Pablo begin to make the film about the tango, Pablo assumes the film will be similar to his professional tango performances, only with a film camera instead of an audience. Mirrors symbolize Pablo's narcissistic desire for self-admiration that lies behind the wish to be in a film. Shortly after Sally and Pablo have communicated to each other their long-nourished wishes—hers to be a dancer and his to be in films—we see Pablo reading actor Marlon Brando's autobiography, every now and then lifting the book to look at himself in a mirror (unit 26). Pablo associates stardom with filmmaking and conceives of the screen as a surface that will reflect his new image as a star.[69] Later on, when Sally and Pablo meet with Gustavo and Fabian, two other dancers, to discuss the film about the tango, Pablo performs in front of a mirror and blows a kiss at his reflection (unit 47). Fabian picks up the sense of self-admiration and asks jokingly whether Pablo will be the star in the film.

Pablo's return to his home, Buenos Aires, where the film is going to be made, gives rise to a wave of admiration, reminiscent of the admiration Pablo received for his performances on stage. When Sally and Pablo enter a dance hall, Pablo is surrounded by people and instantly announced as a special guest (unit 46). To return to Buenos

Aires to make a film means for Pablo to return to earlier fame. The fact that Pablo is first under the impression that he will be doing "dance numbers" also implies that he thinks of the film as a continuation of his stage practice (unit 48). Pablo has to learn, however, that to make a film is very different from his stage performances. Filmmaking, like performing on stage, involves being seen. But it does not only mean to be seen appreciatively by director Sally but also to be vulnerable to her look and the audience's look.

The making of the film about the tango begins with Sally's appreciative look at Pablo. When Sally announces her wish to abandon *Rage* in favor of a more personal project, a film about the tango, Pablo begins an improvised solo dance through his flat, using as instruments of rhythm whatever he finds in the kitchen—lettuce leaves, a sieve, a knife, and aluminum foil (unit 28). Sally watches Pablo with amazement, and the more she is fascinated the more inventive he becomes. As Pablo begins to dance, we hear the same synthesizer music that has earlier accompanied Sally while working on her script *Rage*. The music characterizes Pablo's dance as the first inspiration for Sally's next script, the film about the tango. Thus, the film about the tango begins not with an idea of a storyline but with Sally's fascinated and appreciative look at Pablo, a look that receives Pablo in his uniqueness as a dancer and a human being. The more Sally looks at Pablo, the more original his dance becomes; Sally's look provides the visual acknowledgment that helps constitute Pablo as a subject.

Unit 47, where Sally, Pablo, and the two other dancers discuss the film, underlines again the importance of Sally's appreciative look. While Sally watches, the three men revel in trying out different tango moves in front of a huge mirror; as soon as Sally looks away, their dance ends with a crash into the mirror. Sally's look, which simply appreciates as Other the people she is watching, is crucial for the dancers' inventiveness and uniqueness as dancers to develop. Contrary to the voyeurs' look in *Rage*, Sally's interest is to encourage the dancers' activity, rather than to render them passive objects of her look.

Sally's look in these units, with its objective of bringing out the originality in people, is mirrored on the level of *The Tango Lesson* as a whole in Potter's design of the characters. Because of Potter's decision to make *The Tango Lesson* with "real" people, who act themselves in the film rather than play completely invented roles, the three male characters, especially Pablo, remain Other to Sally's imagination. Pablo finds it very difficult simply to follow Sally's directions. Although Sally, as a director, would like him to follow, Pablo refuses to fit easily into Sally's story line and instead remains stubbornly

Other to what Sally would want him to be. Sally, the director within *The Tango Lesson,* who is Potter's alter ego in the film, cannot simply make the male characters into embodiments of her own wishes. Instead she can only appreciate them as people who are different from her and cannot be incorporated into her imagination. Contrary to the fetishist's look in *Rage,* Sally's look does not reproduce at a distance from herself wishes that are within her.[70]

If Sally has to learn to look in a way that appreciates Pablo's otherness, that tries not to assimilate Pablo's otherness to her self, as Silverman would say, Pablo needs to accept as part of his screen image aspects that seem Other to his self and that he might choose not to represent, could he design his screen image as his ideal image. When working on the film, Pablo realizes that he will not be able to control his screen image in the way he controlled his image during his performances. Pablo asks how many dance numbers he will be doing, but Sally tells him that he will be part of a story that she writes (unit 48). Pablo has to learn that his screen image will not so much represent how he would like to be seen but how Sally sees him.

Pablo alludes to the incongruity of screen image and mirror image in a conversation with Sally (unit 55). Sally and Pablo stand next to each other, facing a mirror. When Pablo asks her what she sees while looking at him in the mirror, Sally replies, "I see you on the screen." Pablo counters, "Then you are not here with me. You have become a camera." To be seen by Sally on the screen and not in the mirror implies a greater distance between Sally and Pablo and the interference of a third agent, a camera. While Pablo's mirror image showed him exactly in the way he was posing, exactly as he wanted to be seen, the screen image is not as easily controlled and, instead, introduces the notion of vulnerability to the look of the camera, whose viewpoint is independent and forever changing.

The screen image might render visible what Pablo had hidden when posing in front of the mirror or the audience, parts of himself that he is estranged from.[71] Sally wishes to show Pablo's emotions as part of his screen image, for example. Pablo should cry in one scene of the film. Pablo tries to control his screen image by stating that he has no wish to cry on screen (unit 48). Sally reacts with anger because Pablo has not yet understood that filmmaking is not about controlling how one would like to be seen but about entrusting another person with the look and about trusting that the other sees one in a benevolent way, even though she might see things that Pablo did not originally intend to show.

Not only Pablo but Sally, too, is vulnerable to the look of the camera. In contrast to *Rage*, where Sally was the director behind the camera, she is now acting in front of the camera together with Pablo. Contrary to *Rage*, Sally is represented in *The Tango Lesson* not as an incomplete man but as a woman. With regard to *The Tango Lesson* as a whole, Potter is still directing but has given away her direct look through the camera to her cameraman in order to be seen like Pablo.[72] Both Pablo and Sally are vulnerable as people in front of the camera in that they act themselves rather than act a role behind which they could hide. Thus, they expose themselves to the possibility of being seen in ways unfamiliar to themselves. As Silverman might say, through the look of the camera, they can come to see the otherness in themselves.[73]

The look of the camera upon Sally and Pablo is even more unpredictable because film as an art is based on a discrepancy in time and space between the making of the film and its viewing. In his dance performances, Pablo reckons not only with the controllability but also with the immediacy of the audience's look. The audience is present during the performance as a counterpart for Pablo to relate to, and it has the possibility to react immediately after the performance. People from the audience always come to meet Pablo face-to-face after the performances (units 3 and 38).

This direct contact with and acknowledgment from an audience is not possible with filmmaking. To make a film is to work without the immediate look of the audience. When working on *Rage*, Sally sits down on one of several empty chairs, looking at a staircase she has chosen for a setting (unit 4). The empty chairs signify the absence of an audience's look during the process of making a film. Likewise, when Sally, Pablo, Gustavo, and Fabian begin with filmmaking, there is no audience present. It takes time and Sally's directorial effort to convince her three partners to dance their way into a completely empty hall in which dust floats through the air as if the room had been left untouched for a long time (unit 53). In this emptiness, the four dancers have to perform without an acknowledging look, without a counterpart to relate to. When Pablo hears that they are working even without the acknowledgment of a producer, simply living off the hope that in the future the film might find its audience, he is seriously worried (unit 54). The audience's look is thus implied in the film performance as its justification but it is not as predictable as the audience's look during a performance, as it is neither fixed to one particular viewpoint nor to a specific time.

The film can be projected in different times and places and the audience can look at Sally and Pablo without even requiring their presence. In a particular viewing situation, removed from the original time and location of the making of the film, the audience might see something that they were not intended to see. Therefore, the audience's look is not merely a surface, like a mirror, to reflect Pablo or Sally's ideal image but is a challenge to this image, as it might uncover parts of their personalities that are unfamiliar to them. To make a film is to agree to this challenging look.

Before Sally and Pablo begin to make the film, Potter indicates this characteristic of filmmaking when she shows Sally and Pablo embodying Jacob's fight as a tango pose (unit 43). Inspired by a painting of Jacob's fight in a church, Sally leaves a message on Pablo's answering machine, retelling the story in her own words. Jacob, she says, fought with a stranger whom he could not defeat because the stranger was an angel or God. Or, she ends, Jacob might have been fighting with himself. While holding open the possibility that the stranger might have been God or an angel, Sally seems attracted to interpreting Jacob's fight against the stranger as a fight against the Other within his own self. The stranger would stand metaphorically for parts of Jacob's self that he had not acknowledged previously.

The scene where Sally and Pablo pose in front of the painting of Jacob and the stranger occurs as a turning point between the end of Pablo and Sally's tango performance and the beginning of the filmmaking. Potter thus postulates that the making of the film will bring Sally and Pablo to encounter the Other within their own selves and in each other, not as one's own mirrored reflection but as different.

Sally and Pablo's pose of Jacob and the stranger is also expressive of Silverman's concept of identification.[74] Through the pose, Sally and Pablo are shown to be strangers to each other. The pose can be interpreted in two ways. On the one hand, it can be seen as showing one person, with the second person representing an inner aspect of the first person. On the other hand, it can be considered to show a relationship between two people. If the emphasis is on the two people as elements of one pose, each comes to represent unfamiliar parts of the partner's self or, to use Silverman's phrase, to represent "the otherness of the desired self." If the emphasis is on how the partners in the pose relate to each other as two different people, the pose is an image of how to be in direct, physical touch with a partner who is different from the self rather than to feel completely separated from the partner or even repudiating him or her. As Silverman suggested, the

self in this pose would not feel separated from the stranger but would instead recognize her or his physical closeness and familiarity.

The closure of Sally and Pablo's posing in front of the painting of Jacob resembles in some aspects the ending to the narrative in the book of Genesis, on which the painting and the pose are based. The book of Genesis records a fight between two parties. No partner is able to defeat the other and they end the fight with a blessing when realizing that they are equally strong. In fact, in essence the experience is an encounter rather than a fight. Jacob summarizes the event by saying that he saw God face-to-face and survived (Gen. 32:31). Sally and Pablo, after facing each other as strangers in the tango pose, are shown blessing one another by trickling water over each other's faces (unit 44). Their pose, coming as it does at the beginning of their filmmaking, means to express that the filmmaking will be about recognizing as other parts of themselves, and recognizing each other as different yet familiar. If they can sustain the tension of the tango pose in their relationship, Sally and Pablo can be a blessing for each other.[75]

The trickling of water over each other's faces brings to mind the rite of baptism and thus classifies the relationship expressed in the tango pose and, with it, the process of making the film as something that gives new life.[76] This point is underlined by what happens in the next few shots. Sally and Pablo are standing by the water. Sally lowers her head until her face comes to lie on the surface of the water (unit 46). Then a cut to a scene in the water—we are allowed to participate in what Sally "sees" in it. It is Pablo, shot in color, first floating in the position of an embryo, then expanding to his full size. What we hear is, first, the synthesizer sounds that have always accompanied Sally's work on her earlier script, then the sound of a heartbeat, amplified through the water. Because this shot is in color, like the earlier script *Rage*, and because of the reappearance of the music that has accompanied the work on *Rage*, we know that Sally sees in the water not the "real" Pablo but Pablo as a script, Pablo in her director's imagination. The water, the embryonic position, and the heartbeat are reminiscent of a womb and signify birth. Sally's directorial look at Pablo is thus revealed as life giving. It is life giving especially in its capacity to see beyond the black and white Pablo to Pablo in a different light, in unrealistic red and blue tones. Sally's look is life giving because Sally does not mirror Pablo's black and white image but sees him in a way in which he does not present himself. Sally's look as a director is creative in the sense that she sees aspects in Pablo that were unseen before and, through her work, helps them

into existence. Her life-giving look is the opposite of the fetishist's and the voyeurs' destructive looks in *Rage*.

Earlier in the film, Pablo was concerned that they should separate their love relationship from their work. Before they begin to work on the professional tango performance, Pablo suggests they sublimate their attraction into their work, meaning to say that they end what he considers to be their relationship (unit 32). Through the making of the film, Sally does, in a way, sublimate her love for Pablo into her work, not as a means to end but in order to continue their relationship. For her, there is no separation between work and private life. In the conversation with Pablo in front of the mirror (unit 55), Sally counters Pablo's accusation that she has become a camera with, "But that is how I love you, Pablo. With my eyes. With my work." To work for her means to see and to see means to create by helping into being something that was previously unseen. To see Pablo creatively means to love.[77]

Through her love/work, Sally gives Pablo a visible gestalt that is more lasting than that of his tango performances. In the film's last scene, Pablo speaks to Sally about his fear of not belonging anywhere and disappearing without leaving a trace (unit 57). Sally uses the opportunity to answer an earlier question and, at the same time, to react to Pablo's present fear by suggesting that Pablo's fear of remaining unseen was the reason why they met.

By making a film with Pablo, Sally has created him as a work of art with lasting visibility. Through the tools of filmmaking, Pablo remains visible not only for the short-lived audience of a performance but for a variety of audiences who, by seeing his image on screen, will be aware of his existence. If "to be" is "to be seen," the experience of being in a film will help constitute Pablo's identity in that the camera mediates between him and audiences across various times and places. It overcomes discrepancies of time and space between the making of the film and its viewing and creates a relationship between the audience and the characters and events of the film.

In the remainder of this section I give an analysis of the camera work and narrative technique of *The Tango Lesson*, through which I shall attempt to describe the relation between film viewers and the film. This relationship is different from the relationship of Pablo to his audiences when he performs, and, instead, is more like the relationship between Pablo and Sally in the film. On the one hand, the camera builds up closeness between the viewers behind and Sally and Pablo in front of it; on the other, it insures that Sally and Pablo remain to some extent Other to the viewers.

Pablo's audience during his performances is situated at a fixed distance and does not have the opportunity to relate freely to Pablo. Instead, it functions as a surface to reflect Pablo's self-created image. By comparison, the camera, and, by implication, the viewers, relate more independently and more closely to Sally and Pablo. Unlike the audience in Pablo's performances, the camera can be close or distant. During Pablo's first performance, for example, the camera remains fairly distant; it is static and simply shows Pablo from the front as he performs for the audience and the camera (unit 2). The camera assumes the same frontal position when Pablo performs his dance with kitchen utensils for Sally (unit 28).

But the camera can also be involved in the dance by being close and moving with the dancers. In one of Sally's lessons with Gustavo and Fabian, for example, the camera pays particular attention to Sally's kicks between her partners' legs (unit 16). Rather than observing from a distance, the camera work gives the viewers a feeling of involvement by showing the legs only and by moving swiftly in order to keep them in focus. When Sally and Pablo dance in a Parisian café, a sense of participation in the dance is created for viewers through the way in which the scene is cut (unit 22). Toward the end, when the tango music and the dancers' movements reach a climax before the dance comes to an end in a finishing pose, the cuts of the film material occur in unison with the pronounced rhythm of the music, so as to transmit the atmosphere of the dance by reinforcing its rhythm visually.[78]

The camera is most involved in the dance, however, when mingling with the dancers on the dance floor. When Sally is dancing for the first time in a café in Buenos Aires with her teachers, Gustavo and Fabian, for example, the camera glides across the dance floor with the dancers (unit 17). The sense of movement intrinsic in the dance is transmitted to the viewers via the constantly changing background of the picture, as the camera tracks across the room. Thus, the tango is not something happening between two people to be observed from a distance but, rather, an atmosphere that transcends the couple to involve much more than two people. The tango that the camera allows the viewers to participate in includes all the people on the dance floor, the pillars, the lights that move across the picture from time to time, and the walls of the room that provide the moving background. All of this together creates a dancing picture that leaves viewers with a sense of dizziness. The camera behaves like a partner in the dance rather than a distant observer.[79]

While relating the viewers directly to the tango, this scene also shows the camera's freedom of relating as an equal partner, of seeing

what it wants to see and not only what it is presented with. Toward the end of the scene, Sally and a partner turn very swiftly in their dance. Observing from a fixed viewpoint in the distance, as Pablo's audience during a performance would, viewers would register the movement of the couple against the motionlessness of the surroundings. But the camera in its independence turns this impression upside down completely. Instead of observing from a fixed viewpoint, it decides to turn with the couple, remaining locked on to their faces continually. What was originally moving—the turning couple—thus becomes the center of stillness within the picture and what would have been still—the surroundings of the dance hall—is moving like a carousel. The camera, in contrast to the audience of a performance, has the freedom to be an equal partner in the dance and follow, like a dance partner, the impulses of the dancer who leads. Its look is as active and involved as the dance itself.

Because the camera acts like a partner, rather than a distant observer, it also transmits the tension between Sally and Pablo and presents their relationship in a demystified way. When Sally and Pablo practice for the professional tango performance, the camera tries as hard as Sally to follow Pablo's impulses (units 33 and 36). Most of the time, the camera does not give a view of Sally and Pablo together but is fixated on Sally's upper body from up close. When Sally tries to react instantly to Pablo's leading, the camera follows her body. Through the sudden change from a picture of concentrated stillness to a picture with a quickly moving, unfocused background, viewers sense the jerkiness of Pablo's leading movements.

During the performance as well as just before and immediately after it, the camera exercises once more its freedom of relating to Sally and Pablo by seeing what it wishes to see, rather than what Pablo as choreographer presents to the audience (unit 37). Through the camera's way of looking, viewers are left not with admiration but with a sense of nervousness about the performance. Just before the performance begins, the camera follows Sally and Pablo through the corridors behind the stage. Pablo walks ahead; Sally runs behind him to catch up and behind Sally comes the camera, registering the hectic atmosphere. After the performance, the camera picks up Pablo's anger by facing him as he runs again through the corridors backstage. He has already pushed a musician out of his way, and the camera moves quickly backward in order not to be treated in the same way.

Anger and a sense of restlessness are apparent not only backstage but also during the performance in a very pronounced way. While Pablo has choreographed the performance to be seen from the point

of view of the audience, the camera chooses a perspective directly opposing the intended viewpoint. Crouching at the back of the stage, it looks toward Pablo and Sally and the audience behind them and is able to register stresses that are hidden from the audience. Because of its position, the camera is always close to the couple and, in order to show their dance, needs to move fast. Cuts in quick succession are necessary in order to follow the dancers across the stage. Adding to the sense of agitation made visible through the speed of the cuts and the movement is the fact that Sally and Pablo, seen from the camera's position, are always fighting against the backlighting of the spotlight.

One single shot toward the end of the performance is contrasted with all the other shots in this unit. As if to show viewers what it has decided not to show them, the camera takes, for a split second, the viewpoint of the audience while Pablo leads Sally into a jump. The distance of the camera contrasts with its earlier closeness to the couple; the slow motion used here contrasts the earlier sense of restlessness and the well-balanced lighting of this shot is set against the earlier threat from the backlighting. All of this makes the audience perceive the harmony and beauty of the performance and the film viewer aware of what the camera has decided not to show.

The camera's independence of perspective becomes obvious also when Pablo's second performance (unit 37) is compared to his first (unit 2). The first time, the camera allowed Pablo to present himself through its frontal position; at that time it took the viewpoint that Pablo assigned to his audience. But the second time, the camera chooses its own viewpoint and thus signals that it can relate to Pablo much more as an equal than his audience can.

The camera thus, according to my arguments so far, brings the viewer of the film in much closer contact with Sally and Pablo than the setup of a tango performance does, in line with Silverman's claim that the Other in front of the viewers' eyes should not be perceived as totally separate but, rather, as familiar. The techniques through which the camera achieves this effect are the reduction of physical distance between it and the characters in front of it and the exercising of an independent viewpoint in order to relate as an equal to the characters, to be a partner rather than an observer. The portrayal of tensions between Sally and Pablo, too, works to effect closeness between viewers and characters, as the tensions are only noticeable from a short distance.

The tensions prevent viewers from considering Sally and Pablo as their desired mirror reflection. Indeed, at the same time as enabling

familiarity between the viewers and the characters, the camera work as well as the narrative structure of the film prevent viewers from identifying with the characters completely by excluding the viewers from full visual and narrative access to them. The film thus illustrates the second aspect of Silverman's ideal of identification by insisting on the characters' otherness to the viewers.

White screens, which were already part of *Rage,* remain a stylistic element throughout *The Tango Lesson.* During Sally and Pablo's professional tango performance, white light often occupies a large part of the picture and threatens the visual existence of the characters (unit 37). Before they even begin to dance, they disappear for a moment completely into a white screen.

The last scene of the film shows how Sally and Pablo have finally found each other (unit 57). Although their relationship is not under threat any more, as it was when they danced on stage—on the contrary, at last they kiss—the white screen still remains. Sally and Pablo's embrace is broken up for the viewers as it dissolves into a white screen several times only to reappear in a slightly different shape. Almost at the same time as making manifest a happy ending in a kiss, the film withdraws its characters from view and, to some extent, visually excludes the viewers from full identification with the couple.

On the level of the narrative, too, the film withdraws from identificatory access the characters it otherwise exposes. *The Tango Lesson* has a documentary feel about it, as the actors, Sally Potter and Pablo Veron, act themselves and make viewers feel as if they were participating in Sally's and Pablo's "real" lives. The sense of authenticity is increased as Potter and Veron act in the film with their real names. To expose the characters in this way was a deliberate decision on Potter's part. In her published screenplay, she explains: "With invented names I felt it would seem that I was trying to hide something. With our own—given how the film would be as tightly written and structured as any fiction—I could work directly with the notion of exposure, vulnerability, seeing and being seen."[80]

But if the narrative framework of *The Tango Lesson* is considered closely, the first impression of realism does not hold. In fact, the story line is rather confusing, as the film attempts the logical impossibility of telling the story of its own making. *The Tango Lesson* relates how Sally abandons a script idea in order to follow a new one—a film about the tango. Viewers watch Sally finding actors and practicing with them (units 47, 48, 52, and 53), but *The Tango Lesson* never actually shows the film that Sally makes. What film did Sally make,

after all, in *The Tango Lesson*? The only explanation is that it is *The Tango Lesson* itself that she made.

The Tango Lesson is thus, despite its documentary feel, a film that is completely unrealistic. As the film returns to its own beginning, it reminds one of the sort of puzzle picture where viewers follow numerous steps, arranged across the whole picture, always going upward, only to realize that they never reach the top but instead perpetually go round in circles, knowing neither the top nor bottom of the steps. Although the whole arrangement of the puzzle picture is completely unrealistic, the sets of steps, taken individually, are still realistic in appearance.

The Tango Lesson works in a similar way in that the individual elements of which it is composed appear to be real. Taken as a whole, however, it loses its realistic plastering to reveal a framework that is, indeed, a piece of tightly written fiction.[81] As a result, full identification of the viewers with Sally and Pablo is rendered impossible. Taken individually, many of the incidents in *The Tango Lesson* offer ample opportunity for viewers to identify with Sally and Pablo because they seem so real. But, taken as a whole, *The Tango Lesson* denies viewers access to Sally and Pablo through its illogical nature. Although real in their emotional makeup, in their narrative conception Sally and Pablo remain stubbornly Other to viewers.[82]

Silverman opts for a model of identification that describes a two-sided process of relation between a subject and its opposite. Rather than rejecting the opposite as totally separate from the self and projecting onto it what the self dislikes about itself, the self would, according to Silverman's proposition, recognize the familiarity and closeness of the Other. On the other hand, the identifying self would not consider the opposite as its mirror reflection, as its self-same body, but would acknowledge it as Other. To see another person in this way would enable a love relationship between the self and the Other.

I have considered *The Tango Lesson* as an attempt to exemplify a love relationship along the lines Silverman has indicated. On the level of its contents, the film portrays the tango as a dance of two partners who are in close physical contact while being different. Sally sums up the nature of the dance in the line of her final song, "one is one and one are two." The professional tango performance shows how the dance is in danger if one of the dancers looks for her or his own mirror reflection in the partner or in the audience instead of wanting the partner to be different or the audience to exercise an independent look. On the level of its form, too, through its camera work and

narrative organization, *The Tango Lesson* establishes a relationship between viewers and film characters that appears to fit Silverman's model of identification. While allowing for close contact between viewers and characters, the film also insures that the viewers do not mistake the characters for their own, self-same mirror image.

Finally, I return to the beginning of this discussion of *The Tango Lesson* as well as to Sally's statement in the café scene (unit 24), and to Pablo's question at the end of the film (units 24 and 57). What does it mean to feel Jewish? Sally and Pablo try a visit to a synagogue (unit 56) but Pablo remarks afterward that he does not feel at home there (unit 57). Sally and Pablo do not seem to belong in the synagogue, as they both sit in the last row. In fact, the scene in the synagogue is reminiscent of Pablo's "relationship" to his audience during his performance. People with a liturgical function act inside a space set apart from the seats occupied by the congregation. Sally and Pablo watch from the distance, like an audience, across many empty rows of seats; they cannot relate to what is happening at the front.

In *The Tango Lesson,* to feel like a Jew has nothing to do with the synagogue. Feeling Jewish has, instead, everything to do with Sally's and Pablo's everyday lives where they relate to each other through dancing, seeing, and being seen.[83] *The Tango Lesson* is a plea for a look that is not consumerist by trying to make the other part of the own self, as the voyeurs have done in *Rage*. It is appreciative of what it sees, letting the other retain her or his difference. At the same time, *The Tango Lesson* seeks to transform the look of the fetishist, who reproduces his own lack at a distance from himself, into Sally's creative look that helps Pablo to see the unfamiliar within him. To relate to each other is to see the Other as different, yet close, and one's self as known yet sometimes unfamiliar.

To relate in this way is to feel Jewish, since it is Jacob's way of relating to the stranger. Sally's feeling Jewish and Pablo's Jewishness show not when they go to the synagogue but when they encounter each other in the way Jacob encounters the stranger. To feel the friction of a dance where no partner prevails over the other, to encounter the other without swallowing or being swallowed is for Pablo and Sally to feel Jewish. It is to maintain the balance between being one in the relationship and remaining two different people. It is to be face-to-face in a relation and still survive as an individual.

LEARNING TO LOVE WITH ONE'S EYES: A THEOLOGICAL VIEW OF *THE TANGO LESSON*

SEEING IS REDEMPTIVE

I developed throughout this book the thought—and the hope—that seeing may have a positive effect on a person. This hope grew out of the realization that seeing has destructive potential if human beings are looked at in objectifying ways. Seeing, as the philosophers discussed at the beginning of this book have suggested, can be objectifying, especially if it is a one-sided process of one person looking at another while remaining an invisible spectator. I have argued that the film *Artemisia* suggests a way out of this objectifying look by showing how the young painter, Artemisia, is both seeing and seen at the same time. As McFague points out, seeing is objectifying if it results in a nonreciprocal relationship. She suggests that a more reciprocal relationship is achieved if people relate using other senses, hearing and touching, for example. In contrast to McFague, I proposed that seeing and being seen can mean being in a reciprocal relationship if people learn to look at each other in nonobjectifying ways.[1]

The Tango Lesson describes a way of looking that is mutual. The looks exchanged between Sally and Pablo create a relationship between the two in which each of them is seen as a subject—not in all parts of the film but in its moments of hope. Seeing means relating, says *The Tango Lesson;* relating means redeeming, say a number of writers of feminist theology.[2] Thus, the tentative hope that seeing

might be positive receives a strong foundation: seeing can be redemptive. But how is seeing redemptive in *The Tango Lesson?*

Seeing, in *The Tango Lesson,* is redemptive because it is creative of a relationship in two ways. Seeing means appreciating another person in their presence, and it means relating in a way that redraws the boundaries between self and Other.[3] In both cases, seeing implies a relationship of mutuality, and the film thus echoes one of the concerns of a feminist theology of redemption.[4] Mutuality is found in Sally's way of making the film with Pablo. The film about the tango does not begin with an idea of a script or the securing of a budget to make it. It begins with Sally's appreciative look at Pablo. In the previous chapter, I described the scene that marks the inspiring moment for the making of the film about the tango. In it, Pablo performs an improvised dance while Sally watches, and it is Sally's attention that brings out his inventiveness as a dancer and helps him develop as a subject. Sally's look is not objectifying; on the contrary, Pablo enjoys being seen. He literally needs to be held in another person's look in order to develop his talent to the fullness of its potential. This relationship of appreciation expressed in the act of seeing is characterized by mutuality, because it requires the presence of the person who looks. In order to feel Sally's appreciation, Pablo needs not only to be seen by Sally, but also to see her in her act of looking. To see her watching him reassures him of her attention and helps him to grow in her eyes.

The need to see Sally watching him is evident not least when they have started shooting. Pablo finds it more difficult to come to terms with Sally's look because, to his mind, she is hiding behind the camera and he cannot see her to the extent to which he saw her before. As a symbolic expression of the inaccessibility of her eyes during this phase, Sally wears sunglasses.

In the initial stages of the filmmaking, in contrast, seeing and being seen imply a mutual relationship because Sally is available to Pablo while she watches. She is bodily present in her act of looking, unlike the Absent One in cinema, the invisible surveyor in the panopticon, or the disembodied eye of an invisible God.[5] The producers of *Rage,* Sally's script for Hollywood, expect her to control her script from outside. They say she should be like God, all-knowing and all-seeing.[6] At the same time, she remains invisible as a director behind dark sunglasses. In contrast to this way of seeing as a director, Sally decides to be present and visible when making the film about the tango.

Sally's look is not powerful, like that of an invisible spectator, but puts her on an equal footing with the person she sees. In her case, looking does not mean dominating the other person, as was the case

in *Artemisia,* but rather being completely receptive to the presence of the other and to the impulses of that person.

Seeing, in Sally's case, means being vulnerable, and this emphasizes most strongly that Sally's look is not domineering. To offer her utmost attention and appreciation in this relationship makes her vulnerable because Pablo takes her eyes for granted, not as her gift of love but as a mirror to catch his self-image.[7] Sally's living, loving eyes are in danger of being mistaken for a dead object, a mirror. In a relationship of mutual seeing, objectification is thus not only a threat to those who are seen, as Sartre, Lacan, Foucault, and Levinas suggest, but also to those who see. Sally's act of making herself vulnerable by seeing attentively shows that she is in a relationship characterized by willingness for mutuality on her part. A characteristic of a mutual relationship is that people can be hurt. The potential hurt contained in Sally's act of seeing shows that seeing is, indeed, a way of relating.

It is, however, not only the character Sally who is visible in her act of looking. To some extent, Potter makes herself visible as a director by acting her own character, a character who pursues Potter's real-life profession under her real name. Through this way of being seen as a director in her film, Potter renders herself vulnerable. She is vulnerable to the audience's look, because the film reveals some of the struggles contained in her attempt to see someone appreciatively, some of the difficulties of her task as a filmmaker. Not least of all, making herself visible as a director means becoming vulnerable to the looks of critics who felt that she put herself in the limelight unnecessarily.[8] But a filmmaker can only become visible to a certain extent. Viewers will never know how truly the "real" Sally Potter is represented by her screen image.[9]

The audience is the party for whom becoming visible in the act of seeing is most difficult, because they sit in a darkened room while watching. For them, to be part of a relation of seeing and being seen is something that cannot be fully achieved. But even though the film cannot make the viewers visible, cannot turn the light on them, *The Tango Lesson* at least makes viewers aware of their vulnerability as viewers. Viewers come with an interest to watch a film; they want to see a plot unfold and want to understand a narrative. They open themselves to the film and hope to have their needs fulfilled by being attentive viewers. But if a film withdraws its characters from view and leaves spectators in the dark about its narrative, it disappoints the viewers' hopes to see.[10] *The Tango Lesson* does not make viewers visible, but it reminds them that seeing, like relating, means being vulnerable.

Buber, in *Ich und Du,* connects seeing with relating, and his description of the impact of the act of seeing on human beings helps us to understand at a deeper level what seeing means in *The Tango Lesson.* Buber's work is enlightening because he argues that, in order to relate, both partners in a relationship must be present to each other with their whole being, and that, as a consequence, relating can harm.

Buber distinguishes two states of mind that the "I" can assume in relation to the world. Both are described with a two-word term, a "Grundwort" as he calls it.[11] The I says, "I-It" when it considers what it relates to as a thing to be compared to other things. The I says "I-Thou" when it is immersed in a relationship to the extent that the Other and the I are exclusively present to each and cannot be reduced to any of their characteristics. Human beings have to speak I-Thou and I-It alternately because it is not possible to live in the I-Thou continually. I-It needs to be spoken in order to live in security, where a home can be built among things that one can describe, recognize, and order. I-Thou has to be spoken from time to time in order to be fully human. Buber summarizes: "Ohne Es kann der Mensch nicht leben. Aber wer mit ihm allein lebt, ist nicht der Mensch."[12]

Both I-Thou and I-It are at the basis of our relation to images and to the visible. The world, for one thing, consists of things that can be seen, that belong to the sphere of I-It. An image is one visible object among others and belongs to I-It also. The act of looking at an image, of *schauen,* however, belongs to I-Thou.[13] Images, even though belonging to I-It, contain the response of an I to the presence of its Thou. The image, once it has become an It, both contains and captivates the Thou. The destiny of the Thou, spellbound in the image, is to be released again in an I-Thou encounter. It is the act of seeing, schauen, that releases the Thou, because seeing is an act of relating in which the Thou in the image can reveal itself to the eyes of an I. Buber explains: "Immer wieder . . . soll das Gegenständliche zu Gegenwart entbrennen, einkehren im Element, daraus es kam, von Menschen gegenwärtig geschaut und gelebt werden."[14] Thus seeing, according to Buber, is not an act of victimization and imprisonment as was the case in the panopticon, but an act of liberation of the Thou. Sally's attentive, appreciative look at Pablo is like the look that Buber describes; it frees Pablo's potential as a dancer.

But not every look is liberating for the person who is seen. I pointed out above that, in *Artemisia,* looks can be restrictive for those who are seen, and many texts in feminist film criticism have made this observation for numerous films. If a look is to be liberating for the person who is seen, the I who sees must be fully present in order to fully

appreciate and accept the other. In this way, seeing and being seen can mean being in a mutual relationship.

Relating is a risk, however, and so is seeing in *The Tango Lesson*. Seeing is not a risk if it is perceived to be the powerful position in a relation of dominance and submission. The surveyor in the panopticon is not at risk of being seen or attacked by the inmates. On the contrary, because they internalize the surveyor, the inmates forget that the surveyor is real and can be confronted. And the place of the voyeur behind the keyhole and the sunglasses, behind the camera and the wired frame, is a place of withdrawal, where the risk of being caught in the act of watching is minimized. For the surveyor and the voyeur, seeing is reveling in the fantasy of the other's total visibility, is using that fantasy for personal enjoyment while not risking to reveal themselves to the other.

If seeing is relating, however, it means taking a risk by revealing oneself. In order to accept fully the presence of the Other, writes Buber, one needs to risk revealing one's own desire to meet. It is like walking one's way toward the Other, who approaches from the distance. With one's will, one must go out to meet this Other.[15] Where Sartre, Lacan, and Foucault were assuming that a person is defined through her or his permanent and total visibility, Buber argues that the revelation of the Other cannot be willed. Another person's visibility is out of reach for the I and, for this reason, Buber speaks only about the attitude of the I, the one who sees. Whether the Other reveals him- or herself is a matter of grace.

Seeing, if it is relating, means taking the risk of vulnerability, making known the desire to behold, making seen the wish to see, not watching from behind the keyhole; but one can never make the Other available, never take the Other as an object. One can only wait for the Other to show her- or himself. If she or he does, it is grace. Relating is always mutual. If the one who sees does not withhold her or his presence by staying behind the camera or the keyhole, then seeing and being seen can be a mutual relationship.

Seeing and being seen is a mutual act when Sally sees Pablo. Sally goes out to Pablo, steps in front of the camera in order to meet him, makes visible her desire to see. But he does not always show himself. Sally has chosen Pablo, but he does not always choose her. Sometimes he reveals himself, shows all he can do with his feet, trusts, and experiments with dance and rhythm while his movements bring joy to her eyes. But sometimes he withdraws. He is the stranger on the stage, the one who is not there when she wants to dance on New Year's eve, the one who does not want a relationship any more, the one who

does not trust her eyes when they make the film. Then Sally cries; her eyes are hurt. No matter how strong the will to see and meet Pablo, Sally's choice of him is not enough; she also has to be chosen, like a dance partner. Her desire to see Pablo is actively pursued, but it is an attitude of passivity at the same time because she has to wait for Pablo to show himself, and she suffers his withdrawal.

The mutuality of Pablo's and Sally's relationship of seeing and being seen is not only shown in Sally's acceptance of Pablo's presence and her willingness to become visible and vulnerable in wanting to see him. The fact that they relate to each other in a mutual way is also emphasized when they imagine one another, one by making a film with the other, and one by seeing the other as a professional tango dancer. In the way in which they imagine each other, Sally and Pablo also draw attention to some of the questions I asked when discussing feminist theology on redemption.[16]

By imagining each other, they are involved in a relationship that is more than a simple point of contact between a self and an Other who leave the relationship as they have entered it. In the relationship between Sally and Pablo, the boundaries between self and Other are redrawn, and imagining each other means creating each other anew and being created.[17]

In Sally and Pablo's relationship, self and Other are never fully separated. When Sally and Pablo imagine each other, they never just imagine themselves or the other person, but they imagine the self and the Other in a relationship. When Sally imagines Pablo as part of her film, it is not Pablo alone who fills her image, but Pablo as he relates to Sally and to other dancers in front of the camera. She creates Pablo by placing him in a context and sees him as shaped by the presence of others. The same applies when Pablo teaches Sally to dance. He does not see Sally as an individual dancer but choreographs her body in relation to his; he sees her not just as a self but as a self in relation. In the dance, each of them is molded to the shape of the other, each sustained by the other's counterbalance.

Sally's and Pablo's acts of imagining each other as part of a relationship show that there is no self that exists in and of itself, only a self that exists in relation to an Other. Therefore, a self is never fixed but will change and be reshaped in every relationship it enters. Every Other in a relationship will have an influence on the self, and the self is created by assuming ever-new roles in relating to an Other.

This flexibility of the self in a relationship is also a theme in the story of Jacob and the angel that appears at a key moment in *The Tango Lesson*. The way the story is integrated in the film emphasizes the

theme of the changeability of the self in relationships. Gen. 32:23–33 recounts a fight between Jacob and a man. In this fight, Jacob's identity is reshaped through a close encounter with an opponent whose identity remains ambiguous.[18] The sense of confusion created by this element is increased when, at times, the text refuses to be clear about who is who in the fight. The two characters appear almost interchangeable in verse 26. In this verse, it is impossible to determine which of the opponents is referred to because the Hebrew text holds the reader off until the very end before identifying Jacob as the one who is hurt ("when-*he*-saw that *he*-could not overpower *him* then-*he*-touched on-the-socket of the hip-of-*him* so-it-was-wrenched the socket-of the hip-of *Jacob*"). Until the end of the verse, both participants in the fight seem vulnerable. Roland Barthes considers this textual technique as an "intertwined style" and explains that "the identity of the participants is oblique; the legibility is indirect."[19]

Barthes also points out how the text sets out to differentiate between a winner and a loser through allowing one participant to deal the other an unusual blow, a secret knowledge that will make him win. But then the text disappoints by not going through with this differentiation. Instead, there is neither winner nor loser, and the participants remain interchangeable even after the end of the fight.[20] Also, the motif of the wrestling itself indicates turmoil and confusion. The participants are intertwined not only through the style of verse 26 but also through the physical closeness and confusion of bodies that the image of wrestling evokes. From this point of view, Potter's choice for the tango is not coincidental. The tango is characterized by kicks between the partner's legs and steps that make the partners invade each other's space. Because the partners cross over the boundaries into the other's space, I have described the tango in the previous chapter as a fight between two dancers. The partners in the tango are just as intertwined as the two parties wrestling with each other in verse 26.

When Sally refers to the story of Jacob and the angel in a telephone message to Pablo, it is this sense of confusion of boundaries between self and Other, between Jacob and the opponent that seems to interest her. She finds it difficult to identify the Other, says he could be a stranger, an angel, God or a part of the self, thereby showing difficulty in locating the Other unambiguously inside or outside of the self.[21] When Sally points out at the end of her voice-over that Jacob is unable to defeat the stranger, she draws attention to the fact that the confusion of the fight is never fully broken. Neither of the two parties prevails. The stranger has to ask Jacob to let him go and Jacob leaves the place of the fight limping.

Moreover, Sally's fascination with the confusion between the characters is expressed throughout the whole film in the characterizations of Sally and Pablo. The fact that Sally and Pablo pose as Jacob and the angel is of great significance for the roles they assume during the film. Potter, with her characterizations of Sally and Pablo, picks up the sense of confusion about the biblical characters, but not only that. She also increases this sense of confusion by suggesting the possibility of role reversal in her film: Pablo is not just the dancer who transforms Sally, like the transforming angel; he is at the same time someone who receives a blessing, like Jacob. And Sally is not only someone who fights for a blessing, like Jacob, she is also someone who gives a blessing, like the angel.[22] Each one is to the other both Jacob and the angel.

Sally's and Pablo's ways of imagining each other, and Potter's way of casting them as Jacob and the angel, bring to light two aspects about the self and the Other in a relationship. First, the film shows that the self and the Other can exist only in relation to each other. I have already noted how Sally and Pablo never imagine the Other as an unrelated self, but always as a self sustained by an Other. To them, the other person does not exist in and of themselves but only in relation. Potter makes this point forcefully when she has Sally and Pablo pose as Jacob and the angel. Sally and Pablo's pose occurs in front of a painting of Jacob's fight with the angel by Eugène Delacroix. The way the painting depicts the fight is reminiscent of a dance pose in which Jacob leans on the angel. The weight of Jacob's body is counterbalanced by the angel, whose body is shaped to receive and hold Jacob's body. By embodying this pose of Jacob and the angel, Sally and Pablo become a self through the relationship with the Other, just as their bodies are sustained through the other's counterweight when they lean toward each other in front of the painting.[23]

The pose of Sally and Pablo speaks of the act of seeing, as it represents the beginning of the making of the film about the tango. While they pose, Sally asks Pablo whether he was ready to be in this film, ready to be seen by her. Seeing and being seen are thus characterized through the pose as a relationship in which two people emerge as individuals while relying on each other. None of them can be a self without the Other, just as none of the partners in the pose could sustain their body if it was not for the other's counterbalance. Thus, to see someone and to be seen is redemptive in the sense in which feminist theology understands redemption. In feminist theology, there is no self or Other that exists prior to and independently of a relationship; it is only through a relationship that the I comes to be.

There is no self without an Other, or, as Buber puts it, "Der Mensch wird am Du zum Ich."[24] Likewise, the act of seeing is grounded in relation. There is no seeing or seen self without another who is seen and who sees. Seeing and being seen is being a self in relation.

The second aspect illuminated by the consideration of *The Tango Lesson* refers to the effect of a relationship on the self and the Other. A relationship is not simply an event that brings together a predefined self and an Other to deal with each other in love and mutuality, justice and peace. Primarily, a relationship is an event in which previous definitions of a self and an Other are undone, and this is why a relationship is redemptive. It is redemptive because elements previously bound by outlines of identities are freed and transformed, redeemed in an explosive moment of encounter that confuses radically the self and the Other who are immersed in it. The redeeming moment of the relationship is a moment of confusion as to who is who, in which identities dissolve in order to emerge newly created and imagined.

The Tango Lesson expresses this element of mingling of self and Other in a relationship through the reference to the story of Jacob and the angel and its confusion of who is who in the fight. I pointed out in the previous chapter that the tango as a dance recalls the confusion of a fight because its figures often make the dancers cross over each other's spatial boundaries on the dance floor into the space of the other. The crossing of boundaries and the mingling of identities, I argued, is not only part of the tango but also part of the experience of filmmaking. The filmmaking is, for Sally and Pablo, a process of recognizing the Other within themselves and of seeing themselves in the Other.[25]

With this description of the relation between Sally and Pablo, *The Tango Lesson* has something to offer feminist theology. I pointed out above that relationships between human beings are described by feminist theology in a way different to relationships between human beings and God.[26] When speaking of relationships between human beings and God, authors acknowledge that the God-Other is an imagined Other. The imaginary nature of the God-Other frees them to question the boundaries between the self and this Other and to see the two parties as reaching into each other, and the God-Other as creative of the human self. In contrast, when writing about human relationships, feminist scholars, perhaps bound by the physicality of the human body, do not acknowledge the human self and the human Other as an imagined self and Other. They speak of ways in which the human self and Other deal with each other, following patterns of love and friendship, but they cannot see that human beings create each other with their imagination just as they might feel created and imagined by their

God-Other. *The Tango Lesson* shows that a relationship between two human beings, more than being an event between two people, affects the self and the Other in a fundamental way. "Sally" and "Pablo" are not completely separate as characters. While being a self, each also exists in the Other's imagination of them as a dancer and a character in a film, and self and Other are not detached. Because their selves reach into each other, Sally and Pablo emerge from the moment of relation created anew, renamed, and transformed.

The imbrication of self and Other is also part of the I-Thou relationship as Buber sees it, and his description illuminates the relationship between Sally and Pablo. I and Thou come very close. In fact, Buber suggests that they overlap in the encounter. Speaking to an I, the reader, about the world of Thou, he says: "Sie steht nicht außer dir, sie rührt an deinen Grund, und sagst du 'Seele meiner Seele', hast du nicht zuviel gesagt; aber hüte dich, sie in deine Seele versetzen zu wollen—da vernichtest du sie."[27] Who is to know who is who in this encounter? The Thou does not respect previous boundaries of the I; reaching right inside, it is the I's foundation, becomes its very soul. In the moment of encounter, the I and the Thou cease to exist as they existed beforehand. The relationship is a moment removed from knowing, a moment of invisibility perhaps, like a blank screen. Nothing can be said about it except that the I and the Thou reach into each other in a moment of confusion as to who is who, from which they emerge to be seen in new ways.

To my mind, *The Tango Lesson* and Buber's work describe relationships at a deeper level than does feminist theology's use of general terms, such as "friendship" and "love". In contrast to *Artemisia,* seeing, in *The Tango Lesson,* is positive because it is a way of relating. As a way of relating, seeing is redemptive in *The Tango Lesson.* And yet seeing and being seen in *The Tango Lesson* differ from the way in which feminist theology has described relationships between people. Feminist theology could learn from *The Tango Lesson* and continue to learn from Buber, who has been inspiration for both the film and feminist theology. Seeing is positive and more: it is redemptive because it is a moment of relating from which people emerge transformed, visible in ways in which they have not been seen before.

SEEING IS AN ACT OF FAITH

Seeing, I argued in the theological discussion of *Artemisia* earlier, is not a simple registering of reality, and vision is not objective. We have a choice in how we look at things and seeing is an act that involves

our imagination and creativity.[28] In *Artemisia,* realities can be created and transformed by the vision of the inner eye, as is suggested in the scene where Tassi conjures up a landscape with the sheer power of his words.[29] *Artemisia* makes clear that seeing is an act, and not simply a passive registering. Most of the time, however, seeing is not a redemptive act. It is an act of violating someone else's space, of trying to gain the position of power behind the wired frame by pushing away any others who are aspiring to it.[30]

In contrast to this view of vision, I seek to show in the following section that seeing is not necessarily a destructive act but, rather, can be one through which the Other is created. It can be an act of belief in the Other's unseen potential, an act of faith. In being seen, something happens to the Other, and the Other comes to be something that they would not have been without the look of the person who sees them. In this sense, what I argue in the following might be seen as similar in some ways to Sartre's, Lacan's, and Foucault's claim that a person's identity is determined by the experience of being seen. I will, however, differ significantly from them in that I do not argue that a person's identity is established and defined by the experience of being seen, but that hidden aspects of a person's identity are brought to light through another person's look.

In *The Tango Lesson,* this effect of seeing is expressed in the reference to Jacob's fight, which is positioned as a scene just before Sally begins to make the film with Pablo. Jacob emerges from the fight with a new identity, just as Pablo will be given a new identity in the experience of being seen. In the biblical story referred to at this point in the film, Jacob's encounter with the angel is described as a process of letting go of an old conception of self in order to become a different person. This transformation of identity is symbolically expressed in Jacob's name change to Israel.

The first dialogue between Jacob and his opponent (verse 27) contains two important themes of the narrative—letting go and being blessed. Jacob, a man of great wealth, owns people as well as herds of animals. Jacob's fight occurs before he meets his brother, Esau, who, he fears, might kill him for the wrong Jacob did to him earlier. In this situation, Jacob can only think of saving himself by using his wealth to appease his brother's wrath. Jacob thinks he is self-sufficient and builds solely on his wealth. Hermann Spieckermann remarks appropriately, "Jakobs Sein ist sein Besitz."[31]

In contrast, Jacob's fight by the river is an exercise in letting go. Verses 23 and 24 recount that Jacob, during the night, sends everything he has across the river. He stays behind and, separated from his

possessions and all alone, is attacked by the stranger. Jacob, whose being is his wealth, lets go of all to fight without protection. "Let me go," says the Other, but Jacob cannot let him go, for the opponent is all he has left. He will not let him go unless the Other blesses him.

Delacroix's painting of Jacob and the angel, in front of which Sally and Pablo pose and of which the film shows only a part, depicts Jacob's fight in a pose similar to a dance pose. Like the biblical text, the painting portrays Jacob's struggle as an experience of letting go. His possessions, people, and animals are all on the right-hand side of the picture, which the film does not show. Jacob's weapons lie in a pile on the ground. He lets go of everything to the point of fighting with his bare body only.

Jacob receives his blessing in the form of a new name, Israel.[32] The new identity shows that Jacob became a different person in the struggle.[33] The transformation of Jacob through the combat with the angel comes across also in Delacroix's painting. Frustration and anger seem to lie behind Jacob's attack against the angel's chest with his head down. Delacroix's angel withstands Jacob's anger; he looks down on Jacob calmly while absorbing his frustration. He does not fight back but, instead, holds Jacob in his frustration. Spieckermann sees the angel's position as a dance hold that transforms Jacob's fight: "Der Engel macht aus Jakobs Kampf einen Tanz. Genauer: Während Jakob kämpft, tanzt der Engel mit ihm."[34]

Jacob is transformed in the fight, transformed by the Other. Likewise, both Sally and Pablo have to let go of an old conception of self in order to be transformed by the deed of the Other. Sally has to let go of her self-image as a leader both when she becomes a dance partner and when she makes the film about the tango. At the beginning of *The Tango Lesson,* Sally works on a script for Hollywood. As director, she would have been head of a whole film crew. When she lets the Hollywood script go because the producers expect changes, Sally lets go of her role as leader of a film crew just as Jacob let go of his people and herds. Sally takes on a smaller project, the film about the tango, but lets go a big Hollywood budget and the recognition she might have obtained with a mainstream film. And when Sally becomes Pablo's dance partner, she has to follow, which is only possible by letting go of all her leading instincts.

Pablo, too, has to let go. If Sally has to let go of her leading instincts, Pablo has to let go of his wish to control his image on screen. Assuming the film to be a continuation of his stage practice, he asks Sally how many dance numbers he will do. Sally answers that the film will differ from Pablo's performances in that Pablo cannot

choreograph his image but has to trust Sally in writing a story that includes him. Sally even tells Pablo he must cry in one scene, otherwise she will not make the film with him. Pablo, who is used to creating his own image by choreographing his performances, must let go of his self-control.

By letting go, Sally and Pablo make room for a new part of their identity to develop. When Pablo envisions Sally as his dance partner, Sally becomes visible in his eyes. Working as a director, she was invisible behind the camera, but as a dancer, she is suddenly looked at. Sally enjoys her new visibility; she wears nice dance clothes and new shoes, whereas earlier, when working on her script, she wore thick socks and unobtrusive clothes. Her new visibility, given through Pablo's imagination, also extends to her body. Pablo sees her body as a dancing body, energetic, elegant, and graceful, expressing movement and stillness in ways not seen before, ways that are unique to Sally's body.

Pablo, too, is transformed, like Jacob. Followed by Sally's eyes, he grows as a dancer, invents new movements, is pleased to be called upon to do a solo, and even defies gravity by walking up the wall for Sally. Pablo has always been visible as a dancer, but, nevertheless, Sally gives him a new visibility. In the dance, Pablo is visible as a dancer for the duration of the dance. In Sally's eyes, the eyes of a filmmaker, Pablo continues to be visible as a dancer even when he is no longer dancing. Even when he ceases to exist, he will continue to be a dancer in the work of art that Sally's eyes have created.

In another metaphorical image, which follows directly after the scene referring to Jacob's fight, the act of seeing is interpreted as an act of giving birth.[35] Both this scene and the reference to Jacob's fight make the point that identity and its continual transformation are not achieved by the self but received from another. Jacob, Sally, and Pablo need the Other to name, to think, to imagine, and to create them.

Paradoxically, though, the imagination of the one who creates the Other does not come across so much as an activity in *The Tango Lesson*. It is here where my understanding of vision differs from that of the philosophers discussed at the beginning of this book. Sartre, Lacan, Foucault, and Levinas have described the gaze as actively defining the Other as an object. The seeing I describe here, however, is not an active definition of, but a patient waiting for the Other. Creating the Other is not about actively picking a name for them as one would pick a garment and say to the Other, "Wear this, this suits you." Naming, thinking, imagining, and creating are each seen as an attitude of waiting for the Other that resembles passivity rather than action. It is very well for Pablo to imagine Sally as a dancer, but he

has to wait for her to be ready and open, otherwise he cannot lead her into her new identity. In two dance lessons, Pablo tries to give impulses to encourage Sally's movement as a dancer, but to no avail. Sally is not ready for him, he complains, and all he can do is wait for her to be ready.

Sally waits for Pablo's initiative as a dancer and for his trust in her when they make the film. One scene shows Sally's act of seeing as an attitude of waiting for something to become. In it, Sally, Pablo, and two other dancers are waiting for a filming location to be unlocked for them. The three dancers want to leave but Sally insists on waiting. After a period of silence, she encourages them to improvise a rhythm by dancing and the attention of her eyes draws out the dancers' inventiveness. In the end, Pablo pushes open the door without needing a key. Or is it Sally's attitude of waiting that is the key?

In each case, imagining the Other is an act of belief in them. Imagining them means seeing them in what they are not yet. But one can do no more than believe in the Other; one cannot make them in any way Other than by simply waiting for them to realize their potential, by watching them grow.

Buber's thought helps explain *The Tango Lesson* at a deeper level and reveals how imagining another person can be an act of faith. For Buber, seeing is not just an act of belief in the undeveloped possibilities of another person. Seeing is an act of faith in the divine, because it is divine potential that is contained in the Thou that is not yet. Through being seen, ever-new parts of the world are called to be divine gestalt.[36]

Human beings have the task to make visible the divine. Revelation, Buber explains, cannot simply occur of its own accord, it takes place only through people. Revelation happens insofar as it is spoken by people. Through the human act of naming, worldly spheres become places of theophany. And human beings do not only speak revelation, they also see it into being. Buber explains:

> Der in der Offenbarung Ausgesandte nimmt in seinen Augen ein Gottesbild mit. . . . Der Geist antwortet auch durch ein Schauen, durch ein bildendes Schauen. Ob wir Irdischen auch nie Gott ohne Welt, nur die Welt in Gott schauen, schauend bilden wir ewig Gottes Gestalt.[37]

Imagining, or, as Buber says, seeing with the mind, is never just creating the human Other. It is always creating God in the Other.

The act of creation, the realization of the Other's unseen potential, is described by Buber as a waiting for the Other to become. It is this aspect of Buber's work that might have inspired Potter to think of

seeing as an act of waiting for the Other to develop. And waiting, for Buber, is believing. A relationship contains within it the belief in and the awaiting of the Other. A human being who believes will make visible new being in the world by waiting for it:

> Er lauscht dem aus sich Werdenden, dem Weg des Wesens in der Welt; nicht um von ihm getragen zu werden: um es selber so zu verwirklichen, wie es von ihm, dessen es bedarf, verwirklicht werden will.[38]

Is this how *The Tango Lesson* shows the act of seeing? To some extent, yes. Seeing is an act of waiting for the other person to grow, sustained by the belief in their unseen possibilities. But are Sally and Pablo shown to be creating God when they await each other's visibility? Indirectly, Sally says that Pablo might be God; Pablo poses as the stranger who is, according to her words, an angel or God or part of her own self. But it would be reading too much into the film to conclude that seeing, in it, is unambiguously about creating God. Buber, however, might have thought so, because the person who perceives the Other as partly unseen, yet to become, is in an I-Thou relationship. And through every Thou that we encounter shines what Buber calls the eternal Thou.[39]

Even though imagining the other person is not necessarily creating God in *The Tango Lesson,* I still hold on to the thought that God is created in the world by human beings who see and make visible. I am encouraged by Buber, but also by those feminist theologians who have seen the world as God's body and human creativity as helping God to become. This view of God's visibility allows us to avoid an image of a God who makes the world worthy only by penetrating it at certain times and in certain places. God can be seen everywhere if the seeing see in the right way. Moreover, Buber's and feminist theology's thoughts on God's becoming visible pay human creativity its due respect as an act of cocreation.

Inspired by *The Tango Lesson* and Buber, I think, however, that some criticism of feminist theology's debate around human creativity is in order. I have outlined earlier different ways, within feminist theology, of seeing and interpreting human creativity.[40] Trying to overcome an image of God as a male artist, feminist theologians have searched for alternative images of God that allow women to see themselves as working with God in their own creative acts. I have shown that opinions differ as to whether the emphasis should be on the capacity of women to give birth or on their ability for artistic creation and symbolic competence.

The debate about female creativity, however, should not be centered on distinguishing different ways of being creative. It is not helpful to try to make a case for one way of being creative as preferable to another. A more useful approach, instead, is to describe creativity in terms of its origin and its effect on others and on the world. In *The Tango Lesson,* creativity originates from a moment of encounter and it is life giving for the people involved in the encounter. Whether the creative act is an act of physical birthing or of artistic creation does not make a difference to its life-giving effect. *The Tango Lesson* uses metaphors of artistic and bodily creation to describe the effect of Sally's and Pablo's encounter, not to value one way of creating over another but to appreciate fully what a relationship does for the people involved. Buber, too, does not attach much importance to different ways of being creative as a human being. What is important to him is the moment in which creativity originates, the moment of encounter. If there is an encounter, then a part of the world or a person will emerge from it visible and created, no matter whether they are seen, formed, spoken to, or given birth to. The emphasis on the moment of origin and on the effect of the creative act reaches to the heart of the issue of creativity. By comparison, any debate that simply values one form of creativity over another merely scratches the surface.

In addition, it must be said that there is no rift between different forms of human creativity, despite the fact that some texts of feminist theology have tried to declare a boundary between the physical act of giving birth and the symbolic act of artistic creation, which is sometimes described as distanced and physically uninvolved.[41] Such dichotomies are false because every human, creative act is physical and symbolic at the same time. Human beings have a body, and, therefore, what they do, they do with their bodies. Artistic creation is always physical creation. Whether we use our hands to form the clay, whether we see with our eyes, or speak with our voice, art is never a thought only. It has to be produced, and the production is always physical. The act of creating art cannot be seen as opposed to the act of giving birth on the grounds that creating art is physically uninvolved.

By associating the acts of seeing and filmmaking with images of birth, *The Tango Lesson* makes the point that seeing is an act of physical creation just as birthing is. In the eyes of the artist, the Other is truly, physically created. On the other hand, perhaps *The Tango Lesson* makes the point also that giving birth is a creative act that is just as symbolic as seeing. It is an act that materializes and symbolizes the preceding moment of relation, like Buber's creative act, which realizes its moment of origin, the I-Thou encounter. My earlier question

whether women's creativity is different from that of men can now be answered.[42] Women's bodies differ from men's bodies and, therefore, women can be creative in a way in which men cannot be creative. But this does not set apart women's creativity from men's, nor does it split women's physical creativity from their artistic creativity. Giving birth is one of many forms of human creativity, and all human creativity is physical and symbolic at the same time, whether one brings forth with one's hands, eyes, mouth, brain, or with one's whole body.

Judith Butler's way of seeing language in relation to materiality can help us understand that physical creation cannot be separated from symbolic, artistic creation.[43] Language, the symbolic, is always material because signs are material. Materiality is never separated from language because it is available only through language. Human beings have bodies and, therefore, the way in which they create is always material. The act of speaking is material and so is the act of writing—even the act of thinking, performed with the brain that is part of the body. And yet what human beings create always has a meaning beyond the material. A sculpture, made of clay, of matter, is always made to symbolize something. The physical act of giving birth, likewise, is never a material act only but always symbolic—of a relationship that preceded it, of a new beginning, of love.

The Balance between the Visible and the Invisible

If seeing is to be a positive act, I argued in the above interpretation of the film *Artemisia*, it is important that the person who sees is visible.[44] The act of seeing results in a power structure if the person who sees remains completely invisible. This power structure is operative not only in the panopticon, in which the inmates are imprisoned in their total visibility by the invisible surveyor, but also in mainstream cinema, in which the invisible spectator occupies the powerful position. Moreover, the power structure is also inherent in a religion that believes in a totally invisible, yet all-seeing God.

Artemisia, I argued, tries to overcome this power structure by being both painting subject and painted object, seeing and seen at the same time.[45] While the person who sees must be visible, like Artemisia, it must also be acknowledged that the person who is seen has an invisible side. Seeing can be redemptive only if one "sees" the invisible in the Other, acknowledges that the Other will not be fully accessible to the eye. Seeing is redemptive if it means seeing everything as both visible and invisible at the same time.

There, however, lies a difficulty, because, physically, we can only see what is visible. We cannot see that something might have an invisible side. Seeing is both an ability to perceive the visible and an inability to appreciate the invisible. Because of this inability, seeing can be hurtful and being seen is always a mixed blessing. *The Tango Lesson* shows this both in its imagery and in the allusion to Jacob's fight. For Pablo, being seen by Sally is a blessing in one way. In a conversation with Sally, he speaks of his fear of being without roots and disappearing without a trace.[46] Pablo wants to be remembered and the film about the tango is a way to safeguard his memory, because it is an art form with longer lasting visibility than the dance.

In another way, however, being seen is hurtful. Pablo is used to seeing himself in mirrors. Posing and dancing in front of them, he creates his own self-image.[47] Being seen by Sally is hurtful because she sees sides of him that he might find unpleasant. Additionally, the danger of misrepresentation inheres in any image making. Sally can only realize her own vision of Pablo, and while the "real" Pablo will transform again after the filmmaking, in the cinematic image he is frozen in one form that hides the multiple and ever-changing layers of a person.

Being seen is like being Jacob in the struggle; one is blessed and hurt at the same time, visible and wounded. Jacob is blessed because he emerges from the fight with a new name, a new identity. And yet the taboo, placed on the part of Jacob's body that had been touched by the angel, adds a hint of paradox to this story of a blessing. The angel touches Jacob's hip in a way that causes Jacob to limp (verse 26). The angel wounds Jacob and a taboo, a ban of contact, is subsequently placed on the wound (verse 33). The Israelites are not to touch the wound. For any wound to heal, it is essential that it be left untouched. Is this why the taboo is placed on Jacob's wound? So that it is left untouched and, with time, might heal? No, for Jacob needs the wound to be remembered as one who was once touched by an angel. The taboo is there to keep the wound open and remembered. The wound must never heal because Jacob must never be forgotten. To be made visible, for Pablo, is to be remembered. It is to be wounded also because no image will do justice to a person. Seeing, the film suggests through its reference to the story of Jacob and the angel, is always opening the wound by which the Other will be remembered.

Should seeing be avoided, then, so as not to hurt the Other? This is not the right question to ask, because we have no choice in the matter. Seeing and being seen are facts of life, and seeing is always making

the Other visible, not only when one is creating a work of art or making a film of the Other. Anyone who sees is always making the Other visible, if only by creating an image of the Other in their own mind. A person exists and is remembered partly through an other person's imagination, even though the same person is also wounded because the Other's imagination will never fully know them. And in the case of the filmmaker, who produces her imagination of the dancer on the filmstrip, representation is at the same time making the Other present and misrepresenting him. Seeing is a blessing that hurts—the wound that comes with being seen is at the same time our guarantee of existence and of memory.

The simultaneity of blessing and hurt also shines through Buber's way of describing the becoming of people and things in relationships. The becoming of people and things is a process of change between being Thou and being It in relation to an I. Underlying Buber's concept is the idea of an eternal Thou, which will never become an It, never be describable or visible as a thing with a color or a particular form. The eternal Thou's indescribability, however, does not make it inaccessible to human beings. On the contrary: The eternal Thou is always present; it is only human beings who are not always present.[48] If the eternal Thou is present through its indescribability, then to make something visible and describable must mean to make it absent, in some way. Becoming visible and taking shape means becoming an It, and the visible shape is not a token of the presence but a sign for the absence of the Other, a placeholder behind which the presence of the Other is hidden. In every worldly relation, human and other beings are partly hidden from each other through their visible shape.[49] The visibility of beings is reason for enjoyment, because it allows for the mutual recognition of those who differ from each other. But, at the same time, the visible shape denies full knowing of the Other. "Jede wirkliche Beziehung in der Welt ruht auf der Individuation; die ist ihre Wonne, denn nur so ist Einandererkennen der Verschiedenen gewährt, und ist ihre Grenze, denn so ist das vollkommene Erkennen und Erkanntwerden versagt," writes Buber.[50]

Seeing is the blissful recognition of the Other in their difference but it bears the danger of reducing the Other to his or her visible shape. Any being can be known by others through its visible shape, but, at the same time, every being remains hidden behind its visible shape.

A work of art, as Buber describes it, is precisely this: a visible creation that both connects with and separates from that which it represents. A work of art originates in an I-Thou encounter in which the Other is exclusively present to the artist. The work is the result

of gestalt that faces the artist, desiring to become. "Das ist der ewige Ursprung der Kunst, daß einem Menschen Gestalt gegenübertritt und durch ihn Werk werden will. Keine Ausgeburt seiner Seele, sondern Erscheinung, die an sie tritt und von ihr die wirkende Kraft erheischt."[51] The work of art originates not from the artist but through the artist. At first, gestalt reveals itself fully in the encounter and the artist can neither describe nor experience it, for what approaches him or her is true *Gegenwart,* presence. Making visible is not creating ex nihilo from the artist's mind, but making one's creative powers available to the Other so that they can be revealed through the artist. But the work of art, made visible and describable, becomes an It, a thing among other things behind which the presence of the Other disappears.[52]

All human response to an I-Thou encounter binds the Thou to the world of It.[53] The bliss of the encounter necessitates response, but the response that makes visible the Other makes them into an It. This process is at the basis of human creativity, of all image making, including filmmaking: "Das ist die Schwermut des Menschen, und das ist seine Größe," writes Buber. "Denn so wird Erkenntnis, so wird Werk, so wird Bild und Vorbild in der Mitte der Lebendigen."[54]

Seeing and being seen are, therefore, necessary; without them there is no memory, no being. But, at the same time, it is important to remember that there is more to being than being seen, and more to visible beings than meets the eye. While seeing can appreciate the visible side of things, it should also include an awareness of an invisible side behind every visible being. Kelly Oliver emphasizes this point in her discussion of the term "recognition," explaining that "recognition is a form of love that requires witnessing to that which is beyond recognition, witnessing to what cannot be seen."[55]

When appreciating the world as visible and invisible at the same time, it is important not to allow a strict division between the visible and the invisible in through the back door. For all it offers toward valuing positively the act of making visible, Buber's work is still founded on a division between the visible and the invisible. Buber's eternal, indescribable Thou is reminiscent of the Absent One, the invisible God, even though he insists on its presence to human beings. It is more conducive to the belief in the visibility and invisibility of everything not to postulate any concept of a total invisibility that has no visible side. Butler avoids such strict divisions. She thinks, like Buber, that no visible sign can capture fully what it attempts to represent. But, unlike Buber, she does not assume the existence of something set apart from the visible world as totally indescribable.

Everything has to be named, God and the world, and yet nothing can be named once and for all because everything has something indescribable, invisible, within it.[56]

Through *The Tango Lesson,* Potter tries to teach viewers that there is an invisible reality to the characters that extends beyond their screen presence. I showed in the previous chapter how the camera work and the narrative structure deny full access to the characters. Potter's film has a feel of realism to it that is deliberate. *The Tango Lesson*'s characters have an ambiguity about them; they are characters, but, at the same time, they are more than that. They appear to be "real people" because they are fashioned on and closely connected with flesh-and-blood people—Sally Potter, a filmmaker, and Pablo Veron, a tango dancer. Even though it is, in the end, impossible to tell to what extent the characters overlap with flesh-and-blood people, the filmmaker is nevertheless lending her creativity to real people who become visible through her efforts. *The Tango Lesson,* I am convinced, is born of a real encounter between two flesh-and-blood people; it originated from and still contains the seed of the real, deep apprecia-tion of Pablo Veron's gifted feet through Sally Potter's gifted eyes. Through *The Tango Lesson,* the real Sally Potter lends her filmmaking talent to the real Pablo Veron, who becomes visible through her.

But apart from this seed of reality, contained in the film, it is impossible to determine whether the visible is also the real, whether what we see of the characters connects us with or separates us from the people represented. Through one scene in particular, *The Tango Lesson* shows its viewers that the visible representation of a person can separate viewers from that person. In that scene, Sally is trying to convince Pablo to cry in front of the camera. But Pablo does not want to cry; he does not fit easily into Sally's screen image of him. Sally leaves, furious.

Earlier in the film, we have already seen Pablo cry, we have already seen completed the scene that now appears to be in the making as Sally and Pablo discuss whether or not Pablo should cry. How is this pos-sible? It is possible through the film's narrative technique. *The Tango Lesson* tells the story of its own making. When we see Sally making the film about Pablo and the tango, we realize gradually that we are already watching the finished product. It is confusing for viewers to watch one scene in which Pablo cries, and another one after that sug-gesting that he did not want to cry in the first scene. Even though Pablo was crying, Potter makes viewers realize that "Pablo," whoever he is, is not fully contained in this image. He cried, yes, but there was another side to this image that viewers could not see then, the fact

that Pablo did not want to cry. And if this line of thought is pursued, viewers must also question the scene that shows how Pablo did not want to cry. This, too, is only an image.

What, then, is "real" in this film that tells the story of its own making and that, therefore, contains the key to its own unmaking? Who are "Sally" and "Pablo"? Do they even exist? *The Tango Lesson* tempts viewers with its appearance of realism, using the real-life names of the people who act in it, portraying them in their real-life professions. But it also, and deliberately so, confuses viewers in order to teach them that images can never fully contain a person.

By emphasizing that people are not fully contained in images, *The Tango Lesson* makes its own concern the claim also made by some texts of feminist theology, namely that there is a visible and an invisible side to everything. This concern is essential if seeing is to be redemptive. As we saw above, Pritchard and Daniell argue that there is an invisible side to every visible referent, and it is this invisible side that makes people "see" the fragility and the inadequacy of the visible.[57]

To my knowledge, redemption and seeing have not been mentioned in relation to each other in the feminist theological debate. Redemption, feminist theologians have argued, is being a self-in-relation, but they have not addressed whether it can be effected through seeing. Feminist theologians have discussed seeing—the visible and the invisible—but not in terms of redemption. There is, however, a connection between seeing and redeeming, and the key to it lies in the look that senses the invisible side of things.

I have argued earlier in this chapter that relationships can be redemptive through their potential to transform the people involved in them. A relationship can free people to change and exist in ways not seen before. It is the invisible side of people and of things that brings about their transformation. Pritchard argues that the invisible pushes against its visible referent, thereby always questioning the visible and effecting its continual renaming. The side in people that is not yet visible will transform and free them to a new way of being. What, then, of the act of seeing? What role does it play in the transformation of a person? Seeing must be a knowing that there is an invisible to every visible. The look of the Other who "sees" the invisible assists in the redemptive transformation of the self.

Ich und Du offers a way of expressing the connection between relation and transformation, between relation and conversion, which is, says Buber, redemption.[58] The work of art that has become visible does not remain an It forever, because it contains as a seed the destination to reveal itself again as a person's Thou. It is meant to

transcend the confinement of that visible shape, which is perceivable as a thing, and to be rid of all possible description in the exclusivity of an I-Thou encounter. What is absent behind the material form of the artwork wants to become present once again, through its material form, because it is the material form that will trigger the transforming look.

Buber describes the interweaving of It and Thou, of absence and presence, in relation to the work of art thus: "Das geschaffene Werk ist ein Ding unter Dingen, als eine Summe von Eigenschaften erfahrbar und beschreibbar. Aber dem Empfangend Schauenden kann es Mal um Mal leibhaft gegenübertreten."[59] It is the act of schauen, of seeing receptively, that brings about the transformation from It to Thou.

Buber grounds his thinking about the work of art in his notion of a twofoldness that forms the basis of the world as a whole in its relation to what is not world. Two processes lie at the heart of the world and the un-world and, together, the two processes form a paradox, the secret origin of both. On the one hand, there is a turning away from an original ground. This movement allows for the becoming of the universe; it is a process of extension in which individual things are born.[60] On the other hand, there is a turning to the original ground. This movement allows for the return to relation and it is through this movement that the universe is redeemed.[61]

Does Buber's concept lead us to recognize properly the visibility and invisibility of everything, God and world? In his writing, Buber shows deep appreciation of everything visible: art, human beings, and nature. And yet there should not be a distinction between world and un-world, there should not be an I-Thou encounter in which an individual vanishes into an indescribable relation with another. Fundamental to Buber's concept is the continual alternation between relation and individuality, between I-Thou and I-It. When it comes to the eternal Thou and the processes at the basis of the world, Buber thinks in extremes. In contrast to Buber's opposites of relation and individuality, of I-Thou and I-It, I argue that I-It and I-Thou should not take turns but coexist. Relation should not be a move inward that is the opposite of the move outward into individuality. Individuality should not be seen as opposed to relation. Feminist theology's wish for the self-in-relation seems to overcome Buber's extremes by acknowledging the coexistence of the self and relation.

Nevertheless, those parts of *Ich und Du* in which Buber considers the world independent of its relation to the eternal, indescribable Thou describe beautifully how the visible can be appreciated fully for its capacity to lead to the invisible. The work of art, seen and

created, is not simply "material" or "non-material." It is a site that manifests the simultaneous presence of the two, of I-It and I-Thou, *Gegenstand* and Gegenwart, the describable and the indescribable, absence and presence, the visible and the invisible, wound and healing. The twofold presence, the paradox of the secret origin, is manifest in the work of art. The act of seeing a work of art, of seeing a person as a work of art, or of seeing a person is an act of understanding and of deep appreciation of the original paradox that manifests itself in the Other before one's eyes. Seeing is not redemptive if the one who sees thinks that the Other should be nothing but forever visible and embodied. Nor is it redemptive if one shuts one's eyes to "see" the Other as forever invisible and disembodied. It is redemptive only if it knows the paradox of the Other, appreciates the visible and "sees" the visible's invisible, the seed of its transformation. If seeing is to be redemptive, there can be no being that is completely visible or completely invisible. There can be no invisible spectator, no Absent One, no disembodied God. Every being, human and divine, is both visible and invisible as though it was written: God created people in God's image; visible and invisible God created them.

CONCLUSION

My point of departure in this book has been the question what it means to see and to be seen. The texts of twentieth-century philosophy I consulted all had a negative view of what this means—negative in the sense that the person who is seen has been thought to become an object in the eyes of the one who sees. Moreover, it is difficult for the person who is seen to even remember that he or she is originally a subject, who has only become an object under the gaze of the invisible Other. Many texts of feminist film theory have argued, in striking similarity with the philosophers I discussed, that being seen on the cinema screen has been an experience of objectification. In contrast with much of twentieth-century philosophy, feminist film theory has recognized that the question what it means to see and to be seen is a deeply gendered one. In cinema especially, but also in much other artwork, it is mostly men who see and women who are seen. Those feminist film critics I have engaged with describe cinema to be accommodating the needs of male spectating subjects. For reasons that lie in the psychological development of boys—reasons which feminist film critics explain with Freudian and Lacanian psychoanalysis—the male needs a female Other to bolster up his ego. The woman represented in Hollywood cinema acts as a screen onto which are projected the unwanted parts, needs, and desires of the male ego. In addition, Hollywood cinema objectifies women through establishing a pattern of dominance and submission between the women on the screen, who are totally accessible to the gaze of the invisible male spectators behind the film camera and in the darkened cinema. In the view of feminist film critics, the look has but negative implications for those who are looked at.

In order to see what happens when the gender roles are reversed, and in order to provide an alternative to conceptualizing the act of seeing as one of pure objectification, I have dealt in this book with films that show how women see and how they produce art. I have interpreted three films with a female main character who is an artist. By way of introduction, *Camille Claudel* illustrated problems that women who have claimed the artistic gaze have been facing, namely their struggle to be recognized by society as independent of relationships with men, to be recognized for their artistic skills and vision. The two films directed by women, *Artemisia* and *The Tango Lesson*, which I interpreted in detail, played a major part, along with texts of feminist theology, in a dialogue between films and theology, during which I drew theological conclusions about the act of seeing.

In interpreting *Artemisia* and *The Tango Lesson*, I developed a more positive concept of vision that is characterized by three main aspects. The first, important aspect that emerged from the discussion of both films was the recognition that seeing is a potentially positive act of relation. The interpretation of *Artemisia* has brought to light that seeing has as much potential for a mutual relationship as other senses, for example, touching (and that, equally, touching is not necessarily all positive, but can result in an objectifying relationship, too). For Artemisia, seeing represents a way of acquiring symbolic competence, which allows her to overcome hurtful and overpowering experiences while still being able to relate. *Artemisia* thus offers an alternative to the preference of other senses over seeing, be it Lacan's preference for language, Levinas's for the act of speaking, or McFague's for the act of touching.

The Tango Lesson has shown that seeing, more than simply being a potentially positive relation, can be redemptive in the sense in which feminist theologians have understood redemption. The term, according to the texts I discussed in this book, signifies mutual relation, and I interpreted seeing and being seen in *The Tango Lesson* as enabling the kind of mutual relation that feminist theology has described as redemptive. Seeing and being seen, in *The Tango Lesson*, are acts of appreciation of the Other in her or his presence, acts of respect for the personality of the Other. The interpretation of the film thus offers an alternative to the twentieth-century philosophers' discussions of the objectifying nature of the look referred to in chapter 1 of this book. The act of seeing has been described there as an act of definition of the Other in which the "original" personality of the Other disappears. In contrast, I have suggested on the basis of *The Tango Lesson*

that seeing is an act of interest in the personality of the Other, who is allowed to shine in the look of another person.

Seeing and being seen means deep and radical relation, a relation that touches the core of those involved. Seeing and being seen, as well as the tango, are shown in *The Tango Lesson* to enable a relation in which the boundaries of self and Other are redrawn. What is described in the film is not just an exchange of skills but a mysterious moment of encounter during which both identities are questioned, and from which both emerge in a new way. In this sense, I argue, seeing and being seen are truly redemptive, because they help to redeem into the visibility of creation new possibilities of being. The radical nature of mutual relation shown in *The Tango Lesson* thus offers a fruitful addition to some texts of feminist theology, which might be encouraged by the film to go deeper in their analysis of human relationships, and to acknowledge to a greater extent the ability of human beings to be creative with and of each other in relationships.

The second aspect, which is part of the view of vision developed in this book, is that seeing is an activity on the part of the person who looks. Seeing is never a passive or even objective registering of reality and of the Other. The activity of seeing "does" something to the person who is seen. In *Artemisia*, the gaze of the male painters turns out to be an activity through which they order the world they see and decide what to paint and how to paint it, despite their attempts at making it appear as though they were simply registering what was naturally in front of their eyes. In this respect, *Artemisia* suggests, like the philosophers discussed at the beginning of this book, that seeing is an act of definition of the Other, that, in the "relation" of seeing and seen, the seeing person is the acting subject, whereas the Other is the passive, acted upon, and powerless object. Feminist film theory has been arguing this point with regard to gender divisions in cinema, saying that, in traditional Hollywood films, men have been in the possession of the gaze and have actively defined the image of women, who in turn have been the powerless objects defined by the male gaze. *Artemisia* brings these concerns to the viewers' attention through its main character, a young woman painter who struggles against her definition through the male gaze and refuses to succumb to it.

The Tango Lesson, too, makes the point that seeing is not a passive registering but an activity through which the person who looks is acting on the person who is seen. More than that, however, I have been describing the act of seeing in *The Tango Lesson* as an act of faith. While seeing is an activity of the person who looks, and while

it is essential to recognize this activity, it is not an act that defines the Other in his or her identity, as Sartre, Lacan, Foucault, and Levinas have argued, but an act of waiting for the Other to develop potential that is yet unseen. Seeing is an active, but patient waiting. It is active in the sense that the person who sees is going out toward the Other and is making known her or his desire to see. Through this active approach toward the Other, the seeing person becomes vulnerable to the disappointment of perhaps not being able to see, the disappointment of finding that the Other hides what one was hoping to see. Seeing, therefore, is an activity that requires great patience because the Other's revelation is a self-revelation, a grace that cannot be willed by the person who sees.

The third aspect that, throughout the interpretations of *Artemisia* and *The Tango Lesson,* has become crucial to my understanding of vision is the balance that needs to be, and be recognized, between the visible and invisible sides of both the person who sees and the person who is seen. The philosophers discussed at the outset did, on the whole, not acknowledge this balance. Sartre's look, Lacan's gaze, and Foucault's powerful surveyor are all conceptualized as entirely invisible. Even the face of Levinas's I, the face who speaks to the Other and who sees the Other, is thought by him to be strangely invisible to the person who is addressed by this I. The young painter in *Artemisia* presents an alternative to the strict division between the invisible but seeing "subject" and the totally visible "object" of the look. In her act of looking, the young painter Artemisia is both seeing and seen, painter and painted, dissolving the strict boundaries between seeing subject and seen object. Through the interpretation of *Artemisia,* I have identified the balance between visibility and invisibility of both the seeing and the seen person as crucial to a positive relation of seeing and seen. Texts in feminist film theory have pointed out that, in cinema, the recognition of this balance is missing. The visible, female character on the screen, they note, never looks back, and therefore never addresses the seeing subjects in their visibility. *Artemisia* draws attention to this fact. At the same time, however, it does not offer an alternative, as the film camera still acts as a spy who exposes the film's characters while remaining invisible.

The Tango Lesson, too, makes the point that the balance between the visible and the invisible needs to be remembered, that every visible has an invisible side. In this respect, *The Tango Lesson* differs from the philosophies discussed earlier that have argued that the seen person is characterized by and through visibility to the invisible gaze. According to my interpretation of *The Tango Lesson,* a seeing

person can never see all there is about another person. The seeing person is thus not an all-powerful subject. It is unable to see those sides that are invisible in the Other, and yet it needs to appreciate the existence of those sides. The fact that the seeing person will never be able to behold another person wholly with their eyes makes seeing a mixed blessing through which the seen person is both visible and wounded. To be seen means to be recognized and appreciated by the Other, and yet it also means not to be recognized for what one is. The image that the Other takes away from the encounter can never contain the "whole essence" and "true nature" of the seen person. In this sense, it wounds the seen person, and yet this partly wounding look of the Other is needed in order to be remembered. *The Tango Lesson* acknowledges this characteristic of the act of seeing by withholding its characters from the viewers' full visual and identificatory access. *The Tango Lesson*, I argue, does not show everything there is to see or explain everything there is to understand. It thus makes viewers aware that they are not all-powerful and all-seeing; it makes them recognize their vulnerability in looking; and it reminds them of the respectful distance that they owe to the individual they see on the screen. There is an invisible side to the characters, this film reminds its viewers, which is clearly a part of the film, but which does not appear on the screen, indeed, which cannot appear on any screen.

This book owes a lot not simply to the films that were discussed, but to the dialogue that took place between the films and feminist theology, as well as Buber's thought, which has been one of the inspiring sources of feminist theology. Even though it was *Artemisia* and *The Tango Lesson* that contained the vision of a new look, it was the dialogue of these films with feminist theology that brought the vision to light. Engaging with *Artemisia* and *The Tango Lesson* alone would not have enabled me to see and describe their particular way of looking. Engaging with feminist theology, in contrast, made it possible for me to articulate the vision that I saw in both *Artemisia* and *The Tango Lesson*.

It was, however, not only feminist theology that had an influence on my interpretation of *The Tango Lesson* and of *Artemisia*. My interpretations, too, had their influence on my theological discussions and on my choice of theological writings. Through the interpretation of *Artemisia*, I was able to look critically at Sallie McFague's theology of seeing, and, by engaging with both the film and McFague's theology, I could lay the foundations for a different way of describing the act of seeing, a way that is not developed either in *Artemisia* or McFague's theology but inspired by both.

Discussing *The Tango Lesson* together with feminist theology and Buber's work made it possible to elaborate on the interest of various feminist theologians in the general question what it means to relate. Through engaging with *The Tango Lesson,* I could be more specific than some feminist theologians about what it means to relate because I focused my interest on a particular relationship, the relationship between those who see and those who are seen, and I could explore what relating means in practice. Thus, I argued that feminist theology should acknowledge the making of an image of the Other as part of every relationship, not only the relationship between human beings and God but also that between human beings. At the same time, feminist theology might be encouraged to work on the principle that, while image making is an inevitability in every relationship, no image can ever fully capture the Other, whether God or a human being, because everything has an invisible side to it.

Inspired by *The Tango Lesson* and feminist theology, I see the human act of seeing and of making visible as a religious act, an act of creating God in the world. At the same time, I criticize, on the basis of my interpretation of *The Tango Lesson,* some feminist theologians for separating bodily and artistic creation and for arguing that physical creation is more valuable than symbolic creation. I argue instead that every creative act is physical and symbolic at the same time and that emphasis should not be placed on how one should be creative but on the effect that one's creativity has on those who are created.

Finally, can what happened in this book between films and theology be called a "dialogue"? A dialogue is not taking place if films are used simply to illustrate theology or if theology is thought merely to echo what one considers the message of a film. A dialogue between film and theology or, indeed, between any two parties must yield something original, a new thought that neither of the two parties would have been capable of thinking without the contribution of the Other. Rather than simply exchanging opinions, the two sides in a dialogue must arrive at a new conclusion together. Only when an insight gained from a film becomes an indispensable part of a theological concept has theology really been in a dialogue with film.

This is the kind of dialogue I have sought to create between *Artemisia, The Tango Lesson,* and feminist theology. By looking at the films in great detail, I ensured that I did not use films to illustrate theology. When consulting theology, I did not simply point out parallels in meaning between the films and theology but used theology to understand more deeply the relationships portrayed in the films. Proceeding from a question that I described to arise from philosophy and

feminist film theory, considering *Artemisia* and *The Tango Lesson* and consulting feminist theology, I arrived at a view of the act of seeing that is new in the sense that it is not inherent, as a whole, in any of the films or the theology I discussed. My view of the act of seeing is inspired by all the materials I consulted, but it cannot be reduced to any one film or text. Instead, it arose from the interaction between the films and theology.

My presence as an interpreting human being has been crucial in this encounter of film and theology. It should be clear that films and theology can neither speak nor listen. Texts, whether of a cinematic or of a theological nature, need to be read by human beings. It was I who was touched by the films and interested in theology, I who interpreted films and theology in a way that made them fit together in a bigger picture. Films and theology became alive when I saw and read them, and, even though unequal as dialogue partners in the sense that they communicate meaning in different ways—one through words alone, the Other through moving images, words, and music—they could communicate through the question I asked. Through engaging with the films and with theology, through asking a question and gaining insights from both sides, I created a dialogue through which I can now see the act of seeing in a new way.

APPENDIX 1

———◆———

FILM SCRIPT *ARTEMISIA*

Unit

24 Tassi mistakes Artemisia for a male pupil; he wishes to see a painting by Artemisia
25 Tassi sees Artemisia's self-portrait in her studio
26 Artemisia selects drawings to present to Tassi
27 Tassi refuses to teach Artemisia
28 Painters on scaffolds at work
29 Orazio has brought Tassi to teach Artemisia
30 Tassi welcomes Artemisia and her maid, Marisa, at his house
31 First lesson, first part: exercises on perspective indoors
32 First lesson, second part: exercise on shipwreck outdoors
33 Former lover visits Tassi at his house
34 Second lesson: Artemisia is introduced to the wired frame that Tassi uses
35 Third lesson: Artemisia draws Marisa indoors
36 Tassi wishes to know the name of Artemisia's male model
37 Tassi poses for Artemisia
38 Tassi tricks Marisa into staying outside his house
39 Tassi rapes Artemisia and takes her virginity; he says he loves her
40 Artemisia and Marisa return home
41 Artemisia relives the experience with Tassi as if in a dream
42 Artemisia draws
43 Tassi poses for Artemisia; they make love
44 Tassi's friend hears of Tassi's relationship with Artemisia
45 Artemisia leaves Tassi's bed in a hurry
46 Orazio hears rumors about Tassi and Artemisia
47 Orazio questions Artemisia about her last lesson
48 Orazio spies on Artemisia and Tassi
49 Artemisia hears that Orazio knows about her and Tassi
50 Orazio takes Tassi to task
51 Tassi is arrested upon Orazio's initiative
52 Artemisia confronts Orazio
53 Artemisia on the way to court
54 Artemisia's face
55 In court: Orazio accuses Tassi of having raped Artemisia
56 In court: Artemisia's virginity is examined
57 In court: Tassi's sister testifies against him
58 Tassi states that he will not testify against Artemisia
59 Artemisia visits Tassi in jail; she confirms her love
60 Artemisia works on her Judith-Holofernes painting
61 In court: Tassi's friend testifies against Artemisia
62 Artemisia is tortured, Tassi confesses
63 Artemisia is ill; Orazio grieves; Tassi's sentence is pronounced

APPENDIX 2

FILM SCRIPT *THE TANGO LESSON*

Unit

1 Sally works on her screenplay, *Rage*, in her flat
2 Sally watches Pablo's tango performance in Paris
3 Sally talks to Pablo after the performance
4 Sally examines possible settings for *Rage*
5 "The first lesson," in Paris in Pablo's flat
6 Sally returns to her flat in London
7 Sally works on *Rage*; death of the yellow model
8 Sally works on *Rage*; death of the blue model
9 "The second lesson"; tea dance in London
10 Sally works on *Rage*; red model is shot at
11 "The third lesson"; Sally's floor needs to be repaired
12 Sally in a taxi in Buenos Aires
13 Sally in a tango café in Buenos Aires
14 Sally has a tango lesson in Buenos Aires with Gustavo and
 Fabian
15 Sally buys dance shoes
16 Sally has a second lesson with Gustavo and Fabian
17 Sally in a tango café with her teachers, dancing with several men
18 Sally returns to her hotel
19 Sally returns to her flat in London
20 Sally works on *Rage*; death of the red model; a hole in the ceiling
 of her flat
21 "The fourth lesson"; with Pablo in Paris in his flat
22 Sally dances with Pablo in a café in Paris
23 Sally and Pablo dance alongside the Seine

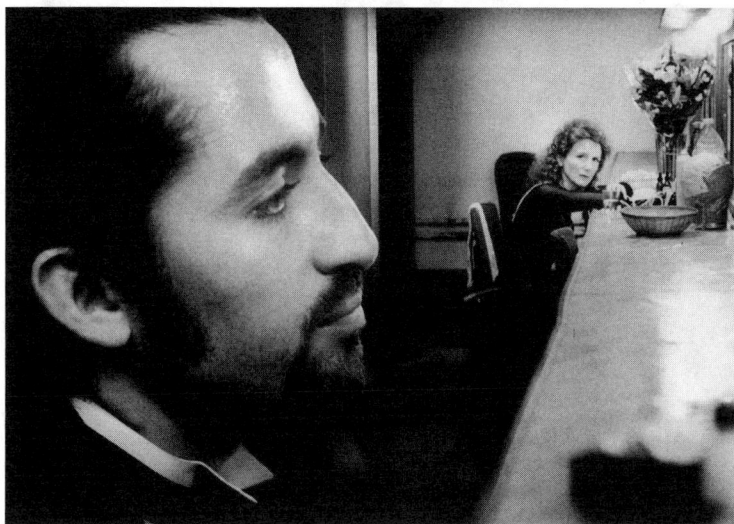

Image 1 Sally and Pablo's relationship seems broken after the professional tango performance.

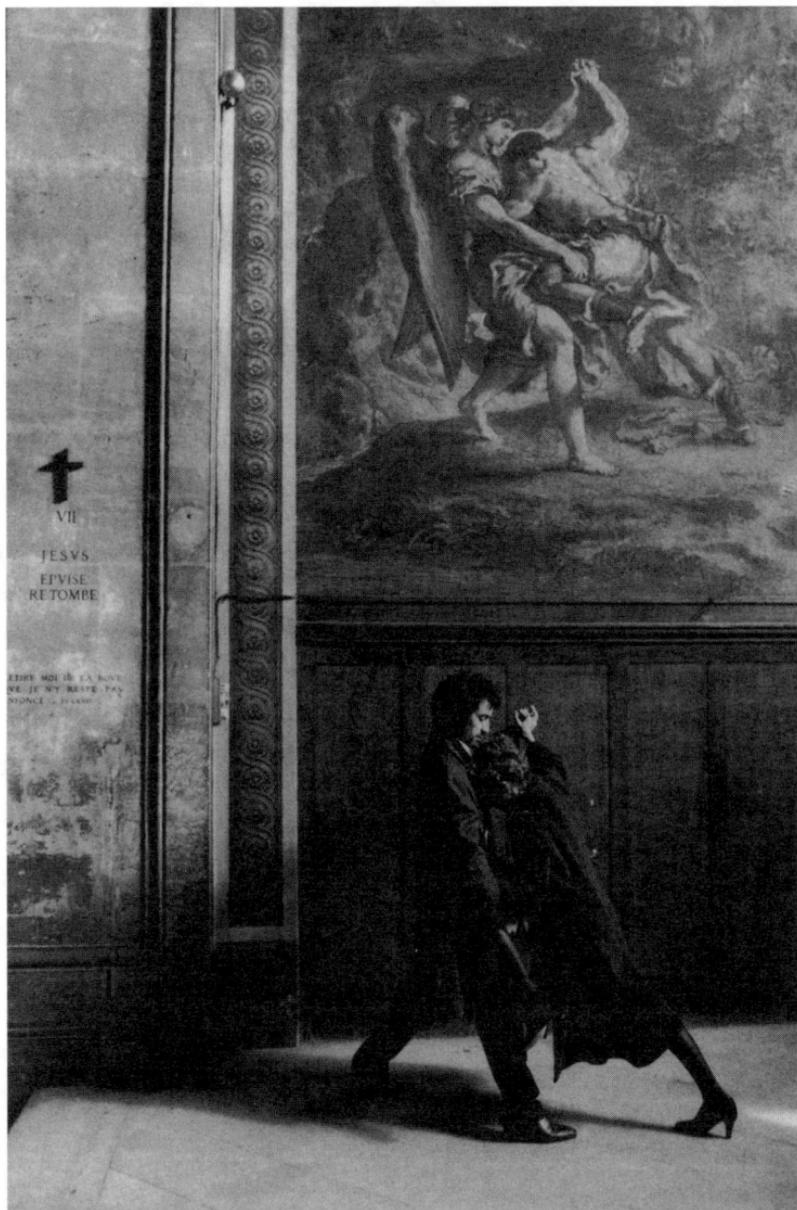

Image 2 Sally and Pablo pose as Jacob and the angel in front of Delacroix's painting in St. Sulpice, Paris.

APPENDIX 3

———◈———

INTERVIEW WITH SALLY POTTER

UV: I was struck by the fact that your film *The Tango Lesson* is made in black and white with insertions of color film. What made you decide to use black and white, given that this is an unusual contemporary choice?

SP: Black and white can signify, in a strange way, emotional color. There are so many layers inside the film, not least the film within the film (the imagined film which is not yet made). In effect, the black and white signals the real world and the color the imaginary world, which is approximately the reverse of how it would normally be seen. My direct experience of black and white is that it is a closer approximation of how the retina perceives light. Color film is cruder. Its colors are an approximation of the colors we are filming whereas black and white has an inbuilt detachment—it therefore paradoxically more closely resembles the imaginative leap you make when you're looking at a portrayal of reality.

UV: I think sometimes viewers find it difficult to know where to identify themselves with *The Tango Lesson*. Sometimes you have a completely white screen, as if the characters were withdrawn from view. In addition, due to the narrative structure, as a viewer I'm left not knowing what is real and thus how far can I identify with what I've seen. In this context, is your use of black and white also a way of separating the viewer from the material?

SP: I don't think so. If one thinks about early black and white cinema, for example, it's not necessarily a more detached or withheld or with-

drawn way of seeing any more than a charcoal drawing is compared
to a painting. The eye can adapt to black and white and can project
emotional color into it. In many ways, color could be seen to be more
withdrawn because it *pretends* to approximate to reality. It's like being
in the theater. You know you're in the theater, you know you're sitting
there in the seat, you see other people sitting in their seats, and yet
your mind accepts the fourth wall and the privileged view/entry into
what you're looking at. So the mind is capable of being both detached
and involved at the same time. Maybe black and white film works in
the same way. Of course there are many other examples of film where
color and black and white are used in a reverse way, for example, if
one thinks of Powell/Pressburger and *A Matter of Life and Death*.
There, heaven is portrayed in black and white and real life on earth is
portrayed in color.

UV: You mention earlier films made in black and white. Were you
also trying to pay tribute to that period of filmmaking?

SP: In some ways, yes, I suppose so. Not to any particular movement
of film or any one film, but maybe to the idea of roots. The roots of
cinema are black and white. But then cinema had its roots in painting
and theater, so where do you begin with roots? What black and white
really does, how it works, and how it is that we can interpret things in
black and white, given that we see things in color, is a very interesting
question. That we see everything in gradations of light and shade,
shadow and light, is in itself an act of visual interpretation.

UV: Were you inspired by the work of other filmmakers? There were
some familiar shots that I couldn't place, such as the spiral staircase
filmed from the top and the steps in the park on which the models
walk up and down.

SP: Staircases have been used a lot in films. *A Matter of Life and
Death* is linked by a staircase from heaven to earth. The spiral stair-
case shot is not a conscious quote from anything. There are only so
many ways that you can film a staircase. You're either looking from
below or you're looking from the top. But I was very aware, whilst
doing it, nonetheless, of the fact that it's a spiral and the structure
of the film has a certain spiral aspect to it. So there's some slight
reference there. As for the other steps—classical buildings and parks
tend to have grand steps and I used them in a very frontal way,
from below, very symmetrical. I think it would probably evoke the

many staircase sequences that there have been on film, for example, in Busby Berkeley choreographies—people making their entrances, walking up and down staircases. But other than that, I don't think there was a conscious staircase reference, not that I'm aware of.

UV: I misunderstood "Sally's" statement about feeling Jewish and took it literally. You since wrote that this isn't the case and I was intrigued by the fact that "Sally" feels she is a Jew without being one. I wondered whether this feeling was motivated by her relationship with Pablo, who is a Jew. Does she just feel Jewish in this relationship? If he had said, "I'm Argentinean," would "Sally" have said, "I feel I'm Argentinean?" Do you become a particular person in a relationship?

SP: No. And, first of all, actually, how do you know that Pablo is a Jew? His father is Jewish, but not his mother; technically therefore he's not Jewish either. The meaning of being Jewish, historically and today, is not the same as a national meaning like being Argentinean or Dutch or English. Every national identity has a meaning, however to be "Jewish" is both a very highly charged word and a confusing and confused one because even amongst Jews there is a lot of disagreement. Is it a racial category, a national category, a cultural category, a social category? If you have a Jewish father, you're not technically a Jew; if you have a Jewish mother but you're not religious, do you still count as being a Jew and so on? So Jew/non-Jew is a considerable issue for Jews. Of course, historically, it was a matter of life and death because during the Holocaust if you were a Jew, you were going to die and if you weren't a Jew or you could prove you weren't really a Jew, you might live. So it can never be an innocent name/badge/identity.

Looked at in another way, the extermination of the Jews or, rather, the attempted extermination of the Jews could never have happened if everybody said, "I'm a Jew," because you can't kill everybody in the world. So that's one way of protecting a people where there isn't a final clear, visible signal. It's not like being African; everybody can see when someone's got black skin. But nobody quite knows whether somebody is Jewish or not. There are Jews with small noses, big noses, they are fat, thin, there are Ethiopian Jews, there are black Jews, and many Jews in Brazil happen to be blond, so there isn't really a visible sign. Of course it's quite subtle to say, "I *feel* I'm a Jew;" you're not the first person to be confused about what was said there. I deliberately left it ambiguous to some degree, because, of course, in English, to say you *feel* you're such and such can either mean you are

or it can just mean that you have the *sensation* that you are, but you're not really. And, so, for the purposes of the story, for the "reality" of the film, he is Jewish, she *feels* Jewish. However, we see her studying Buber while he is looking at a book about Marlon Brando. In other words, identity is something that we also choose. Her Jewishness is about her relationship with Buber, with *I and Thou* in particular as a book. *I and Thou* is like a key that unlocks a lot of the dance, the story, the metaphysics that lie behind the whole idea, and that's, in a way, part of the key to the door. The two characters are finding out about their identities, who and what they are, dancer, filmmaker, star, lover, friend. There are lots and lots of facets to a relationship and to a person.

UV: Judaism is touched upon in this film and also in *The Man Who Cried*. What is it that fascinates you personally about the Jewish religion, or some aspects of it?

SP: A lot of things. The first of which is the role of doubt in Judaism. It's okay to be Jewish and doubt that God exists, or to argue with God. It allows for the role of reason. It doesn't demand a blind leap of faith or expect a sort of complicit passivity in the face of a powerful, almighty God. So there's a strong, intellectual, philosophical tradition that is linked with Judaism, which doesn't seem to be the case with Christianity or Islam. Of course there are Islamic intellectuals and Christian intellectuals, but there's something about how Judaism is run in parallel with philosophy that's, if anything, closer to Buddhism, which calls itself a philosophy rather than a religion. So that's one point of attraction. Another is, simply, that I grew up, as anybody did who was born in the second half of the last century, under the shadow of the Holocaust, and therefore tried to make sense of it; I wanted to know and understand more about the whole phenomenon. A lot of my parents' friends were Jews, mostly secular Jews, nonbelieving Jews, refugees of one kind or another or musicians and so on. I think we are all haunted by the deaths of the Jews and, certainly, *The Man Who Cried* was a way of trying to give a voice to the voiceless, or at least make sense of some of that story, to restore life where it was taken away, if such a thing is possible. I don't mean literally, of course. Perhaps, with *The Tango Lesson* the theme of Jewishness and identity was also almost a premonition of *The Man Who Cried*, which was my following film. I find that often happens. There's like a little seed of the next film planted in the one before.

UV: The allusion to the Jewish story of Jacob and the angel is placed in the center of your film. How would you describe its significance? Do you think in some ways it acts as a key to the film?

SP: I think it does. It's a very interesting story, Jacob and the angel, and I've read it interpreted in widely different ways, depending on who is telling the story and from what point of view. At the very least, it's a struggle between a man and an angel, a fight, and the angel only reveals himself to be so at the very end. It's a story between the earthly and heavenly realm, between the earth-bound nonbeliever and some kind of invisible world, the world of the angels, the world of God. Or it can be interpreted as a struggle between lies and truth, what's real and what's not real. In many ways, the painting in St. Sulpice, as opposed to the story, became central. The image very much resembles the tango and you could say that the tango was a metaphor for the experience of wrestling with the divine. When you learn to dance it's very physical, you're very much in your body, wrestling with your own limitations, and sometimes wrestling with the other person, as you try to figure out what they are trying to get you to do. You can't follow, or they can't lead, or you can't lead and they can't follow. Borgès said that the tango was like a fight, and to some people it looks like a fight because of the way the feet move so quickly; they look like daggers and like knives between each other's legs. But mostly the nature of the struggle is simply a struggle to connect with your partner, rather than a fight. But in attempting to become one with another person—because it is a *shared* dance, a shared art form—you inevitably find yourself wrestling with your own ego and also with some kind of principle which is neither you nor your partner but a third principle, which I came to understand as a divine principle. Therefore, my way of describing the tango is that it's a meditation for two.

UV: It seems to me that in the way the story of Jacob and the angel is used there is the possibility for "Sally" and "Pablo" to be both Jacob and the angel.

SP: That's absolutely right. They take both roles at different points. They can be variously angelic or just fighting, struggling.

UV: Is that something that applies to the tango as well, or is the tango very much a dance of one person leading and another person

following? A lot of people seem to think that in the tango the man leads and the woman follows. Can there be a role reversal in the tango?

SP: There are a lot of misunderstandings about what leading and following really are. Yes, the traditional division of labor in the tango, as in most social dances, is that the man leads and the woman follows. To lead, you move forward wearing flat shoes, as opposed to following, where you move backward wearing high heels. Who's to say which is the most skillful of the two? And, in reality, to lead well, you have to listen and understand your partner's body just as much as if you're following. At an advanced stage of the dance, it feels for both partners as if neither one person nor the other is really leading or following, but you're moving as one, because you've come to understand and read and sense each other's signals so well. One thing for sure is that it's totally interdependent because if the man is leading and there's no person to follow, there's nothing he can do; the dance doesn't exist any more. In other words, he is completely dependent on his follower and vice versa. It's a mutually interdependent relationship in which, in effect, there is a division of labor for the sake of clarity. But yes, of course, when I started I was completely rebellious. I thought I'm not going to follow some bloody man, I'm going to learn how to lead and I *did* learn how to lead. Quite a lot of women learn how to lead, and it's very useful partly because you're a much better follower afterward. But in my life, I lead most of the time as a film director, so part of my attraction to the dance in the beginning was to have a holiday from leading. Marvellous, luxury! To be following somebody else who's thinking about where we're going; fantastic. All I have to concentrate on is doing brilliant steps. Of course, that all changes very quickly. When you're following you have to think, you have to be very alert, it's like a martial art, you can't stop concentrating for a moment, you can't just lie back and think of nothing and follow as if you're wafted around on a cloud. It's a phenomenally concentrated activity and both partners have to be very alert to each other.

UV: This reminds me of Martin Buber saying in *Ich und Du* that the highest state of passion is the same as being completely active.

SP: Yes. With all the limbs of the body.

UV: It means being expectant.

SP: Expectant and awake. You can't be in a sleepwalking state. You have to be absolutely in the present. This happens in the story, too. My character is initially someone who's present in a different way: somebody who's living in her mind, in her imagination, in a very cerebral world—it's like a kind of awakening to have to come down, literally, into her feet. Both are different forms of being awake, of course.

UV: It seems to me that both partners have to wait for each other. "Sally" waits for "Pablo's" impulses but "Pablo" also waits for "Sally" to be ready.

SP: Yes. One of the greatest compliments that an Argentinean man can make about a woman he is dancing with is: "She waits so well." The state of waiting is like a Zen state. In other words you're in the present, in a state of waiting, ready to go in any direction.

UV: Waiting for the other person also plays an important role in Martin Buber's *Ich und Du*.

SP: Yes.

UV: Apart from the connection between the story of Jacob and the angel and the tango, is there also a connection between the story of Jacob and the theme of seeing and being seen?

SP: Yes, because much of Jacob and the angel is a case of mistaken identity. *The Tango Lesson* is a play on what's true and what isn't true, what's fiction and what's real, what's in a name, what's in an identity. From the beginning my character is looking at a real environment and projecting an imagined film that she might make onto that environment, then turning that gaze onto "Pablo" and starting to imagine a film he might be in. Of course, by the end we realize it's the film we've been watching all along. Seeing, therefore, becomes a kind of worship in the sense of really recognizing, acknowledging what's there, or trying to see beyond the three dimensions into some other dimension. By seeing, absorbing, and interpreting what's there, we create or recreate the world anew; it is born through our eyes in some sense. The act of seeing and being seen runs like a theme through the whole story. It's my character who does the seeing of "Pablo" and that is a role reversal because, in general, it's the male who does the looking and the woman who is looked at. It's an old idea now,

but very beautifully expressed by John Berger in *Ways of Seeing*. In this story there is a conscious, but realistic reversal of that because a film director's job is to be the one doing the looking, the framing, the holding, and the creating. And "Pablo," who is the leader in the dance, is framed, held, and created within the film.

UV: I would like to return to the idea of seeing as worship later. Before I move on: It seemed to me that "Pablo" is both hurt and blessed, like Jacob is, through this film. He's worried about roots and being forgotten. The film seems to give him memory and the attention of somebody else's eyes. But he doesn't always like the particular way it is made about him. Since there is the possibility of role reversal in the story, I was wondering whether there is also blessing and hurt for "Sally" in the act of seeing?

SP: I puzzled over that question when you sent it because I found it was meaningful for me. It was certainly close to a certain aspect of the experience of making the film, which was both a painful one and a blessing at the same time. In reality—as opposed to fiction—I think Pablo would say something similar about his experience. But in the end, for both of us, it was a great blessing. Blessing and being hurt—where does it come from, that question, in you?

UV: For me, it originates in the story because Jacob is given a new identity, which, to me, is a blessing, and he's asking for a blessing. But then he's also wounded in the encounter and his wound is going to be remembered.

SP: There is a close relationship between creation and destruction, and I think the very moment that one pins something down, makes it visible in some way, you know how much you're leaving out. That's a great pain. When you're making a film, or making anything—I'm writing a script now and I'm having the same experience—it's agony. There will be moments of joy as well, but it's not an easy or a light process at all. One is painfully aware when making a film of everything that it is *not*, everything that it was meant to be and fails to be. In that sense, when you set something up as a blessing, you're setting yourself up for a wound as well. But, as you were speaking, it also reminded me of the whole idea of the wounded healer. You can only heal if you are yourself wounded, then you understand the wounds of others. Maybe you can only create out of a sense of what destruction means. And maybe you can only give a blessing if you have been hurt

yourself. And maybe giving a blessing is a wounding thing to do also. I'm thinking of some societies where people feel that to take a photograph of somebody is to rob them of their soul. A great suspicion of photographs. So what does a film do, then?

UV: I've been thinking about the issue of the visible versus the invisible and how they relate. Your task is to make visible. What does the invisible mean to you as a filmmaker?

SP: Everything. It's entirely what I'm doing. I think filmmaking is an absolutely paradoxical activity because you're dealing with material and visible elements in order to conjure the invisible, the unseeable, the unhearable, and the unthinkable. You're constantly aware that you are circling around that void. The whole business is smoke and mirrors in that sense. The invisible world, the world of experience: thought, emotion, and the unquantifiable, the mysterious that is hard to address or describe but everybody knows exists. That, I think, is the filmmaker's business.

UV: The relationship between the visible and the invisible reminded me very much of Buber's thoughts on how you develop as a human being or how things become and return to the center in order to become something else. For Buber, being visible is like being away from the center of the original encounter, where a person is not describable. Is making a film, making things visible, like making the person absent, because the presence is only in the original encounter, which can't be described?

SP: Yes, that's the wound. In the very act of trying to make a portrait, a thing, or creation, whether or not it's closely related to the person—if it wasn't "Pablo" and "Sally" but "Fred" and "Mary" or any other character—there's some sense in which you're inevitably leaving out everything that's important. But it's an iconographic medium and, therefore, in some sense it's sacrilegious because, as in Judaism, you don't make images of your God. In Islam you don't even use the word. In that sense Christianity can be considered blasphemous, pagan even, for having images of Christ. But film has to deal with the visible, so does painting, it's a visual medium. But Buber's sense of moving away from the center—say it again, what does Buber say about it?

UV: I think the idea is that there is the original encounter, where a person is fully present but not describable, there's only the relationship.

But then, after this moment, everybody becomes an "it," describable, with certain characteristics, so you can be compared to other objects. He says it's necessary to become an "it," you can't live in the complete presence all the time, but, nevertheless, at some moment in time there will be another I-Thou encounter.

SP: The Buddhists say there is an infinite mind, we come from it and go to it. It's all around us, and objectification is illusory. But Buber talks about it in a different way. Any form of objectification is a limitation. In a film you are creating a character, it *is* a form of objectification, but at the same time it should be conjuring something *more* than that, something transcendent. Graham Greene used to say about script writing—I think he said it about novel writing as well—that you have to research and prepare and write infinitely more than you ever show or tell on the page or in the finished film. And so, when you read a script, just like when you read a poem that can be very short, you can sense hundreds of hours around it, or all the work that went, somehow, *behind* it. And then it becomes a distillation of thought and experience and an evocation, rather than an objectification. A stereotype is the opposite of that; it really is a limitation.

UV: Part of my work was to look at what makes a film religious. Different people have tried to define the religious in film in different ways. As a filmmaker, is seeing an act of faith for you?

SP: I wish I knew what faith was. The whole business of cinema making, or writing, is without doubt a sort of devotion, devotion to a principle of trying to see what's true. And if trying to see what's true and what's behind the appearance of things is connected with faith, then it's a kind of faith. But there's a rigor in the act of looking, if you are open, which means that you can't make any assumptions. The word "faith" for me usually means that somebody at a certain point relinquishes reason and makes a kind of leap, because they assume something exists, or they are told something exists, or will adhere out of faith to a collective viewpoint about what God is or how to live or be. So, I'm not sure I would define "seeing" as a filmmaker in that way, but I would certainly think of it as very, very linked with meditation and a sense of the sacred or of truth, a kind of philosophical reaching for something.

UV: In *The Tango Lesson,* both seeing and being seen are important. In your opinion, why are seeing and being seen important to people?

SP: I think in human terms, it's part of being alive. If we're not witnessed or seen by somebody else, we cease to exist. A child that's deprived of the eyes of a carer, whether it is a father or mother, grandparent or friend will become withdrawn, catatonic. The attention, the eyes, the witnessing of one intelligence upon another is an essential human activity, a relationship. The feeling of being seen, *really* seen, as opposed to somebody looking at you and not seeing you, which is not nice, is an experience of grace and illumination. It is a great gift and one feels enriched. One expands and glows in the eyes of another. And the act of seeing, I think, is also an act of love as it takes effort and decision.

For a film director, learning how to see is a crucial part of your activity, your trade; without it you don't have your craft. When you're learning life drawing, you sit and study: look at the model, look at the page, look at the model, look at the page, back and forth, back and forth. You feel your eyes start to sharpen, and you realize how little you normally see, how little detail, how vague and approximate your sense of form, light, and space is. That same kind of sharpened vision and heightened awareness is what you have to develop when you're making a film. When directing, you have to make lots of visual decisions, not only about the person you're looking at, but the space, the light, the objects, everything. Also, as a director, when you look at a performer you become their audience and that gives them, in a way, permission to perform. You attempt to become the first and best audience they have ever had and will ever have. This act of seeing is a very active seeing, you're looking for the potential of the person, you're looking for their genius. You're not necessarily looking at their faults, although you may look at those as well and try to figure out how to compensate for them. So it's both active and creative. In my experience, when I'm looked at by a director (which doesn't happen very often), I feel myself under this burning gaze from which I can't escape. Sometimes I wonder if that's how it is for people when I look at them. It's something I discussed a lot with Pablo.

UV: You were saying that an audience is almost creating, or appreciating the performance of, in this case, the dancer. I feel there is a difference between the way the audiences within the film look at "Pablo" and the way "Sally" looks at "Pablo." His audiences aren't creative for him because he uses them as if he were dancing in front of mirrors, looking at himself, kissing his image. The way "Sally" looks at him is very different from that.

SP: Yes. Her look is an intervening look, a shaping kind of look, a look that might say yes to some things and no to others, whereas a mirror will always say yes. The former is a much more problematic relationship and an alive one. It has two points of view in it, not one.

UV: "Sally" says to "Pablo," "I love you with my eyes." What exactly does it mean to love with one's eyes?

SP: I think in a human way it would be to give a look of respect and openness, a kind of unconditional awareness and appreciation of what one is looking at. That's a look of love. But I think also to look beyond how somebody is to how they *might* be or how they *want* to be, to the hidden things, that's also a look of love; to not take things on the surface. Then I think there's a whole other level, which is what does it mean for an artist to look, because it's what they do professionally. It becomes a way of looking that at times could be quite devouring, maybe even destructive or invasive. But I think the fundamental look from the artist at the material has to be one of love. You can't make things based on hatred and sneering; it has to be, essentially, a look of wonder at the world, which isn't dissimilar to a scientist's way of looking. There's a kind of coolness in it, because it's detached, but there's also a passion because it's an amazement at everything that exists. And the conundrum is how to make sense of this chaotic mass of material and shape it into something, order it in such a way that people can recognize their own experience on some level within it. It's a process of digesting and making meaning.

UV: "Sally" loves "Pablo" with her eyes. Was this the same in the relationship between you as a director and what is in front of the camera?

SP: You can love a table or a chair or a vase of flowers, but I think one is always going to love a person more, probably, and I think the "I love you with my eyes" line was referring to the kind of love that can exist between a director and a performer, an artist and his muse or her muse, as opposed to a romantic love relationship. But it's an acknowledgment of the intensity of that, an embracing look.

UV: When you think of *The Tango Lesson* as a whole, do you think you have succeeded in this embracing look?

SP: To some degree, because of people's responses to it. I've had more responses to it than anything else that I've made, surprisingly,

and countless numbers of people have either written to me or told me that the film—they all used the same phrase—"changed my life." That's a big responsibility; what can it really mean for a film to change somebody's life? But, obviously, something about it did something. There must have been something in the embracing look that people felt embraced by themselves, that it would allow them to change something that they wanted to change, whatever that was. Personally, though, I'm always very aware of the shortcomings of what I've done and *The Tango Lesson* is no exception. I know, for example, that I was able to embrace "Pablo" as a character and shape his character in a way in which I wasn't able to shape my own. I wasn't very happy with the portrayal of my own "self," whatever that self was. I didn't put enough attention into it and it suffered as a consequence. I didn't give the look of unconditional love to myself that I was giving out.

UV: That's probably a very difficult thing to do.

SP: Yes.

UV: I was wondering about you as a director looking at yourself through the camera. Is there a clear distinction between the two, the "Sally" in front and the Sally behind the camera, or do they influence each other? Is one creating the other? Does "Sally" influence Sally?

SP: I'm sure that, finally, there is a dialectical relationship between the two personae. But at least at the beginning, I was very aware that I was creating a character. I referred to her as "she," never as "me." Also I was quite clear when I was on and when I was off; there's a kind of magic line that you cross over when you're in front of the camera and to some extent, you have to shed everything else. I didn't always succeed in doing that and sometimes found myself being filmed and looking at the light falling on Pablo, wondering if the camera was in the right place for him. I couldn't always be there as a performer as much as I wanted to be there. But there are some very tiny ways in which there was an influence the other way. I noticed that in the footage of one or two people who filmed the shoot; they caught the moment when I would say "cut" in the shot, and then I'd start moving around and doing stuff, and talking, and you could see it was a schizophrenic situation. Because there is this character, called "Sally," looking relatively relaxed; I'd say "cut," my face would crease into a great frown, and I'd be rushing around, doing things, and

my voice would change, I'd be louder. So, the character on screen tended to have a softer voice, a slightly more relaxed face, and be rather more still generally, than the way I usually behave. But these are questions of behavior and habits, and what I think you're trying to do on film is to divest yourself of irritating habits and things that you carry otherwise.

But about the deeper levels of cross-influence from one to the other . . . I wonder. There are certain things that I do in the film that I would never do as a director, but which I wrote and allowed myself to do for the sake of the story. For example, when "Pablo" and "Sally" are walking in the park in Buenos Aires and she says, "Maybe I'd want you to be in this scene, maybe you'd cry," and of course that's a reference to the scene we've already seen in the film, and then it turns into a terrible argument. I would never argue with a performer like that in reality. If Pablo or any other performer had said to me, "I don't want to cry," we'd sit down and talk about it and figure it out. I wouldn't go stomping off like that. But for the story it needed to happen that way, there.

UV: I find the idea of seeing yourself in different contexts interesting. In the other film I'm discussing in my work, there is a scene where the main character paints a self-portrait. The Artemisia character is on the left-hand side of the frame and she holds her self-portrait to her right. And, because she is painting with a mirror, there is a mirror with her image in the middle, between the other two "Artemisias." It fascinated me, this idea of becoming a self by putting yourself in different, maybe fictionalized contexts. And, in the end, maybe all of us do it in a way.

SP: All the time.

UV: You put yourself in different relationships and that's how you become a self. Or you see yourself as part of a story and identify with different characters.

SP: Yes. We draw and redraw ourselves every day; literally, when we look in the mirror and change our appearance to psychologically match the way that we behave or the kind of role we think we're required to play or think we are. There's then this thing called a "personality" that we believe we are, as if we can't reinvent ourselves all the time. It's as if we live in some invisible script that somebody else wrote. It's a quite complicated business of self-portraiture.

Of course there's a long tradition of it in literature, people inventing a fictional version of themselves that they insert into the story. Colette did it a lot, it happens in much Latin American literature, Borgès for example, but not so commonly in film.

UV: Some feminist theologians think it important that women should have female role models, from the Bible or from other historical contexts, in order to develop as women. In *The Tango Lesson*, you identify with your character "Sally," but also with Jacob and to some extent also with the male fashion designer. You see yourself as a woman, but also as two men.

SP: Historically, men have claimed the universal principle to themselves and "woman" is the other. We hear that very obviously in language, so that, for example, you say "a poet" if it's a man, you say "a female poet" or "poetess" when it's a woman. A film director is a man, unless it's a "female film director." So we're always the exception or the one who doesn't occupy the central place. I think it's not helpful; I think we all need to claim the universal principle. We don't necessarily have to have a female role model. That can have its own limitations as well, it can be a kind of trap. All of a sudden, the only kind of females that a woman can model herself on are earth mothers or goddesses or things to do with weaving and child care, when maybe it's more appropriate to be doing nuclear physics, playing football, or to be the pope.

UV: That also reminds me of the difference between men and women with regard to creation. Men are often stereotyped into having the ability for abstract and artistic creation, whereas women are stereotyped into having the ability for physical creation. I noticed, in *The Tango Lesson*, that there are allusions to both artistic creation and to giving birth.

SP: Where is the metaphor of birth giving in *The Tango Lesson?*

UV: In the scene where "Sally" gazes in the water and sees "Pablo" in a foetal position.

SP: Yes, that's absolutely right.

UV: How would you see your creativity as a filmmaker in this context, between abstract and physical creation?

SP: I've always kicked against the definitions very strongly. It doesn't tally with my own experience, and I don't find it's a useful position philosophically to gender the world of ideas and creation. Yes, physically, women can give birth but not all women do. Men have a great capacity for abstract thought but not all men do. Some women have a great capacity for abstract thought and aren't very good at caring, some men are very good at caring. So there's always a possible contradiction to the stereotype. Of course, there's now a whole field of evolutionary psychology that claims that everything that we do is in our genes and that we are absolutely, genetically predetermined to act and think in a certain way, according to whatever will help the survival of the species. But in reality we don't know what the blend is of what we learn, what's conditioned into us, and what material we arrive with genetically. But it has to be, at the very least, logically, a combination. There's something about most female training and upbringing, what we learn to be and what we see in other women, that leads to a tendency to learn to read subtle signals, to very quickly feel the feeling states of other people and your own. And to *care* about how other people feel, but that can be turned around as well. The main difficulty for women's development—in any direction, as an intellectual, as an artist, as a writer, as a person—now seems to be a feeling of limits; not being able to go either high enough, big enough, excellent enough, far enough, abstract enough, whatever it may be. It's a sense of being imprisoned in limitations. The revolutionary and the progressive or liberating thing to do is to try and cast off those limits, and one of these limits would be the notion of being incapable of abstract thought and big ideas.

UV: Speaking of creation, some feminist theologians would speak of "redemption" in terms of creating, of helping somebody into being. Have you thought about "redemption"?

SP: A lot. It's a very meaningful word to me, and, as a matter of fact, I spent several hours on it today in the other script that I'm working on and then, just before you came, I had a quick glance at your questions and I looked the word up in the dictionary because I suddenly couldn't remember what it really meant, despite the fact that I've been working on it for so long. I still don't really know what it means in terms of film. Perhaps the idea of transformation from nonmeaning into meaning. To take apparently random historical events, either on a small scale or a big scale, and make sense of them can redeem

the sense of loss. The dictionary talks about redemption as being an atonement for sins, but I don't think that's the only way to understand it, do you?

UV: No. I would think of it more in terms of transformation, as you said.

SP: The whole notion of transformation—we were talking about the invisible world—that *is* the project of all of my films in a way.

UV: "Sally" and "Pablo" have a conversation about finding one's destiny. Being creative, to me, means helping someone find their destiny. But, on the other hand, "Sally" says that we find our destiny with our own will. How do we find our destiny? Is it with our own will or through the eyes of another person or their appreciation, or both?

SP: I worked for months on that speech. I think my character says something like "I don't believe our lives are written." They're not written and, therefore, we have the freedom to create ourselves. With the latest science that I'm reading at the moment, that's really what happens when we develop after conception, there's a sense in which we create ourselves out of the genetic material. But destiny versus free will is a very old argument. Certainly, the idea of free will takes us down a road which is much more interesting than the idea of fate. The idea of fate leads us to a place of passivity and fear and acceptance of everything, the bad and the good, that it's somehow meant to be. The idea of free will says we may be born into circumstances beyond our choosing, but once we arrive we can choose what to do about it. And so immediately, we are in a position of both responsibility and creativity. So it's a much more energizing, philosophical point of view, even if it's not true. But as we don't know which is true, why not choose the point of view which is the most dynamic, creative, and interesting?

UV: But then there's still something that "Sally" calls "destiny." Are you meant to arrive at a particular point at the end?

SP: At the end of the film?

UV: No, at the end of searching for yourself and creating yourself. I find it difficult to relate the word "destiny" to the aspect of free will.

SP: Ah. I think there's another sense of destiny, which is more like potential, *purpose*. So if you say, "What is my destiny?" you mean, "What is my purpose, what am I meant to do, what could I do?" We don't necessarily live out our perceived destiny, therefore it doesn't mean that it's preshaped and whatever we do or don't do it's always going to turn out the same anyway. But, having said that, even if one does believe in free will, and that here we are, surrounded by random events and chance, trying to make choices in the middle of it all and to make *good* choices, then, suddenly, these things called coincidences happen; how do you interpret them? Why do you meet certain people at certain times? Then you start thinking maybe this is part of some plan, and all kinds of other ways of thinking about fate and destiny start to come into operation.

UV: I'm thinking about the desire to make visible. In *The Man Who Cried,* you were working with well-known actors who had already developed their image as actors. Would you still say that your look as a director helps them to become, even though their image seems so well developed already?

SP: I would hope so. Obviously, when somebody is just starting and it's their first role in a film, it's a different situation. The child in *The Man Who Cried,* for example, hadn't been in a film before, so, obviously, I would be more responsible for how she would shape herself. And, similarly, Pablo, who hadn't done a film role; whereas indeed it is different with Cate Blanchett or Johnny Depp. But however experienced an actor is, they still need a director, at the very least to mirror back what's happening and to discuss and to shape what's happening, to make choices.

UV: Does that refer to them as actors or also as people? Is there also a personal element in this?

SP: It's totally individual. But, from my point of view, making a film like *The Man Who Cried* is a very different experience than making a film like *The Tango Lesson,* which had a long research period and a long and evolving, complex relationship with Pablo, where he became my muse and the material, then we both became the material, and our lives became the research laboratory for the work. So it's a much more integrated and complex process and self-reflective, obviously. Whereas with *The Man Who Cried,* people came in to do a job, with

almost no rehearsal, then straight into the shooting. It's a different kind of relationship, I think, more detached.

UV: Ultimately with the film, it's not just "Sally" looking from behind the camera or you looking from behind the camera, but it's also the viewers who look at the film afterward. What is my role as a viewer? If "Sally" helps "Pablo" to find his destiny, do I, as a viewer, also help somebody find their destiny, in my act of looking?

SP: I think the audience creates the film by watching it. There's no doubt about that. And each individual creates it for him or herself and each collective audience creates it anew; and you feel that in the cinema when you watch it with them. The greater the extent to which someone can pay attention and dig into and engage with a film from the start, the more they're going to get out of it. But also, there isn't a fixed meaning; it's a question of interpretation, just as everybody who reads a book creates the book for themselves and edits it to some degree in their mind as they pick and choose, pick it up, put it down, remember some bits, forget other bits, recreating it in that way. However, there is a difference with the act of looking during the making of the work, which is that at the moment of projection, the film is finished, it's fixed. As the book is when it's printed. Whereas, in the process of making something, you're in a very fluid, mutable state, in which things can change and go in different directions at any moment. So the sphere of influence is a little different.

UV: You seem to have been inspired a lot by the work of other people. *Orlando,* for example, deals with Virginia Woolf's novel. Also, in a number of your films, there is something "inside" the film. In *The Gold Diggers,* there's a theater inside the film, in *The Tango Lesson,* there's a film inside the film, in *The Man Who Cried,* there's an opera inside the film. Is there a certain fascination of putting works of art or other performances inside your films?

SP: I guess there is. I guess it's a fascination with the process itself. It's a way of examining the process of its making within the film itself. It's interesting if you look at Iranian cinema at the moment, it does the same thing. Have you been following some of these Iranian films?

UV: No.

SP: They're absolutely wonderful; they're very austere and self-referential, so they'll often contain some discussion of the form. I think that fascination with process comes up for anybody or any culture where the form you're working with is not innocent or neutral or transparent. You're puzzling over what happens in the process of telling a story or making a portrait or trying to tell the truth about something or represent something, that in the act of doing so you *create* it and you change it by looking at it: you have a hidden point of view that influences what you see. So if you refer to another work of art within it, or the process of making or the process of looking at something that's already been made, I suppose you make reference to that bit of self-knowledge. You are asking the question.

UV: When Buber speaks about works of art, he says they originate in an I-Thou encounter. After the work is produced, it is an "It," but then it can become alive again in another I-Thou encounter if somebody looks at it or builds a relationship with it. Did you also feel that with some of the works of art that you included in your films, that you were inspired by? What was your relation to the artists or works of art that inspired you?

SP: For example to *I and Thou*? The book itself?

UV: Yes, why not?

SP: It was my favorite book when I was about 16, and I read it a lot of times. Then I put it away and didn't come back to it again until I took up the tango. So it was a long time afterward. Something in me was drawn to it, as a way of trying to find words that would express the experience I was having. When I picked it up and read it again I thought, my god, this is so dense, it's so difficult as a book, and so beautiful and so abstract, and does it mean anything, or is it a poem? What is it? And how could I have loved it so much when I was 16? What was I seeing? I've even forgotten now what your question was. What was your question?

UV: About your relationship to works of art that you've included in your films. Whether you felt in a direct relationship with them in the sense in which Buber says works of art can become alive for us.

SP: Yes, I felt that with *I and Thou*. I felt inspired, awed by its beauty and by the basic, single concept that is in its title, "I and Thou," and

by the idea of meditating on the notion of relationship itself, asking all the questions like, what is the I, who is the Thou? Who is the other? What is the self? What happens when you relate? What is the energy that passes between two people, to put it another way? What do we find out in the act of relationship? So I thought it would be a nice juxtaposition to put his book in the film especially as people don't think of tango and Buber as anywhere close to each other. But I'm always very excited if I find that work somebody was doing, maybe 100 years ago, somewhere, in some far-off country is alive and burning in somebody else's brain, in another form somewhere else. To find these parallels is very exciting. I think I probably had a very personal relationship with *I and Thou* when I first read it. I remember looking at the cover many times, studying Buber's face, wondering about him as a person, and feeling that his words and his work were speaking directly to me. And that's always been part of my ambition, if you can call it that, with the films I make, to create that quality of relationship with the unknown viewer somewhere out there. A very intimate relationship, where the person feels that they are really discovering it for themselves, or finding themselves in it. Of course, sometimes it doesn't work at all, but sometimes it does.

London, October 4, 2002

NOTES

INTRODUCTION

1. See for example Carl Skrade's article "Theology and Films" in *Celluloid and Symbols* (ed. J. Cooper and C. Skrade [Philadelphia: Fortress Press, 1970]), p. 22, and Robert Jewett's book *St. Paul at the Movies* (Louisville: John Knox Press 1993), pp. 7, 11. See also Robert K. Johnston's book *Reel Spirituality* (Grand Rapids, MI: Baker Academic, 2000), which makes clear in the subtitle that it is about *Theology and Film in Dialogue*. Ambros Eichenberger, in his article "Approaches to Film Criticism" in *New Image of Religious Film* (ed. J. R. May [Kansas City: Sheed & Ward, 1997]), employs the term "dialogue" for the relation between film and theology (p. 9). See also *Hinter den Augen ein eigenes Bild* (ed. M. Kuhn [Zürich: Benziger, 1991]) and *Aus Leidenschaft zum Leben* (ed. Z. Cavigelli [Zürich: Benziger, 1993]), two publications of the international research group *Film and Theology*. In the introductions to both volumes, the editors emphasize their interest in a dialogue between film and theology (see *Hinter den Augen ein eigenes Bild*, 17–20 and *Aus Leidenschaft zum Leben*, 8). More recently, the same international research group have been pursuing the interest in the dialogue between film and theology with their book series *Film und Theologie* (see L. Karrer, *Gewaltige Opfer: Filmgespräche mit René Girard und Lars von Trier* [Cologne: KIM, 2000]; S. Orth et al., *Göttliche Komödien: Religiöse Dimensionen des Komischen im Kino* [Marburg: Schüren Verlag 2001]; J. Valentin, *Weltreligionen im Film: Christentum, Islam, Judentum, Hinduismus, Buddhismus* [Marburg: Schüren Verlag, 2002]; L. Karrer and C. Martig, *Traumwelten: Der filmische Blick nach innen* [Marburg: Schüren Verlag, 2003]; C. Wessely et al., *Zeit, Geschichte und Gedächtnis: Theo Angelopoulos im Gespräch mit der Theologie* [Marburg: Schüren Verlag, 2003]). In *Explorations in Theology and Film* (Oxford: Blackwell, 1997), the editors Clive Marsh and Gaye Ortiz use the term "conversation" to describe the relation they envision between film and theology (2).
2. In Inge Kirsner's whole book, *Erlösung im Film: Praktisch-theologische Analysen und Interpretationen* (Stuttgart: Kohlhammer, 1996), we find but two sentences to define "Erlösung" (redemption) vaguely as liberation from bodily and spiritual suffering (12) and, with regard

to the viewer, as "transmission of meaning through contemplation and/or participation in the story" (46).

3. See Robert Jewett, *St. Paul at the Movies* (Louisville: John Knox Press, 1993) and Margaret Miles, *Seeing and Believing: Religion and Values in the Movies* (Boston: Beacon Press, 1996). For an approach contrasting that of Jewett, see George Aichele and Richard Walsh's edited volume *Screening Scripture: Intertextual Connections Between Scripture and Film* (Harrisburg, PA: Trinity Press International, 2002). Aichele and Walsh make clear in the introduction that they do not privilege the scriptural side of a conversation between film and the Bible or biblical theology but, instead, consider both the theological and the cinematic interpretation of the Bible as equally valid (ix).

4. Christian Metz, *Language and Cinema* (trans. Donna Jean Umiker-Sebeok [The Hague: Monton, 1974]), 105.

5. A language system is a—theoretically envisaged—group of codes that employs similar types of signifiers. Thus, painting, as a language system, employs color and shape; music employs sound.

6. Metz makes a distinction between language system and textual system. A language system is a theoretical construct, an accumulation of codes that are specific to a particular medium, such as painting or theater. A textual system is a materialization of a language system, an actual text or film, for example (78). In contrast to the language system, the textual system may contain signifiers that are not similar to each other. In other words, the textual system can employ codes from different language systems.

7. Metz, *Language and Cinema*, 99.

8. The methodology is described in detail in Hahn's book *Het zout in de pap: Levensbeschouwing en televisie* (Hilversum: Gooi en Sticht bv, 1988). A summary is given in Hahn's article "A Methodology for Finding the Filmmaker's Weltanschauung in Religious Film", in J. R. May (ed.), *New Image of Religious Film* (Kansas City: Sheed & Ward, 1997), 213–234.

9. *Het zout in de pap*, 127. Hahn bases his concept on Seymour Chatman's theory of narrative, as laid out in his book, *Story and Discourse: Narrative Structure in Fiction and Film* (Ithaca: Cornell University Press, 1978).

10. Hahn defines units as "the smallest combination of shots that yields an internal significance" ("A Methodology for Finding the Filmmaker's Weltanschauung," in *New Image of Religious Film,* ed. John R. May. Communication, Culture and Theology [Kansas City: Sheed and Ward, 1997], 224).

CHAPTER 1

1. Jean-Paul Sartre, *Being and Nothingness: An Essay on Phenomenological Ontology,* trans. Hazel E. Barnes (London: Routledge, 1969).

2. Ibid., 252–256.

3. In this discussion of Sartre's approach, I use "his" when referring to the Other because Sartre uses the male personal pronoun throughout when he is referring to the Other.

4. Sartre, *Being and Nothingness*, 256.

5. Ibid., 268. The translation uses the term "objectivation" throughout.

6. Sartre, *Being and Nothingness*, 257–258.

7. Ibid., 258.

8. Ibid.

9. Ibid., 259.

10. Ibid., 288. Other responses to the look of the Other are, according to Sartre, fear, pride, and a recognition of my slavery (*Being and Nothingness*, 268).

11. Sartre, *Being and Nothingness*, 276.

12. Ibid.

13. Ibid., 277.

14. Ibid., 278.

15. Ibid., 259–260.

16. Ibid., 262.

17. Ibid., 270.

18. Ibid., 260.

19. Ibid., 274–275.

20. Ibid., 261.

21. Ibid., 267.

22. Ibid., 263.

23. Michel Foucault, *Discipline and Punish: The Birth of the Prison*, trans. Alan Sheridan (Harmondsworth: Penguin, 1979).

24. Ibid., 200. With *Discipline and Punish*, Foucault builds on two of his earlier works, which also consider vision in relation to institutions of society. In *Madness and Civilization* (trans. Richard Howard [London: Tavistock Publications, 1967]), Foucault looks at the psychiatric tradition of observing patients and makes the point that, in the classical age, "madness" has become something to be looked at. *The Birth of the Clinic* (trans. A. M. Sheridan Smith [London: Tavistock Publications, 1973]) examines the gaze in medical institutions, arguing that the penetrating, medical gaze into the dead human body allowed the modern science of the individual to develop. For an insightful discussion of these and other of Foucault's works, see Martin Jay, *Downcast Eyes: The Denigration of Vision in Twentieth-Century French Thought* (Berkeley: University of California Press, 1994), 381–434.

25. Foucault, *Discipline and Punish*, 198–199.

26. Ibid., 197.

27. Ibid., 198.

28. Ibid., 199.

29. Where Sartre's distinction is between the eye and the look, Lacan's is between the eye and the gaze.

30. Foucault, *Discipline and Punish*, 201.
31. Ibid.
32. Ibid., 202.
33. Ibid., 201.
34. Ibid.
35. Ibid., 202–203.
36. In this respect, Foucault differs from Sartre, who argues that an object can never give to itself its own object state (see the section on Sartre above).
37. Foucault, *Discipline and Punish*, 205.
38. Ibid., 205–206.
39. Ibid., 210–211.
40. Ibid., 211–212.
41. Ibid., 213–215.
42. Ibid., 216.
43. Ibid., 200.
44. In his study of Foucault's concept of vision, Martin Jay, quoting from one of Foucault's last interviews, makes the point that Foucault was interested solely in the analysis of problems, and never searching for any alternatives or solutions to the "problem" of vision (*Downcast Eyes*, 416). Also, Jay states that Foucault did not consider language a better form of relating than vision. This point becomes clear in Foucault's study of the writer Raymond Roussel (*Downcast Eyes*, 399).
45. Lacan is a psychoanalyst in the Freudian tradition. A number of his thoughts on vision are outlined in his lectures on the gaze, which form part of his *The Four Fundamental Concepts of Psychoanalysis* (ed. Jaques-Alain Miller, trans. Alan Sheridan [London: Hogarth Press, 1979]).
46. In Lacan's terminology, the concept of the phallus stands for what the I desires but can never reach. Like the gaze, it is an unattainable object in comparison with which the I perceives itself as lacking. The term of the phallus will be explored in more detail in chapter 7 of this book.
47. Lacan, *Four Fundamental Concepts*, 72–73.
48. Ibid., 72.
49. Ibid., 74.
50. Ibid., 75.
51. What Lacan describes as "geometral" vision coincides with the technique of linear perspective, which was introduced during the Renaissance, and which functions by imagining lines that lead from objects within the field of vision back to the perceiving eye as a center in which all lines converge. The technique has often been seen as symbolic of a Cartesian view of the individual as at the center of the surrounding world.
52. Lacan, *Four Fundamental Concepts*, 86–87.

53. Ibid., 87.

54. Ibid., 88–89.

55. Ibid.*cepts,* 89.

56. Ibid., 95.

57. Ibid., 96.

58. Lacan recounts that, at the time when he felt "seen" by the can on the surface of the sea, he also felt that he did not fit into the community of fishermen, in which he had this experience (*Four Fundamental Concepts,* 95–96).

59. Like Sartre, Lacan always speaks of the subject in the male form only.

60. Lacan, *Four Fundamental Concepts,* 100.

61. Ibid., 83.

62. Ibid., 84.

63. Ibid., 85.

64. Ibid., 111.

65. Ibid., 115.

66. Lacan argues that seeing is closely related to envy because the word for envy, "invidia," is derived from the word for seeing, "videre" (*Four Fundamental Concepts,* 115–116).

67. Lacan, *Four Fundamental Concepts,* 115.

68. Ibid., 118–119. The question was asked by F. Wahl in relation to the Mediterranean tradition of prophylactic eyes, which have a protective function.

69. Emmanuel Levinas, *Totality and Infinity: An Essay on Exteriority* (trans. Alphonso Lingis [Dordrecht, Boston, London: Kluwer Academic Publishers, 1991]), 35–40.

70. Ibid., 39.

71. Ibid., 40.

72. Ibid., 80.

73. Ibid., 38–39.

74. Ibid., 191.

75. Ibid., 189.

76. Ibid., 191.

77. Ibid., 194.

78. Ibid., 124.

79. Ibid., 123–124.

80. Ibid., 39.

81. Like Sartre and Lacan, Levinas always refers to the subject in the male only.

82. Levinas, *Totality and Infinity,* 50–51.

83. Ibid., 51.

84. Ibid.

85. Ibid., 195.

86. Ibid., 197–201.

87. Ibid., 194.

CHAPTER 2

1. Molly Haskell, *From Reverence to Rape: The Treatment of Women in the Movies* (Chicago: University of Chicago Press, 1987), 40. For the critique that film offers too few, too stereotypical roles for women see also Sharon Smith's article, "The Image of Women in Film: Some Suggestions for Future Research" (In *Feminist Film Theory: A Reader,* ed. Sue Thornham [Edinburgh: Edinburgh University Press, 1999]), 14–19.

2. Haskell, *From Reverence to Rape,* 12.

3. Claire Johnston, "Women's Cinema as Counter-Cinema," in *Feminist Film Theory: A Reader,* ed. Sue Thornham (Edinburgh: Edinburgh University Press, 1999), 33.

4. Laura Mulvey, "Visual Pleasure and Narrative Cinema," in *Feminist Film Theory: A Reader,* ed. Sue Thornham (Edinburgh: Edinburgh University Press, 1999), 63.

5. Ibid., 64–65. For a more detailed analysis of film on the basis of psychoanalytic theories, see Kaja Silverman's book, *The Acoustic Mirror: The Female Voice in Psychoanalysis and Cinema* (Bloomington: Indiana University Press, 1988), which I treat in more depth in chapter 7.

6. Mary Ann Doane, "Film and the Masquerade: Theorising the Female Spectator," in *Feminism and Film,* ed. E. Ann Kaplan. Oxford Readings in Feminism (Oxford: Oxford University Press, 2000), 422.

7. Ibid., 420.

8. Ibid., 421.

9. I outlined earlier how both Sartre and Levinas argue that when seen, the I becomes an object in the world of the one who sees. Lacan and Foucault make the point that the seen I is entirely determined in its identity through the gaze of the Other.

10. Mulvey, "Visual Pleasure," 64.

11. Laura Mulvey, "Afterthoughts on 'Visual Pleasure and Narrative Cinema' Inspired by King Vidor's *Duel in the Sun* (1946)," in *Feminist Film Theory: A Reader,* ed. Sue Thornham (Edinburgh: Edinburgh University Press, 1999), 124–125. For a response to Mulvey's "Visual Pleasure" that considers the question how a film can conceptualize its viewers as female, see Teresa de Lauretis's article, "Aesthetic and Feminist Theory: Rethinking Women's Cinema" (in *Female Spectators: Looking at Film and Television,* ed. Deidre E. Pribram. Questions for Feminism. London: Verso, 1988).

12. See for example Mary Ann Doane, *The Desire to Desire: The Woman's Film of the 1940s* (London: Macmillan, 1987).

13. Ibid., 16.

14. Mary Ann Doane, "Woman's Stake: Filming the Female Body" (In *Feminism and Film,* ed. E. Ann Kaplan. Oxford Readings in Feminism. Oxford: Oxford University Press, 2000), 96–98.

15. *Riddles of the Sphinx* (Laura Mulvey and Peter Wollen, 1977).

16. Doane, "Woman's Stake," 90–94.

17. Ibid., 94.

18. Ibid., 96.

19. E. Ann Kaplan, *Women and Film: Both Sides of the Camera* (London: Routledge, 1993), 26–30.

20. Ibid., 30.

21. Alison Butler, "Feminist Theory and Women's Films at the Turn of the Century," *Screen* 41, no. 4 (Spring 2000): 75.

22. Ibid., 74.

23. B. Ruby Rich, *Chick Flicks: Theories and Memories of the Feminist Film Movement* (Durham, N.C.: Duke University Press, 1998), 5.

24. Ibid., 379.

25. See especially Judith Butler's books *Gender Trouble: Feminism and the Subversion of Identity* (London: Routledge, 1990) and *Bodies that Matter: On the Discursive Limits of "Sex"* (London: Routledge, 1993). For treatments of gender in film see Harry M. Benshoff and Sean Griffin, *America on Film: Representing Race, Class, Gender, and Sexuality at the Movies* (Oxford: Blackwell, 2004); Anu Koivunen, *Performative Histories, Foundational Fictions: Gender and Sexuality in Niskavuori Films* (Helsinki: Finnish Literature Society, 2003); Jun Xing and Lane Ryo Hirabayashi, *Reversing the Lens: Ethnicity, Race, Gender, and Sexuality through Film* (Boulder: University Press of Colorado, 2003); John D. Erickson, Lynn A. Higgins, Dalton Krauss, and Steven Ungar, *Gender and French Film since the New Wave* (Lexington: University of Kentucky, 2002); Murray Pomerance, *Ladies and Gentlemen, Boys and Girls: Gender in Film at the End of the Twentieth Century* (Albany: State University of New York Press, 2001); Jude Davies and Carol R. Smith, *Gender, Ethnicity and Sexuality in Contemporary American Film* (Chicago: Fitzroy Dearborn, 2000); Elzbieta Oleksy, Elzbieta Ostrowska, and Michael Stevenson, *Gender in Film and the Media: East-West Dialogues* (Frankfurt am Main: Peter Lang, 2000); Yvonne Tasker, *Working Girls: Gender and Sexuality in Popular Cinema* (London: Routledge, 2000); and Carolyn A. Durham, *Double Takes: Culture and Gender in French Films and Their American Remakes* (Hanover, NH: University Press of New England, 1998).

 For treatments of gay and lesbian films see Gary P. Cestaro, *Queer Italia: Same-Sex Desire in Italian Literature and Film* (New York: Palgrave Macmillan, 2004); and Ruth Vanita, *Queering India: Same-Sex Love and Eroticism in Indian Culture and Society* (London: Routledge, 2002).

26. Butler, "Feminist Theory and Women's Films," 75.

27. Ibid.

28. For this reason, Rich's book is presenting recollections of women's filmmaking (*Chick Flicks*, 1–6). Butler, too, discusses individual films

in order to safeguard the memory of actual films made by women ("Feminist Theory and Women's Films," 76–77).

29. Rich, *Chick Flicks,* 387.

30. I share the interest in an ethics of seeing with S. Brent Plate. In his article "Religion/Literature/Film: Toward a Religious Visuality of Film" (*Literature and Theology* 12 [March 1998]), he points out the necessity of an "ethics of vision," using Kaja Silverman's work as an example of a development in this direction (Silverman's work will be discussed later in this book). The understanding of seeing to be put forward in this present book should be another development in the direction that Plate has indicated (although naturally not fully developed) in his article ("Religion/Literature/Film," 32–33). Plate repeats the need for an ethics of seeing in a later article, but again does not fully develop what this might mean ("The Re-creation of the World: Filming Faith," *Dialog: A Journal of Theology* 42, no. 2 [Summer 2003]).

Chapter 3

1. See for example Isabel Carter Heyward, *The Redemption of God: A Theology of Mutual Relation* (Lanham: University Press of America, 1982); Mary E. Hunt, *Fierce Tenderness: A Feminist Theology of Friendship* (New York: Crossroad, 1992); Mary Grey, Redeeming the Dream: Feminism, Redemption and Christian Tradition (London: SPCK, 1989); Elisabeth Moltmann-Wendel, *Rediscovering Friendship: Awakening to the Power and Promise of Women's Friendships* (trans. John Bowden. Minneapolis: Fortress Press, 2001).

2. For this approach see especially Sallie McFague's books: *Metaphorical Theology: Models of God in Religious Language* (London: SCM Press, 1982) and *Models of God* (Philadelphia: Fortress Press, 1988).

3. See especially Heyward, *The Redemption of God,* 34–44. Heyward uses the term "functional Christology" (*The Redemption of God,* 34) in order to describe the shift of interest from Christ's essence to the relationships of the biblical Jesus. See also Elisabeth Moltmann-Wendel, *A Land Flowing with Milk and Honey* (London: SCM Press, 1986), 117–148.

4. The film is based loosely on the life of the Italian Renaissance painter Artemisia Gentileschi.

5. "In the beginning is the relation" (Martin Buber, *Ich und Du* [Leipzig: Insel Verlag, 1923], 25). All translations of German and French language quotations in this book are my own. For writings of feminist theology that make reference to Buber, see Hunt, *Fierce Tenderness,* 11; Grey, *Redeeming the Dream,* 32; Heyward, *The Redemption of God,*1; Mary Daly, *Beyond God the Father* (London: Women's Press, 1986, 39, 178); Daphne Hampson, *After Christianity* (London: SCM Press, 1996, 240–241).

6. Grey, *Redeeming the Dream.* Rosemary Radford Ruether, in her book *Women and Redemption: A Theological History* (London: SCM Press, 1998), places her emphasis differently. She considers redemption in terms of the dissolution of gender hierarchy, expressed in the early Christian hope that there will be no male and female in the community of the baptized (Gal. 3: 27–28).

7. Grey, *Redeeming the Dream,* 31; George Eliot, *The Mill on the Floss* (London: Penguin, 1965), 365.

8. Grey, *Redeeming the Dream,* 31.

9. Ibid., 32. Even though I find Grey's emphasis on relation as the basis of the world very appealing, I think it is not really necessary to use systems theory in order to argue her viewpoint. Systems theory is trying to "prove" relation as the basis of the world, using sometimes pseudoscientific arguments based on energy patterns between atomic particles. Grey's statement that the world is relational at its core is a particular worldview and does not need to be argued at the level of "science," and not with the use of a theory that advocates a particular worldview but disguises it as "science."

10. Grey, *Redeeming the Dream,* 34. Daly, too, is inspired by process thought. She criticizes patriarchal theology for separating "being" from "becoming" and thus considering "being" as static and timeless. In process thought, by contrast, being is one with becoming and a God imagined in those terms does not "have" a being that preexists creation but "is" in becoming creation (Daly, *Beyond God the Father,* 188).

11. Grey, *Redeeming the Dream,* 34.

12. See for example Mary C. Grey, *Sacred Longings: Ecofeminist Theology and Globalization* (London: SCM Press, 2003); Anne Primavesi, *Sacred Gaia: Holistic Theology and Earth System Science* (London: Routledge, 2000); and Rosemary Radford Ruether, *Gaia and God: An Ecofeminist Theology of Earth Healing* (San Francisco: HarperSan-Francisco, 1992). "Relation" has also remained an important factor in other areas of feminist theology. Natalie K. Watson's ecclesiology, for example, presents an understanding of the sacraments as both enabling and expressing the relation among members of the faith community, as well as between the faith community and God (*Introducing Feminist Ecclesiology,* Introductions in Feminist Theology 10. Sheffield: Sheffield Academic Press, 2002, 81).

13. Grey, *Redeeming the Dream,* 35, and also McFague, *Models of God,* 69–78. Later in this chapter, I will discuss in more detail ways of seeing the relation between God and world.

14. Grey, *Redeeming the Dream,* 35. For a more detailed discussion of human creativity see below in this chapter. The idea of the world as God's body is also prominent in Sallie McFague's book, *The Body of God: An Ecological Theology* (Minneapolis: Fortress Press, 1993).

15. The emphasis on redemption as being in relation is prevalent in some writings on Christology from a feminist viewpoint. Traditionally, the

idea of redemption is, in Christianity, linked to the belief in Jesus Christ. His life, death, and resurrection are thought to be crucial for the world to be redeemed. Feminist writers have moved away from the traditional emphasis on the person of Jesus, claiming that it is the community initiated by Jesus that is redemptive. In this view, redemption becomes an ongoing process and human beings have a responsibility and a potential to bring it about by being in relation. For concepts that emphasize the redemptive nature of the Christian community see, for example, Rita Nakashima Brock, *Journeys by Heart: A Christology of Erotic Power* (New York: Crossroad, 1988); Rosemary Radford Ruether, *Sexism and God-Talk* (London: SCM Press, 1986), 138; Mary Grey, "Jesus—Einsamer Held oder Offenbarung beziehungshafter Macht? Eine Untersuchung feministischer Erlösungsmodelle" (In *Vom Verlangen nach Heilwerden: Christologie in feministisch-theologischer Sicht*, ed. Doris Strahm and Regula Strobel [Fribourg: Edition Exodus, 1991]); Lisa Isherwood, *Introducing Feminist Christologies*, 124–130. See also Elisabeth Schüssler Fiorenza's introduction of the term "Ekklēsia of Wo/men" in order to indicate an alternative space for a community from which liberating Christologies can be articulated (*Jesus, Miriam's Child Sophia's Prophet: Critical Issues in Feminist Christology* [London: SCM Press, 1995], 24–31).

16. "Right relation" is used, for example, by Hunt (*Fierce Tenderness*, 87).

17. Moltmann-Wendel, *A Land flowing with Milk and Honey*, 117–124. Mary Ann Tolbert relativizes this opinion by pointing out that Jesus can be reluctant in learning from women, as is the case in Mk 7:24–30 ("Mark," in *The Women's Bible Commentary*, ed. Carol A. Newsom and Sharon H. Ringe [London: SPCK, 1992], 268–269).

18. Moltmann-Wendel, *A Land flowing with Milk and Honey*, 124–127. For a similar view on the mutuality of Jesus's relationships in Mark's Gospel, see Elisabeth Moltmann-Wendel, "Beziehung–die vergessene Dimension der Christologie: Neutestamentliche Ansatzpunkte feministischer Christologie" (In *Vom Verlangen nach Heilwerden: Christologie in feministisch-theologischer Sicht*, ed. Doris Strahm and Regula Strobel [Fribourg: Edition Exodus, 1991]). It should be noted, however, that the Gospel of Mark does not have Jesus treat all women positively. Jesus's mother, for example, is treated in a negative way by Jesus and depicted in a negative light in this gospel (Tolbert, "Mark," 271–272).

19. Radford Ruether, *Sexism and God-Talk*, 135.

20. Ibid., 136.

21. McFague, *Models of God*, 49–57.

22. Hampson, *After Christianity*, 52–69, especially 61. For a similar view of biblical texts see J. Cheryl Exum, *Fragmented Women: Feminist (Sub)Versions of Biblical Narratives* (Journal for the Study of the Old Testament Supplement Series 163 [Sheffield: JSOT Press, 1993]).

23. Hampson, *After Christianity*, 68.

24. Ibid., 69.

25. Radford Ruether, in discussing Augustine and Thomas Aquinas, explains that, in their view, the man was made in God's image while the woman was a deficient man (*Sexism and God-Talk*, 47–71, 94–99). Catharina Halkes, in her book *New Creation: Christian Feminism and the Renewal of the Earth* (London: SPCK, 1991), shows that, in patriarchy, women are identified with nature, slaves, and savages, and, together with them, represent the inferior Other to men (10–73).

26. Radford Ruether, *Sexism and God-Talk*, 54.

27. For a discussion along similar lines of dualistic thinking see Halkes, *New Creation*, 10–18.

28. Daly, *Beyond God the Father*, 74–75.

29. Ibid., 75.

30. Tina Beattie, *New Catholic Feminism: Theology and Theory* (London: Routledge, 2006, 187–289).

31. Ibid., 270.

32. Daly, *Beyond God the Father*, 97.

33. While Daly was right in saying that "motherhood" should not act as a stereotype for what it means to be a woman, it has to be noted that women's potential for motherhood has been recovered in a positive sense as giving women a unique role in shaping the destiny of the world. Beverly J. Lanzetta writes: "Women are wed to creation, being the guardian of its life-giving function and the creatrix of human birth. Women thus have an immediate stake in its wellness, integrity, and destiny. Women have a covenantal relationship with the flourishing and preservation of the body of God in creation." (*Radical Wisdom: A Feminist Mystical Theology*. [Minneapolis: Fortress Press, 2005], 166).

34. Mary Shawn Copeland, "Differenz als Kategorie in kritischen Theologien für die Befreiung von Frauen"(*Concilium* 1 [1996]), 102.

35. Ibid., 103.

36. "Rather, difference gets going a struggle for life in its uniqueness, variation and fullness; difference is a festive option for life in all its integrity, in all its distinctiveness" (Copeland, "Differenz," 104).

37. Copeland, "Differenz," 104.

38. Ibid., 108.

39. SchusslerShould be spelt "Schüssler" Fiorenza, *Jesus, Miriam's Child*, 24.

40. Grace Jantzen, *Becoming Divine: Towards a Feminist Philosophy of Religion* (Manchester: Manchester University Press, 1998), 241.

41. Ibid., 246.

42. Hampson, *After Christianity*, 231–232.

43. McFague, *Models of God*, 76.

44. Hampson, *After Christianity*, 231.

45. Ibid., 233.

46. Ibid., 238.
47. Ibid., 239.
48. Ibid., 250.
49. Halkes refers to the old, Christian tradition of regarding the body as a temple of the Holy Spirit (*New Creation*, 156, see also 1 Cor 6: 19). She credits McFague's *Models of God* as inspiration to her dream of the presence of the God-Other within the human self. I will return to the thought that the world is God's body later in this chapter.
50. As regards the act of seeing, I will argue later that a way of seeing that is beneficial to the seen person will, while appreciating the Other's visibility, always be aware of the Other's invisible side as well, of the fact that the Other's physicality is not all there is to her or him, and of the fact that no image can fully contain the Other.
51. Grey, *Redeeming the Dream*, 61.
52. Ibid., 25–28.
53. Ibid., 21.
54. Ibid., 61. In her book *Introducing Feminist Images of God* (Introductions in Feminist Theology 7 [Sheffield: Sheffield Academic Press, 2001]), Grey finds very adequate words to express both the danger of role-stereotyping, as well as the immense value of the qualities of compassion, empathy, relating, caring, and nurturing: "Women, because of role socialization, gender stereotyping, and because of the long-rooted conviction that these qualities are crucial to human flourishing, have been carrying the torch in society for qualities and responsibilities which belong to the whole human race" (*Introducing Feminist Images of God*, 23).
55. See Daly's critique of stereotyping mentioned earlier in this chapter.
56. Daly, *Beyond God the Father*, 60.
57. Radford Ruether, *Sexism and God-Talk*, 185.
58. Elisabeth Gössmann, Should be spelt "Gössmann" "Das Konstrukt der Geschlechterdifferenz in der christlichen theologischen Tradition" (*Concilium* 6 [1991]), 483.
59. Ina Praetorius, "Auf der Suche nach der conditia feminina"(*Concilium* 6 [1991]), 451.
60. Hampson, *After Christianity*, 169. See Simone de Beauvoir, *The Second Sex* (trans. H. M. Parshley. London: Cape, 1953).
61. Schüssler Fiorenza, *Jesus, Miriam's Child*, 55. In her study on ecclesiology, Natalie K. Watson points out that women much more often than men take on the role of creating community through the preparation of meals. This mostly female-owned, community-building act, however, is not adequately recognized by Christian churches, which devalue it by substituting it with the male-defined sacrament of the Eucharist (*Introducing Feminist Ecclesiology*, 88–89).
62. Schüssler Fiorenza, *Jesus, Miriam's Child*, 56. Schüssler Fiorenza prefers the term "kyriarchy" over "patriarchy" because it shows more clearly the fact that patriarchy is not the domination of all women by

all men, but the rule of an emperor, master, lord, father or husband over his subordinates (*Jesus, Miriam's Child*, 14). The term was introduced earlier in Schüssler Fiorenza's *But She Said: Feminist Practices of Biblical Interpretation* (Boston, MA: Beacon Press, 1992).

63. Grey, *Redeeming the Dream*, 24.
64. See Rebecca S. Chopp, "Evas Wissen" (*Concilium* 1 [1996]), 85, in which Chopp refers to Valerie Saving Goldstein's article, "The Human Situation: A Feminine Viewpoint" (in *The Nature of Man*, ed. Simon Doniger [New York: Harper, 1962]).
65. Moltmann-Wendel, *A Land Flowing with Milk and Honey*, 160–165. See also her book, *I am My Body: New Ways of Embodiment* (trans. John Bowden [London: SCM Press, 1994]).
66. Daly, *Beyond God the Father*, 54.
67. Hampson, *After Christianity*, 145.
68. Grey, *Redeeming the Dream*, 5–6.
69. Lanzetta, *Radical Wisdom*, 168–170.
70. Carol Christ has been among the most vocal defenders of goddess religion (see especially her article, "Why Women Need the Goddess: Phenomenological, Psychological and Political Reflections," in *Womanspirit Rising: A Feminist Reader in Religion*, ed. Carol Christ and Judith Plaskow [New York: Harper & Row, 1979]).
71. Moltmann-Wendel, *A Land Flowing with Milk and Honey*, 181–201. Moltmann-Wendel explains that even though the number of women witnessing the resurrection differs in the Gospel accounts, the artistic motif common until the fourteenth century always represents the group as three women (*A Land Flowing with Milk and Honey*, 188–191).
72. Grey, *Redeeming the Dream*, 156. It will become clear in chapter 6 that *Artemisia* questions Grey's argument here. The identification of Artemisia with Judith is not liberating but stereotyping.
73. Hampson, *After Christianity*, 68.
74. See her book, *Fragmented Women*.
75. Green refers to Irigaray's argument that women need a female, divine figure in order to reach transcendence ("Das Denken der Geschlechterdifferenz und die Theologie," *Concilium* 1 [1996], 91; see also Luce Irigaray, *Divine Women* [Sydney: Local Consumption Publications, 1986]).
76. Green, "Das Denken der Geschlechterdifferenz," 93.
77. In chapter 7 of this book, I discuss the concept of the self-same body as the governing principle of Lacan's concept of self in relation to the work of Kaja Silverman.
78. Green's discussion is reminiscent of Laura Mulvey's discussion of transgender identification of female viewers of Hollywood films with male heroes, outlined in chapter 2. Mulvey makes the point that transgender identification of women is not a matter of choice but of necessity. In "Visual Pleasure and Narrative Cinema" (in *Feminist*

Film Theory: A Reader, ed. Sue Thornham [Edinburgh: Edinburgh University Press, 1999]), she argues that women have no place in cinema because they cannot identify as women with either male or female characters in a film. Identification with male heroes constructs female viewers as male and identification with female characters is self-destructive, since female characters in Hollywood films are portrayed as powerless and dominated by the males' looks. In her article "Afterthoughts on 'Visual Pleasure and Narrative Cinema' Inspired by King Vidor's *Duel in the Sun* (1946)" (in *Feminist Film Theory: A Reader,* ed. Sue Thornham [Edinburgh: Edinburgh University Press, 1999]), a reaction to "Visual Pleasure," Mulvey changes her argument, acknowledging the possibility of pleasurable transgender identification of women with the male hero. But the lack of female figures for identification remains a problem.

79. "The text is body, and the body of a being is text, and a deep relation can happen between both." (Elsa Tamez, "Das Leben der Frauen als heiliger Text," *Concilium* 3 [1998], 289).

80. Tamez, "Das Leben der Frauen," 292.

81. See chapter 7 for a discussion of the idea of the self-same body.

82. Heyward, *The Redemption of God,* 9.

83. Ibid., 150–153.

84. Ibid., 149–172.

85. Grey, *Redeeming the Dream,* 5.

86. Ibid., 47. Hampson opposes this view of redemption. She argues with Schleiermacher that human beings do not interact with God because God is the foundation of their being (*After Christianity,* 217). People are dependent on God but God is not dependent on people in the same way (216). In this view, it seems there is no need for people to participate in and bring about redemption.

87. Radford Ruether, *Sexism and God-Talk,* 154.

88. In this understanding, the term "incarnation" refers not just to the presence of God in one human being, Jesus Christ, but to the presence of God in all of created reality. To restrict the presence of God to the incarnation in the figure of Jesus Christ equals, according to Mary Grey, a cheapening of the metaphor of incarnation (*Introducing Feminist Images of God,* 73).

89. McFague, *Models of God,* 72.

90. Ibid., 101–116.

91. Ibid., 109. See also McFague's article, "Mutter Gott" (*Concilium* 6 [1993], 546–547).

92. Johanna Kohn-Roelin, "Mutter. Tochter. Gott,"*Concilium* 6 (1993): 497.

93. Ibid., 498.

94. Ibid., 500.

95. Ibid.

96. Ursula King, "Das Göttliche als Mutter," *Concilium* 6 (1993): 543.

97. Ibid., 541.

98. Green, "Das Denken der Geschlechterdifferenz," 90.

99. Ibid., 91.

100. Rosemary Radford Ruether, "The God of Possibilities: Immanence and Transcendence Rethought," *Concilium* 4 (2000): 45–48.

101. The concept of the sacramental character of the world has been especially important within Catholic theology. Tina Beattie, for example, focuses especially on the sacramentality of the human body and argues that female and male bodies are equally able to represent the divine (see her chapter "Redeeming Sacramentality" in *New Catholic Feminism*, 290–311).

102. Halkes, *New Creation*, 152. Halkes also argues this point earlier in *New Creation* (91).

103. Grey, *Sacred Longings*, 166.

104. Ibid., 167.

105. See for example Anne Marie Hunter, "Numbering the Hairs of our Heads: Male Social Control and the All-Seeing Male God" (*Journal of Feminist Studies in Religion* 8, no. 2 [Fall 1992], 10–14). See also Cynthia Eller, who concludes that in order to change the imbalance between female visibility and male invisibility, artists need to direct their look more at the male body ("Divine Objectification: The Representation of Goddesses and Women in Feminist Spirituality," *Journal of Feminist Studies in Religion* 16, no. 1 [Spring 2000], 37–38).

106. Hunter, "Numbering the Hairs," 14. See also Eller, who argues that in Western culture, the invisible position is powerful, whereas the visible one is powerless ("Divine Objectification," 41).

107. Hunter, "Numbering the Hairs," 10–14.

108. Ibid., 21–22. See also Eller, who mentions the theory that women are split internally between a viewing subject and a viewed object ("Divine Objectification," 31–32).

109. The expression "The Absent One" for the position behind the camera is used by Jean-Pierre Oudart in "Cinema and Suture" (*Screen* 18, no. 4 [Winter 1977/78]), 36.

110. Mulvey explains various narrative and camera techniques that Hollywood film uses to hide the fact that male viewers in the cinema do not own the gaze. The films try to satisfy the needs of the male ego by making male spectators believe they own the power of the look (Mulvey, "Visual Pleasure," 63–64).

111. See below for Elizabeth A. Pritchard's explanation why the invisible God still appears to be male.

112. Elizabeth A. Pritchard, "Feminist Theology and the Politics of Failure" (*Journal of Feminist Studies in Religion* 15, no. 2 [Fall 1999]), 52.

113. Ibid., 55–58.

114. Ibid., 58.

115. Ibid., 59.
116. Ibid., 61.
117. Eller, "Divine Objectification," 37–38.
118. Ibid., 39–40.
119. Ibid., 39.
120. Judith Butler, *Bodies that Matter: On the Discursive Limits of "Sex"* (London: Routledge, 1993), 67.
121. Ibid., 69.
122. Ibid., 67.
123. Pritchard, "Feminist Theology," 63–67.
124. Ibid., 63.
125. Anne Daniell, "The Spiritual Body: Incarnations of Pauline and Butlerian Embodiment Themes for Constructive Theologizing toward the Parousia" (*Journal of Feminist Studies in Religion* 16.1 [Spring 2000]), 18–19.
126. Pritchard, "Feminist Theology," 66.
127. She states: "I wanted to show how at root, social dancing is a philosophical enquiry into the nature of the eternal other" (Sally Potter, *The Tango Lesson* [London: Faber and Faber, 1997, x), and expresses her opinion "that Martin Buber and the early Jewish mystics have more to say about the nature of the tango than any modern dance critic (see I and Thou)" (xii).

CHAPTER 4

1. This biographical information is based on Angelo Caranfa, *Camille Claudel: A Sculpture of Interior Solitude* (Lewisburg: Bucknell University Press, 1999), 21–47. Caranfa dates Claudel's first meeting with Rodin around 1883, whereas the film dates it in 1885.
2. This information is based on Odile Ayral-Clause, *Camille Claudel: A Life* (New York: Harry N. Abrams, 2002), 96. It has to be said that the relationship between Claudel and Rodin is surrounded by a lot of uncertainty. Ayral-Clause, for example, suggests that Claudel enjoyed a stable relationship with Rodin in the year 1891 (*Camille Claudel*, 104–106), while Caranfa assumes that by the year 1888, their relationship was already showing signs of the coming end (*Camille Claudel*, 34). Reine-Marie Paris, Claudel's grand-niece, author of a biography on Claudel as well as collector of her works, gives the years 1884–1890 as the duration of the relationship between Claudel and Rodin (Interview with Reine-Marie Paris, *Le Journal des Femmes* [January 2004]. http://www.linternaute.com/femmes/itvw/0401rmparis.shtml).
3. While being with Claudel, Rodin had also been in a relationship with his long-time partner, Rose Beuret, with whom he had a son. Rodin was unable to decide between Claudel and Beuret, and his indecisiveness is often seen as the reason why Claudel broke with Rodin.

Paris states that Claudel left Rodin because she wanted to work on her own, independent of his influence (Interview with Reine-Marie Paris). This view coincides with Caranfa's analysis of Claudel's artistic style (see note 4).

4. Caranfa analyzes Claudel's style in opposition to that of Rodin and in relation to the literary work written by her brother, Paul Claudel (*Camille Claudel*, 88–113). Caranfa also makes the point that Rodin and Claudel's relationship broke up mainly because their artistic styles and visions had become irreconcilable, and Claudel's sculpture was clearly going in a direction very different from that of Rodin (*Camille Claudel*, 35–36).

5. Anne Delbée, *Une Femme* (Paris: Presses de la Renaissance, 1982).

6. Reine-Marie Paris, *Camille Claudel 1864–1943* (Paris: Gallimard, 1984); *Camille Claudel* (Washington, D.C.: National Museum of Women in the Arts, 1988).

7. Caranfa, *Camille Claudel*, 23.

8. In this sense, *Camille Claudel* differs from *Artemisia*, which, as will be discussed later, diverts from historical fact by representing the relationship between Artemisia and her painting teacher as a love relationship.

9. Rodin is quoted to have said these words by his friend and art dealer, Mathias Morhardt (quoted in Ayral-Clause, *Camille Claudel*, 50).

10. Roger Ebert, "Camille Claudel," *Chicago Sun-Times*, March 9, 1990. http://rogerebert.suntimes.com/apps/pbcs.dll/article?AID=/19900309/REVIEWS/3090302/1023. In this, the film can be seen as partly paralleling a trend within liberal, feminist art criticism. L. Ryan Musgrave points out that much of this kind of art criticism concentrates on the context of female art production, for example, on women's access to the learning of skills and on recognition, while neglecting to deal with the aesthetic characteristics of the works produced by women (see Musgrave, "Liberal Feminism, from Law to Art: The Impact of Feminist Jurisprudence on Feminist Aesthetics," *Hypatia* 18, no. 4 [Fall/Winter 2003]).

11. Rodin, for example, writes to Claudel, complaining about her silence: "My poor head is very sick, and I can't get up any more this morning. Last night, I wandered for hours in our favorite places without finding you. . . . Where are you going? To what suffering have I been destined? . . . I kiss your hands, my love, you give me such exalted and ardent enjoyment, near you my soul lives intensely and in its passionate love my respect for you is always above everything, the respect I have for your character, for you my Camille is a cause of my violent passion" (Ayral-Clause, *Camille Claudel*, 59–60). Claudel, on the other hand, writes to Rodin when she needs help and addresses him formally: "Monsieur Rodin, I have started a note for Mr. Gauchez and I got completely tied up in it. . . . Could you correct it please. . . . Return the corrected note as soon as possible otherwise Mr. Gauchez

will be mad at me again. Camille" (Ayral-Clause, *Camille Claudel*, 65). In contrast to the letter to Rodin, Claudel writes quite emotionally to a female friend, Florence Jeans: "When you left on Saturday, I felt a horrible void, I saw you everywhere . . . impossible for me to get used to the idea that you had left. . . . I will never forget my beautiful days with you in Shanklin, they are certainly the most pleasant ones of my life. Look, I have tears in my eyes just to think about it" (Ayral-Clause, *Camille Claudel*, 71).

12. Caranfa makes the important points that, in art interpretation, Claudel is perceived too little, that her work has not been integrated into the French artistic context as it should have been, and that, without good reason, her work is linked far too much with that of Rodin (and with her relationship with him) and needs to be disentangled from him (*Camille Claudel*, 9). Rather disappointingly, however, he proceeds instead to interpret Claudel's work not on its own terms but in terms of the work of another man, her brother, Paul. He treats Claudel's sculpture as a "visual expression" of her brother's poetry, which, in his interpretation, is needed in order to understand Claudel's sculpture (*Camille Claudel*, 12). To give Paul Claudel so much credit as a key to his sister's art seems slightly unfair, considering that Paul did little to support his sister during her time in the asylum, did not attend her funeral, and did not attempt to have her bones buried with the rest of the Claudel family, with the result that her mortal remains have been lost completely (see Ayral-Clause, *Camille Claudel*, 187–253).

13. I will discuss later on how these restrictions are also expressed in *Artemisia*.

14. Ayral-Clause, *Camille Claudel*, 102.

15. Ibid., 104.

16. The film shows an exhibition of Claudel's works, organized by Blot, at which she appears in eccentric garments, with heavy makeup and unrefined behavior. Upon Claudel's appearance, guests leave the exhibition, some saying that she is frightening.

17. By contrast, *Artemisia* allows its main character to look at the male body. This look, however, has its own problems, as will be shown below.

18. Ayral-Clause, *Camille Claudel*, 54.

19. Ibid., 54. Ayral-Clause also explains that the question of authorship was complicated even more in the case of Claudel and Rodin because of their personal relationship and because of the fact that they often used the same models (54).

20. Claudel suffered from persecution fantasies and from fears of being poisoned and was committed to the mental hospital Ville-Evrard for this reason. Her condition was much exacerbated through her isolation and lack of support from her family.

21. Ayral-Clause, *Camille Claudel*, 147–148.

22. Ibid., 140.

23. Caranfa, *Camille Claudel*, 41–42.

24. Ayral-Clause, *Camille Claudel*, 186.

25. Quoted in Ayral-Clause, *Camille Claudel*, 180.

26. Ayral-Clause quotes from various dictionaries that place Claudel's death in 1920, the latest one published in 1976 (*Camille Claudel*, 57, footnote 2).

CHAPTER 5

1. In many parts, the film follows historic records on Artemisia's life. The relationship between Tassi and Artemisia, however, is presented as a love relationship, even though the rape trial, which is based on historic records, still features in the film. In *Artemisia*, Tassi takes Artemisia's virginity unintentionally and Orazio later accuses him of having raped his daughter. According to the records of the rape trial, however, which still exist, Artemisia Gentileschi testified clearly during the trial that she was raped by Agostino Tassi, and that she tried to defend herself fiercely against his attack (see the translation of the historic records in Mary Garrard, *Artemisia Gentileschi: The Image of the Female Hero in Italian Baroque Art* [Princeton, New Jersey: Princeton University Press, 1989], 403–487).

2. My interpretation of *Artemisia* is based on a detailed film analysis that consisted of the following steps: (1) I examined the film's shots and then combined one or several shots into units. The resulting film script is included in Appendix 1. When referring to film scenes, I refer to the unit number of the film script in the appendix. (2) Regarding the film's contents, I analyzed the setting, the object relations within the pictures, and the dialogue. The setting and object relations give important clues to the three painters' relationships with their paintings and to the reality they paint. The dialogue provides an additional layer of meaning and further describes the relations between characters. (3) With regard to the film's form, I paid particular attention to the movements of the camera and to the positions it takes in relation to the filmed objects. It is important to examine how the camera looks at what is in front of it because, on the level of its contents, the film establishes the act of looking as one of its major themes.

3. Later in the film, the character Artemisia paints Gentileschi's *Judith Slaying Holofernes*. Like Artemisia's voice-over in unit 1, this painting, according to Mieke Bal's interpretation, represents arms and legs in striking similarity. Bal bases her interpretation of Gentileschi's painting on this similarity, using it to connect beheading with castration (see Bal's article "Head Hunting: 'Judith' on the Cutting Edge of Knowledge," *Journal for the Study of the Old Testament* 63 [September 1994]). I shall return to Bal's interpretation in chapter 6.

4. Below, I will use the voice-overs to describe Artemisia as an eyewitness of events that come to pass on her canvas.

5. This self-portrait in the film is a representation of a self-portrait by Artemisia Gentileschi, *Allegory of Painting*, which is part of the British Royal Art Collection.

6. The camera work will be examined in more detail below.

7. See the discussion of feminist film theory and of Mulvey's term in chapter 2.

8. For an explanation of this incident see below.

9. See chapter 2 for a discussion of how feminist film theory has treated the question how women can see.

10. See for example Christian Metz's book *The Imaginary Signifier: Psychoanalysis and the Cinema* (trans. Celia Britton et al. [Bloomington: Indiana University Press, 1982]) and Laura Mulvey's articles, "Visual Pleasure and Narrative Cinema" (in *Feminist Film Theory: A Reader*, ed. Sue Thornham [Edinburgh: Edinburgh University Press, 1999]) and "Afterthoughts on 'Visual Pleasure and Narrative Cinema' Inspired by King Vidor's *Duel in the Sun* (1946)" (in *Feminist Film Theory: A Reader*, ed. Sue Thornham [Edinburgh: Edinburgh University Press, 1999]).

11. Madan Sarup, *Jacques Lacan* (New York: Harvester Wheatsheaf, 1992) 48–49, and Sigmund Freud, "Der Untergang des Ödipuskomplexes" (in *Sexualleben*, Studienausgabe 5, ed. Alexander Mitscherlich, Angela Richards, and James Stratchey [Frankfurt am Main: S. Fischer Verlag, 1972]).

12. Sarup, *Jacques Lacan*, 48–49.

13. For a discussion of Ann Kaplan's concept of the dominance-submission pattern of a look see chapter 2.

14. In unit 17, Tassi scrutinizes different women as potential models while he discusses with Orazio their collaboration on the frescoes of a church.

15. For Claire Johnston's argument see chapter 2.

16. It is possible that the relationship begins even earlier, again with Artemisia's look. The man who makes love to the woman on the beach while Artemisia watches could be Tassi; his dark, curly hair looks much like Tassi's (unit 7).

17. This step in Artemisia's artistic development resembles the acquisition of symbolic competence in the development of a personality as seen by Lacan. Artemisia can be considered as passing from a perception of self as in immediate contact with surrounding objects to a perception of self as part of a symbolic system in which objects are designated by their absence (Sarup, *Jacques Lacan*, 53). The fact that it is Tassi who introduces Artemisia to symbolic representation makes the film appear traditional. The realm of symbolic representation is gendered male in Lacan's view, and *Artemisia* does not challenge this.

18. Tassi's defense thus misinterprets the apocryphal text. Judith is in the text not described as a criminal but as a heroine who saves her people (see Amy-Jill Levine's article "Sacrifice and Salvation: Otherness and

Domestication in the Book of Judith," in *A Feminist Companion to Esther, Judith and Susanna,* ed. Athalya Brenner [Sheffield: Sheffield Academic Press, 1995]).

19. This succession of events must form the basis for fundamental criticism of *Artemisia*. According to historical records, Tassi was convicted of raping Artemisia Gentileschi. Why should a film about Gentileschi, a film that, we assume, would take her perspective on things, so readily forgive and trivialize an act of rape against its main character? I will develop my criticism of the film in chapter 6.

20. I will give an in-depth interpretation and criticism of the fusion of Artemisia with Judith in chapter 6. Griselda Pollock criticizes the film for conflating Artemisia and Judith and, thereby, linking the relationship between Judith and Holofernes with that of Artemisia and Tassi. To have Artemisia and Tassi pose as Judith and Holofernes is Merlet's decision, explains Pollock, since, according to the records, Gentileschi's painting postdates the rape trial and Tassi's imprisonment. The film thus abuses the story of Judith and Holofernes by reducing Judith's motivation for decapitating Holofernes to sexual reasons. In this, Pollock says, *Artemisia* follows a tradition of misinterpreting Judith's act in terms of sexual desire only ("A Hungry Eye: What Does *Artemisia* Tell Us about Sex and Creativity?" *Sight and Sound* 8, no. 11 [November 1998], 28). For similar criticism, based on a comparison between apocryphal text, Gentileschi's painting, and Merlet's film, see my article, "Auf Leinwand gebannt: Judith im (Miss-)Verständnis von Malerei und Film" (special issue on Bible and Film, *Biblical Interpretation* 14, nos. 1–2 [2006]).

21. Artemisia's choice of subject is a target for critique of the film. Artemisia reflects on her life by stepping into the role of Judith. If, learning to paint, Artemisia is shown to identify with Judith, then the film offers a problematic view of what it means for a woman to look and to paint. I shall develop this critique in chapter 6.

22. Orazio, well meaning, says once that Artemisia paints like a man, in order to secure a place for her at the Royal Academy of Painting (unit 14).

23. I will argue below, however, that *Artemisia* places too much emphasis on Artemisia's connectedness with what she paints, thereby locking her in traditional ways of being female (see chapter 6).

24. This camera technique leaves much opportunity for criticism. Pollock writes that, despite the potential for transgression of established patterns of looking inherent in Artemisia's act of drawing her own body, the film maintains the conventional, gendered hierarchy of viewing and viewed. While Artemisia undresses to look at her own body, viewers, like in any conventional Hollywood film, simply see a woman undress (Pollock, "A Hungry Eye," 28). I will criticize the look of the camera in chapter 6.

25. One of Mulvey's arguments in "Visual Pleasure" is that the Hollywood films she discusses have a male main character who is in power

of the gaze throughout the whole film. In reality, it is, of course, the
camera that owns the gaze, but Mulvey maintains that Hollywood
films build on the illusion of a male main character in possession
of the gaze so that viewers can identify without feeling powerless
("Visual Pleasure," 62–67). *Artemisia* does not have such a powerful
main character.

26. See chapter 2.
27. Artemisia, as a woman, may look at things in a new way, but the film
as a whole does not present a new way of looking, even though it is
directed by a woman. In fact, the art historian Mary Garrard accuses
it of being "relentlessly masculinist" (see her review "Artemisia's Trial
by Cinema: A New Film by Agnès Merlet on Baroque Female Painter
Artemisia Gentileschi," *Art in America* 86, no. 10 [October 1998],
http://www.findarticles.com/cf_0/m1248/n10_v86/21250047/
p1/article.jhtml?term=artemisia).
28. For an art historian's treatment of Gentileschi's life see Garrard's
books, *Artemisia Gentileschi* (Rizzoli Art Series. New York: Rizzoli,
1993), *Artemisia Gentileschi around 1622: The Shaping and Reshap-
ing of an Artistic Identity* (Discovery Series 11, Berkeley: University
of California Press, 2001), and *Feminism and Art History: Question-
ing the Litany* (Icon Editions. New York: Harper & Row, 1982).
29. It is the misrepresentation of Gentileschi's life that builds the corner-
stone of many critiques of *Artemisia*. Critics argue that the film takes
too many liberties with the historic records on Tassi's and Artemisia's
relationship. The records, according to which Artemisia accuses Tassi
of rape, are seen as offering little basis for the love story Merlet has
created. See for example Pollock, "A Hungry Eye"; Peter Bradshaw,
"Art Attack" (*Guardian* [May 7, 1999], http://film.guardian.
co.uk/News_Story/Critic_Review/Guardian/0,4267,48166,00.
html); Deborah Solomon, "Out of the Past: An Ur-Feminist Finds
Stardom" (*New York Times* [May 3, 1998], 24; and Tracy Marks,
"Artemisia: The Movie." When Artemisia was released in the United
States, Gloria Steinem and Garrard launched a campaign to warn
viewers that the film was not a true story, as Miramax, the production
company, had promised in its advertisement. For Garrard's criticism
of the film, see her article, "Artemisia's Trial by Cinema: A New
Film by Agnès Merlet on Baroque Female Painter Artemisia Gen-
tileschi" (*Art in America* 86, no. 10 [October 1998], http://www.
findarticles.com/cf_0/m1248/n10_v86/21250047/p1/article.
jhtml?term=artemisia). In addition to criticizing the portrayal of the
relationship between Tassi and Artemisia, *Artemisia* has also been
criticized by Pollock and Garrard for reducing Gentileschi's signifi-
cance to this relationship, while neglecting her later life as an artist.
The film, writes Pollock, fits readily into the tradition of twisting
female painters' biographies "to hinge on a powerfully sexual, male

figure," leaving no room for independent, female art ("A Hungry Eye," 27–28 and Garrard, "Artemisia's Trial")."Artemisia's Trial by Cinema: A New Film by Agnès Merlet on Baroque Female Painter Artemisia Gentileschi," *Art in America* 86, no. 10 [October 1998], http://www.findarticles.com/cf_0/m1248/n10_v86/21250047/ p1/article.jhtml?term=artemisia).

CHAPTER 6

1. Sallie McFague, *Super, Natural Christians: How We Should Love Nature*, London: SCM Press, 1997, 68.
2. Ibid., 67.
3. Ibid., 68, 79.
4. Ibid., 71–72.
5. Ibid., 72–73.
6. Ibid., 67–68.
7. Ibid., 92.
8. Ibid., 77.
9. Ibid., 77.
10. McFague coins the term "subject-subjects relationship" in *Super, Natural Christians* (95).
11. McFague, *Super, Natural Christians*, 116.
12. Ibid., 72. McFague refers to Annie Dillard's book, *Pilgrim at Tinker Creek: A Mystical Excursion into the Natural World* (New York: Bantam Books, 1975).
13. McFague, *Super, Natural Christians*, 79. It is, of course, telling that McFague avoids the proper term "multiple perspective" here. The impression she thereby creates is that the Renaissance way of looking is perspectival, whereas the way of looking of primitive art is innocent of perspective. In fact, in a footnote, McFague calls the look of primitive art "nonperspectival" and falls victim to the illusion of realism when claiming that this look was capable of showing things as they were. For her, "the interesting point here is that nonperspectival painting renders things in terms of what they are in themselves (their most characteristic features) rather than how they appear to a viewer; the point of view of so-called primitive (as well as much contemporary art) is, therefore, more 'realistic' or 'objective' in its concern to render the thing characteristically than is the perspectival rendering, where the main concern is how things appear from one privileged point of view, that of the spectator" (187, footnote 1). It is quite unrealistic indeed to idealize one way of looking over another in this way. Instead, it is essential to recognize that both primitive and Renaissance art are ways of looking that make use of, however different, perspectival techniques. Let us be realistic: looking always implies a viewpoint; it cannot be done in a nonperspectival way.

14. McFague, *Super, Natural Christians*, 101–103.
15. Ibid., 103.
16. See chapter 5 for a more detailed description of how Orazio and Tassi distance themselves from what they paint.
17. See chapter 5.
18. See description of this scene in chapter 5.
19. See discussion of Tassi's technique in chapter 5.
20. See description of this unit in chapter 5.
21. See description of this scene in chapter 5.
22. I do not consider Tassi's look as more arrogant than Orazio's simply because he uses linear perspective. On the contrary, Tassi's use of this technique can be a basis to question McFague's characterization of it as arrogant. I offer a critique of McFague's concept later in the present chapter.
23. McFague, *Super, Natural Christians*, 79.
24. See description of this scene in chapter 5.
25. McFague compares the centrality of the painter who uses linear perspective to the centrality of the subject within the Cartesian model of knowledge. Within this model, the world is allowed to show itself only inasfar as it relates to a particular question posed by the subject (*Super, Natural Christians*, 74–75). For a similar view of Descartes' model of knowledge, see also Catharina Halkes's discussion in *New Creation: Christian Feminism and the Renewal of the Earth* (London: SPCK, 1991), 33–40.
26. According to Freud, fetishism originates from the moment when the boy discovers that his mother does not have a penis. The boy understands this fact as a lack on the mother's part and uses the fetish in order to substitute for the "missing" penis (Sigmund Freud, "Fetischismus," in *Psychologie des Unbesußten*, Studienausgabe 3, ed. Alexander Mitscherlich, Angela Richards, and James Stratchey [Frankfurt am Main: S. Fischer Verlag, 1972], 383–384).
27. According to Freud, fetishism is built around the fear of castration. The fact that the mother has no penis is perceived as a threat by the boy. He concludes that he, too, may be castrated by the father and uses the fetish in order to repress the fear of castration (Freud, "Fetischismus," 384). In rare cases, Freud reports, the fetish can even have the ambiguous function of simultaneously hiding and proclaiming castration ("Fetischismus," 387). The wired frame can be seen to work in this twofold way: the wiring reminds Tassi and Artemisia of the dismembering cut while at the same time hiding lack through the realism it enables according to Tassi.
28. See chapter 2 on feminist film theory. Mulvey has explained how women are fetishized by the camera, so that the threat of lack that they pose to the male viewer is hidden ("Visual Pleasure and Narrative Cinema," in *Feminist Film Theory: A Reader*, ed. Sue Thornham [Edinburgh: Edinburgh University Press, 1999], 64–65).

29. See discussion of this scene in chapter 5.
30. See description of this scene in chapter 5.
31. See chapter 5.
32. McFague, *Super, Natural Christians*, 77.
33. See description of this in chapter 5.
34. While emphasizing that she is in touch with what she sees and paints, Artemisia's touching of Fulvio, however, also acts as a destabilizing agent to McFague's idea of the loving look. The touch of the fully clothed Artemisia is intimidating for the naked Fulvio and the simple fact that Artemisia touches Fulvio before drawing him does not make her look loving. I shall use this argument below when I evaluate critically McFague's concept from the perspective of the film.
35. She watches an orgy and is raped (see chapter 5).
36. See description of this in chapter 5.
37. See description of this scene in chapter 5.
38. See description of this scene in chapter 5.
39. Later in this chapter, I argue that people can be objectified in various ways, not only through vision. The film's connection between looking, touching, and sexuality is reminiscent of Freud's view of looking and touching. Freud's view is discussed below.
40. Lacan considers the self-image provided by the mirror as the first appearance of the evolving "I": "We have only to understand the mirror stage as an identification, in the full sense that analysis gives to the term: namely, the transformation that takes place in the subject when he assumes an image" ("The Mirror Stage," in *Écrits: A Selection*, ed. Jacques Lacan, trans. Alan Sheridan [London: Routledge, 1977], 2). According to Lacan, this self-image precedes the identification of the "I" as a subject within language.
41. McFague, *Super, Natural Christians*, 91–92.
42. I explore in chapter 7 the principle of the self-same body at the heart of Lacan's concept of self.
43. In the previous chapter, I explained not only how the painting *Judith Slaying Holofernes*, but also how the voice-overs narrated in the third person show Artemisia's ability to look at her life as though it was someone else's.
44. I explore below in more detail how exactly Artemisia is shown to relate to Tassi by representing herself as Judith and Tassi as Holofernes. The fact that Artemisia as Judith is beheading Tassi as Holofernes does, of course, question the positive view of Artemisia's symbolic competence presented here and creates great ambiguity for viewers.
45. McFague is not the only feminist theologian who privileges the sense of touching over seeing on the grounds of an idealist understanding of touch. Moltmann-Wendel, too, values touch over other senses without acknowledging how hurtful touch can be (*I am My Body: New Ways of Embodiment*, trans. John Bowden [London: SCM Press, 1994], 60–65.).

46. McFague, *Super, Natural Christians*, 94.

47. Sigmund Freud, "Drei Abhandlungen zur Sexualtheorie," in *Sexual-leben*, Studienausgabe 5, ed. Alexander Mitscherlich, Angela Richards, and James Stratchey (Frankfurt am Main: S. Fischer Verlag, 1972), 66.

48. Ibid., 60.

49. McFague, *Super, Natural Christians*, 94.

50. Freud, "Drei Abhandlungen," 60.

51. Mieke Bal, *Reading "Rembrandt": Beyond the Word-Image Opposition* (Cambridge: Cambridge University Press, 1991), 173.

52. She also mentions medieval paintings that intermix nature and human beings on a flat surface without using perspective (McFague, *Super, Natural Christians*, 68).

53. McFague, *Super, Natural Christians*, 93.

54. Ibid., 94.

55. See chapter 5.

56. See description of this unit in chapter 5.

57. McFague, *Super, Natural Christians*, 79.

58. Michel Foucault, "The Eye of Power, " in *Power/Knowledge: Selected Interviews and Other Writings, 1972–77*, ed. Colin Gordon, trans. Colin Gordon et al. (New York: Pantheon, 1980), 155.

59. Chapter 2. For the pattern of dominance and submission inherent in the look, see Ann Kaplan, *Women and Film: Both Sides of the Camera* (London: Routledge, 1993); for the genderedness of the invisible gaze, see Mulvey, "Visual Pleasure."

60. McFague, *Super, Natural Christians*, 69.

61. It is, of course, a contradiction in terms to think of God as invisible and at the same time to use the masculine personal pronoun. I use the masculine form here not because I consider it appropriate but because I wish to draw attention to the still very common paradox of conceptualizing God as invisible while still "seeing him" as masculine. For a discussion on the paradox of an invisible God with a male pronoun see Elizabeth A. Pritchard, "Feminist Theology and the Politics of Failure" (*Journal of Feminist Studies in Religion* 15, no. 2 [Fall 1999]), 51, 59. Pritchard explains that the ability to avoid the gaze of scrutiny has been an index of male privilege (59).

62. Pritchard, "Feminist Theology," 61–62.

63. Ibid., 63–66.

64. See especially Foucault's notion of the invisible surveyor in the central tower of the ideal prison and Lacan's concept of the invisible gaze discussed in chapter 1 of this book.

65. See for example the scene described in chapter 5, of Artemisia in the act of painting the picture.

66. For a discussion of the voice-overs, see chapter 5.

67. See chapter 5 for discussion of Tassi's description of what he sees.

68. Vision and sexual power are often related in Western culture. Mieke Bal discusses Rembrandt's *Tobias Curing His Father's Blindness* as

an example of this connection (*Reading "Rembrandt,"* 298–303). Rembrandt changes the original theme of curing blindness by providing Tobias with a piercing instrument that he uses to remove the veil from his father's eyes. "As a consequence of this 'deviation,'" writes Bal, "the operation is altered from the removal of the veil to the penetration of it" (*Reading "Rembrandt,"* 299). Also, Bal sees a resemblance between the instrument in Tobias's hand and a paintbrush. This similarity strengthens the suspicion that Tobias's vision is seen as an act of penetration. Tobias's vision is not curing but blinding his father.

69. In some respects, the film relates the story of Artemisia's artistic development as a story of a male artist growing up and learning to see. This is evident through parallels between the film and Rembrandt's Tobias as interpreted by Bal. Bal sees Rembrandt's painting as a painting about the development of an artist. She notices that the piercing paintbrush, supposed to cure Tobit's blindness, is directed toward his beard, the sign of age (*Reading "Rembrandt,"* 301). The beard itself is, to Bal, reminiscent not so much of a beard but of a sheet of paper, a surface to be painted on. Thus, Tobias's act of blinding the father with his piercing paintbrush is at the same time his moment of coming into his own as an artist. Bal describes the view of self-generation implied by the allusions to vision, age, and sexual ability: "The father needs to be eliminated in his vital capacity for the son to come into his own. If the son is to become a great visual artist, then the father must not be able to see." (*Reading "Rembrandt,"* 301) The relationship between Tobias and Tobit in Rembrandt's painting thus conflates two relationships: the relationship between father and son and between the young artist and his predecessor. Both relationships are determined by the struggle for sexual ability, for the power to create. The son/young artist can only develop by doing away with the father's/predecessor's power to create; he can only learn to see by blinding the other (*Reading "Rembrandt,"* 301–302). Artemisia, even though she is a woman, fits well into this model of self-generation. As explained above, learning to see, in *Artemisia,* is connected with the power to penetrate. Seeing, in *Artemisia,* is, therefore, an act similar to Tobias's act of seeing/piercing with his pointed paintbrush. Also, seeing is related to the occupation of a privileged viewpoint. In *Artemisia,* the position behind the perspectival frame signifies vision and the power to create and is occupied at the beginning of the film by Tassi, the painting teacher. Learning to see means for Artemisia to acquire the position behind the frame by pushing Tassi away. When painting *Judith Slaying Holofernes,* Artemisia has gained full command of her vision and her power to create at the cost of Tassi's loss of his position behind the frame. Like Rembrandt's Tobias, Artemisia, the novice artist, can only learn to see by "blinding" her teacher.

70. Ann Sutherland Harris, "Gentileschi, Artemisia," in *The Dictionary of Art,* vol. 12, ed. Jane Turner (London: Macmillan, 1996), 307. The

rape trial took place in 1612 (Antonietta Dell'Agli, "Tassi, Agostino," in *The Dictionary of Art*, vol. 30, ed. Jane Turner [London: Macmillan Publishers, 1996], 356). Artemisia Gentileschi produced various paintings of the Judith topos during her lifetime. The painting used in the film was painted by Gentileschi c.1613–1614 and could, therefore, be seen as related to the rape trial. The fact, however, that Gentileschi painted the Judith topos in 1611 already suggests that Gentileschi's interest in the theme is at least in part unrelated to her experience with Tassi (Harris, "Gentileschi, Artemisia," 307).

71. Mieke Bal, "Head Hunting: 'Judith' on the Cutting Edge of Knowledge." *Journal for the Study of the Old Testament* 63 (September 1994): 7. Sigmund Freud, "Das Tabu der Virginität," in *Sexualleben*, Studienausgabe 5, ed. Alexander Mitscherlich, Angela Richards, and James Stratchey (Frankfurt am Main: S. Fischer Verlag, 1972), 226–227.

72. Bal, "Head Hunting," 21. For Freud's connection between the fear of castration and virginity, see "Das Tabu," 224–225.

73. Freud reports the dream of a newly married woman, who, according to him, revealed without doubt the woman's wish to castrate the husband and to keep his penis. According to Freud, the dream shows the bitterness of the young wife toward the husband and her wish to take revenge for the hurt of the defloration. The taboo of virginity, writes Freud, is in place in so-called "primitive" cultures in order to protect the man from the woman's wish for revenge. Freud does offer an alternative interpretation of the young woman's dream—she may simply have wanted to repeat the sexual act—but dismisses this interpretation immediately. Through his dismissal, Freud places the emphasis of his examination on the male fears connected to the act of making love to a virgin rather than on the woman's feelings ("Das Tabu," 225–226).

74. Bal, "Head Hunting," 30.

75. Ibid., 30–31.

76. See chapter 5.

77. Bal, "Head Hunting," 30; the change of speech to the third person plural is mine.

Chapter 7

1. I find it a shame that Marli Feldvoß, writing about *The Tango Lesson*, does not recognize the theme of relation expressed through the dance and the filmmaking. She treats the film in a superficial way as a musical that owes its power to the virtuosity and the beauty of its dancing protagonists (see her article, "Eine Lektion in Sachen Musical," in *No Body is Perfect: Körperbilder im Kino,* ed. Margit Frölich, Reinhard Middel, and Karsten Visarius [Marburg: Schüren, 2001], 128–129).

2. As with *Artemisia,* my interpretation of *The Tango Lesson* is based on a detailed film analysis, which consisted of the following steps: (1) I examined the shots of the film and grouped them into units. Throughout this section, I refer to the script in Appendix 2, as I have done with *Artemisia.* (2) In relation to the film's contents, I looked at contrasts used in *The Tango Lesson* as stylistic features. I examined, for example, the contrasts between dancing and filming, seeing and being seen, light and darkness, leading and following, man and woman, work and private life, closeness and distance, movement and stillness, chaos and order. (3) With regard to the film's form, I examined the camera's relation to the characters. I looked at moments when the camera is close to them and when it is distant, when it is still and when it is moving, and I looked at where the camera is in relation to the source of light in order to find out what impression the camera creates of the characters.

3. Laura Mulvey. "Visual Pleasure and Narrative Cinema," in *Feminist Film Theory: A Reader,* ed. Sue Thornham (Edinburgh: Edinburgh University Press, 1999), 62. See also discussion of Mulvey's theory in chapter 2.

4. Many writers within the field of feminist film criticism have supported Mulvey's analysis in principle, although Mulvey also had to face criticism for her extreme argument that Hollywood films conceptualized all cinemagoers as male (see e.g., Ruby Rich, who challenges Mulvey, asking, "How does one formulate an understanding of a structure that insists on our absence even in the face of our presence?" ["Women and Film: A Discussion of Feminist Aesthetics," *New German Critique* 13 (Winter 1978): 87]). Judith Mayne has tried to find a way out of a film analysis that is preoccupied with the concept of the strictly opposed categories of male and female by focusing on the category of the screen (see her book *The Woman at the Keyhole: Feminism and Women's Cinema* [Bloomington: Indiana University Press, 1990]).

5. Kaja Silverman, *The Acoustic Mirror: The Female Voice in Psychoanalysis and Cinema* (Bloomington: Indiana University Press, 1988), 6.

6. Ibid., 8.

7. Ibid., 7.

8. See for example Christian Metz, who in his book *Language and Cinema* (trans. Donna Jean Umiker-Sebeok [The Hague: Monton, 1974]) argues that cinema is structured like a language that would situate it within Lacan's symbolic order, the world of meaning, and not within reality.

9. Christian Metz, *The Imaginary Signifier: Psychoanalysis and the Cinema,* trans. Celia Britton et al. (Bloomington: Indiana University Press, 1982), 7, 69–71.

10. Silverman mentions writings of Jean-Pierre Oudart, Daniel Dayan, and Jean-Louis Comolli. Oudart and Dayan argue that cinema is characterized by the absence of a fourth side to complement the three sides represented through a picture that appears to be three-dimensional. This fourth side is the side of the unseen spectator who

originally recorded the picture. Oudart describes this spectator as follows: "Every filmic field is echoed by an absent field, the place of a character who is put there by the viewer's imaginary, and which we shall call the Absent One" ("Cinema and Suture," *Screen* 18, no. 4 [Winter 1977/78]: 36. See also Dayan, "The Tutor Code of Classical Cinema," in *Movies and Methods,* ed. Bill Nichols [Berkeley: University of California Press, 1976]). Comolli compares the human eye with the camera. In relation to the camera's more perfect vision, human vision is characterized by lack ("Machines of the Visible," in *The Cinematic Apparatus,* ed. Teresa de Lauretis and Stephen Heath [New York: St. Martins, 1980], 124). This lack gives rise to the wish of disavowing the difference between reality and its photographic representation ("Machines of the Visible," 124).

11. Silverman, *The Acoustic Mirror,* 27.
12. Ibid., 29. See also Mary Ann Doane's "Film and the Masquerade: Theorising the Female Spectator" (in *Feminism and Film,* ed. E. Ann Kaplan. Oxford Readings in Feminism [Oxford: Oxford University Press, 2000]), discussed in chapter 2 of this book.
13. Mulvey, "Visual Pleasure," 65.
14. Ibid.
15. Metz, *The Imaginary Signifier,* 74.
16. Mulvey, "Visual Pleasure," 68.
17. Ibid., 63.
18. Ibid.
19. Ibid., 64.
20. Ibid., 65.
21. Silverman, *The Acoustic Mirror,* 31.
22. Ibid., 31.
23. This split in female identity occurs also in Potter's film *The Gold Diggers* (1983). The film features two women; one, in a magnificent dress, is carried around in a sedan chair by a crew of males, and the other, in plain dress, stands for the actual production of goods, but is not given the credit for her work. Celeste, the workingwoman, works in a bank where all the workers are females who work for their male directors and thus help reproduce the male-dominated system. In *Rage,* the work of the seamstresses is also important but hidden and serves to maintain the system of imbalance where males own the look and females are looked at.
24. Mulvey, "Visual Pleasure," 62.
25. Silverman, *The Acoustic Mirror,* 20.
26. Ibid., 29.
27. I will explain below in what way Sally's and the designer's imaginations are connected.
28. Luce Irigaray, *Speculum of the Other Woman,* trans. Gillian G. Gill (Ithaca: Cornell University Press, 1985), 27.

29. Luce Irigaray, *This Sex Which Is Not One,* trans. Catherine Porter (Ithaca: Cornell University Press, 1985), 170–197.

30. Silverman, *The Acoustic Mirror,* 2.

31. Ibid., 30.

32. Ibid., 30.

33. Ibid., 27.

34. Ibid., 12. In his introductory book on film, James Monaco refers to the technique of presenting within the picture, and ideally in the center, everything that is of importance to the viewers as the "tightly closed form" of Hollywood style (*How to Read a Film: The Art, Technology, Language, History and Theory of Film and Media* [Oxford: Oxford University Press, 1981], 185).

35. Silverman, *The Acoustic Mirror,* 12.

36. Mulvey, "Visual Pleasure," 63.

37. In her later essay, "Afterthoughts on 'Visual Pleasure and Narrative Cinema' Inspired by King Vidor's *Duel in the Sun* (1946)"(in *Feminist Film Theory: A Reader,* ed. Sue Thornham [Edinburgh: Edinburgh University Press, 1999]), Mulvey recognizes the possibility of identification not only of the male but also of the female viewer with the male character, which continues the tradition of trans-sex identification of women.

38. Mulvey refers here to a phase in the life of a child described by Lacan as the "mirror phase," in which the child's identity is constituted by the recognition of its reflection in the mirror that is perceived as more perfect than the child's actual body (Jacques Lacan, "The Mirror Stage," in *Écrits: A Selection,* ed. Jacques Lacan, trans. Alan Sheridan [London: Routledge, 1977], 1–7).

39. Sally Potter, Introduction to the screenplay of *The Tango Lesson,* xii.

40. I shall show in a moment that Sally does in fact appear in *Rage* in a way that she may not be aware of.

41. According to Lacan, the subject, in order to feel meaningful, needs to become a signifier. When acquiring language, the subject becomes a signifier within the chain of signifiers that language is. Thus, it is not so much the subject who acquires language but language that absorbs the subject. The subject is inserted as a signifier into the signifying system of language from which he or she derives her or his meaning as subject (Jacques Lacan, *The Four Fundamental Concepts of Psychoanalysis,* ed. Jaques-Alain Miller, trans. Alan Sheridan [London: Hogarth Press, 1979], 203–215]). The subject within this symbolic order has no freedom of speech but functions instead as a placeholder within a system that exceeds him or her, a system that speaks itself through the subject turned signifier. Lacan describes this process of insertion into a symbolic order as one of alienation in which meaning occurs at the cost of being. The term "alienation," Lacan explains, describes a division of the subject, a division that "if it appears on one side as

meaning, produced by the signifier, it appears on the other as apha-
nisis" (*Four Fundamental Concepts,* 210). Lacan defines "aphanisis" as
a "fading of the subject" (*Four Fundamental Concepts,* 208).

42. On the other hand, of course, the viewers have no direct influence
on the production of a film, since it is only their anticipated wish that
is taken into account. The producers of Hollywood reproduce what
they think the viewers would like to be projected.

43. Irigaray, *Speculum of the Other Woman,* 27.

44. Ibid.

45. Kaja Silverman, *The Threshold of the Visible World* (New York: Routledge,
1996). 73; Jacques Lacan, *The Seminar of Jacques Lacan: Book I; Freud's
Papers on Technique, 1953–54,* trans. John Forrester (Cambridge:
Cambridge University Press, 1988), p. 276.

46. Silverman, *Threshold of the Visible World,* 11.

47. This development takes place during the mirror stage, when the child
appropriates its mirror reflection as Ideal-I. Lacan writes of the appro-
priation: "This jubilant assumption of his specular image by the child . . .
would seem to exhibit in an exemplary situation the symbolic matrix
in which the I is precipitated in a primordial form" ("The Mirror
Stage," 2).

48. Silverman, *Threshold of the Visible World,* 24.

49. Ibid.

50. Lacan, *Seminar,* 145.

51. Silverman, *Threshold of the Visible World,* 42.

52. Ibid., 169.

53. Ibid., acknowledgments.

54. Ibid., 92–93.

55. Ibid., 71.

56. Ibid., 170.

57. The tango has featured in a number of films, such as *Indochine* (Regis
Wargnier, 1991), *Scent of a Woman* (Martin Brest, 1992), *True Lies*
(James Cameron, 1994), and *Happy Together* (Wong Kar Wai, 1997).
The Tango Lesson is unique among these films through its imbrication
of the tango with the plot, the story of Pablo and Sally's relationship.
In all the other films, the tango is danced as a one-off, separated as a
dance scene from the rest of the film.

58. Unit 43 will be interpreted in more detail below.

59. The equality of the partners with respect to dance figures sets the
tango apart from other dances, where it is often the female dancer
who performs the more elaborate figures and thereby acts as decora-
tion of the male dancer. Richard Martin writes about the tango: "What
is most astonishing is that the woman is not called upon to perform
any extraneous gestures unaccompanied by the male—gestures
which do not necessarily typify female liberty (as some dance critics
have averred) but are instead incidents of the male gaze directed to

mandated performance imposed upon the female" ("The Lasting Tango," in *Tango: The Dance, the Song, the Story*, ed. Simon Collier et al. [London: Thames and Hudson, 1997], 176).

60. For a more detailed interpretation of the encounter between Jacob and the angel see chapter 8.

61. According to Martin, the tango, as opposed to other dances, introduces female aggression through the woman's kicks ("The Lasting Tango," 172).

62. Although usually danced by a man and a woman, the tango has also been attractive to many same-sex couples. See such films as *The Conformist* (Bernardo Bertolucci, 1969) and *Happy Together* (see note 57 in this chapter).

63. Martin emphasizes the novelty of this gesture of the woman who invades male space by kicking her leg between her partner's legs (Martin, "The Lasting Tango," 178). In *The Tango Lesson*, the kicks are performed by both dancers.

64. Potter, too, considers *The Tango Lesson* to be about "the attraction of opposites: between Anglo-Saxon and Latin American cultures; between male and female; between the watcher and watched" (Claire Monk, "The Tango Lesson," *Sight and Sound* 12 [1997]: 55).

65. Human subjectivity occurs, according to Lacan, as a succession of splittings between the subject and objects that were once part of the self but became separated from it. Because the subject is outlined more clearly with every split, objects are essential for the subject's existence. In *Four Fundamental Concepts*, Lacan associates the gaze with the position of an object: "In the scopic relation," he says, "the object on which depends the phantasy from which the subject is suspended in an essential vacillation is the gaze" (Lacan, *Four Fundamental Concepts*, 83). The subject's relation to the gaze is, in analogy to the subject's relation to objects, characterized by separation. The gaze is therefore as essential for human subjectivity as is the separated object. Lacan refers to Sartre, who thinks that self-awareness is prompted through the gaze that others direct at the subject, but at the same time contradicts Sartre. The gaze, Lacan thinks, is not a gaze of others but "a gaze imagined by me in the field of the Other" (Lacan, *Four Fundamental Concepts*, 84). Thus, the gaze occurs not so much in the relation between two subjects but helps "the subject sustaining himself in a function of desire" (Lacan, *Four Fundamental Concepts*, 85).

66. Silverman, *Threshold of the Visible World*, 222.

67. Clearly, Pablo exemplifies the Lacanian subject's relation to the gaze by preconceiving the audience's gaze rather than being surprised by it. When dealing with the look of the audience, Pablo is not dealing with the look of others but with the gaze that he imagines in the field of the Other, as Lacan has said (see note 65 in this chapter).

68. Karlheinz Oplustil, "Tango Lesson," *epd Film* 10 (1997): 34.

69. Pablo reads Marlon Brando's autobiography in what may be seen as an allusion to Brando's role in Bernardo Bertolucci's *Last Tango in Paris* (1972).

70. I am interpreting positively the fact that Pablo is very different from what Sally wishes him to be. This fact, however, could also be interpreted negatively. Potter has gone to great lengths in order to emphasize Sally's and Pablo's differences, but may in fact have gone too far for Pablo to be taken seriously. In his over-the-top machismo, Pablo can appear very much a construction of Potter's mind rather than a true Other.

71. The attempt to show parts of a self that have not previously been seen runs as an undercurrent through Potter's work. In an interview just after the release of her film *Orlando* (1993), Potter says it was her intention "to create on screen that sense of recognition of the self, of the hidden or unspoken self, giving voice to something that's been unspoken or suppressed in some way. Rendering Visible" (Penny Florence, "A Conversation with Sally Potter," *Screen* 34, no. 3 [Autumn 1993]: 282).

72. Ursula Vossen comments on Potter's decision to appear in the film, an appearance characterized, as Vossen notes, through close-up portraits. Vossen suspects this will be criticized: "Dies wird man ihr genauso vorwerfen wie man es bei Barbra Streisand, Clint Eastwood oder Mel Gibson merkwürdigerweise nicht tut" (She will be reproached for this in the same way, in which, strangely enough, Barbara Streisand, Clint Eastwood or Mel Gibson are not reproached. "Tango Lesson," *film dienst* 20 [September 1997]: 18). Vossen's cautious statement anticipates Erwan Higuinen's harsh criticism in *Cahiers du Cinéma*. He writes: "Avec *La Leçon de Tango,* sorte d'autofiction cinematographique fortement narcissique, Sally Potter s'est probablement fait plaisir" (With *The Tango Lesson,* a kind of strongly narcissistic, cinematic auto-fiction, Sally Potter has probably pleased herself. "La Leçon de Tango," *Cahiers du Cinéma* 523 [April 1998]: 82). Even though he acknowledges Potter's appearance on screen as a "mise en danger," rather than a *mise en scène,* he still criticizes it: "Mais surtout, alors que le projet semble impliquer une certaine mise en danger de la cinéaste-actrice, celle-ci se donne constamment le beau rôle: Sally Potter en grande artiste brimée par ses producteurs incultes qui devisent bêtement devant leur piscine; Sally Potter en amante éplorée face a Pablo Veron, macho argentin infidèle et changeant qui ne la comprand pas et rêve seulement de devenir une star" (But especially, even though the project seems to imply a certain mise en danger of the director-actress, she constantly gives herself the beautiful role: Sally Potter as grand artist, bullied by her uncultivated producers who converse stupidly in front of their swimming pool; Sally Potter as

tearful lover facing Pablo Veron, macho Argentinian, unfaithful and fickle, who does not understand her and dreams only of becoming a star. "La Leçon de Tango," 82). Claire Monk, however, sees Potter's decision to act differently: "*The Tango Lesson*, based on real experiences from Potter's life, is a significant personal risk, one intensified by Potter's decision to play herself on screen. . . . *The Tango Lesson* will inevitably be rejected by some viewers and critics as self-indulgent. But for a film-maker like Potter who has never marketed herself as a media or screen personality, the experience must have been closer to self-exposure" ("The Tango Lesson," 54).

73. See Silverman's concept of identification, discussed earlier in this chapter.

74. Silverman argues that, in processes of identification, the Other should not be assumed to be the same as the self (see discussion earlier in this chapter).

75. Sadly, Feldvoß cannot appreciate the many layers of meaning of Sally and Pablo's pose in front of the painting of Jacob and the angel and the importance of the scene for the entire film. To her, the scene represents nothing but a frozen pose ("Eine Lektion in Sachen Musical," 129).

76. The baptismal rite is important in the context of Christianity. I employ the term "baptism" here because Potter uses the term in her published screenplay (Potter, *The Tango Lesson*, 58).

77. The continuity between work and love is also emphasized by Monk. She finds that "*The Tango Lesson* is also an exploration of the relationships between pleasure and work, life and art. Rather than dramatizing the distance between rehearsal and performance, inspiration and artefact, *The Tango Lesson* constantly continuity-edits them together" ("The Tango Lesson," 55).

78. Oplustil notes the film's musicality and credits cutter Hervé Schneid with creating this impression (Oplustil, "Tango Lesson," 34).

79. Oplustil explains two different ways of filming dance that have been practiced in dance films. According to one philosophy, the dance should be left intact by filming it from a distance and, if possible, in one single shot. In films that contrast this practice, the camera is itself "dancing" and working with unusual viewpoints as well as with fast montage. *The Tango Lesson* follows the second way of filming the dance, but Oplustil praises it because it still manages not to fragment the dance (Oplustil, "Tango Lesson," 34). Higuinen does not see the camera movements and montage as carried out appropriately. He writes: "L'élan des danseurs est trop souvent cassé par les mouvements de caméra et les effets de montage" (The momentum of the dancers is too often broken by the camera movements and the effects of montage. "La Leçon de Tango," 82). In an interview, Potter said it was her intention that the film itself should dance like a tango (Margret Köhler, "Die Kraft der Bilder," *film dienst* 20 [September 1997]: 34).

80. Potter, Introduction to the screenplay of *The Tango Lesson*, x.
81. See Potter's statement earlier in this chapter.
82. Speaking about Sally, Monk notes her "ambiguous screen presence" and asks the inevitable question: "Is it Potter we are watching, or a construction named 'Sally Potter'?" ("The Tango Lesson," 54).
83. Vossen criticizes *The Tango Lesson* for introducing the issue of feeling Jewish. According to Vossen, the film attempts too much at once: "Die Schwäche von *The Tango Lesson* ist, daß der Film mehr sein will als ein überdurchschnittlicher Tanzfilm und so zum 'Dirty Dancing' für Intellektuelle gerät. Denn der Mythos eines deterministischen Füreinanderbestimmtseins wird mittels Martin Bubers dialogischem 'Ich und du'-Prinzip philosophisch überhöht. Erschwerend kommt hinzu, dass Sally und Pablo ihre empfundene Wurzellosigkeit auf ihre jüdische Identität zurückführen" (The weakness of *The Tango Lesson* is that it wants to be more than an above average dance movie, and that it thus becomes a kind of "Dirty Dancing" for intellectuals. This is because the myth of a being destined towards each other in a deterministic way is philosophically exaggerated via Martin Buber's dialogic "I and Thou"-principle. The fact that Sally and Pablo attribute their perceived lack of roots to their Jewish identity is an additional, complicating factor. "Tango Lesson," 18).

CHAPTER 8

1. See discussion in chapter 6.
2. See my discussion of feminist theological concepts of redemption in chapter 3 of this book.
3. My understanding of seeing thus differs from the way in which the philosophers discussed at the beginning of this book have described vision. Foucault especially has emphasized the total absence of relation in his concept of seeing. According to Foucault, seeing is a visual means of control that avoids the danger of contamination inherent in earlier methods of supervision, methods that were based on the physical presence of the supervisor. (See the discussion of Foucault's work in chapter 1.)
4. In her article "The Look of Love" (*Hypatia* 16, no. 3 [Summer 2001]), Kelly Oliver is searching for a new way of describing vision. She points out that, in much twentieth-century philosophy, vision has been seen as a separation between a seeing subject and a seen object, because the space between them has been theorized as empty. In contrast to such theories, Oliver's new understanding of vision is based on the work of Irigaray, who emphasized the fact that the space between beings is not empty but filled with air and light. Because of the connection through air and light, Oliver maintains that vision, rather than separate, has the potential to connect beings in the sense that it

makes them realize that they live within the same element. Oliver's intention is thus to "develop a new conception of vision that can give birth to a new conception of relationships beyond subject-object/ other hierarchies." ("The Look of Love," 65). Oliver's concept of vision as based within an awareness of the elements is fascinating and can solve a lot of the problems connected with an objectifying look. I wonder, however, how useful her point that vision is based on touch, which she develops later in the article, is. Vision, touch, and hearing are all part of the senses with which human beings perceive the world. As such, they should all be equal, and vision should not need to be approved of on the grounds of its similarity to, or its being based on, one of the other senses.

5. In Christian iconography, a disembodied eye inside a triangle has often served to symbolize God. See also my discussion in chapter 6.
6. See description of this scene in chapter 7.
7. See discussion in chapter 7 for Pablo's fascination with his mirror image.
8. See Erwan Higuinen's criticism, chapter 7, note 72.
9. For the interpretation of the film's technique of simultaneously revealing and hiding the characters both visually and through the narrative see chapter 7.
10. In the previous chapter, I argued that the film occasionally withdraws its characters from view by inserting white screens, pictures that show nothing, into the flow of images. I also pointed out that the film leaves questions unanswered as far as its narrative is concerned.
11. "Word of origin" (Martin Buber, *Ich und Du* [Leipzig: Insel Verlag, 1923], 9).
12. "A human being cannot live without the It. But whoever lives with the It alone is not a human being" (Buber, *Ich und Du,* 43).
13. Buber, *Ich und Du,* 50.
14. "Time after time, the concrete shall burn as presence, return into the element from which it came, be contemplated and lived as presence by human beings" (Buber, *Ich und Du,* 50).
15. Buber, *Ich und Du,* 90.
16. See chapter 3.
17. See the discussion of relationships in chapter 3.
18. The identity of Jacob's opponent is veiled. This effect is created by various techniques. The text uses the word "'îš" ("man") to introduce the opponent (verse 25b), but refers to him in the following verses with the personal pronoun. Asked for his name (verse 30), he does not reveal it and thus draws the reader's attention even more to the fact of his ambiguous identity (Johannes Taschner, *Verheissung und Erfüllung in der Jakoberzählung [Gen 25,19–33,17],* Herders Biblische Studien 27 [Freiburg: Herder, 2000], 153). Verse 29, where Jacob is said to have fought with God and men, seems to

contradict verse 26, where he fights with a single "man." Furthermore, the text uses the motif of the fight during the night to veil the antagonist's identity. The ambiguity of the opponent's identity has encouraged a number of interpretations. Some authors are convinced that the opponent is Esau (see e.g., John G. Gammie, "Theological Interpretation by Way of Literary and Tradition Analysis: Genesis 25–36," in *Encounter with the Text: Form and History in the Hebrew Bible*. Semeia Supplement, 8, ed. Martin J. Buss [Philadelphia: Fortress Press, 1979], 123). This interpretation is based on the fact that Jacob, saying he saw God face-to-face (32:31), uses the same word for "face," "pānîm" that he uses elsewhere to refer to his brother's face (32:21–22 and 33:10). Others argue that Jacob's antagonist is God. Fokkelman bases this argument on parallels between Jacob's struggle with other apparitions of God in Genesis (*Narrative Art in Genesis* [Amsterdam: Van Gorcum, 1975], 219). For the opinion that the opponent is God, see also Karl Elliger, *Kleine Schriften zum Alten Testament* [Munich: Chr. Kaiser Verlag, 1966], 163; Gerhard von Rad, *Genesis: A Commentary* [London: SCM Press, 1972], 324; and Hermann Spieckermann, *Der Gotteskampf: Jakob und der Engel in Bibel und Kunst* [Zürich: Theologischer Verlag, 1997], 19. Michael Fishbane assumes Jacob's antagonist to be a messenger of God and bases this on the relation of Gen. 32:23–33 to Gen. 28:10–22 (*Text and Texture* [New York: Schocken Books, 1979], 53–55). Claus Westermann thinks the opponent is a river demon (*Genesis 12–36: A Commentary* [London: SPCK, 1985], 515). I agree with Taschner who thinks that it is important for an interpretation of Gen. 32:23–33 to maintain the sense of ambiguity that is deliberately created by the text (Taschner, *Verheissung und Erfüllung*, 156–157). Any search for a definitive answer takes the fascination from this text.

19. "The Struggle with the Angel: Textual Analysis of Genesis 32. 23–33," in *Structural Analysis and Biblical Exegesis,* ed. Roland Barthes et al., trans. Alfred M. Johnson, Jr. [Pittsburgh, PA: Pickwick Press, 1974], 26.

20. Barthes, "Struggle," 26–27. For the opposing view that God is the undoubted winner, see Elliger, *Kleine Schriften,* 162–173.

21. For a discussion of the scene where Sally and Pablo pose as Jacob and the angel and of Sally's words on Pablo's answering machine, see chapter 7.

22. I explain in more detail below how it is that Sally and Pablo imagine each other and how they are both blessed.

23. For a more detailed discussion of Delacroix's painting and of ways in which Sally and Pablo are both Jacob and the angel see my article, "I Will Not Let You Go unless You Teach Me the Tango: Sally Potter's *The Tango Lesson*" (*Biblical Interpretation* 11, no. 1 [2003]).

24. "A human being becomes 'I' in relation to the Thou." (Buber, *Ich und Du*, 36).
25. See discussion of this in chapter 7.
26. See chapter 3.
27. "It does not stand outside you, it touches your foundation, and if you say 'soul of my soul' you have not said too much; but beware of wanting to place it within your soul—for then you destroy it" (Buber, *Ich und Du*, 41).
28. See the development of this point in chapter 6.
29. See discussion of this scene in chapters 5 and 6.
30. See chapter 6.
31. "Jacob's being is his wealth" (Spieckermann, *Gotteskampf*, 30).
32. Von Rad explains that in the context in which the story of Jacob originated, a name was not given arbitrarily but would have been seen as closely linked to its bearer's character (Von Rad, *Genesis*, 321).
33. Spieckermann, *Gotteskampf*, 22.
34. "The angel transforms Jacob's fight into a dance. More precisely: While Jacob is fighting, the angel is dancing with him" (Spieckermann, *Gotteskampf*, 82).
35. See interpretation of this scene in chapter 7.
36. Buber, *Ich und Du*, 135.
37. "The one who has been sent in revelation takes away within his eyes an image of God. And the spirit responds with a seeing, with a shaping kind of seeing. Even if we earthly beings will never see God without world, only the world in God, seeing we shape God's *Gestalt* eternally" (Buber, *Ich und Du*, 135).
38. "He listens to what is becoming from within itself, to the way of being in the world; not in order to be carried by it: in order to materialize it as it wants to be materialized by him, whom it needs" (Buber, *Ich und Du*, 71–72).
39. Buber, *Ich und Du*, 89.
40. See chapter 3.
41. Sallie McFague, *Models of God* [Philadelphia: Fortress Press, 1988], 109.
42. I developed this question in chapter 2.
43. See discussion of Butler in chapter 3.
44. See chapter 6.
45. For this argument, see chapter 6.
46. See description of this scene in chapter 7.
47. See discussion in chapter 7.
48. Buber, *Ich und Du*, 115. I offer below a critique of Buber's eternal Thou.
49. Buber, *Ich und Du*, 115.
50. "Every true relation in the world rests on individuation; this is its bliss, for it is the only guarantee of mutual recognition between

diverse beings, and it is its limit, for through it are denied complete knowing and being known" (Buber, *Ich und Du*, 115–116).

51. "This is the eternal origin of art, that Gestalt faces a human being and desires to become work through him. No figment of his soul but phenomenon, which approaches the soul and demands from it its working strength" (Buber, *Ich und Du*, 16).

52. Buber, *Ich und Du*, 17.

53. Ibid., 49–50.

54. "This is the melancholia of human beings, and it is their greatness. For in this way come into existence knowledge, work, image and archetype in the midst of the living" (Buber, *Ich und Du*, 50).

55. Oliver, "The Look of Love," 64–65.

56. See discussion of Butler in chapter 3.

57. For Pritchard's and Daniell's argument see chapter 3.

58. Buber, *Ich und Du*, 138.

59. "The created work is a thing among things, to be experienced and described as a sum of characteristics. But time and time again it can face as incarnation the one who sees receptively" (Buber, *Ich und Du*, 17).

60. Buber, *Ich und Du*, 117, 134.

61. Ibid.

BIBLIOGRAPHY

Aichele, George, and Richard Walsh, eds. *Screening Scripture: Intertextual Connections between Scripture and Film.* Harrisburg, PA: Trinity Press International, 2002.

Ayfre, Amédée. *Cinéma et Mystère.* Paris: Édition du Cerf, 1969.

Ayral-Clause, Odile. *Camille Claudel: A Life.* New York: Harry N. Abrams, 2002.

Bach, Alice, ed. *Women in the Hebrew Bible: A Reader.* London: Routledge, 1999.

Bal, Mieke. "Head Hunting: 'Judith' on the Cutting Edge of Knowledge." *Journal for the Study of the Old Testament* 63 (September 1994): 3–34.

———. *Reading "Rembrandt": Beyond the Word-Image Opposition.* Cambridge: Cambridge University Press, 1991.

Barthes, Roland. "The Struggle with the Angel: Textual Analysis of Genesis 32. 23–33." In *Structural Analysis and Biblical Exegesis,* edited by Roland Barthes et al., translated by Alfred M. Johnson, Jr. Pittsburgh, PA: Pickwick Press, 1974, 21–33.

Beattie, Tina. *New Catholic Feminism: Theology and Theory.* London: Routledge, 2006.

Beauvoir, Simone de. *The Second Sex.* Translated by H. M. Parshley. London: Cape, 1953.

Benshoff, Harry M., and Sean Griffin. *America on Film: Representing Race, Class, Gender, and Sexuality at the Movies.* Oxford: Blackwell, 2004.

Bird, Michael. "Film as Hierophany." In *Religion in Film,* edited by John R. May and Michael Bird. Knoxville: University of Tennessee Press, 1982, 3–22.

Bradshaw, Peter. "Art Attack." *Guardian* (May 7, 1999). http://film.guardian. co.uk/News_Story/Critic_Review/Guardian/0,4267,48166,00.html.

Brenner, Athalya, ed. *The Feminist Companion to the Bible.* Sheffield: JSOT Press, 1993–1995.

Brock, Rita Nakashima. *Journeys by Heart: A Christology of Erotic Power.* New York: Crossroad, 1988.

Buber, Martin. *Ich und Du.* Leipzig: Insel Verlag, 1923.

Butler, Alison. "Feminist Theory and Women's Films at the Turn of the Century." *Screen* 41, no. 4 (Spring 2000): 73–79.

Butler, Judith. *Bodies that Matter: On the Discursive Limits of "Sex."* London: Routledge, 1993.

————. *Gender Trouble: Feminism and the Subversion of Identity.* London: Routledge, 1990.

Caranfa, Angelo. *Camille Claudel: A Sculpture of Interior Solitude.* Lewisburg: Bucknell University Press, 1999.

Cavigelli, Zeno, ed. *Aus Leidenschaft zum Leben: Film und Spiritualität.* Zürich: Benziger, 1993.

Cestaro, Gary P. *Queer Italia: Same-Sex Desire in Italian Literature and Film.* New York: Palgrave Macmillan, 2004.

Chatman, Seymour. *Story and Discourse: Narrative Structure in Fiction and Film.* Ithaca: Cornell University Press, 1978.

Chopp, Rebecca S. "Evas Wissen." *Concilium* 1 (1996): 84–89.

Christ, Carol. "Why Women Need the Goddess: Phenomenological, Psychological and Political Reflections." In *Womanspirit Rising: A Feminist Reader in Religion,* edited by Carol Christ and Judith Plaskow. New York: Harper & Row, 1979, 273–288.

Comolli, Jean-Louis. "Machines of the Visible." In *The Cinematic Apparatus,* edited by Teresa de Lauretis and Stephen Heath. New York: St. Martin's, 1980, 121–142.

Copeland, Mary Shawn. "Differenz als Kategorie in kritischen Theologien für die Befreiung von Frauen." *Concilium* 1 (1996): 102–110.

Daly, Mary. *Beyond God the Father.* London: Women's Press, 1986.

Daniell, Anne. "The Spiritual Body: Incarnations of Pauline and Butlerian Embodiment Themes for Constructive Theologizing toward the Parousia." *Journal of Feminist Studies in Religion* 16, no. 1 (Spring 2000): 5–22.

Davies, Jude, and Carol R. Smith. *Gender, Ethnicity and Sexuality in Contemporary American Film.* Chicago: Fitzroy Dearborn, 2000.

Dayan, Daniel. "The Tutor Code of Classical Cinema." In *Movies and Methods,* edited by Bill Nichols. Berkeley: University of California Press, 1976, 438–451.

Delbée, Anne. *Une Femme.* Paris: Presses de la Renaissance, 1982.

Dell'Agli, Antonietta. "Tassi, Agostino." In *The Dictionary of Art,* edited by Jane Turner. Vol. 30. London: Macmillan, 1996, 355–356.

Dillard, Annie. *Pilgrim at Tinker Creek: A Mystical Excursion into the Natural World.* New York: Bantam Books, 1975.

Doane, Mary Ann. *The Desire to Desire: The Woman's Film of the 1940s.* London: Macmillan, 1987.

————. "Film and the Masquerade: Theorising the Female Spectator." In Kaplan, *Feminism and Film,* 418–436.

————. "Woman's Stake: Filming the Female Body." In Kaplan, *Feminism and Film,* 86–99.

Durham, Carolyn A. *Double Takes: Culture and Gender in French Films and Their American Remakes.* Hanover, NH: University Press of New England, 1998.

Ebert, Roger. "Camille Claudel." *Chicago Sun-Times* (March 9, 1990). http://rogerebert.suntimes.com/apps/pbcs.dll/article?AID=/19900309/REVIEWS/3090302/1023. 9/

Eco, Umberto. *Im Wald der Fiktionen: Sechs Streifzüge durch die Literatur.* Translated by Burkhart Kroeber. Munich: Hanser, 1994.

Eichenberger, Ambros. "Approaches to Film Criticism." In May, *New Image of Religious Film,* 3–16.

Eliade, Mircea. *The Sacred and the Profane: The Nature of Religion.* New York: Harcourt, Brace Jovanovich, 1959.

Eliot, George. *The Mill on the Floss.* London: Penguin, 1965.

Eller, Cynthia. "Divine Objectification: The Representation of Goddesses and Women in Feminist Spirituality." *Journal of Feminist Studies in Religion* 16, no. 1 (Spring 2000): 23–44.

Elliger, Karl. *Kleine Schriften zum Alten Testament.* Munich: Chr. Kaiser Verlag, 1966.

Erickson, John D., Lynn A. Higgins, Dalton Krauss, and Steven Ungar. *Gender and French Film since the New Wave.* Lexington: University of Kentucky, 2002.

Exum, J. Cheryl. *Fragmented Women: Feminist (Sub)Versions of Biblical Narratives.* Journal for the Study of the Old Testament Supplement Series 163. Sheffield: JSOT Press, 1993.

———. *Plotted, Shot, and Painted: Cultural Representations of Biblical Women.* Journal for the Study of the Old Testament Supplement Series 215. Sheffield: Sheffield Academic Press, 1996.

Feldvoß, Marli. "Eine Lektion in Sachen Musical: Zu Sally Potter's *The Tango Lesson.*" In *No Body is Perfect: Körperbilder im Kino,* edited by Margit Frölich, Reinhard Middel, and Karsten Visarius. Marburg: Schüren, 2001, 120–129.

Fishbane, Michael. *Text and Texture.* New York: Schocken Books, 1979.

Florence, Penny. "A Conversation with Sally Potter." *Screen* 34, no. 3 (Autumn 1993): 275–284.

Fokkelman, Jan P. *Narrative Art in Genesis.* Amsterdam: Van Gorcum, 1975.

Foucault, Michel. *The Birth of the Clinic.* Translated by A. M. Sheridan Smith. London: Tavistock Publications, 1973.

———. *Discipline and Punish: The Birth of the Prison.* Translated by Alan Sheridan. Harmondsworth: Penguin, 1979.

———. "The Eye of Power." In *Power/Knowledge: Selected Interviews and Other Writings, 1972–77,* edited by Colin Gordon, translated by Colin Gordon et al. New York: Pantheon, 1980.

———. *Madness and Civilization.* Translated by Richard Howard. London: Tavistock Publications, 1967.

Freud, Sigmund. "Das Tabu der Virginität." In Mitscherlich, Richards, and Stratchey, *Sexualleben,* 211–228.

———. "Der Untergang des Ödipuskomplexes." In Mitscherlich, Richards, and Stratchey, *Sexualleben,* 243–251.

———. "Drei Abhandlungen zur Sexualtheorie." In Mitscherlich, Richards, and Stratchey, *Sexualleben,* 37–145.

———. "Fetischismus." In *Psychologie des Unbesußten,* Studienausgabe 3, edited by Alexander Mitscherlich, Angela Richards, and James Stratchey. Frankfurt am Main: S. Fischer Verlag, 1972, 379–381.

Gammie, John G. "Theological Interpretation by Way of Literary and Tradition Analysis: Genesis 25–36." In *Encounter with the Text: Form and History in the Hebrew Bible.* Semeia Supplement, 8, edited by Martin J. Buss. Philadelphia: Fortress Press, 1979, 117–134.

Garrard, Mary. *Artemisia Gentileschi.* Rizzoli Art Series. New York: Rizzoli, 1993.

———. *Artemisia Gentileschi around 1622: The Shaping and Reshaping of an Artistic Identity.* Discovery Series 11. Berkeley: University of California Press, 2001.

———. *Artemisia Gentileschi: The Image of the Female Hero in Italian Baroque Art.* Princeton, NJ: Princeton University Press, 1989.

———. "Artemisia's Trial by Cinema: A New Film by Agnès Merlet on Baroque Female Painter Artemisia Gentileschi." *Art in America* 86, no. 10 (October 1998). http://www.findarticles.com/cf_0/m1248/n10_v86/21250047/p1/article.jhtml?term=artemisia.

———. *Feminism and Art History: Questioning the Litany.* Icon Editions. New York: Harper & Row, 1982.

Gilligan, Carol. *In a Different Voice: Psychological Theory and Women's Development.* Cambridge, MA: Harvard University Press, 1982.

Gössmann, Elisabeth. "Das Konstrukt der Geschlechterdifferenz in der christlichen theologischen Tradition." *Concilium* 6 (1991): 483–488.

Goldstein, Valerie Saving. "The Human Situation: A Feminine Viewpoint." In *The Nature of Man,* edited by Simon Doniger. New York: Harper, 1962.

Green, Elizabeth. "Das Denken der Geschlechterdifferenz und die Theologie." *Concilium* 1 (1996): 90–95.

Grey, Mary. "Jesus—Einsamer Held oder Offenbarung beziehungshafter Macht? Eine Untersuchung feministischer Erlösungsmodelle." In *Vom Verlangen nach Heilwerden: Christologie in feministisch-theologischer Sicht,* edited by Doris Strahm and Regula Strobel. Fribourg: Edition Exodus, 1991, 148–171.

———. *Introducing Feminist Images of God.* Introductions in Feminist Theology 7. Sheffield: Sheffield Academic Press, 2001.

———. *Redeeming the Dream: Feminism, Redemption and Christian Tradition.* London: SPCK, 1989.

———. *Sacred Longings: Ecofeminist Theology and Globalization.* London: SCM Press, 2003.

Hahn, Johan G. "Die Bedeutung des kleinsten Details—Bausteine zur analytischen Interpretation sich bewegender Bilder." In *Hinter den Augen ein eigenes Bild: Film und Spiritualität,* edited by Michael Kuhn. Zürich: Benziger, 1991, 91–130.

———. *Het zout in de pap: Levensbeschouwing en televisie.* Hilversum: Gooi en Sticht bv, 1988.

———. "A Methodology for Finding the Filmmaker's Weltanschauung in Religious Film." In May, *New Image of Religious Film,* 213–234.

Halkes, Catharina. *New Creation: Christian Feminism and the Renewal of the Earth.* London: SPCK, 1991.

Hampson, Daphne. *After Christianity.* London: SCM Press, 1996.

Hasenberg, Peter. "Der Film und das Religiöse. Ansätze zu einer systematischen und historischen Spurensuche." In *Spuren des Religiösen im Film: Meilensteine aus 100 Jahren Filmgeschichte,* edited by Peter Hasenberg, W. Luley, and Ch. Martig. Mainz: Grünewald Verlag, 1995, 9–23.

Haskell, Molly. *From Reverence to Rape: The Treatment of Women in the Movies.* Chicago: University of Chicago Press, 1987.

Heyward, Isabel Carter. *The Redemption of God: A Theology of Mutual Relation.* Lanham: University Press of America, 1982.

Higuinen, Erwan. "La Leçon de Tango." *Cahiers du Cinéma* 523 (April 1998): 82.

Hunt, Mary E. *Fierce Tenderness: A Feminist Theology of Friendship.* New York: Crossroad, 1992.

Hunter, Anne Marie. "Numbering the Hairs of Our Heads: Male Social Control and the All-Seeing Male God." *Journal of Feminist Studies in Religion* 8, no. 2 (Fall 1992): 8–26.

Hurley, Neil P. *Theology through Film.* New York: Evanston; London: Harper and Row, 1970.

Irigaray, Luce. *Divine Women.* Sydney: Local Consumption Publications, 1986.

———. *This Sex Which is Not One.* Translated by Catherine Porter. Ithaca: Cornell University Press, 1985.

———. *Speculum of the Other Woman.* Translated by Gillian G. Gill. Ithaca: Cornell University Press, 1985.

Isherwood, Lisa. *Introducing Feminist Christology.* Introductions in Feminist Theology 8. London: Sheffield Academic Press, 2001.

Jantzen, Grace. *Becoming Divine: Towards a Feminist Philosophy of Religion.* Manchester: Manchester University Press, 1998.

Jasper, David. "On Systematizing the Unsystematic: A Response." In Marsh and Ortiz, *Explorations in Theology and Film,* 235–244.

Jay, Martin. *Downcast Eyes: The Denigration of Vision in Twentieth-Century French Thought.* Berkeley: University of California Press, 1994.

Jewett, Robert. *St. Paul at the Movies: The Apostle's Dialogue with American Culture.* Louisville: John Knox Press, 1993.

———. *St. Paul Returns to the Movies.* Grand Rapids, MI: William B. Eerdman's Publishing Company, 1999.

Johnston, Claire. "Women's Cinema as Counter-Cinema." In Thornham, *Feminist Film Theory,* 31–40.

Johnston, Robert K. *Reel Spirituality: Theology and Film in Dialogue.* Engaging Cultures. Grand Rapids, MI: Baker Academic, 2000.

Kaplan, E. Ann. ed. *Feminism and Film.* Oxford Readings in Feminism. Oxford: Oxford University Press, 2000.

———. *Women and Film: Both Sides of the Camera.* London: Routledge, 1993.

Karrer, Leo, ed. *Gewaltige Opfer: Filmgespräche mit René Girard und Lars von Trier.* Film und Theologie 1. Cologne: KIM, 2000.

Karrer, Leo, and Charles Martig, eds. *Traumwelten: Der filmische Blick nach innen.* Film und Theologie 4. Marburg: Schüren Verlag, 2003.

King, Ursula. "Das Göttliche als Mutter." *Concilium* 6 (1993): 539–545.

Kirsner, Inge. *Erlösung im Film: Praktisch-theologische Analysen und Interpretationen.* Stuttgart: Kohlhammer, 1996.

Köhler, Margret. "Die Kraft der Bilder." *film dienst* 20 (September 1997): 34–35.

Kohn-Roelin, Johanna. "Mutter. Tochter. Gott." *Concilium* 6 (1993): 497–502.

Koivunen, Anu. *Performative Histories, Foundational Fictions: Gender and Sexuality in Niskavuori Films.* Helsinki: Finnish Literature Society, 2003.

Kreitzer, Larry J. *Gospel Images in Fiction and Film: On Reversing the Hermeneutical Flow.* The Biblical Seminar 84. Sheffield: Sheffield Academic Press, 2002.

———. *The Old Testament in Fiction and Film: On Reversing the Hermeneutical Flow.* The Biblical Seminar 24. Sheffield: Sheffield Academic Press, 1994.

———. *Pauline Images in Fiction and Film: On Reversing the Hermeneutical Flow.* The Biblical Seminar 61. Sheffield: Sheffield Academic Press, 1999.

———. *The New Testament in Fiction and Film: On Reversing the Hermeneutical Flow.* The Biblical Seminar 17. Sheffield: JSOT Press, 1993.

Kuhn, Michael, ed. *Hinter den Augen ein eigenes Bild: Film und Spiritualität.* Zürich: Benziger, 1991.

Lacan, Jacques. *The Four Fundamental Concepts of Psychoanalysis.* Edited by Jaques-Alain Miller. Translated by Alan Sheridan. London: Hogarth Press, 1979.

———. "The Mirror Stage." In *Écrits: A Selection,* edited by Jacques Lacan, translated by Alan Sheridan. London: Routledge, 1977, 1–7.

———. *The Seminar of Jacques Lacan: Book I; Freud's Papers on Technique, 1953–54.* Translated by John Forrester. Cambridge: Cambridge University Press, 1988.

Lanzetta, Beverly J. *Radical Wisdom: A Feminist Mystical Theology.* Minneapolis: Fortress Press, 2005.

Lauretis, Teresa de. "Aesthetic and Feminist Theory: Rethinking Women's Cinema." In *Female Spectators: Looking at Film and Television,* edited by Deidre E. Pribram. Questions for Feminism. London: Verso, 1988, 174–195.

Levinas, Emmanual. *Totality and Infinity: An Essay on Exteriority.* Translated by Alphonso Lingis. Dordrecht, Boston, London: Kluwer Academic Publishers, 1991.

Levine, Amy-Jill. "Sacrifice and Salvation: Otherness and Domestication in the Book of Judith." In *A Feminist Companion to Esther, Judith and Susanna,* edited by Athalya Brenner. Sheffield: Sheffield Academic Press, 1995, 208–223.

Malone, Peter. "Jesus on Our Screens." In May, *New Image of Religious Film,* 57–71.

———. *Movie Christs and Antichrists.* New York: Crossroad 1990.

Marks, Tracy. "Artemisia: The Movie." http://www.geocities.com/tmartiac/artemisia/movie.htm.

Marsh, Clive. "Religion, Theology and Film in a Postmodern Age: A Response to John Lyden." *The Journal of Religion and Film* 2 no. 1 (1998). http://www.unomaha.edu/~wwwjrf/marshrel.htm.

Marsh, Clive, and Gaye Ortiz, eds. *Explorations in Theology and Film: Movies and Meaning.* Oxford: Blackwell, 1997.

Martin, Joel W., and Conrad E. Ostwald, eds. *Screening the Sacred: Religion, Myth and Ideology in Popular American Film.* Boulder, CO: Westview Press, 1995.

Martin, Richard. "The Lasting Tango." In *Tango: The Dance, the Song, the Story,* edited by Simon Collier et al. London: Thames and Hudson, 1997, 170–196.

May, John R., ed. *Image and Likeness: Religious Visions in American Film Classics.* Mahwah, NJ: Paulist Press, 1991.

———. ed. *New Image of Religious Film.* Communication, Culture and Theology. Kansas City: Sheed and Ward, 1997.

May, John R., and Michael Bird, eds. *Religion in Film.* Knoxville: University of Tennessee Press, 1982.

Mayne, Judith. *The Woman at the Keyhole: Feminism and Women's Cinema.* Bloomington: Indiana University Press, 1990.

McFague, Sallie. *The Body of God: An Ecological Theology.* Minneapolis: Fortress Press, 1993.

———. *Metaphorical Theology: Models of God in Religious Language.* London: SCM Press, 1982.

———. *Models of God.* Philadelphia: Fortress Press, 1988.

———. "Mutter Gott." *Concilium* 6 (1993): 545–549.

———. *Super, Natural Christians: How We Should Love Nature.* London: SCM Press, 1997.

Merlet, Agnès. *Artemisia.* PAL TVT 1325. VHS.

Metz, Christian. *The Imaginary Signifier: Psychoanalysis and the Cinema.* Translated by Celia Britton et al. Bloomington: Indiana University Press, 1982.

———. *Language and Cinema.* Translated by Donna Jean Umiker-Sebeok. The Hague: Monton, 1974.

Miles, Margaret. *Seeing and Believing: Religion and Values in the Movies.* Boston: Beacon Press, 1996.

Mitscherlich, Alexander, Angela Richards, and James Stratchey, eds. *Sexualleben.* Studienausgabe 5. Frankfurt am Main: S. Fischer Verlag, 1972.

Moltmann-Wendel, Elisabeth. "Beziehung—die vergessene Dimension der Christologie: Neutestamentliche Ansatzpunkte feministischer Christologie." In *Vom Verlangen nach Heilwerden: Christologie in feministisch-theologischer Sicht,* edited by Doris Strahm and Regula Strobel. Fribourg: Edition Exodus, 1991, 100–111.

———. *I am My Body: New Ways of Embodiment*. Translated by John Bowden. London: SCM Press, 1994.

———. *A Land Flowing with Milk and Honey*. London: SCM Press, 1986.

———. *Rediscovering Friendship: Awakening to the Power and Promise of Women's Friendships*. Translated by John Bowden. Minneapolis: Fortress Press, 2001.

Monaco, James. *How to Read a Film: The Art, Technology, Language, History and Theory of Film and Media*. Oxford: Oxford University Press, 1981.

Monk, Claire. "The Tango Lesson." *Sight and Sound* 12 (1997): 54–55.

Mulvey, Laura. "Afterthoughts on 'Visual Pleasure and Narrative Cinema' Inspired by King Vidor's *Duel in the Sun* (1946)." In Thornham, *Feminist Film Theory*, 122–130.

———. "Visual Pleasure and Narrative Cinema." In Thornham, *Feminist Film Theory*, 58–69.

Mulvey, Laura, and Peter Wollen. *Riddles of the Sphinx* (1977).

Nolan, Steve. "The Books of the Films: Trends in Religious Film-Analysis." *Literature and Theology* 12 (March 1998): 1–15.

Nuytten, Bruno. *Camille Claudel*. Arthaus 500388. DVD.

Oleksy, Elzbieta, Elzbieta Ostrowska, and Michael Stevenson. *Gender in Film and the Media: East-West Dialogues*. Frankfurt am Main: Peter Lang, 2000.

Oliver, Kelly. "The Look of Love." *Hypatia* 16, no. 3 (Summer 2001): 56–78.

Oplustil, Karlheinz. "Tango Lesson." *epd Film* 10 (1997): 33–34.

Orth, Stefan, Joachim Valentin, and Reihnold Zwick, eds. *Göttliche Komö-dien: Religiöse Dimensionen des Komischen im Kino*. Film und Theologie 2. Marburg: Schüren Verlag, 2001.

Oudart, Jean-Pierre. "Cinema and Suture." *Screen* 18, no. 4 (Winter 1977/78): 35–47.

Paris, Reine-Marie. *Camille Claudel*. Washington, D.C.: National Museum of Women in the Arts, 1988.

———. *Camille Claudel 1864–1943*. Paris: Gallimard, 1984.

———. "Interview with Reine-Marie Paris." *Le Journal des Femmes* (January 2004). http://www.linternaute.com/femmes/itvw/0401rmparis.shtml.

Plate, S. Brent, ed. *The Apocalyptic Imagination: Aesthetics and Ethics at the End of the World*. Glasgow: Trinity St Mungo Press, 1999.

———. "The Re-creation of the World: Filming Faith." *Dialog: A Journal of Theology* 42, no. 2 (Summer 2003): 155–160.

———, ed. *Religion, Art and Visual Culture: A Cross-Cultural Reader*. New York: Palgrave, 2002.

———. "Religion/Literature/Film: Toward a Religious Visuality of Film." *Literature and Theology* 12 (March 1998): 16–38.

Pollock, Griselda. "A Hungry Eye: What Does *Artemisia* Tell us about Sex and Creativity?" *Sight and Sound* 8, no. 11 (November 1998): 26–28.

Pomerance, Murray. *Ladies and Gentlemen, Boys and Girls: Gender in Film at the End of the Twentieth Century.* Albany: State University of New York Press, 2001.

Potter, Sally. *The Tango Lesson.* Artificial Eye 151. VHS.

———. *The Tango Lesson.* London: Faber and Faber, 1997.

Praetorius, Ina. "Auf der Suche nach der conditia feminine." *Concilium* 6 (1991): 450–455.

Primavesi, Anne. *Sacred Gaia: Holistic Theology and Earth System Science.* London: Routledge, 2000.

Pritchard, Elizabeth A. "Feminist Theology and the Politics of Failure." *Journal of Feminist Studies in Religion* 15, no. 2 (Fall 1999): 50–72.

Radford Ruether, Rosemary. *Gaia and God: An Ecofeminist Theology of Earth Healing.* San Francisco: HarperSanFrancisco, 1992.

———. "The God of Possibilities: Immanence and Transcendence Rethought." *Concilium* 4 (2000): 45–54.

———. *Sexism and God-Talk.* London: SCM Press, 1986.

———. *To Change the World: Christology and Cultural Criticism.* London: SCM Press, 1981.

———. *Women and Redemption: A Theological History.* London: SCM Press, 1998.

Ranke-Heinemann, Uta. *Putting Away Childish Things: The Virgin Birth, the Empty Tomb and Other Fairy Tales You Don't Need to Believe to Have a Living Faith.* Translated by Peter Heinegg. San Francisco: HarperSanFrancisco, 1992.

Rich, B. Ruby et al. *Chick Flicks: Theories and Memories of the Feminist Film Movement.* Durham, NC: Duke University Press, 1998.

———. "Women and Film: A Discussion of Feminist Aesthetics." *New German Critique* 13 (Winter 1978): 83–107.

Roth, Wilhelm, and Bettina Thienhaus, eds. *Film und Theologie: Diskussionen, Kontroversen, Analysen.* Stuttgart: J. F. Steinkopf Verlag, 1989.

Ryan Musgrave, L. "Liberal Feminism, from Law to Art: The Impact of Feminist Jurisprudence on Feminist Aesthetics." *Hypatia* 18, no. 4 (Fall/Winter 2003): 214–235.

Sartre, Jean-Paul. *Being and Nothingness: An Essay on Phenomenological Ontology.* Translated by Hazel E. Barnes. London: Routledge, 1969.

Sarup, Madan. *Jacques Lacan.* New York: Harvester Wheatsheaf, 1992.

Schneider, Hans-Helmuth. *Rollen und Räume: Anfragen an das Christentum in den Filmen Ingmar Bergmans.* Frankfurt am Main: Peter Lang, 1993.

Schottroff, Luise. *Lydias ungeduldige Schwestern: Feministische Sozialgeschichte des frühen Christentums.* Gütersloh: Chr. Kaiser, 1994.

Schrader, Paul. *Transcendental Style in Film: Ozu, Bresson, Dreyer.* Berkeley: University of California, 1972.

Schroer, Silvia. *Die Weisheit hat ihr Haus gebaut: Studien zur Gestalt der Sophia in den biblischen Schriften.* Mainz: Matthias Grünewald Verlag, 1996.

Schüssler Fiorenza, Elisabeth. *But She Said: Feminist Practices of Biblical Interpretation.* Boston, MA: Beacon Press 1992.

———. *In Memory of Her: A Feminist Theological Reconstruction of Christian Origins.* New York: Crossroad, 1983.

———. *Jesus, Miriam's Child, Sophia's Prophet: Critical Issues in Feminist Christology.* London: SCM Press, 1995.

Sheen, Erica. "The Light of God's Law: Violence and Metaphysics in the '50s Widescreen Biblical Epic." In *Beyond the Biblical Horizon: The Bible and the Arts,* edited by J. Cheryl Exum. Biblical Interpretation 6. Leiden: Brill, 1998, 34–54.

Silverman, Kaja. *The Acoustic Mirror: The Female Voice in Psychoanalysis and Cinema.* Bloomington: Indiana University Press, 1988.

———. *The Threshold of the Visible World.* New York: Routledge, 1996.

Skrade, Carl. "Theology and Films." In *Celluloid and Symbols,* edited by John C. Cooper and Carl Skrade. Philadelphia: Fortress Press, 1970, 1–24.

Smith, Sharon. "The Image of Women in Film: Some Suggestions for Future Research." In Thornham, *Feminist Film Theory,* 14–19.

Solomon, Deborah. "Out of the Past: An Ur-Feminist Finds Stardom." *New York Times,* May 3, 1998, 24.

Spieckermann, Hermann. *Der Gotteskampf: Jakob und der Engel in Bibel und Kunst.* Zürich: Theologischer Verlag, 1997.

Stern, Richard C., Clayton N. Jefford, and Guerric Debona O. S. B., eds. *Savior on the Silver Screen.* New York: Paulist Press, 1999.

Strahm, Doris, and Strobel, Regula, eds. *Vom Verlangen nach Heilwerden: Christologie in feministisch-theologischer Sicht.* Fribourg: Edition Exodus, 1991.

Sutherland Harris, Ann. "Gentileschi, Artemisia." In *The Dictionary of Art,* edited by Jane Turner. Vol. 12. London: Macmillan, 1996, 306–309.

Tamez, Elsa. "Das Leben der Frauen als heiliger Text." *Concilium* 3 (1998): 288–296.

Taschner, Johannes. *Verheissung und Erfüllung in der Jakoberzählung (Gen 25,19–33, 17).* Herders Biblische Studien 27. Freiburg: Herder, 2000.

Tasker, Yvonne. *Working Girls: Gender and Sexuality in Popular Cinema.* London: Routledge, 2000.

Tatum, W. Barnes. *Jesus at the Movies: A Guide to the First Hundred Years.* Santa Rosa, CA: Polebridge Press, 1997.

Telford, William R. "Jesus Christ Movie Star: The Depiction of Jesus in the Cinema." In Marsh and Ortiz, *Explorations in Theology and Film,* 115–139.

Thornham, Sue, ed. *Feminist Film Theory: A Reader.* Edinburgh: Edinburgh University Press, 1999.

Tolbert, Mary Ann. "Mark." In *The Women's Bible Commentary,* edited by Carol A. Newsom and Sharon H. Ringe. London: SPCK, 1992, 263–274.

Trible, Phyllis. *Texts of Terror: Literary-Feminist Readings of Biblical Narratives.* Overtures to Biblical Theology 13. Philadelphia: Fortress Press, 1984.

Valentin, Joachim, ed. *Weltreligionen im Film: Christentum, Islam, Judentum, Hinduismus, Buddhismus.* Film und Theologie 3. Marburg: Schüren Verlag, 2002.

Vanita, Ruth. *Queering India: Same-Sex Love and Eroticism in Indian Culture and Society.* London: Routledge, 2002.

Verbeek, Marjeet. "Too Beautiful to be Untrue: Toward a Theology of Film Aesthetics." In May, *New Image of Religious Film*, 161–177.

Vollmer, Ulrike. "Auf Leinwand gebannt: Judith im (Miss-)Verständnis von Malerei und Film." Special issue on Bible and Film, *Biblical Interpretation* 14, nos. 1–2 (2006): 76–93.

———. "I Will Not Let You Go unless You Teach Me the Tango: Sally Potter's *The Tango Lesson.*" *Biblical Interpretation* 11, no. 1 (2003): 98–112.

Von Rad, Gerhard. *Genesis: A Commentary.* London: SCM Press, 1972.

Vossen, Ursula. "Tango Lesson." *film dienst* 20 (September 1997): 18.

Wall, James. *Church and Cinema: A Way of Viewing Film.* Grand Rapids, MI: William W. Eerdman's Publishing Company, 1971.

Watson, Natalie K. *Introducing Feminist Ecclesiology.* Introductions in Feminist Theology 10. Sheffield: Sheffield Academic Press, 2002.

White, Robert A. "The Role of Film in Personal Religious Growth." In May, *New Image of Religious Film*, 197–212.

Wessely, Christian, Gerhard Larcher, and Franz Grabner, eds. *Zeit, Geschichte und Gedächtnis: Theo Angelopoulos im Gespräch mit der Theologie.* Film und Theologie 5. Marburg: Schüren Verlag, 2003.

Westermann, Claus. *Genesis 12–36: A Commentary.* London: SPCK, 1985.

Xing, Jun, and Lane Ryo Hirabayashi. *Reversing the Lens: Ethnicity, Race, Gender, and Sexuality through Film.* Boulder: University Press of Colorado, 2003.

Zwick, Reinhold. "Pfade zum Absoluten? Zur Typologie des religiösen Films." In *Theologie und Ästhetische Erfahrung: Beiträge zur Begegnung von Religion und Kunst,* edited by Walter Lesch. Darmstadt: Wissenschaftliche Buchgesellschaft, 1994, 88–110.

INDEX

6

Lacan, Jacques, 11, 19, 22–6,
30, 32, 58, 86, 88, 94, 102,
115–18, 130–1, 137, 146–7,
149–50, 154, 173, 175, 181,
183, 195, 198, 235, 237, 245,
252, 257, 258, 261, 263–5
"either you or me" logic, 150, 154
on subjectivity, 265
See language; mirror phase;
self-same body; symbolic
competence
lack, 34, 36, 107–8, 113, 129, 131,
137, 139, 140, 143, 146–8,
150, 170, 236, 256, 262
See the eye; the gaze; phallus
language, 26, 29, 48, 34–5, 52, 58,
63, 86, 94, 146–7, 155, 187,
196, 257, 261, 263
androcentric, 52
founded on male body, 34–5
and materiality, 63, 187
language systems, 6–8, 234
Compare textual systems
Lanzetta, Beverly, 53
leprosy, 17–18
Levinas, Emmanuel, 11, 26–30,
173, 183, 196, 198, 237–8
See infinity; religion; speech;
totality
linear perspective, 101–3, 106–7,
113, 118–20, 122–3, 125,
236, 255–6
Compare multiple perspective
the look, 2, 12–17, 20, 22, 25–6,
31, 35, 42, 95–100, 138, 142,
198, 235
See the eye; the gaze
love relationship, 148–50, 169, 173
loving eye, 66, 101–4, 109–12,
114, 117, 118, 120–1, 125,
127, 132, 149, 257
Compare arrogant eye

male body, 34–5, 72–5, 85, 88, 90,
98, 109, 113, 250, 257
restrictions on looking at, 72–5

the male gaze, 3, 4, 32–3, 35–6,
39, 72–4, 108, 138–40, 144,
197, 253–4, 261–2, 264–5
The Man Who Cried (2000), 214,
228
Martin, Richard, 264–5
Mary, 54, 57
masculinity, 31–4, 36–7, 39, 46,
52–3, 57, 58, 61, 91, 124,
129–30, 137–9, 238, 244,
247, 254, 258, 262
in cinema, 31–3, 36–7, 39, 46,
137–8, 238, 262
masculinization, 31–4, 238
See father figure; invisibility; the
male gaze; phallus; subject
masochism, 33–4
materiality, and language, 63, 187
Mayne, Judith, 261
McFague, Sallie, 44, 49, 57, 66,
101–4, 106, 109, 112, 114–15,
117–25, 127, 132, 171, 196,
199, 244, 255–8
See arrogant eye; loving eye; touch
melodrama, 33
Merlet, Agnès, 4, 38, 79, 82–84,
126–7, 253–4
See Artemisia
Metz, Christian, 6–8, 137–8, 234,
261
methodology, 4–9, 35, 66, 199–
201, 234, 251, 260–1
and question, 6, 7, 8, 66, 200–1
mimicry, 22, 25, 35
mirror, 82, 111, 151, 156, 159–60,
162, 163–4, 167–9, 173,
221–2, 224, 228, 269
See mirror phase
mirror phase, 115–16, 149, 151,
155, 158, 257, 263, 264
models, 71, 73, 82, 84, 87–92,
100, 104–6, 108, 113, 115,
136–7, 139–42, 144–6, 149,
150, 155, 252
in *Rage*, 136–7, 139–42, 144–6,
149, 150, 155